The Art Instinct

THE ART INSTINCT

Beauty, Pleasure, & Human Evolution

DENIS DUTTON

BLOOMSBURY PRESS
NEW YORK · BERLIN · LONDON

Published by Bloomsbury Press, New York

All papers used by Bloomsbury Press are natural, recyclable products made from wood grown in well-managed forests. The manufacturing processes conform to the environmental regulations of the country of origin.

LIBRARY OF CONGRESS CATALOGING-IN-PUBLICATION DATA

Dutton, Denis.
The art instinct : beauty, pleasure, and human evolution / Denis Dutton.—1st U.S. ed.
p. cm.
Includes bibliographical references and index.
ISBN-13: 978-1-59691-401-8 (alk. paper)
ISBN-10: 1-59691-401-7 (alk. paper)
1. Aesthetics. 2. Art—Philosophy. 3. Evolution (Biology) 4. Instinct. I. Title.

BH39. D84 2009
701'.17—dc22
2008028304

First U.S. Edition 2009

1 3 5 7 9 10 8 6 4 2

Designed by Rachel Reiss
Typeset by Westchester Book Group
Printed in the United States of America by Quebecor World Fairfield

For Margit, Sonia, and Ben

Contents

Introduction

These pages offer a way of looking at the arts that flies in the face of most writing and criticism today—a way that I believe has more validity, more power, and more possibilities than the hermetic discourse that deadens so much of the humanities. It is time to look at the arts in the light of Charles Darwin's theory of evolution—to talk about instinct and art.

What can Darwin possibly tell us about artistic creation? To be sure, Darwinian evolution may explain our physical features—the function of the pancreas or the origin of our opposable thumb—but our love for Emily Dickinson's poetry, Bach's Chaconne, or Jackson Pollock's *One: Number 31, 1950*? The idea that humans have a mating instinct—perhaps. A maternal instinct, maybe. But an art instinct? The very idea seems oxymoronic.

Instincts, we tend to think, are automatic, unconscious patterns of behavior. The spider's web that glistens in the morning dew was dictated by a genetic code in the spider's tiny brain. The web may be a lovely sight to our eyes, but its beauty is a mere by-product of a spider's way of enjoying breakfast. From the standpoint of either the spider or the human observer, such pretty accidents of nature are a long way from how we normally regard works of art.

Art works are the most complex and diverse of human achievements, creations of free human will and conscious execution. Art-making requires rational choice, intuitive talent, and the highest levels of learned, not innate, skills. Every member of a web-spinning spider species produces essentially the same web from the same code as every other member. Art works, on the other hand, tend toward a personal expression that gives them dazzling variety: no two Monet water-lily paintings,

Attic tragedies, or Brahms intermezzos are identical—not even two performances of the same tragedy or intermezzo. The arts are about particularity. They bring together traditions, genres, an artist's private experience, fantasy, and emotion, fused and transformed in aesthetic imagination.

On top of this, artistic works and performances are often among the most gaudy and flamboyant of human creations—seemingly the opposite of pragmatic behavior—while at the rarefied level of the most profound and enduring masterpieces, they can reveal an elevated spirituality unparalleled in human experience. Any way you look at it, the arts have nothing to do with the mundane facts of body and brain that Darwinian evolution typically explains.

Everything I've just said about the arts is accurate—except the last sentence. In this book I intend to show why thinking that the arts are beyond the reach of evolution is a mistake overdue for correction.

Darwin himself wrote at the conclusion of *On the Origin of Species*, "In the distant future, I see open fields for far more important researches. Psychology will be based on a new foundation, that of the necessary acquirement of each mental power and capacity by gradation." How right he was: recent years have seen immensely productive applications of Darwinian ideas in anthropology, economics, social psychology, linguistics, history, politics, legal theory, and criminology, as well as the philosophical study of rationality, theology, and value theory. Underlying this Darwinian sea change in research and scholarship is evolutionary psychology, the science that explains many hitherto curious aspects of social, sexual, and cultural life. While it is true that the arts, and the cultural worlds out of which they arise, are immensely complex, they are not isolated from evolution. Why should the study of the arts shut itself off from a perspective that has already enriched and revitalized so many other fields of inquiry?

The arts in all their glory are no more remote from evolved features of the human mind and personality than an oak is remote from the soil and subterranean waters that nourish and sustain it. The evolution of *Homo sapiens* in the past million years is not just a history of how we came to have acute color vision, a taste for sweets, and an upright gait. It is also a story of how we became a species obsessed with creating artistic experiences with which to amuse, shock, titillate, and enrapture our-

selves, from children's games to the quartets of Beethoven, from firelit caves to the continuous worldwide glow of television screens.

This book is about that obsession: its ancient evolutionary sources and how they ultimately affect artistic tastes and interests today. My line of attack is rather different from other approaches. I do not begin with experimental psychology—for example, with studies of how colors or sounds are perceived—and interpret the present character of the arts from those findings. Such an approach explains too much: not only the perception of paintings but the practical use of eyesight and every other sense. Nor do I start off with prehistory, beginning with the invention of jewelry perhaps eighty thousand years ago, moving on to remarkable ivory carvings of mammoths and the haunting cave paintings of Lascaux, in order to come out at the other end talking about Michelangelo and Picasso. Arguments in this manner try to extrapolate too much from a small, fragmentary, and still poorly understood body of surviving Paleolithic art. The state of the arts today can no more be inferred from looking inside prehistoric caves than today's weather can be predicted from the last Ice Age.

I begin instead in chapter 1 with something familiar and down-to-earth: calendars and the kinds of landscape illustrations that decorate them across the world. Like landscape painting and the design of public parks and even golf courses, calendars have an intriguing relationship to the African savannas and other landscape forms hospitable for human evolution. As I will show, human landscape tastes are not just products of social conditioning, stemming from manipulative choices made by calendar manufacturers (or by landscape artists); rather, people who make and sell calendars are catering to prehistoric tastes shared by their customers across the globe.

My method is therefore to start with what we know by direct, first-hand experience: the state of the arts worldwide today. From this vantage point we can then look back toward what is known about human evolution, bolstered by ethnographies describing preliterate hunter-gatherer tribes that survived into the twentieth century, since their ways of life reflect those of our ancient ancestors. Piecing this evidence together, we are able to construct a valid picture of something that, as

I show in chapter 2, has been sought after by philosophers since the Greeks: *human nature*, with its innate interests, predispositions, and inclinations in intellectual and social life, including tastes in entertainment and artistic experience.

An innate human nature applied cross-culturally in turn points to a naturalistic, cross-cultural definition of the concept of art, as discussed in chapter 3. The arts must be understood in terms of a cluster of features—skill display, pleasure, imagination, emotion, and so forth—that normally allow us to identify art objects and artistic performances through history and across cultures. These features are persistent in human life and arise spontaneously wherever artistic forms are adapted or invented, whether for instruction or amusement. Too many disputes in art theory tiresomely rehash the artistic status of amusing modernist provocations, such as Andy Warhol's signed soup cans or John Cage's sitting at a piano with a stopwatch. We need first to focus on what makes *La Grande Jatte* or *Anna Karenina* or the Chrysler Building art. Having established a cross-cultural definition of art as a cluster concept, we can move out from the uncontested center of the arts to discuss (as inevitably we must) controversial objects at the disputed borders of the concept.

Whether a cross-cultural definition of art is even possible is disputed by some anthropologists and art theorists, so the next chapter examines the academic seminar-room objection, "But they don't have our concept of art." The whole idea of asking whether a culture has a "different concept" of art from ours raises a curious challenge: you cannot even call it a different concept of art unless it shares something in common with our concept. Otherwise, why did you use the word "art" in the first place? Chapter 4 explores this paradox, arguing that cross-cultural transformations have been wildly exaggerated and misunderstood by anthropologists and others intent on exoticizing foreign cultures and denying the universality of art.

What does it mean to call the arts evolutionary adaptations? How do the pleasures of playing video games or listening to fugues derive from instinctive processes that were in place tens of thousands of years ago? Is the pleasure-seeking at the heart of artistic experience a by-product of ancient instincts that evolved for other purposes, or is it a discrete instinct in itself? Paleontologist Stephen Jay Gould regarded such high-

order cultural activities as the arts as evolutionarily useless spin-offs of the oversized human brain—phenomena about which evolutionary science can have nothing to say. This false picture ignores the fact that the arts, like language, emerge spontaneously and universally in similar forms across cultures, employing imaginative and intellectual capacities that had clear survival value in prehistory. The obvious surface differences between art forms cross-culturally no more argues against their instinctual origins than the differences between Portuguese and Swahili show that language does not rely on a universal ensemble of instinctive capacities.

Creative storytelling—perhaps the oldest of arts—is found throughout history and, like language itself, is spontaneously devised and understood by human beings everywhere. Chapter 6 examines human pleasure in imaginative fictions, from tales told in preliterate tribes through Greek theater, bulky nineteenth-century novels, and film and televised entertainments today. Far from being derived from sets of cultural conventions, the enjoyment of fiction shows clear evidence of Darwinian adaptation, for instance, in how even very young children can rationally deal with the make-believe aspects of stories, distinguishing story-worlds from each other and from reality with a high degree of innate sophistication. Not only does the artistic structure of stories speak to Darwinian sources: so does the intense pleasure taken in their universal themes of love, death, adventure, family conflict, justice, and overcoming adversity.

The survival value provided by imaginative and linguistic capacities is only part of evolution, however. Darwin himself knew that many of the most visibly striking features of animals are products not of natural selection for survival against the rigors of nature, but of sexual selection. In this separate evolutionary process, what counts is an animal's capacity to generate interest in the opposite sex in order to reproduce. While natural selection can give a bird species brownish feathers that camouflage it on its nest, sexual selection produces the brilliantly colored plumage that birds may use to impress mates. As chapter 7 shows, with human beings, sexual selection explains some of the most creative and flamboyant aspects of the human personality, including the most gaudy, profligate, and "show-off" characteristics of artistic expression.

Chapter 8 turns to three classic disputes in art and aesthetic theory in

order to see how they look in light of evolution: (1) whether artists' intentions should be decisive in interpreting works of art (the "intentional fallacy"); (2) the aesthetic challenge of a convincing art forgery (if everybody loves a fake, and can't distinguish it from an original, why complain?); (3) the artistic status of Dada and its deliberately controversial gestures, such as Marcel Duchamp's famous urinal on a plinth, *Fountain*. These three issues are perennial art-theory talking points because they involve conflicts between contradictory factors in our aesthetic experience: "disinterested" contemplation, for instance, butting up against an instinctive concern with the character of the artist, including admiration of skill.

The conflicts described in chapter 8 show that the art instinct proper is not a single genetically driven impulse similar to the liking for sweetness but a complicated ensemble of impulses—sub-instincts, we might say—that involve responses to the natural environment, to life's likely threats and opportunities, the sheer appeal of colors or sounds, social status, intellectual puzzles, extreme technical difficulty, erotic interests, and even costliness. There is no reason to hope that this haphazard concatenation of impulses, pleasures, and capacities can be made to form a pristine rational system.

Moreover, as I go on to explain in chapter 9, not only cultural traditions but evolved capacities set limits on what is possible for an art form. Smell, for example, despite being of crucial survival value in prehistory and being a source of intense aesthetic pleasure, did not become the basis for a fully developed art tradition. Pitched sounds, in contrast, when combined and rhythmically presented are material for one of the most important art forms of all. This despite the curious fact that a sensitivity to pitched sounds had no particular survival value in our evolutionary past. Added to the paradoxes of the previous chapter, this comparison between smell and music shows the contingent character of our evolved aesthetic responses: the art instinct did not evolve in prehistory and come to flower in the myriad cultures and technologies as a complete, coherent theoretical system.

As objects of feeling, nevertheless, works of art provide some of the most profound, emotionally moving experiences available to human beings. Having begun the book with landscape calendars and chocolate

boxes, and having discussed along the way the high-intensity visual spectacles of Hollywood, soap operas, and romance novels, I turn at the end to the exalted summits of aesthetic experience, what Clive Bell called the "cold white peaks of art"—masterpieces such as the *Iliad*, the cathedral at Chartres, Leonardo's *Lady with an Ermine*, *King Lear*, Breughel's *Hunters in the Snow*, Hokusai's *Thirty-six Views of Mt. Fuji*, Wordsworth's "Tintern Abbey," Schubert's *Winterreise*, Van Gogh's *Starry Night*, and Beethoven's Sonata op. III. Works of this caliber may not have the biggest artistic audiences at any given point in history, but they possess a relentless capacity to arrest attention and excite the mind, generation after generation. Their nobility and grandeur also flow from their ability to address deep human instincts. They will live as long as we do.

A word about animals. Some readers will notice that while animals appear in this book to illustrate generic evolutionary processes, they are completely absent from explanations of the high-order adaptations involved in the human art instinct. This is a deliberate omission. Animal lover though I am, I am bound to say that it does chimpanzees no favors to promote their delightful scrawls to the status of art in the distinctly human sense defined in chapter 3.

In captivity, chimpanzees enjoy brushing vivid colors onto white paper. Indeed, physically altering the sheet—expressing what the philosopher Thierry Lenain has aptly described as the chimp's joy in "disruption"—is the very essence of the thing. Many chimpanzee "art works" exist as objects with aesthetic appeal to us only because trainers remove the paper at the right point; otherwise, the chimp will continue to apply paint till there is nothing to see but a muddy blob.

This "pseudo-artistic play," as Lenain terms it, is a moment-by-moment engagement with pigment that involves no planning or intellectual context. Human art not only requires calculation of effects, it also needs an intention to create something you're going to want to look at after you've finished. Here, the contrast with chimpanzees is most telling: once they have been interrupted, or have ceased of their own accord to brush on paint, chimps show no interest in their productions, never returning again to look at them.

The gulf between human and chimpanzee "art" should be no surprise: our ancestors branched off from theirs six million years ago. The ensemble of adaptations that became the human art instinct go back in our prehistory only a hundred thousand years or so, a tiny one-sixtieth fraction of the time span back to our ancestral split with the chimps. A lot has happened in the meantime, both to their family and to ours.

In contrast to chimps, the single example of an animal adaptation that comes closest to human art-making occurs—amazingly—in a species so remote from *Homo sapiens* that it isn't even a mammal, let alone a primate. The male bower bird of New Guinea displays behavior that, in a human, would certainly be called artistry. His woven bower, which may be six feet or taller, is extravagantly ornamented, both inside and outside. On the floor and on interior walls, the bird arranges clumps of berries, red leaves, displays of flowers, acorns, bright feathers from other birds, iridescent beetle elytra, and, if available, brilliantly colored human detritus—cigarette wrappers, bottle tops, tinfoil, or scraps of magazines.

He then opens his bower to that most demanding critic, the female bower bird. Only when the decorations meet her exacting criteria will she favor their creator with mating rights. What makes the bower bird case so extraordinary is that one sex creates an ornamented object open to imaginative invention that is then critically contemplated by the other sex. The only other animal species that does anything like this is the one that, inter alia, constructs elaborate art galleries on the island of Manhattan and elsewhere.

As I explain in chapter 8, the desire to impress—and bed—a member of the opposite sex with displays of artistic creativity or the ownership of rare objects tastefully arranged is not unknown in our species ("Would you like to come up and see my etchings?"). But as we smile, let us not forget the differences. By any animal standard, the bower bird's performance is stupendous. As with the chimp, however, the bower bird has no interest in his creation once it has done its job. The bowers are constructed for female critical assessment in terms of one single purpose. They are not part of an artistic culture, to be preserved, discussed, and appreciated outside a pattern of animal mating. Yes, the most fascinating bowers in New Guinea are evolutionary products that may remind

us of Simon Rodia's Watts Towers or Antonio Gaudí's Sagrada Família in Barcelona. But these architectural achievements are fundamentally different because they emerge in the context of human culture and self-consciousness.

The Art Instinct is a book about human beings and the peculiarly human impulses and drives that underlie our culture. It is entirely in the Darwinian spirit that we respect other animals as the astonishing creatures they are, with purposes precisely suited to their lives. From beaver dams to African termite mounds to New Guinea bowers, animals construct stunning objects and put on spectacular performances. Animals, nevertheless, do not create art.

Hauling in animal instincts to compare with human activities can be a suitable way to show the grand continuity of life as Darwin understood it. But it can also be a rhetorical strategy to cut humans down to size, to reduce one (human) thing to another, much simpler (animal) thing. There is no such reductionist or deflationary strategy entailed by Darwinian aesthetics. In *The African Queen*, the Humphrey Bogart character excuses his drinking by telling Rose Sayer, played by Katharine Hepburn, that "it's only human nature." It may surprise some readers, but this book is on the side of Rose's famous retort: "Nature, Mr. Allnut, is what we are put in this world to rise above." There is no need to accept Rose's theology in order to acknowledge that great works of music, drama, painting, or fiction set us above the very instincts that make them possible. Paradoxically, it is evolution—most significantly, the evolution of imagination and intellect—that enable us to transcend even our animal selves, and it is a purpose of this book to show how natural and sexual selection placed *Homo sapiens* in this odd situation.

It follows from my approach that after the analysis is done, the aesthetic masterpieces we love so much lose nothing of their beauty and importance. This makes *The Art Instinct* different from recent evolutionary treatments of religion. Religion by its very nature makes grand claims about morality, God, and the universe. It follows necessarily that explaining religious beliefs in terms of an evolutionary source attacks

religion at its core. Works of art, however, seldom make overt assertions of fact or instruct people on how they must behave. Art's world of imagination and make-believe is one where analysis and criticism spoil none of the fun.

For the last fifty years an assortment of interlocking ideas in philosophy and the humanities has preached pessimism about the possibility of cross-cultural understanding in matters aesthetic. Strands in the philosophy of Wittgenstein were construed as pointing toward the irreducible uniqueness of what he termed "forms of life." In linguistics, Benjamin Lee Whorf persuaded many people that different languages imposed radically different mental worlds on their speakers. Thomas Kuhn's influential *The Structure of Scientific Revolutions* (1962) convinced generations of college students that epochs in science were so intellectually sealed off from each other that mutual comprehension and criticism was impossible. If even chemists and astronomers working in different "paradigms" could not communicate, what chance would any of the rest of us have of bridging the gulf that separates us from people in remote cultures?

Anthropology appeared to support this outlook. In an understandable reaction against the racism and ethnocentrism of earlier attitudes toward tribal peoples, anthropologists in the postwar period turned away from a search for cross-cultural values that might form a universal human nature governed by evolutionary principles. Under the shadow of writers such as Margaret Mead and Clifford Geertz, young ethnographers were expected to return from fieldwork arguing that the worldviews and values of their tribes were unique, special, and not comparable to those of Western culture. Since indigenous tribes constructed their own cultural realities, it was foolish or, worse, imperialistic and demeaning even to compare their ways of life with ours. It went "without saying," as one anthropologist put it, that indigenous, preliterate tribes did not have "art" in our sense. After all, if Eskimos had five hundred words for snow, it followed that they must experience a cultural world altogether alien from ours.

When I headed for rural India as a Peace Corps volunteer after college, it is fair to say that I accepted most of this outlook, not only the

myth of the Eskimo snow vocabulary but the idea of a general incomparability of cultures. In Andhra Pradesh, however, these academic dogmas came up against my experience of village reality. To be sure, an ancient culture that speaks a Dravidian language and is permeated by a caste system and Hinduism is not Southern California. But the fundamental human categories—the hopes, fears, vices, follies, and passions that motivate human life—were entirely intelligible, as was much of India's art. Although my musical background had been limited to the European canon, in particular piano literature, I learned the sitar in Hyderabad at the feet of Pandit Pandurang Parate, himself a student of Ravi Shankar. Learning that instrument and some of its repertoire opened doors to a musical world no more remote from Western music than Carlo Gesualdo is from Duke Ellington. The lure of rhythmic drive, harmonic anticipation, lucid structure, and divinely sweet melody cuts across cultures with ease.

Years later I was able to head in another aesthetic direction, expanding a keen interest in Oceanic sculpture with fieldwork in the Sepik River region of northern New Guinea. Based in the Middle Sepik village of Yentchenmangua, I studied with Pius Soni and his cousin Leo Sangi, both redoubtable carvers, along with their mentor Petrus Ava. My principal research objective was to find out if local criteria for beautiful art agree with what Western aficionados and connoisseurs of Sepik art call beautiful. My conclusion was unequivocal: Sepik standards of beauty closely match the opinions of Western experts, including curators and collectors who enjoy a wide experience with Sepik museum collections but who have never set foot in the country.

But then, the whole idea that art worlds are monadically sealed off from one another is daft. Do we need to be reminded that Chopin is loved in Korea, that Spaniards collect Japanese prints, or that Cervantes is read in Chicago and Shakespeare enjoyed in China? Not to mention pop music and Hollywood movies, which have swept the world. The time is right for a reexamination from the widest possible perspective of aesthetic pleasure and achievement. Indeed, bringing an understanding of evolution to bear on art can enhance our enjoyment of it. A determination to shock or puzzle has sent much recent art down a wrong path. Darwinian aesthetics can restore the vital place of beauty, skill, and pleasure as

high artistic values. Charles Darwin laid the foundation for the proper study of art as not only a cultural phenomenon, but a natural one as well. I hope I have done justice both to him and to the great artists whose achievements so captivate us.

CHAPTER 1

Landscape and Longing

I

America's Most Wanted was an audacious painting, even by the inflated standards of the contemporary art scene. In 1993, Vitaly Komar and Alexander Melamid, expatriate Soviet artists who had settled in the United States, received money from the Nation Institute to study the artistic preferences of people in ten countries. They oversaw a detailed worldwide poll, conducted for them in the United States by Marttila & Kiley and by various other public opinion firms overseas. In some locales, the polls were followed up with town hall meetings and focus groups. All participants were asked what they would like to see a picture of, whether they preferred interior or landscape scenes, what kinds of animals they liked, favorite colors, what sorts of people they enjoyed seeing depicted—famous or ordinary, clothed or nude, young or old—and so forth. Extrapolated to the general populations of the countries polled, the graphs and tables of figures produced by Komar and Melamid's People's Choice project claimed, not unreasonably, to be a reliable report on the artistic preferences of "close to two billion people."

But this project produced more than numerical preferences: these talented artists (they were originally trained as socialist realists) then went on actually to paint most-wanted and least-wanted paintings for every country in the study—pastiches based on favorite colors, shapes, and subject matters for each nationality.

The least-wanted paintings are bad news for anyone hoping someday

to see modernist abstraction achieve mass acceptance. People in almost all nations disliked abstract designs, especially jagged shapes created with a thick impasto in the commonly despised colors of gold, orange, yellow, and teal. This cross-cultural similarity of negative opinion was matched on the positive side by another remarkable uniformity of sentiment: almost without exception, the most-wanted painting was a landscape with water, people, and animals. Since the overwhelmingly favorite color in the world turned out to be blue, Komar and Melamid used blue as the dominant color of their landscapes. Their *America's Most Wanted*, the painting based on the poll results from the United States, combined a typical American preference for historical figures, children, and wild animals by placing George Washington on a grassy area beside an attractive river or lake. Near him walk three clean-cut youngsters, looking like vacationers at Disneyland; to their right two deer cavort, while in the water behind Washington a hippopotamus bellows.

To consider the survey seriously and then turn to Komar and Melamid's painted results is to realize you've been conned. It is as though the Nation Institute had been persuaded by two clever chefs to commission an expensive poll to determine America's most-wanted food. The chefs study the resulting statistical preferences—a highly varied list that is nevertheless topped by ice cream, pizza, hamburgers, and chocolate—and then come up with America's most-wanted food: hamburger-flavored ice cream with chocolate-coated pizza nuggets. Just because people like George Washington, African game, and children in their pictures, it doesn't follow that they want them all in the same one.

It would be wrong, however, to write off the People's Choice project as worthless, for it did reveal one stunning fact. People in very different cultures around the world gravitate toward the same general type of pictorial representation: a landscape with trees and open areas, water, human figures, and animals. More remarkable still was the fact that people across the globe preferred landscapes of a fairly uniform type: Kenyans appeared to like landscapes that more resembled upstate New York than what we might think of as the present flora and terrain of Kenya. In an interview in *Painting by Numbers*, the book that presented the data and paintings for the project, Alexander Melamid remarks (apparently into a tape recorder):

It might seem like something funny, but, you know, I'm think-
ing that this blue landscape is more serious than we first be-
lieved. Talking to people in the focus groups before we did our
poll and at the town hall meetings around the country after . . .
almost everyone you talk to directly—and we've already talked
to hundreds of people—they have this blue landscape in their
head. It sits there, and it's not a joke. They can see it, down to
the smallest detail. So I'm wondering, maybe the blue landscape
is genetically imprinted in us, that it's the paradise within, that
we came from the blue landscape and we want it . . . We now
completed polls in many countries—China, Kenya, Iceland, and
so on—and the results are strikingly similar. Can you believe it?
Kenya and Iceland—what can be more different in the whole
fucking world—and both want blue landscapes.

He goes on to say that a dream of modernism was to "find universal
art," that "the square was what could unite people." But modernism's
dream turns out to be a delusion: "The blue landscape is what is really
universal, maybe to all mankind."

Komar and Melamid drop the subject, but it is raised again by the phi-
losopher and art critic for the *Nation*, Arthur Danto, in his philosophical
meditation on the most-wanted paintings. He is annoyed by George
Washington and a hippo sharing the scene, calling *America's Most Wanted*
a "mischievous" painting that ironically no one actually wants. He also
finds it predictable that a poll of American tastes should yield a landscape
in "Hudson River Biedermeier" style. But he, too, is surprised that

throughout the world the results have been strikingly congru-
ent, in the sense that each country's *Most Wanted* looks like, give
or take a few details, every other *Most Wanted* . . . And it is at
the very least cause for reflection that what randomly selected
populations of the world round "most want" are paintings in the
generic, all-purpose realist style the artists invented for *America's
Most Wanted* . . . The "most wanted painting," speaking transna-
tionally, is a nineteenth-century landscape . . . the kind of paint-
ing whose degenerate descendants embellish calendars from
Kalamazoo to Kenya.

Danto then tosses out a remark that is consistent with Melamid's meditation and, if true, would undermine a generation or two of art theory (including Danto's own theory of art): "The 44-percent-blue landscape with water and trees must be the a priori aesthetic universal, what everyone who thinks of art first thinks of, as if modernism never happened."

As if modernism never happened? Having put forward this hypothetical challenge to his own deeply held theoretical commitments, Danto then tries to explain the uncanny cross-cultural uniformity: "It is possible, of course, that everyone's concept of art was formed by calendars (even in Kenya), which now constitutes a sort of paradigm of what everyone thinks of when they think of art." Referring to psychological research that shows there are paradigms that govern what people will think of first when asked to identify something in a category (asked to name a bird, people will usually think robin or sparrow, not albatross or kiwi), Danto tries to argue that calendars have come to govern worldwide what people initially think of when they think of art. This would explain, he suggests, the worldwide resistance to modernism. "It is altogether likely," he says, "that what Komar and Melamid have unearthed is less what people prefer than what they are most familiar with in paintings."

Danto's analysis presupposes that picture preferences are culturally produced and are indefinitely malleable, depending on what our culture makes familiar to us. When we think of a robin (instead of a grebe) if asked to imagine a bird, or think of a man (instead of a woman) if asked to imagine an airline pilot, we fall victim to stereotypes derived from childhood socialization—our experiences of walking in the park or flying in airplanes. For Danto, it all must come down in the end to enculturation: there is no category of *natural* interests in pictorial representations. "That would be why," Danto claims, "when throughout history anything has deviated significantly from the predominantly blue landscape, the spontaneous response has been that it is not art." It follows that the true villain in the persistent, worldwide resistance to modernism—roughly, abstraction—is therefore the world calendar industry: "Why else would the Kenyans, for example, come out with the same kind of painting as everyone else even though 70 percent of them answered 'African' to question 37—'If you had to choose from the following list, which type of art would you say you prefer?'—when the other choices were Asian,

American, and European?" Danto then concludes his analysis with three contentious sentences:

> There is nothing in the least African about the Hudson River Biedermeier style of landscape with water. But it may be exactly with reference to such images that Kenyans learned the meaning of art. It is no accident that in the Kenyan questionnaire, in response to the question on what types of art people have in their homes, 91 percent mentioned prints from calendars (though, in fairness, 72 percent mentioned "prints or posters").

This position on the blue landscapes is consistent and thoughtful. It is also profoundly wrong. First, an incidental point: it is incorrect to say that there is nothing African about the landscape in *America's Most Wanted*. Remove George Washington, the children, and the deer and, even with the apparently deciduous tree in the foreground, the landscape could pass for one of the mountainous areas of East Africa, e.g., much of Mount Kenya National Park. Speaking of visual stereotypes, Danto himself may be in the thrall of images of the dusty plains that extend from eastern Kenya and into Somalia and Ethiopia, but central Kenya has many areas with mountains, rivers, and lakes. Even if most Kenyans involved with the poll did not live in the mountainous areas, they would know of them.

Danto argues that if Kenyan landscape preferences happen to coincide with Hudson River Biedermeier, it is because Hudson River imagery has somehow been powerfully embedded in African minds. He believes he has fingered the source for this: the calendars that 91 percent of Africans report having in their homes. Although he momentarily raises the theoretical possibility that a liking for blue landscapes might be an innate feature of the human mind, he quickly discards the notion, placing the blame squarely on the calendar industry. In Danto's frame, an African liking for images of a certain type can only be explained by exposure to other images, a process of visual enculturation. This is consistent with his art critic's eye for the issue: he sees *America's Most Wanted* in terms of Biedermeier and Hudson River School styles, rather than seeing Komar and Melamid's painting for what it is as a realist representation—a generic, lushly forested scene of hills surrounding

water that could be anywhere from New York to New Zealand to Alaska to Asia to Africa.

Danto's certainty that landscape tastes must be acquired by individuals through exposure to images is an unexamined presupposition, and a false one at that. Human and animal life in general may be full of interests, inclinations, and sentiments that are not learned, from the experience either of images or of anything else, though they may be elicited and shaped by experience and learning. An example: the window of my office at the New Zealand university where I teach is high, and its ledge offers a convenient perch and nesting place for pigeons. Whatever their charms, these creatures, alas, are extremely messy; they finally made the ledge so unhygienic that the window had to be kept shut at all times. How to keep them away? My solution is a rubber snake on the ledge. I have seen the birds land on the ledge, see the snake, and immediately depart. They don't come back. The odd fact is that, although European pigeons have been in New Zealand for a couple of hundred pigeon generations, there are no snakes in New Zealand and never have been. The phobic reaction of the birds is therefore learned neither from exposure to snakes nor from images of snakes. In snake-free New Zealand it is a perfect instance of a natural atavism: an innate fear-response that is passed, unnecessarily in these parts, from generation to generation of pigeons.

Human responses to landscapes also show atavisms, and the Komar and Melamid experiments are a fascinating, if inadvertent, demonstration of this. The lush blue landscape type that the Russian artists discovered is found across the world because it is an innate preference. This preference is not explained just by cultural traditions. Specifically, the suggestion that the pervasive power of the worldwide calendar industry might explain why even Kenyans think Hudson River School when asked about favorite pictures evades a more plausible hypothesis: that calendars—and the picture preferences they reveal in completely independent cultures—tap into innate inclinations. This fundamental attraction to certain types of landscapes is not socially constructed but is present in human nature as an inheritance from the Pleistocene, the 1.6 million years during which modern human beings evolved. The calendar industry has not conspired to influence taste but rather caters to preexisting, precalendrical human preferences. The tantalizing question is: why is there such a persistent preference for the blue, watery landscape?

II

The psychological literature on paradigm theory is what Danto appeals to in his explanation of why Kenyans gave the same response as everyone else when asked for their favorite landscape. There exists, however, another body of psychological scholarship that is much more potent in addressing cross-cultural landscape tastes. It is a wide-ranging literature, some of it statistical (not unlike Komar and Melamid's poll) and also theoretical, offering hypotheses to explain pervasive tastes for natural habitats. Though the ideas behind it are old, it was initiated in its contemporary incarnation in the 1970s by Jay Appleton, particularly in his book *The Experience of Landscape*. Appleton's ideas were deepened and extended by Roger S. Ulrich, connected to larger issues of cognition and perception by Stephen and Rachel Kaplan, and validated and given a summary expression by Gordon H. Orians and Judith H. Heerwagen. Orians put forward a general account of the kind of ideal landscape that human beings would find intrinsically pleasurable. In his formulation, this landscape has much in common with the savannas and woodlands of East Africa where hominids split off from chimpanzee lineages and much of early human evolution occurred; hence it is called "the Savanna Hypothesis." Briefly, this landscape type includes these elements:

- open spaces of low (or mown) grasses interspersed with thickets of bushes and groupings of trees;
- the presence of water directly in view, or evidence of water nearby or in the distance;
- an opening up in at least one direction to an unimpeded vantage on the horizon;
- evidence of animal and bird life; and
- a diversity of greenery, including flowering and fruiting plants.

By now, this research is developed enough to be able to say much more about innate landscape preferences. These preferences turn out to be more than just vague, general attractions toward generic scenes: they are notably specific. African savannas are not only the probable scene of a significant portion of human evolution, they are to an extent the habitat meat-eating hominids evolved for: savannas contain more protein

per square mile than any other landscape type. Moreover, savannas offer food at close to ground level, unlike rain forests, tropical or temperate, which are more easily navigable by tree-dwelling apes.

Human beings are less attracted to absolutely open, flat grasslands and more toward a moderate degree of hilly undulation, suggesting a desire to attain vantage points for orientation. Verdant savannas are preferred experimentally to savannas in the dry season. The type of savanna that is ideal appears to be the very savanna imitated not only in paintings and calendars but in many great public parks, such as portions of New York's Central Park. The modern design of golf courses can make stunning use of such savanna motifs.

It is not only the presence of trees that can increase appeal but of trees tending to specific descriptions. High-quality savannas are characterized by *Acacia tortilis*, a spreading tree that branches close to the ground. Tests by Orians and Heerwagen show a cross-cultural preference for trees with moderately dense canopies that fork near the ground (a common tree type in seventeenth-century Dutch landscape painting). Trees with either skimpy or very dense canopies were less preferred, as were trees whose first branches were well out of human reach. A climbable tree was a device to escape predators in the Pleistocene, and this life-and-death fact is revealed today in our aesthetic sense for trees (and in children's spontaneous love for climbing them).

Landscape preference is not always for wildness, a sense of virgin territory, which can appear intuitively forbidding. In particular, the attraction of natural savanna-like scenes can be increased by signs of human habitation—control and intervention. The preferred areas of low grasses may appear to have been grazed by domestic stock. A road going into the distance can increase appeal, or a cottage with smoke curling up from the chimney. Such post-Pleistocene signs of settlement or agriculture have become clichés in calendar or greeting-card art perhaps because they seem to humanize a landscape, rendering it less threatening.

Responses to landscape also depend on possibilities for exploration and orientation, "reading" a terrain. Experimental work by Stephen and Rachel Kaplan shows that the most desirable landscapes have a moderate degree of complexity. Extremes of intricacy, such as an impenetrable forest or jungle, or boring simplicity, such as a flat, open plain, are undesirable extremes. Preferred landscapes are characterized by coherence

and legibility: terrain that provides orientation and invites exploration. A sense of a natural or man-made path is the most common cue for exploration, along with a surface that is even enough for walking. Appealing landscapes frequently center attention, therefore, on a riverbank that disappears around a bend or a walking path that leads into hills or down to a fertile valley. Provision of a focal point or glimpse of a horizon increases the intelligibility of a scene, and hence visual appeal.

The Kaplans have also stressed a preference for an element of mystery, which they define as a feeling that "one could acquire new information if one were to travel deeper into the scene"—following the path or looking around the bend. They speculate that a sense of mystery implies a "longer-range, future aspect" of landscape preference. More than any other component of landscape characteristics, mystery stirs the human imagination and as such is vitally important to landscape as an art form.

Finally, one of Jay Appleton's most original hypotheses continues to be compelling: his idea of "prospect and refuge." A fundamental element in the attractiveness of a landscape, he suggests, is whether it affords the ability to see without being seen. Human beings like a *prospect* from which they can survey a landscape, and at the same time they enjoy a sense of *refuge*. A cave on the side of a mountain, a child's tree house, a house on a hill, the king's castle, the penthouse apartment, and a room with a view are situations with appeal (in fact, with a few exceptions, higher-elevation real estate for housing is more expensive worldwide). People prefer to observe an open but unfamiliar park from its edges rather than stride immediately to its center. Protection afforded by an overhang of some sort (trees, cliff face, trellis, roof) is preferred, along with a sense of being "safe" from observation or attack from behind. The most attractive landscapes tend to combine some of these elements, in pictures as much as in reality. In fact, most landscape representation in the history of painting places the implied viewer either at some desirable vantage point—a cliff edge, perhaps, typically looking down into a valley—or, if at ground level, at a somewhat greater height than what would be accurate for a six-foot human being. (Even in many cityscapes, try to work out the observation point, and the artist seems to be standing on a ladder.)

These landscape preferences and related landform interests have over the last two decades been subject to extensive empirical research. In a

well-known experiment that has been replicated, J. D. Balling and J. H. Falk showed photographs of five natural landscape types to six different age groups, each of which was asked about their preferences to "live in" or to "visit" each. The landscape types were tropical forest, coniferous forest, deciduous forest, East African savanna, and desert. None of the photographs included water or animals. The age groups were eight, eleven, fifteen, eighteen, thirty-five, and seventy and over. From age fifteen on, landscape preferences were varied, with an equal liking for deciduous forest, savanna, and coniferous forest, all three of which still outrated tropical forests and desert, the latter being the least preferred in all age groups. The most striking finding was in the youngest group: eight-year-olds preferred savannas for both living and visiting above all the other age groups. It is hard to explain this result from habituation, since, just as with Komar and Melamid's Kenyans who had never seen the Hudson River, none of the eight-year-olds had ever been in a savanna environment.

These age-related findings have been elaborated by Erich Synek and Karl Grammer, who demonstrated a significant change in landscape reactions that accompanies the onset of puberty: younger children prefer flatter, savanna-type landscapes of low complexity. By age fifteen they have come to favor more mountainous, complex landscapes with more trees. Synek and Grammer regard this as a partial replication of Balling and Falk, but they also see it as demonstrating that outdoors experience increases sophistication in responses to landscapes.

In other words, outdoors experience pulls landscape taste away from its early-age default setting. But such variations do not prove either subjective relativism or that such tastes are social constructions: the very fact that they are altered systematically, in predictable patterns according to age, demonstrates their place in the structure of natural predispositions. Thus Elizabeth Lyons showed that women have a greater liking for vegetation in landscapes than men, which has a likely evolutionary source: women would prefer refuge-rich, fruit- and flower-laden landscapes, while men would turn their heads toward landscapes with prospect views, as well as hunting and exploration possibilities. From a more purely cultural side, studies have shown that farmers cross-culturally stand out from other demographics as preferring productive-looking farmland to all other landscape types. This is not at all inconsistent with an evolutionary

outlook: life goals, experiences, and familiar local environments will engrave innate interests in landscapes and our ability to exploit them. This is no more strange than the fact that learning English will permanently engrave an individual's linguistic capacities.

III

Habitat choice was a crucial, life-and-death matter for people (and proto-people) in the Pleistocene. The decisive significance of habitat selection has been nicely dramatized in a description by Orians and Heerwagen, who ask their readers to try seriously to imagine what daily life would have been like for an articulate, intelligent hunter-gatherer species. They call this nomadic Pleistocene existence "a camping trip that lasts a lifetime." Camping for us means an excursion from modern life; for our ancestors, living from the land was the only existence. You wake up, as Orians and Heerwagen describe it, amid your small band of adults and children. Realizing that you're running out of food, you set off together. Clouds on the horizon indicate rain in the distance, so that is the direction where the group heads. As the sun rises toward the zenith, you seek relief from the heat in the shade of a group of trees. The women in the group discuss the presence of sugary berries in this area they remember from a previous year. The men talk over possibilities for tracking game and haft arrowheads for a possible hunt. The sound of thunder far off in the later afternoon indicates that the dry season is coming to an end. The group drifts off to sleep, though before dawn some members are awakened by a loud crashing sound—a large animal—not far from the camp. At daybreak, the group sets off again, as Orians and Heerwagen put it, to begin a new day in a way of life "that will last for thousands of generations."

From the viewpoint of our ancestors, this way of life had no conceivable beginning or end. From our day back to the time of Socrates and Plato is a mere 120 generations. If we go further back from their Athens to the invention of writing, agriculture, and the first cities, it is a lot longer: another 380 generations. But the Pleistocene itself—the evolutionary theater in which we acquired the tastes, intellectual features, emotional dispositions, and personality traits that distinguish us from

our hominid ancestors and make us what we are—was eighty thousand generations long. Over such a vast period of time, human beings moved out of Africa and into environments very different from the savannas. Our ancestors moved along coastlines, went inland, learned to survive as arctic hunters, and managed to sustain life in the deserts of Asia and Australia. They populated rain forests both temperate and tropical, followed the receding glaciers northward through Europe, and found islands off the east coast of Asia. Human evolution did not occur in any one geographical place but over much of the globe. Unlike many animal species that are adapted to a single physical habitat and will die out if that environment disappears, human beings—clever, social, language-using tool-makers—devised ways to live in almost all physical environments on earth.

Nevertheless, certain characteristics of landscapes continue to evoke emotional human responses, revealed in basic, prerational longings and desires. Such purely emotional responses are not easy to isolate for analysis because they can coincide in respects with rational responses. This overlap between the rational and the emotional in reactions to landscape types can confuse the issue. Consider a thought experiment: a hunter-gatherer group of two dozen souls, perhaps a hundred thousand years ago, has been moving through a rocky, arid terrain in search of food. These ancestors of ours emerge from the end of a narrow canyon to find themselves standing before a grand vista. To their right is an upland temperate landscape. Its green hills and valleys increase toward higher blue mountains. The horizon slopes down on the left toward a vast desert, with no indication of life save sagebrush and no signs of water. That our hypothetical hunter-gatherer band will make its way toward the hills seems to be explainable as a purely rational choice. So why hypothesize an innate emotional response? Isn't emotion here an explanatory fifth wheel?

The first thing to be said is that in actual Pleistocene life the choice might not be nearly as clear-cut as my thought experiment suggests. To older, more experienced members of the band, the desert may offer resources of food that are not immediately obvious. The lush hills, on the other hand, might be inhabited by another, hostile hunter-gatherer band. Many factors, in other words, might affect a rational decision on which way the group decides to go. Still, the odds-on advantage, other

things being equal, is weighted in favor of heading for those hills. Given the eighty thousand generations of the Pleistocene, it would only take a small average survival advantage in the right-turn choice—toward green, watery landscapes, flat or undulating, with open spaces and thickets of forest—for such a response to become ingrained in the species at the level of emotion and aesthetic preference.

In a discussion of the mechanisms of emotion, John Tooby and Leda Cosmides have reviewed issues that have some bearing on the question raised here: why shouldn't we expect that all preference phenomena are explained in terms of rational calculation? The human mind, they argue, is "a crowded network" of innate routines, "programs" in their computer metaphor, for solving problems that confronted our hominid ancestors. As with the example of fear of snakes, these can be highly specific: for instance, face recognition, foraging, mate choice, sleep management, and predator vigilance. Such routines can, in life contexts, conflict with one another: wanting to obtain water can be in conflict with wanting to avoid dangerous predators near a waterhole. That is why some larger domains have cast over them what Tooby and Cosmides call "superordinate programs." Emotions function in this way, "orchestrating" the mind's many subprograms so they function smoothly together. They give the example of fear. This emotion, taking hold of a person who is walking at night in a potential "stalking and ambush" situation (it could be a Pleistocene rain forest or the asphalt jungle of a modern city), can produce outcomes with a strong bearing on survival. Fear will tend to shift attention and make perception more acute (the rustling in bushes is heard more clearly), change weightings of motivations and goals (you lose interest in your immediate destination, no longer feel hungry, etc.), redirect information-gathering interests (where is my baby?), alter the entire context of action from a safe to a dangerous situation, and affect memory, inference systems, and behavioral decision rules. The emotion of fear in this sense initiates something much more complex than just a rush of adrenaline. It affects a person's whole response and outlook, sharpening perception to the limit, and initiating both rational and automatic decisions.

Although Tooby and Cosmides do not mention the emotions implicated in landscape preference, such emotions fit their general account perfectly. Landscapes suitable for human habitation and flourishing are richly

varied, but for our ancestors not infinitely so. The average survival for *Homo sapiens* who had an emotional predisposition toward green and the potential for water in landscapes would have been evolutionarily decisive. Moreover, there is ample evidence to indicate that we share homologous emotional responses with other primates. Even if our early ancestors were making largely rational choices about where to move next, their ancestors before the advent of language were using, as other animals do, nonlinguistic heuristics and emotional reactions in lieu of rational, articulate processes to make life-and-death decisions. The rational and the emotional in responses to landscapes can coincide and reinforce one another. They can also be in conflict, where the emotional impulse that draws us to a landscape can be overridden by the knowledge that it contains unseen dangers. This does not, however, obviate the existence of a prerational, emotional response, nor negate its overall survival advantages.

Another way to look at the issue is to turn it around and ask whether any survival advantage might accrue to a hominid or early human population that was *emotionally indifferent* to landscape types. If human beings could equally well adapt to all landscape types, then favoring a particular subset might even be opposed to survival. Consider this issue in terms of the fear-of-snakes analogy. Given mutations, the natural variability of interests, tastes, and preferences, we would have had a number of potential ancestors who were indifferent or fearless when it came to encounters with snakes. Many of these people and proto-people, though they may be our aunts and uncles tens of thousands of generations removed, are not our direct, bloodline ancestors: on average, they were more likely to be killed by snakes before they produced offspring. Our *direct* ancestors, the people each of us can trace back by adding "greats" until we arrive at our eighty-thousandth great-grandmother and her mate, are the same people who, in the natural variability of things, were on average made more nervous by snakes. Evolution rewarded their phobic emotions by giving them life and the possibility of offering descendants to the world, just as it rewarded people made nervous by standing close to the edges of cliffs or repelled by the smell of rotting, toxic meat. In the Pleistocene, habitat choice was another factor determinative of life and death, and emotional indifference to landscapes is as evolutionarily unlikely as indifference toward snakes, dangerous precipices, and poisonous foods, on the one hand, or sex, babies and sweet and fatty foods, on the other.

IV

The history of landscape painting is about much more than potential Pleistocene habitats. It includes treatments of every imaginable landscape type, from endless arctic snows to desert to dense jungles. Landscape painting as an art form—from Japan, China, and Europe to the New World—is heavily overlaid with historical attitudes toward the land, as well as stresses and style changes internal to national art histories. Landscape art has been motivated by an exoticism, or a will to experience change and variety, and it has been in many ways conditioned by religious or even political values. In the Middle Ages, Europeans did not share our now normal city-dweller's love of nature: the frigid, menacing Alpine forms in the sixteenth-century paintings of Albrecht Altdorfer, for instance, portray mountains as sinister; his dark forests seem ready to swallow anyone who strays too far from the village. In general, people everywhere who have been subject to the will of nature are less inclined to be charmed by its beauties. The rise of modern civilization tracks an increasing sense of nature as benign or as wondrous, and no longer a threat. In fact, landscapes can seem so remote from ordinary experience that it becomes easy to imagine that our tastes in them are as conventional as our tastes in cuisines or clothes. This is an understandable error, but it remains an error nonetheless.

The emotions felt by our distant ancestors toward advantageous landscapes are of little use to us today, since we are no longer nomadic hunters who survive off the land. Nevertheless, since we still have the souls of those ancient nomads, these emotions can flood into modern minds with surprising and unexpected intensity. People who have spent their lives in cities can find themselves on a country road. Rounding a bend, they are confronted with a turnoff that leads up a valley. Pastures and copses of oaks dominate the foreground, while farther up the valley the road winds and disappears into older forest. A stream lined with lush foliage follows the road for some distance and then is lost from view, though its route is indicated by groves of older trees. Far up the valley, a last bend in the road can be glimpsed. Beyond that, higher hills take on a bluish, hazy cast, blending imperceptibly into distant mountains that are flanked between their peaks by great cumulus clouds. Such scenes can cause people to stop in their tracks, transfixed by the intense sense

of longing and beauty, determined to explore that valley, to see where the road leads. We are what we are today because our primordial ancestors followed paths and riverbanks over the horizon. At such moments we confront remnants of our species' ancient past.

CHAPTER 2

Art and Human Nature

I

Homo sum: humani nil a me alienum puto—"I am a man, and nothing human is alien to me." This dictum of the Roman playwright Terence can stand as a motto for anyone who seeks human universals that underlie the vast cacophony of cultural differences through history and across the globe. Thus in the spirit of Terence, Steven Pinker concludes his overview of the state of linguistics, *The Language Instinct*: "Knowing about the ubiquity of complex language across individuals and cultures and the single mental design underlying them all, no speech seems foreign to me, even when I cannot understand a word. The banter among New Guinean highlanders in the film of their first contact with the rest of the world, the motions of a sign language interpreter, the prattle of little girls in a Tokyo playground—I imagine seeing through the rhythms to the structures underneath, and sense that we all have the same minds."

Pinker's general claim about the universality of language and the linguistic capacities of the human mind is indisputable. Is there an analogous way to describe universality in art? Is it also true that, even though we might not receive a pleasurable, or even immediately intelligible, experience from art of other cultures, still, beneath the vast surface variety, all human beings have essentially the same art?

All human cultures display some form of expressive making of a kind European traditions would identify as artistic. This does not mean that

all societies have every art form. The Japanese tea ceremony, widely regarded as an art, does not have any close analogue in the West. The Sepik River people of New Guinea are passionate—almost obsessive— wood-carvers but stand in sharp contrast with their fellow New Guineans from the Highlands, who channel their energies into body decoration and the production of fighting shields, and who carve very little. The Dinka of East Africa have almost no visual art but possess a highly developed poetry, along with a connoisseur's fascination with the shapes, colors, and patterns of the natural markings of the cattle they depend on for their livelihoods.

The universality of art and artistic behaviors, their spontaneous appearance everywhere across the globe and through recorded human history, and the fact that in most cases they can be easily recognized as artistic across cultures suggest that they derive from a natural, innate source: a universal human psychology. In this respect, the universality of art resembles another persistent human proclivity: language use. Languages exist wherever human beings are found. Despite vocabulary and surface grammar differences that make the six thousand or so separate local languages of the world mutually unintelligible, languages are never mutually incommensurable: they can be translated into one another. This is possible because language structure is shared across cultures and because languages are tied to universal prelinguistic interests, desires, needs, and capacities.

Starting from infancy, language abilities unfold in routinely predictable processes that reveal innate abilities of astounding complexity. Spoken competence in a natural language can be expected of every normal infant born into the society of human beings. That this is an inborn capacity is shown by the fact, for instance, that it requires strenuous effort for children to learn the historically recent practices of reading and writing, whereas learning to talk requires no effort at all. (It has even been suggested that children should not be regarded as "learning" speech: with prompts from other speakers, children "grow" language as a natural extension of mental life, just as they grow from crawling to walking and running.)

Experimental and historical evidence—the stages of language acquisition, the cross-cultural nature of "motherese," predictable formation of pidgins when languages collide—proves the existence of species-

specific mental mechanisms beneath linguistic diversity. Noam Chomsky's universal grammar, a structure that underlies local generative grammars, is one such mechanism. This in turn is related to nonlinguistic needs, desires, and affects that also exhibit universal patterns. The tone and stress of speech acts, for instance, are connected with facial expressions such as those indicating fear, grief, or mirth. Such affective experience is rooted in the mental mechanisms that govern species-typical experience and the expression of emotion, including emotional expression in language.

None of this denies the extent to which language is also massively embedded for every language user in culture and history. Our vocabularies and manners of expression are endlessly variable and operate in meaning systems that, unlike the basic rule structures, are culturally produced. In this respect, the field of natural languages resembles the field of art considered cross-culturally: both exhibit an interplay between, on the one hand, deep, innate structures and mechanisms of intellectual and emotional life and, on the other hand, a vast ocean of historically contingent cultural material—the styles, vocabularies, and idiosyncrasies that give both language use and art their individual cultural and personal meanings. No philosophy of art can succeed if it ignores either art's natural sources or its cultural character.

II

The idea that art is tied to human nature is not new, and it is worth a brief look at a few signposts in the history of aesthetics to get a feel for the way the discussion has developed from ancient Greece to the present day. Plato and Aristotle worked out theories of human nature that they tied in different ways to their philosophies of art. Plato's famous dismissal of the arts as a source of knowledge, along with his call in the *Republic* to have the arts censored by the state for the good of the populace, is often seen as a by-product of his metaphysics, his theory of Forms, in which ideal archetypes govern and structure reality as we experience it. For Plato, art is always merely an imitation of an imitation, since it represents—in painting, sculpture, acting, poetry, or prose—the physical world, which is itself but an imitation of the eternal Forms. Art

is therefore systematically misleading: it presents an attractive and entertaining view of reality that leaves most people at best befuddled about the nature of reality and at worst morally degraded. For Plato, the arts tend to incite all the wrong human emotions. Again and again in Plato's dialogues we sense Plato's feeling that the arts are dangerous.

Discussing the makeup of the human soul in the *Republic*, Plato recounts a memorable anecdote about a man named Leontius, who had arrived in Athens and was walking along the North Wall of the city when he came upon some corpses lying at the feet of an executioner. He wanted to look at the dead bodies but at the same time was disgusted with himself and turned away. Leontius struggled with himself and covered his face. Finally, overpowered by his desire, he opened his eyes wide and rushed up to the corpses, saying to his eyes, "Look for yourselves, you evil wretches, take your fill of the beautiful sight!" Some people who have driven past a traffic accident will know what Plato is talking about. From a Platonic point of view, much of the violent entertainment offered by dramatic forms—from the theater of the Greeks to the violence and animal passions of today's entertainment media—is a lot like what Leontius could not resist gawking at. For Plato, the arts at their worst are bad for the soul because they engage and reward its basest elements.

Aristotle's attitude toward the arts is very different. Much more than Plato, he respects the independent integrity and variety of the arts and their capacity to give us insights into the human condition. For Aristotle, a cultural investigation inevitably involves a tension between *nomos*, law—and also, more broadly, the human cultural tradition—and *phusis*, the natural world, including human beings with their peculiarly human psychological nature. In most of his philosophical inquiries, Aristotle, as the original naturalist, comes down on the side of *phusis* as providing the ultimate principles. In his great work on drama and poetry, the *Poetics*, he shows himself to be intimately aware of the history and conventions of the arts of his culture. An adequate explanation for him unites both *nomos* and *phusis*. All art for Aristotle is *mimesis*, imitation of some sort. Even melody and rhythm essentially imitate human emotion, as even more clearly do the arts that use words, marble, or paint.

He regards the human interest in representations—pictures, drama, poetry, statues, and carvings—as an innate tendency. Rather than simply asserting this, he argues for it:

For it is an instinct of human beings from childhood to engage
in mimesis (indeed, this distinguishes them from other animals:
man is the most mimetic of all, and it is through mimesis that
he develops his earliest understanding); and equally natural that
everyone enjoys mimetic objects. A common occurrence indi-
cates this: we enjoy contemplating the most precise images of
things whose actual sight is painful to us, such as forms of the
vilest animals and of corpses.

Human beings are born image-makers and image-enjoyers. Evidence
for Aristotle can be seen in children's imitative play: everywhere children
play in imitation of grown-ups, of each other, of animals, and even of
machines. Imitation is a natural component of the enculturation of in-
dividuals. That is from the creative side: from the experiential side, hu-
man beings enjoy experiencing imitations, whether pictures, carvings,
stories, or play-acting. From an Aristotelian perspective, something like
a child's fascination with a doll's house with its tiny kitchen, pots, pans,
and table settings, or with a model train with its signals and switches, is
not to be reduced to a desire for adult power, nor is it just a way to learn
how to cook or to control a locomotive. There is a bedrock delight in the
tiny represented world just by itself, which also becomes a means, along
with dolls and other figures, for further games of make-believe.

A standard objection to any mimetic theory of art insists that it is not
representations per se that are valued by human beings but rather the
things represented—the content of representation. Aristotle ingeniously
answers this argument by pointing out that we are captivated to see rep-
resentations of objects that would disgust us in real life. Thus a person
afraid of snakes or spiders can be captivated by a marble carving of a
snake or a gold brooch in the intricate form of a spider. And while the
sight of an insect crawling over ripe fruit might disgust us in the kitchen,
to find a fly on a pear meticulously represented in a seventeenth-century
Dutch still life can be a source of delight.

Unlike Plato, Aristotle writes with a clear sense of the potential
variety of cultures spread across the world, which for him meant the
Mediterranean and Asia Minor up to western India, from where his stu-
dent Alexander the Great sent him zoological specimens. So when he
talks of human psychological nature, he intentionally means to generalize

across cultures. We would therefore expect, in Aristotle's thinking, to find roughly similar arts being invented in independent societies all over the world, and this is exactly what he says. Discussing in his *Politics* the various ways the state has been divided into classes by cultures of the Mediterranean, he remarks of these social arrangements, "Practically everything has been discovered on many occasions—or rather an infinity of occasions—in the course of ages; for necessity may be supposed to have taught men the inventions which were absolutely required, and when these were provided, it was natural that other things which would adorn and enrich life should grow up by degrees." Given enough time, then, every people on the face of the earth would, since they are subject to the impulses of the same fundamental human nature, discover for themselves storytelling, drama, painting, music, bodily adornment, and all the other arts.

Moreover, given a shared human psychology, we might expect the arts to follow similar histories, even in different nations. For example, Aristotle viewed tragedy as developing according to its own intrinsic teleology. The inevitability of placing first one and then two actors onstage, adding a chorus, then painted sets, and so forth leads ultimately and inevitably to the fulfillment of the form: "After going through many changes tragedy ceased to evolve, since it had achieved its own nature" (1449a15), its omega point in the tragedies of Sophocles. (About Sophocles being the ultimate goal of the evolution of tragedy Aristotle may have been wrong; on the other hand, since the supremacy of Sophoclean tragedy was not challenged until Elizabethan England, he was right for a very long time.)

More significant, however, are suggestions Aristotle makes about the achievement of organic unity in tragedy, suggestions that do not so much involve the independent essence of the genre but rather explain the genre in terms of the psychology of the audience. Thus, for example, the main topic of tragedy will be the disruption of normal family and love relations: a son who kills his father, two brothers who fight to the death, a mother who murders her children to spite their father. For Aristotle this fascination with stresses and ruptures of families represents a permanent feature of human interest, not merely a local manifestation of Greek cultural concerns, and he would find clear validation today in the continuing story lines of drama, pulp fiction, and soap operas across the world.

Aristotle often speaks as though he were prescribing the formal or physical limits of works of art as independent objects. But his prescriptions are not so much about works of art as they are about the nature of the minds that understand and enjoy them: the psychological conditions that make possible an intelligible grasp of any aesthetic object. An example of this is his discussion of the magnitude of works of art:

> Besides, a beautiful object, whether an animal or anything else with a structure of parts, should have not only its parts ordered but also an appropriate magnitude: beauty consists in magnitude and order, which is why there could not be a beautiful animal which was either minuscule (as contemplation of it, occurring in an almost imperceptible moment, has no distinctness) or gigantic (as contemplation of it has no cohesion, but those who contemplate it lose a sense of unity and wholeness), say, any animal a thousand miles long. So just as with our bodies and with animals beauty requires magnitude, but magnitude that allows coherent perception, likewise plots require length, but length that can be coherently remembered.

In order to succeed, a work of art must be above a certain minimum size, but this requirement is not about the nature of art so much as about the nature of the human perceptive apparatus. Without sufficient size, no object can be perceived as having parts that can be arranged in a pattern, or a perceptible structure. A lion or a shark, therefore, can be beautiful, because their parts form a meaningful, well-structured whole. A flea, however, cannot be beautiful in Aristotle's premicroscope age, not because it is a trifling or disagreeable animal (as a zoologist Aristotle found many disagreeable animals beautiful), but because it is too minute for the unaided eye to perceive parts that are arranged meaningfully. A speck cannot possibly by itself be beautiful; beauty is only possible where an object has visible parts.

The same argument applies to size in the other direction, and not just to the visual arts. How long can a satisfactory novel be? Eight hundred pages? Eight thousand? Aristotle can give us no answer, except to remind us that there is an upper limit set by the human attention span and by our ability to remember information—the names of characters, the

causes of incidents—that is required to make sense of any story. His only suggestion is that the maximum size consistent with coherence and comprehension is very likely best: "greater size, provided clear coherence remains, means finer beauty of magnitude."

Aristotle's *Poetics* takes as unproblematic that human beings have a stable intellectual, imaginative, and emotional nature that is universal across cultures. Other major figures in the history of aesthetics have worked under similar assumptions, including two of the most important, David Hume and Immanuel Kant. In his 1757 essay "Of the Standard of Taste" Hume claims, "The general principles of taste are uniform in human nature." In fact, "all the general rules of art are founded only on experience and on the observation of the common sentiments of human nature." For Hume, this has to be so in order to explain the persistence of aesthetic evaluations through history: "the same Homer, who pleased at Athens and Rome two thousand years ago, is still admired at Paris and at London." Such works pass Hume's famous Test of Time because they are "naturally fitted to excite agreeable sentiments" in human beings of every epoch.

Hume is acutely sensible to the fact that people frequently disagree in their aesthetic judgments, which is why so much of "Of the Standard of Taste" is given over to what contemporary psychologists would call a theory of error. Our uniform human nature, Hume maintains, would ensure that people's aesthetic judgments agreed with each other, were it not for the fact that this same uniform human nature is also prone to systematic mistakes and types of corruption. These include a lack of delicacy: an inability to perceive fine distinctions (of color shade or vocal pitch, for example), on which adequate aesthetic judgments depend. Judgment can also fail because it is insufficiently practiced in actively experiencing and criticizing works of art. This fault goes along with unfamiliarity with a wide comparison base on which to make a judgment (the man who has only seen two operas in his life is not in a position to be an opera critic) and prejudice against an artist or, perhaps, the work's cultural background.

To this basic list of the sources of faulty judgment and disagreement, Hume adds two other considerations: "the different humours of particular men" and "the particular manners and opinions of our age and country." The first includes matters of unfathomable personal prefer-

ence, plainly different aesthetic dispositions, which we find even among the most sophisticated critics. But these too can show systematic patterns: a youth, Hume says, will be more likely to enjoy the hot-blooded poetry of Ovid, while a middle-aged man will prefer the cooler wisdom and insight of Tacitus. Culturally induced differences in taste and personal prejudice are hard to overcome, which is why Hume remarks that the best judgments of an artist will be made by critics judging from the standpoint of posterity or by "foreigners." Such critics are least likely to be swayed by the authority of local cultural and personal prejudice.

A few commentators have mistakenly read a subjectivist "beauty's in the eye of the beholder" tendency into Hume's fastidious attention to the kinds of mistakes human beings are prone to make in aesthetic judgments. But this turns the spirit of his inquiry around the wrong way, since Hume's straightforward advocacy of a stable human nature—including its foibles—underlies his account of how aesthetic judgments go right and how they go wrong. This is demonstrated by Hume's retelling at one point in his essay of an anecdote from Sancho Panza to his squire, Don Quixote:

> It is with good reason, says Sancho to the squire with the great nose, that I pretend to have a judgment in wine: this is a quality hereditary in our family. Two of my kinsmen were once called to give their opinion of a hogshead, which was supposed to be excellent, being old and of a good vintage. One of them tastes it; considers it; and after mature reflection pronounces the wine to be good, were it not for a small taste of leather, which he perceived in it. The other, after using the same precautions, gives also his verdict in favour of the wine; but with the reserve of a taste of iron, which he could easily distinguish. You cannot imagine how much they were both ridiculed for their judgment. But who laughed in the end? On emptying the hogshead, there was found at the bottom, an old key with a leathern thong tied to it.

Sweet and bitter, Hume continues, are "bodily tastes" that refer to subjective experience. In this they are qualities not unlike the "mental tastes" of beauty and ugliness. Despite their apparent subjectivity in experience,

"there are certain qualities in objects," literally *objective* qualities, that predictably produce these experiences. Sensitivity to them, in the case of beauty, requires a delicate and practiced sensibility. Remove the typical error-features of aesthetic judgment, Hume is claiming, and we are left with an ideal taste that, however rare it might be, would enable us to identify greatness in art as surely as Sancho's kinsmen could identify the taste of leather and iron in wine. Hume, in other words, believes that a stable human nature means that there are objective aesthetic standards for criticism: works of art that pass the Test of Time objectively possess qualities capable of affecting human beings across generations. This is an empirical fact about them, not just an aesthetic evaluation.

"Of the Standard of Taste" itself passes a philosophical Test of Time in aesthetics because Hume is so remarkably alive both to the lasting values of art and to the fallibility of singular aesthetic judgments. Immanuel Kant is another eighteenth-century philosopher who postulated an ideal of taste based on a common human nature. Kant, like Hume, considers that the very idea of a "judgment of taste," his terminology for evaluation of beauty, posits as a necessary condition some conception—whether we've worked out its actual content or not—of a *sensus communis,* or shared human nature. If I say, "I like vanilla (or heliotrope, or the smell of burning leaves)," I speak only for myself and do not expect others necessarily to agree: for Kant, a preference for vanilla is a personal, subjective matter. But in Kant's view, if I say, "*Parsifal* is beautiful," I imply that everyone ought to agree with the judgment, even though I realize obviously that many will not. Judgments about beauty are logically separate from mere personal, idiosyncratic preferences since they are founded in the *disinterested contemplation* of works of art. For Kant they are about the way the free play of the imagination combines with rational understanding to give us the pleasure of aesthetic experience. Without a human nature underlying them, judgments of the beautiful would collapse into expressions of personal preference.

Kant differs from Hume in treating the *sensus communis* as a regulative ideal presupposed or postulated by discourse about beauty; beyond his schematic formulations about the free play of the imagination, he declines to analyze its specific psychological content. It must be there, but Kant remains agnostic on the question of its empirical features.

III

I have reviewed these signposts in the history of aesthetic theory as a reminder that there is nothing remarkable or awkward about a philosopher of art taking an interest in some conception or other of human nature. In this respect, it ought to strike us as curious that modern philosophers have been reluctant to connect aesthetic experience to any specifiable notion of human nature, or an empirical psychology that would seek to discover it. There is precious little reference to empirical psychology in contemporary philosophical aesthetics, almost as if philosophers of art have wanted to protect their patch from incursions by psychologists.

This defensiveness is historically understandable. Much of what psychology offered to aesthetics in the last century—the dogmas of Freud, the speculations of Jung, the sterile formulas of behaviorism, all variously empty or misleading—have proved to be intellectual dead ends. Moreover, left just to itself, philosophy of art has not done badly. For example, the sharply analytic writing of Frank Sibley, the generously broad but acutely worked-out views of Monroe C. Beardsley, and the probing aesthetics of Francis Sparshott together make an impressive body of information and argument. Theirs is the kind of work you might expect when brilliant minds with a deep appreciation for the arts engage in intense and extended philosophical analysis of what they love. But as with much else in the last fifty years of analytic or Continental-inspired art theory, empirical psychology is almost entirely absent.

As a subdivision of general philosophy, aesthetics analyzes and explains our basic intuitions about art and beauty—the pleasures that we derive from art, the factors that draw us to it. In the next chapter I provide a list of criteria for art, and one way to understand these is as a systematic enumeration of the most important of these intuitions. As the list will make clear, the value intuitions that motivate an interest in an art can be matched by contrary intuitions—conflicting interests taken from the list itself, or interests that can come from outside the realm of aesthetics altogether. We might admire the skill displayed by an artist in the work of art, say, but deplore the artist personally. Perhaps the formal beauty of the work conflicts in our minds with an immoral content. The desire to see accurate representation in an art work may clash with an

artist's personal expressive aims. For art critics, art historians, and philosophers of art, academic careers are made out of reconciling such paradoxes of intuition, or showing that the conflicts are illusory, or why one side is decisively right, the other wrong. Along with most critics and historians, modern philosophers of art have assiduously avoided asking where the intuitions themselves come from or have simply assumed they are culturally induced.

This latter move—to assume that all our artistic and aesthetic values come to us from our culture—has been highly influential in recent philosophy but has led aestheticians into peculiar situations. The influential institutional theory of art, proposed in the 1970s by the philosopher George Dickie, for instance, argues that art is defined by social institutions and is thus a purely cultural product. It follows, therefore, there is no point in challenging whether something like Marcel Duchamp's so-called readymades, such as his urinal, *Fountain*, are works of art. They have to be works of art because they are recognized as such by recognized art institutions. To be a work of art is just to be socially sanctioned as such.

Yet, when his guard is down, even the theory's founding philosopher inadvertently betrays its limitations. In a notable passage explaining how institutional theory applies to the arts, Dickie uses the theater as an example of the durability of an art institution. His intention is to show how an art form can persist over time because the institutions persist: they are simply two sides of the same phenomenon. "George Bernard Shaw," Dickie writes, "speaks somewhere of the apostolic line of succession stretching from Aeschylus to himself." Typical Shavian vanity, Dickie points out, but the remark does, he says, imply "an important truth." There is a long tradition of theater going back to the Greeks, Dickie observes, and it continues to this day. He goes on to make a striking, and inadvertently revealing, comment: "That tradition has run very thin at times and perhaps even ceased to exist altogether during some periods, only to be reborn out of its memory and the need for art."

The need for art? Given that this phrase appears in the context of a passage arguing that art is virtually defined by its institutions and their attendant cultural practices, this reference to an underlying need for art comes as a jolt. A human "need for art," presumably some kind of psychological impulse, psychic requirement, or instinct perhaps, would have

had to exist independently of art institutions if it is to act as a condition ensuring their reinvention when they have temporarily gone out of existence. Dickie's "need for art" recalls Aristotle's "necessity" that "taught men the inventions" life required and enabled the discovery and rediscovery of technologies and institutions over and over through time eternal. Even the inventor of institutional theory, it seems, recognizes a necessity for art that is prior to art's institutions, a need that guarantees its continual reinvention whenever it lapses.

IV

Aristotle could speak of human technologies and institutions as being inevitably reinvented over and over because he regarded human nature as fixed and the human species, along with all other species, as eternal: the world itself had always existed, and human beings had always walked upon it. In this he differed from his pre-Socratic predecessor Anaximander, who speculated that human beings had evolved out of the mud, as descendants of fish. Today we view human nature—the genetically endowed network of needs, desires, capacities, preferences, and impulses on which culture is built—as having been fixed only since the advent of agriculture and cities, the events that initiated our present epoch, the Holocene, around ten thousand years ago. Before that, our physical and mental makeup was continuously evolving through the generations of our nomadic human and proto-human ancestors in the Pleistocene. While human beings share an unbroken lineage through living things back beyond animals and into the Precambrian sludge, it is the Pleistocene contribution to human nature that is most relevant to understanding the cultural life forms of, for instance, governance, religion, language, systems of law, economic exchange, and the regularization of courtship, mating, and child rearing.

Accounts of human nature organized in terms of evolved features will naturally speculate about whether any universal human behavior pattern or disposition is an adaptation or the result of adaptations. Not all will be: across the globe, people ride bicycles above a minimum speed to keep from falling off. The brain mechanisms that enable them to do this may have evolved, but the minimum-speed behavior is a result of the gyroscopic

physics of bicycles; its universality is no evidence for a genetically adaptive function. It is unlikely that minimum-speed bicycling behavior has any utility in explaining how our Stone Age forebears survived and reproduced. On the other hand, there are an indefinitely large number of universal dispositions and behavior patterns—particularly persistent desires, motives, capacities, and emotions—that point directly back to the Pleistocene conditions where they first arose. These are salient to understanding the cultural life of modern human beings and form the background for writing a Darwinian Genesis for the arts.

The Pleistocene lasted for 1.6 million years. Our modern intellectual constitution was probably achieved in this period by about fifty thousand years ago, fully forty thousand years before the founding of the first cities and the invention of writing. To understand the importance of the Pleistocene as the scene of the development of modern humans, we must keep in mind the immensity of its time scale: calculating at twenty years for a generation, eighty thousand generations of humans and proto-humans in the Pleistocene, as against a mere five hundred generations since the first cities. It was in this long period that selective pressures created genetically modern humans. These pressures might have pushed only very slightly in one direction over another, but a slight pressure over thousands of generations can deeply engrave physical and psychological traits into the mind of any species. Steven Pinker and Paul Bloom cite J. B. S. Haldane's 1927 calculation that "a variant that produces on average 1% more offspring than its alternative allele would increase in frequency from 0.1% to 99.9% of the population in just 4000 generations." Pinker and Bloom point out that a change not even observable in a single generation or in any individual can still over thousands of generations completely alter a species. The dramatic effects of minute selective advantages, they observe, can also work against the survival of a population: "a 1% difference in mortality rates among geographically overlapping Neanderthal and modern populations could have led to the extinction of the former within 30 generations, or a single millennium."

The putative objective of natural selection is to embed those genetic traits in individuals that will produce a maximal increase of *inclusive fitness*. The great evolutionary theorist William D. Hamilton defined inclusive fitness as the sum of a trait's "effects, by any and all causal chains, on the survival and reproduction of the focal individual . . . plus what-

ever effects it may have on the survival and reproduction of the focal individual's relatives." The primary way for individuals to ensure the survival of their genetic material is to survive themselves. However, since we share genetic material with our children, siblings, and other relatives, their survival is also systematically implicated in the evolutionary scheme seen from the individual's point of view: in a multitude of ways, human beings and other animals favor their relatives over non-genetically-related members of the same species, and generally their own social group and their own species above other social groups and species. People, as Pinker puts it in his gloss on Richard Dawkins, do not "selfishly spread their genes; genes selfishly spread themselves. They do it by the way they build our brains. By making us enjoy life, health, sex, friends, and children, the genes buy a lottery ticket for representation in the next generation, with odds that were favorable in the environment in which we evolved."

The brain our genes built can be broken down into a number of what Kant might have called faculties, and what are today variously termed systems, reasoning engines, or, most commonly by evolutionary psychologists, modules. These account for the interests and capacities that best suited the survival of our Pleistocene ancestors. They can explain general differences in our abilities—why, for example, most people might find it easier to learn the words to a song than to learn their Social Security number; why people can more easily remember faces than they can recall names. Stemming largely from the work of Donald E. Brown, and with inclusions from Tooby and Cosmides's *The Adapted Mind* and writings by Steven Pinker and Joseph Carroll, here is a selection from the very long list of innate, universal features and capabilities of the human mind:

- an intuitive physics that we use to keep track of how objects fall, bounce, or bend;
- a sense of biology that gives us a deep interest in plants and animals and a strong feeling for their species divisions;
- an intuitive engineering module for making tools and technologies—not only such processes as flaking stones, but for attaching objects to one another;
- a personal psychology based on the realization that others have minds like our own but entertain different beliefs and intentions;

- an intuitive sense of space, including imaginative mapping of the general environment;
- a tendency toward body adornment with paint, hairstyling, tattooing and decorative jewelry;
- an intuitive sense of numbers, understood exactly for small numbers of objects but extending to an ability to estimate quantities in place of a grasp of larger numbers;
- a feeling for probability, along with a capacity to track frequencies of events;
- an ability to read facial expressions that includes an inventory of universally recognizable patterns (sadness, happiness, fear, surprise, etc.);
- a precise ability to throw such objects as balls, rocks, and spears (including an acute sense of target distance and the correct moment of hand release);
- a fascination with organized pitched sounds, rhythmically produced by the human voice or by instruments;
- an intuitive economics, involving an understanding of exchange of goods and of favors, along with an associated sense of fairness and reciprocity;
- a sense of justice, including obligations, rights, revenge, and what is deserved, sometimes involving the emotion of anger;
- logical abilities, including a faculty for using operators such as *and, or, not, all, some, necessary, possible,* and *cause*;
- and finally, a spontaneous capacity to learn and use language.

This last capacity is among the most astounding in the way that it allows the transition from infant to adult with a full command of a natural language, in literate societies but also long before in preliterate Pleistocene hunter-gatherer life. Yet there is no need to extol language as the most remarkable capacity: each of these faculties is a component of the astounding architecture of mind that was achieved by evolution. To this list could be added other innate propensities—arrays of instincts—that operate sometimes at a remarkable level of specificity. They would include fear of snakes or heights or large animals with big teeth, preferences in foods and a strong sense of their purity or contamination, and mental lists for keeping in memory names and characteristics of friends and enemies.

As we have already seen in chapter 1, the list includes preferences for generally savanna-like habitats that are safe, potentially fruitful or harboring game, and more generally information-rich. But beyond survival in natural habitats, each of our ancestors also faced threats and opportunities posed by other human and proto-human groups and individuals: we evolved to accommodate ourselves to each other, both as individuals in a group and as groups in relations of cooperation or aggression toward each other. These social realities were in play long before the Pleistocene, developing and presumably changing as humans evolved into the large-brained, bipedal creatures we are today. In the Pleistocene we lived in social groups featuring male/female pair bonding and paternal investment in children, who remain helpless from birth longer than any other animal. These human and proto-human groups were riven by disputes but strengthened by cooperation and coalitions. By the time the Pleistocene ended, complex social relations had become a hallmark of the species, as indelibly stamped in it as tool-making or language.

As Joseph Carroll has pointed out in his summary of human nature, one marked result of our developed social nature is that relations between males and females are "not only intense and passionate in their positive affects, but also fraught with suspicion, jealousy, tension, and compromise." The competing demands of this social and familial world, Carroll says, "guarantee a perpetual drama in which intimacy and opposition, co-operation and conflict, are inextricably bound together." While Carroll does not reject the account of adaptive faculties and instincts described by Pinker and other evolutionary psychologists, he does expand on the extent to which Pleistocene evolution saw the emergence of human beings as an intensely social species. Human evolution is not just a story of hunter-gatherers coping with a physical environment but one of *Homo sapiens* cooperating with each other to maximize species survival.

This human sociality can be described in ways that may seem quite specific—or culture-specific—when they are in fact as universal as the blinking reflex. Human beings, for example, are curious about their neighbors, like to gossip about them, pity their misfortunes and envy their successes. People everywhere tell lies, justify and rationalize their own behavior, exaggerate their altruism. Human beings like to expose and mock the false pretensions of others. They enjoy playing games,

telling jokes, and using poetic or ornamented language. (Even joke-making has its specific universal characteristics: across cultures, and as I have observed in New Guinea, it is men, and not women, who have a tendency to enjoy directing joke insults to each other.) As Carroll reminds us in a claim that is not armchair speculation but has the backing of cross-cultural ethnography, "It is human nature to grieve at the loss of loved ones, to feel deep chagrin at failure and defeat, to feel shame at public humiliation, joy at the triumph over enemies, and pride in solving problems, overcoming obstacles, and achieving goals. It is human nature often to have divided impulses and to be dissatisfied even in the midst of success." Such an account of human nature, oriented more toward intensity and complexity of social life, is a useful adjunct to other evolutionary psychological views that emphasize physical survival.

As much as fighting wild animals or finding suitable environments, our ancient ancestors faced social forces and family conflicts that became a part of evolved life. Both of these force-fields acting in concert eventually produced the intensely social, robust, love-making, murderous, convivial, organizing, technology-using, show-off, squabbling, game-playing, friendly, status-seeking, upright-walking, lying, omnivorous, knowledge-seeking, arguing, clubby, language-using, conspicuously wasteful, versatile species of primate we became. And along the way in developing all of this, the arts were born.

What Is Art?

I

If, as thinkers from Aristotle to the evolutionary psychologists have suggested, there is a human instinct to produce and enjoy artistic experiences, how might we begin to establish the fact? What would a universal aesthetics or theory of art look like? Julius Moravcsik is the contemporary philosopher who has given the most systematic thought to this basic question. He begins by stressing a fundamental logical point: a transcultural investigation into art as a universal category must be distinguished from an attempt to determine the meaning of the word "art." This distinction between two kinds of question is regularly confused, intentionally dodged, or just plain ignored in much of the literature on the subject.

"Art" is a word in English, the history and vagaries of which can be usefully studied. "This might be an interesting semantic exercise," Moravcsik says, "but it is not directly related to the many phenomena we can examine" by broadening attention to the concept of art as a universal category. Consider again the analogy of language. It too is both a concept and, with the addition of quotation marks, a word in English. We can argue at length about the meaning of the word "language," how it ought to be defined—whether, given a particular definition, computer codes are "languages," music is a "language," or the song of a mockingbird is an instance of "language." But such disputes about the outer borders of the word's meaning do not necessarily have any bearing on

whether Greek or English or Iatmul is a language. Deciding whether any marginal case, music or birdsong, is or is not language could not disprove the fact that Urdu is a language. The natural languages of the world form a natural category populated by indisputable cases, and recognition of this fact must precede any theorizing about whether the concept of language applies to other areas.

An investigation into the universality of language, or of art, Moravcsik argues, seeks lawlike generalizations that are neither trivially definitional nor accidental, generalizations of the sort "beavers build dams." Dam-building is not part of the definition of "beaver," nor is the statement even true of all existing beavers. What this means, Moravcsik says, is that under normal circumstances in the wild, "a healthy specimen of this species will build a dam." If true, such a generalization is worth knowing because it tells us something significant about beavers. Even if marginal cases might require attention to the terms used ("healthy," "normal"), such hypothesizing, seeking neither definitional nor accidental attributes, is highly desirable in empirical inquiries into the features of widespread social phenomena such as art.

Aesthetic theories may claim universality, but they are normally conditioned by the aesthetic issues and debates of their own times. Plato and Aristotle were motivated both to account for the Greek arts of their day and to connect aesthetics to their general metaphysics and theories of value. David Hume and, more especially, Immanuel Kant explored the emerging complexities of the fine-arts traditions of the eighteenth century. In the last century, as the philosopher Noël Carroll observes, the theories of Clive Bell and R. G. Collingwood mounted defenses of avant-garde practices—"neoimpressionism, on the one hand, and the modernist poetics of Joyce, Stein, and Eliot on the other." Susanne Langer can be read as providing a justification for modern dance, while the initial version of George Dickie's institutional theory requires, as Carroll puts it, "something like the presupposition that Dada is a central form of artistic practice" in order to gain intuitive appeal. The same point can be made about Arthur Danto's continual theorizing about minimalist conundrums and indiscernible art/non-art objects—Ad Reinhardt's black canvases or Andy Warhol's Brillo boxes. As art forms and techniques change and develop, as artistic fashions blossom or fade, so art theory too tags along, altering its focus, shifting its values.

Distortions in emphasis are compounded by another factor. Philosophers of art naturally tend to begin theorizing from their own aesthetic predilections, their own sharpest aesthetic responses, however strange or limited these may be. Kant had a keen interest in poetry, but his dismissal of the function of color in painting is so eccentric that it even suggests a visual impairment. Bell, who candidly acknowledged his inability to appreciate music, centered his attention on painting, extending his views fallaciously to other arts, such as literature. More generally, thinkers who love the beauty of nature, or who fall under the spell of a particular exotic culture or genre, are apt to generalize from individual feelings and experience. This personal element can be vastly enriching for theory (Bell on abstract expressionism) or result in near absurdities (Kant on painting in general). It ought, however, to incite skepticism in us all. General accounts extrapolated from limited personal enthusiasm may persuade us so long as we concentrate on the examples the theorist provides; often they fail when applied to a broader range of art.

Beyond cultural bias and personal idiosyncrasy, adequate philosophizing about the arts has been impeded by a third factor: the character of philosophical rhetoric. Philosophy is most robust and stimulating—frankly, most fun—when it argues for some uniquely and exclusively true position and attempts to discredit plausible alternatives. In the history of art philosophy, this has been a persistent obstacle to understanding. Kant, for example, does not merely separate the intellectual components of aesthetic experience from its primary sensual components but, in sections of *The Critique of Judgment*, denies the value of the latter entirely. Tolstoy is so dogmatic in his insistence on sincerity as the central criterion for art that he famously rejects large swaths of the canon, including most of his own greatest works. Bell, once again the pluperfect aesthetician, does not just elevate the experience of form in abstract painting but insists that painting's illustrative element is aesthetically irrelevant. Such extreme positions in aesthetics are rhetorically arresting in a way that more commonsense theories are not. They are also a pleasure for professors of aesthetics to teach, since they provide students with historical background, genuine (if absurdly one-sided) aesthetic insights, and the intellectual exercise involved in adducing counterexamples and counterargument. Along with the historical development of art itself, such theorizing pushes the argument

forward—not in the direction of resolution, but only to incite more disputation.

Aesthetics today finds itself in a paradoxical, not to say bizarre, situation. On the one hand, scholars and theorists have access—in libraries, in museums, on the Internet, firsthand via travel—to a wider perspective on artistic creation across cultures and through history than ever before. We can study and enjoy sculptures and paintings from the Paleolithic, music from everywhere, folk and ritual arts from all over the globe, literatures and visual arts of every nation, past and present. Against this glorious availability, how odd that philosophical speculation about art has been inclined toward endless analysis of an infinitesimally small class of cases, prominently featuring Duchamp's readymades or boundary-testing objects such as Sherrie Levine's appropriated photographs and John Cage's *4'33"*. Underlying this philosophical direction is a hidden presupposition that is never articulated: the world of art, it is supposed, will at last be understood once we are able to explain art's most marginal or difficult instances. Duchamp's *Fountain* and *In Advance of the Broken Arm* are on the face of it the hardest cases that art theory has to deal with, which explains the size of the theoretical literature these works and their readymade siblings have generated. The very size of this literature also points to a hope that being able to explain the most outré instances of art will help us arrive at the best general account of all art.

This hope has led aesthetics in the wrong direction. Lawyers like to say that hard cases make bad law, and an analogous danger threatens philosophical analysis. If you wish to understand the essential nature of murder, you do not begin with a discussion of something complicated or emotionally loaded, such as assisted suicide or abortion or capital punishment. Assisted suicide may or may not be murder, but determining whether such disputed cases are murder requires first that we are clear on the nature and logic of indisputable cases; we move from the uncontroversial center to the disputed remote territories. The same principle holds in aesthetic theory. The obsession with accounting for art's problematic outliers, while both intellectually challenging and a good way for teachers of aesthetics to generate discussion, has left aesthetics ignoring the center of art and its values.

What philosophy of art needs is an approach that begins by treating art as a field of activities, objects, and experience that appears naturally in hu-

man life. We must first try to demarcate an uncontroversial center that gives more curious cases whatever interest they have. I regard this approach as "naturalistic," not in the sense that it is biologically driven (though biology is relevant to it), but because it depends on persistent cross-culturally identified patterns of behavior and discourse: the making, experiencing, and assessing of works of art. Many of the ways art is discussed and experienced can easily move across culture boundaries, and manage a global acceptance without help from academics or theorists. From Lascaux to Bollywood, artists, writers, and musicians often have little trouble in achieving cross-cultural aesthetic understanding. The natural center on which such understanding exists is where theory must begin.

II

Characteristic features found cross-culturally in the arts can be reduced to a list of core items, twelve in the version given below, which define art in terms of a set of *cluster criteria*. Some of the items single out features of works of art; others, qualities of the experience of art. The items on the list are not chosen to suit a preconceived theoretical purpose; to the contrary, these criteria purport to offer a neutral basis for theoretical speculation. The list could be described as inclusive in its manner of referring to the arts across cultures and historical epochs, but it is not for that reason a compromise among competing, mutually exclusive positions. It reflects a vast realm of human experience that people have little trouble identifying as artistic. The philosopher David Novitz has remarked that "precise formulations and rigorous definitions" are of little help in capturing the meaning of art cross-culturally. But even if, as Novitz says, there is "no one way" to be a work of art, it does not follow that the converse "many ways" are so hopelessly numerous as to be unspecifiable, even if the domain they refer to is as ragged and multilayered as that of art. In fact, that they are specifiable, however open to dispute, is required by the very existence of a literature on cross-cultural aesthetics.

A reminder: granting the existence of myriad marginal cases, by "art" and "arts" I mean artifacts (sculptures, paintings, and decorated objects, such as tools or the human body, and scores and texts considered as objects) and performances (dances, music, and the composition and recitation

of stories). Sometimes when we talk about art we focus on acts of creation, sometimes on the objects created; other times we refer more to the experience of these objects. Working out these distinctions is a separate task. The list is therefore the signal characteristics of art considered as a universal, cross-cultural category. This is not to claim that anything on my list is unique to art or its experience. Many of these aspects of art are continuous with non-art experiences and capacities, and reminders of these are included in parentheses at the conclusion of each entry.

1. Direct pleasure. The art object—narrative story, crafted artifact, or visual and aural performance—is valued as a source of immediate experiential pleasure in itself, and not essentially for its utility in producing something else that is either useful or pleasurable. This quality of the pleasure of beauty, or "aesthetic pleasure," as it is so often called, derives on analysis from rather different sources. A pure, deeply saturated color can be pleasurable to see; grasping the detailed coherence of a tightly plotted story can give pleasure (similar to the pleasure of solving a clever crossword puzzle or grasping a well-formed chess problem); the form and technique of a landscape painting can induce pleasure, but so can the actual misty, bluish mountains it portrays; surprising harmonic modulations and rhythmic acceleration can give intense pleasure in music, and so forth. Of the greatest significance here is the fact that the enjoyment of artistic beauty often derives from multilayered yet distinguishable pleasures that are experienced either simultaneously or in close proximity to each other. These layered experiences can be most effective when separable pleasures are coherently related to each other or interact with each other—as, roughly put, in the structural form, colors, and subject matter of a painting, or the music, drama, singing, directed acting, and sets of an opera. This idea is familiar as the so-called organic unity of art works, their "unity in diversity." Such aesthetic enjoyment is often said to be "for its own sake." (This pleasure is called aesthetic pleasure when it is derived from the experience of art, but it is familiar in many other areas of life, such as the pleasure of sport and play, of quaffing a cold drink on a hot day, or of watching larks soar or storm clouds thicken. Human beings experience an indefinitely long list of direct, non-artistic pleasures, experiences enjoyed for their own sakes. Any such pleasures may, like those notoriously associated with sex, or sweet and fatty foods, have ancient, evolved causes that we are unaware of in immediate experience.)

2. Skill and virtuosity. The making of the object or the performance requires and demonstrates the exercise of specialized skills. These skills are learned in an apprentice tradition in some societies or in others may be picked up by anyone who finds that she or he "has a knack" for them. Where a skill is acquired by virtually everybody in the culture, such as with communal singing or dancing in some tribes, there still tend to be individuals who stand out by virtue of special talent or mastery. Technical artistic skills are noticed in small-scale societies as well as developed civilizations, and where they are noticed they are universally admired. The admiration of skill is not just intellectual; skill exercised by writers, carvers, dancers, potters, composers, painters, pianists, singers, etc. can cause jaws to drop, hair to stand up on the back of the neck, and eyes to flood with tears. The demonstration of skill is one of the most deeply moving and pleasurable aspects of art. (High skill is a source of pleasure and admiration in every area of human activity beyond art, perhaps most notably today in sports. Almost every regularized human activity can be turned competitive in order to emphasize the development and admiration of its technical, skill aspect. *Guinness World Records* is full of "world champions" of the most mundane or whimsical activities; this attests to a universal impulse to turn almost anything human beings can do into an activity admired as much for its virtuosity as for its productive capacity.)

3. Style. Objects and performances in all art forms are made in recognizable styles, according to rules of form, composition, or expression. Style provides a stable, predictable, "normal" background against which artists may create elements of novelty and expressive surprise. A style may derive from a culture or a family or be the invention of an individual; changes in styles involve borrowing and sudden alteration, as well as slow evolution. The rigidity or fluid adaptability of styles can vary as much in non-Western and tribal cultures as in the histories of literate civilizations: some objects and performances, particularly those involved in sacred rites, can be tightly circumscribed by tradition (Russian icon painting, early European liturgical music, or older styles of Pueblo pottery), with others are open to free, creative individualistic interpretive variation (much modern European art, or the arts of northern New Guinea). Very few historical arts allow no creative departure from established style. In fact, were no variance whatsoever allowed, the status of a stylized activity would be called into question as an art; this is true not

only in European traditions. Some writers, particularly in the social sciences, have treated style as a metaphorical prison for artists, determining limits of form and content. Styles, however, by providing artists and their audiences with a familiar background, allow for the exercise of artistic freedom, liberating as much as they constrain. Styles can oppress artists; more often, styles set them free. (Virtually all meaningful human activity above the level of autonomic reflexes is carried out within stylistic framework: gestures, language use, social courtesies such as norms of laughter or body distance in personal encounters. Style and culture are virtually coterminous.)

4. Novelty and creativity. Art is valued, and praised, for its novelty, creativity, originality, and capacity to surprise its audience. Creativity includes both the attention-grabbing function of art (a major component of its entertainment value) and the artist's perhaps less jolting capacity to explore the deeper possibilities of a medium or theme. Though these kinds of creativity overlap, *The Rite of Spring* is creative most strikingly in the first sense, *Pride and Prejudice* in the second. The unpredictability of creative art, its newness, plays against the predictability of conventional style or formal type (sonata, novel, tragedy, and so forth). Creativity and novelty are a locus of individuality or genius in art, referring to that aspect of art that is not governed by rules or routines. Imaginative talent is graded in art according to its ability to display creativity. (Creativity is called for and admired in countless other areas of life. We admire creative solutions to problems in dentistry and plumbing as well as the arts. The persistent pursuit of creativity shows itself, for example, in the reluctance of careful writers to use the same word a second time in a sentence where synonyms are available; the thesaurus exists less for greater precision in writing than for the sake of pleasurable creative variety.)

5. Criticism. Wherever artistic forms are found, they exist alongside some kind of critical language of judgment and appreciation, simple or, more likely, elaborate. This includes the shoptalk of art producers, the public discourse of critics, and the evaluative conversation of audiences. Professional criticism, including academic scholarship applied to the arts where it is evaluative, is a performance itself and subject to evaluation by its larger audience; critics routinely criticize each other. There is wide variation across and within cultures with regard to the complexity of criticism. Anthropologists have repeatedly commented on its rudi-

mentary development, or near nonexistence, in small, nonliterate societies, even those that produce complicated art. It is generally much more elaborate in the art discourse of literate European and Oriental history. (Criticism obviously exists in many spheres of non-aesthetic life with this proviso: criticism of a kind analogous to art criticism applies only to enterprises where the potential achievement is complex and openended. There is generally no criticism applied to performances in the hundred-meter dash: the fastest time wins, no matter how inelegantly. It is only where criteria for success itself are complex or uncertain—in politics or religion, for instance—that critical discourse becomes structurally similar to art criticism.)

6. Representation. In widely varying degrees of naturalism, art objects, including sculptures, paintings, and oral and written narratives, and sometimes even music, represent or imitate real and imaginary experiences of the world. As Aristotle first observed, human beings take an irreducible pleasure in representation: a realistic painting of the folds in a red satin dress, a detailed model of a steam engine, or the tiny plates, silverware, goblets, and lattice-crust cherry pie on the dinner table of a doll's house. But we can also enjoy representation for two other reasons: we can take pleasure in how well a representation is accomplished, and we can take pleasure in the object or scene represented, as in a calendar rendering of a beautiful landscape. The first is about skill, rather than representation as such; the second is reducible to pleasure in the subject matter, rather than representation in itself. Delight in imitation and representation in any medium, including words, may involve the combined impact of all three pleasures. (Blueprints, newspaper illustrations, passport photographs, and road maps are equally imitations or representations. The importance of representation extends to every area of life.)

7. Special focus. Works of art and artistic performances tend to be bracketed off from ordinary life, made a separate and dramatic focus of experience. In every known culture, art involves what the art theorist Ellen Dissanayake calls "making special." A gold-curtained stage, a plinth in a museum, spotlights, ornate picture frames, illuminated showcases, book jackets and typography, ceremonial aspects of public concerts and plays, an audience's expensive clothes, the performer's black tie, the presence of the czar in his royal box, even the high price of tickets: these and countless other factors can contribute to a sense that the work of art, or

artistic event, is an object of singular attention, to be appreciated as something out of the mundane stream of experience and activity. Framing and presentation, however, are not the only factors that induce a sense of specialness: it is in the nature of art itself to demand particular attention. Although some products with artistic value—for instance, wallpaper or mood-inducing music—can be used as background, all cultures know and appreciate special, "foregrounded" art. (Special focus and a sense of occasion are also found in religious rites, the pomp of royal ceremonies, political speeches and rallies, advertising, and sporting events. Any isolable episode that can be said to possess a recognizable "theatrical" element shares something in common, however, with almost all art. This would apply to such disparate experiences as presidential inaugurations, World Series games, or roller coaster rides.)

 8. Expressive individuality. The potential to express individual personality is generally latent in art practices, whether or not it is fully achieved. Where a productive activity has a defined output, like double-entry bookkeeping or filling teeth, there is little room and no demand for individual expression. Where what counts as achievement in a productive activity is vague and open-ended, as in the arts, the demand for expressive individuality seems inevitably to arise. Even in cultures that produce what might seem to outsiders to be less personalized arts, individuality, as opposed to competent execution, can be a focus of attention and evaluation. The claim that artistic individuality is a Western construct not found in non-Western and tribal cultures has been widely accepted and is certainly false. In New Guinea, for example, traditional carvings were unsigned. This is hardly surprising in a nonliterate culture of small settlements where social interactions are largely face-to-face: everyone knows who the most esteemed and talented carvers are, and knows their works without marks of authorship. Individual talent and expressive personality is respected in New Guinea as elsewhere. (Any ordinary activity with a creative component—everyday speech, lecturing, home hospitality, laying out the company newsletter—opens the possibility for expressive individuality. The general interest in individuality in ordinary life seems less about the contemplation of expression than about knowing the quality of mind that produced the expression.)

 9. Emotional saturation. In varying degrees, the experience of works of art is shot through with emotion. Emotion in art divides broadly into

two kinds, fused (or confused) in experience but analytically distinct. First are the emotions provoked or incited by the represented content of art—the pathos of a scene portrayed in a painting, a comic sequence in a play, a vision of death in a poem. These are the normal emotions of life, and as such are the subject of cross-cultural psychological research outside of aesthetics (one taxonomy currently used in empirical psychology names seven basic emotion types: fear, joy, sadness, anger, disgust, contempt, and surprise). There is a second, alternative sense, however, in which emotions are encountered in art: works of art can be pervaded by a distinct emotional flavor or tone that is different from emotions caused by represented content. This second kind of embodied or expressed emotion is connected to the first but not necessarily governed by it. It is the emotional tone we might feel in a Chekhov story or a Brahms symphony. It is not generic, a type of emotion, but usually described as unique to the work—the work's emotional contour, its emotional perspective, to cite two common metaphors. (Obviously, many ordinary, non-art life experiences—falling in love, watching a child take its first steps, listening to an elegy, seeing an athlete break a world record, having a heated row with a close friend, viewing the grandeur of nature—are also imbued with emotion.)

*10. **Intellectual challenge.*** Works of art tend to be designed to utilize the combined variety of human perceptual and intellectual capacities to the full extent; indeed, the best works stretch them beyond ordinary limits. The full exercise of mental capacities is in itself a source of aesthetic pleasure. This includes working through a complex plot, putting evidence together to recognize a problem or solution before a character in a story recognizes it, balancing and combining formal and illustrative elements in a complicated painting, and following the transformations of an opening melody recapitulated at the end of a piece of music. The pleasure of meeting intellectual challenges is most obvious in vastly complicated art, such as in the experience of *War and Peace* or Wagner's *Ring*. But even works that are simple on one level, such as Duchamp's readymades, may deny easy explanation and give pleasure in tracing out their complex historical or interpretive dimensions. (Games such as chess or Trivial Pursuit, cooking from complicated recipes, home handyman tasks, television quiz programs, video games, or even working out tax returns can offer challenges of exercise and mastery that result in achieved pleasure.)

11. Art traditions and institutions. Art objects and performances, as much in small-scale oral cultures as in literate civilizations, are created and to a degree given significance by their place in the history and traditions of their art. As philosopher Jerrold Levinson has argued, works of art gain their identity by the ways they are found in historical traditions, in lines of historical precedents. Overlapping this notion are earlier views, argued by philosophers Arthur Danto, Terry Diffey, and George Dickie, to the effect that works of art gain meaning by being produced in an art world, in what are essentially socially constructed art institutions. Institutional theorists tend to apply their minds to readymades and conceptual art because the interest of such works is close to exhausted by their importance in the historical situation of their production. Such works stand in contrast to other canonical works such as Beethoven's Ninth Symphony, which, although open to extensive historical and institutional analysis, is able to gather for itself a huge and enthusiastic world audience of listeners who know little or nothing of its institutional context. Even a minimal appreciation, on the other hand, of Duchamp's *Fountain* requires a knowledge of art history, or at least of the contemporary art context. (Virtually all organized social activities—medicine, warfare, education, politics, technologies, and sciences—are built up against a backdrop of historical and institutional traditions, customs, and demands. Institutional theory as promoted in modern aesthetics can be applied to any human practice whatsoever.)

12. Imaginative experience. Finally, and perhaps the most important of all characteristics on this list, objects of art essentially provide an imaginative experience for both producers and audiences. A marble carving may realistically represent an animal, but as a work of sculptural art it becomes an imaginative object. The same can be said of any story well told, whether mythology or personal history. The costumed dance by firelight, with its intense unity of purpose among the performers, possesses an imaginative element quite beyond the group exercise of factory workers. This is what Kant meant by insisting that a work of art is a "presentation" offered up to an imagination that appreciates it irrespective of the existence of a represented object: for Kant, works of art are imaginative objects subject to disinterested contemplation. All art, in this way, happens in a make-believe world. This applies to nonimitative, abstract arts as much as to representational arts. Artistic experience takes place in the theater of

the imagination. (At the mundane level, imagination in problem-solving, planning, hypothesizing, inferring the mental states of others, or merely in daydreaming is virtually coextensive with normal human conscious life. Trying to understand what life was like in ancient Rome is an imaginative act, but so is recalling that I left my car keys in the kitchen. However, the experience of art is notably marked by the manner in which it decouples imagination from practical concern, freeing it, as Kant instructed, from the constraints of logic and rational understanding.)

III

Taken individually or jointly, the features on this list help to answer the question of whether, confronted with an artlike object, performance, or activity—from our own culture or not—we are justified in calling it art. The list identifies the most common and easily graspable "surface features" of art, its traditional, customary, or pretheoretical characteristics that are observed across the world. Not included in the list are elements of technical analysis more likely to be used by critics and theorists, such as the analytical terms "form" and "content." In this respect, a chemist's analogy for the list would be the enumeration of the defining features of a liquid, rather than the defining features of methanol. Through history and prehistory, people have had an immediate understanding of the difference between a liquid and a solid, without needing scientists to explain the difference to them. Whether a liquid contains methanol, however, requires technical analysis that might escape ordinary observation. Moreover, while there are borderline cases of liquids, methanol has an unambiguous technical definition: CH_3OH. We may need expert opinion to tell us whether something is methanol or whether it has methanol in it; we need no experts to tell us whether methanol is a liquid.

In this sense, "Is it art?" is not a question that ought to be given over to experts to decide for us. The question, in fact, normally provokes such thoughts as, Does it show skill? Does it express emotion? Is it like other works of art in a known tradition? Is it pleasurable to listen to? More expert-oriented technical questions, such as "Does it have form and content?" or "Is it written in iambic pentameter?" are not a first line of inquiry that comes to mind in trying to figure out whether something is art.

Again, might it happen one day that neurophysiologists will discover a new, technical method for identifying artistic experiences (through brain scans or suchlike) or that physicists will invent some kind of molecular analysis that allows them to distinguish, say, works of art from pieces of ordinary whiteware or automobile parts? An absurd speculation, perhaps, but note that if science ever achieved such a method for identifying instances of art or of art experiences, it will be in the position of matching its scientifically determined properties with a description of art understood in terms of the cluster criteria on my list or on another similar list. The cluster criteria tell us *what we already know* about the arts. The list may be adjusted at the edges, with items subtracted or added to it, but the list can be expected to remain largely intact into the foreseeable future, governing what counts as investigation into the arts by neurophysiologists, philosophers, anthropologists, critics, or historians.

Other nontechnical features might have been included on this list. H. Gene Blocker, who has written about the criteria for art in tribal societies, regards it as significant that artists are "perceived not only as professionals but as innovators, eccentric, or a bit socially alienated." Having observed this in New Guinea just as Blocker has in Africa, I can agree, but there are over the world too many innovative-yet-non-socially-alienated artists, as well as too many eccentric non-artists, for Blocker's feature to be a useful way to recognize art. The same could be said of being rare or costly. As I shall discuss in chapter 7, many works of art are rare, are made of costly materials, or incorporate enormous labor costs, and this is often a component of their interest to audiences. Many, however, are none of these things—for instance, cheap reproductions in the form of prints or MP3 files. Costliness is relevant to art, but it is not a criterion for recognizing it.

My list excludes background features that are presupposed in virtually all discourse about art. These include the necessary conditions of (1) being an artifact, and (2) being normally made or performed for an audience. Works of art are fundamentally intentional artifacts, even if they possess any number of nonintended meanings. This includes found objects—pieces of driftwood and the like that are transformed into intentional objects in the process of selection and display. Being made for an audience is also a refinement on artifactuality and substantially important in understanding art, but it is too thin to be a useful addition to the list, as it applies

to countless other kinds of human actuality outside the arts. Every social or communicative act is essentially connected to the idea of an audience.

Also missing from the list is one further feature that has been inflated by academics into a defining criterion of art: *being expressive or representative of cultural identity*. In the sense that all art arises in a culture and is therefore a cultural product, the claim is trivially true. Normally, however, proponents of this position want to wring from it the idea that artists intend in their work, and audiences expect in their experience, to affirm cultural identity. This is no more true than to claim, for example, that artists intend with their work to be paid, and that audiences expect somehow to pay them: it's sometimes yes, sometimes no. Incidentally, art tends to be used to affirm cultural identity principally in situations of cultural opposition and doubt. It is unlikely that Cervantes, Rembrandt, or Mozart saw affirming Spanish, Dutch, or Austrian culture as a major function of his work (this despite each being a proud Spaniard, Dutchman, and Austrian). Wagner, who set himself overtly against French and Italian music, is a different story; he consciously saw himself as promoting a Teutonic identity. It is hard to see Indian music in its homeland as aimed at affirming Indian identity; it usually comes to serve that function only when Indians move abroad and join Indian cultural societies in Stuttgart or Seattle. Local artistic forms offered to their natural, local audiences seldom occasion worries about affirming cultural identity; such art offers only beauty and entertainment to its closest, most natural audience. In retrospect, we may come to regard Shakespeare as affirming Elizabethan cultural values, but that is a construction we impose on him. His intention was to create theatrical entertainments for the Globe audience. Affirming cultural identity, however important it may be, is not a criterion for recognizing instances of art.

IV

While the cluster-criteria approach to understanding art does not specify in advance how many of the criteria need be present to justify calling an object art, the list nevertheless presents in its totality a definition of art: any object that possessed every feature on the list would have to be a work of art. The definition does not exclude fringe art, avant-garde art, or other controversial cases. It only directs attention back to the qualities

that works of art arguably must to some degree share, and it does this by enumerating the features of indisputable cases—Rembrandt's *Night Watch*, Liszt's *Spanish Rhapsody*, Brecht's *Mother Courage*. Such canonical works, having everything on the list, will therefore stand at one end of a continuum that has at its other end non-art objects and performances such as ordinary passport photos and the accomplishments of skilled plumbers in unclogging drains. These latter may feature a few of the list's criteria, but not enough to make them works of art. The list is therefore not a formula that allows us to crank out an answer to every question about whether something is or is not art, but a useful guide for assessing hard, marginal, or borderline cases of art.

Consider, for instance, a case that has been repeatedly brought up for discussion by my students: sporting events such as a World Cup final in soccer or the American Super Bowl. Such events present spectacles that can embody great skill, high drama, and both emotion and pleasure for audiences. They display a great sense of occasion and are subject to endless postgame critical discourse. Already, they would seem to fulfill my criteria for (1) pleasure, (2) skill, (5) criticism, (7) special focus, and perhaps (9) emotional saturation.

Nevertheless, many people would resist the idea that such championship matches taken as a whole are works of art or artistic performances (which is not to deny the artistry of some virtuoso players or of their individual moves). The reason to resist calling such games works of art has to do with the absence of what must be weighted as one of the most important items on the list: (12) imaginative experience. For the ordinary sports fan who cheers the home team, *who actually wins the game,* not in imagination, but in reality, remains the overwhelming issue. For the fan, the outcome is the decisive interest-generating issue. Winning and losing is the principal source of emotion, which is not *expressed,* as it is in artistic works, but rather *incited* in crowds by a real-world sporting outcome. Were sports fans authentic aesthetes, so my speculation goes, they would care little or nothing for scores and results but only enjoy games in terms of style and economy of play, skill and virtuosity, and expressiveness of movement. There is also the question of how teams engage in a soccer match with each other. A Harlem Globetrotters basketball performance is a true artistic event, because both sides in the match are actually cooperating to entertain their audience. In this respect, they are acting like a

jazz combo or the many people who work together to produce a studio film: their actions are done for the audience, not simply to win the game—which in championship matches literally puts soccer and football teams at cross-purposes.

A championship game is not essentially (or not enough, anyway) a Kantian "presentation," a make-believe event, offered up for imaginative contemplation but is rather a real-world event, rather like an election or battle. The fact that soccer and football could have so much in common with accepted art and yet not be instances of it is something that the cluster-criteria list can help us to understand. It also leaves open the possibility of debate in terms of the list from readers who disagree with this claim. The possibility of fruitful debate and analysis in such cases is an advantage of my list.

Ideas and objects such as "square root" or "neutron" have come to be grasped alongside the rise of the theories that give them a place in understanding. The arts, in ways rough and precise, were created and directly enjoyed long before they came to be objects of theoretical rumination. They are not technical products needing expert analysis but rich, scattered, and variegated realms of human practice and experience that existed long before philosophers and art theorists. In this respect, the arts are like other grand, vague, but real and persistent aspects of human life, such as religion, the family, friendship, society, or war. Despite disputed and borderline cases, they can be in many cases easily recognized across cultures and through history. As for the fear that a definition of art might constrain the very creative imagination we observe and encourage in the arts, that makes about as much sense as worrying that a definition of the word "book" will take us down a slippery slope toward censoring literature, or a definition of "language" will constrain what I have to say. The arts remain what they are, and will be. Aesthetic theory is merely their handmaiden. It is she who must perfect her tune.

CHAPTER 4

"But They Don't Have Our Concept of Art"

I

If art is not a technical concept confined to our culture but is a natural, universal phenomenon—like language, tool-making, and kinship systems—we would expect to see evidence of this in the work of anthropologists over the last century. Indeed, there are many invaluable ethnographies of tribal or so-called primitive art (often far from primitive in its technical expertise and expressive sophistication). Already in the nineteenth century, scholars such as A. C. Haddon were examining Maori art traditions, while ethnographers working for the Bureau of Indian Affairs were meticulously documenting the arts of Native Americans. Much has been made of the "discovery" of African art a hundred years ago by the likes of Picasso and the art theorist Roger Fry, but invaluable work was already being done by academics such as the Columbia University anthropologist Franz Boas and Ruth Bunzel, his student in the 1920s, as well art historians such Robert Goldwater on African art. All of these people, and many others, created a permanent record of the aesthetic achievements of the small-scale, nonliterate, tribal societies.

After the Second World War, however, the attention given to tribal arts by anthropologists was in many respects less satisfactory. Cultural relativism developed into the reigning orthodoxy in academic anthropology, and along with it came a reluctance to judge or even describe tribal peoples in ways suggesting that the writer was using Western values. As a result, the last few generations of anthropologists have been

prone systematically to overemphasize the differences between world cultures while minimizing similarities and pan-cultural universals. The anthropologist Maurice Bloch has gone so far as to accuse his colleagues of a form of "professional malpractice" in the extent to which they have tried in the last half century "to exaggerate the exotic character of other cultures." This exoticizing tendency has in particular infected anthropological approaches to art, where doubtful or misleadingly described cases drawn from the ambiguous margins areas of life—where art gradually fades into ritual, religion, or practical concerns—have been used to promote the idea that "they don't have our concept of art."

The direction of opinion in anthropology for the last half century has been toward the denial of a human psychological nature other than what might have been constructed by local cultural conditions, along with a reluctance ever openly to discuss—or to commit to print—comparisons between the values of peoples in modern industrial societies and those of inhabitants of tribal societies. Not knowing any better—how could they?—many art theorists and historians have bought this anthropological bill of goods and have repudiated the search for artistic universals, or at best remained silently agnostic on the subject. But the central features of art as a universal, cross-cultural phenomenon are not to be denied by bad ethnography. The similarities and analogies in the realm of the arts are in fact not difficult to see, and the anthropological literature leaves no doubt that all cultures have some form of art in perfectly intelligible Western senses of the term.

II

Consider a lively published debate held in 1993 at the University of Manchester over the motion, "Aesthetics is a cross-cultural category." One of the two speakers arguing the negative, anthropologist Joanna Overing, spoke against the motion "because the category of aesthetics is specific to the modernist era." It therefore "characterizes a *specific consciousness of art*." She claimed that "the 'aesthetic' is a bourgeois and élitist concept in the most literal historical sense, hatched and nurtured in the rationalist Enlightenment." At length she refined this view, stating that, thanks to the influence of Kant, "we have disengaged 'the arts'

from the social, the practical, the moral, the cosmological, and have made artistic activity especially distinct from the technological, the everyday, the productive."

Overing's argument depends on conflating the idea of art, broadly conceived, with the specific inflections the idea is given in local cultures. Long before Kant, the question of artistic autonomy was being debated by the Greeks, some of whose music, painting, and drama was as detached from social or ideological content as most modern painting, drama, and music. Is it possible to take seriously that the aesthetic interests of Europeans were ever limited to a special, tiny class of glorified objects (painting and sculpture, once seen only in palaces, today mostly surviving in fine-arts museums), which were given rapt, disinterested attention only by a privileged elite? Most of us conceive of art and aesthetic experience as a broad category that encompasses the mass arts (popular forms such as Attic tragedy, Victorian novels, or tonight's television offerings), historical expressions of religious or political belief, the history of music and dance, and the immense variety of design traditions for furniture, practical implements, and architecture. Far from being a small, rarefied class of objects, in the European imagination back to the Greeks, art includes a staggeringly vast range of activities and creative products.

I can write of art in this manner and expect to be understood not because my readers and I have checked the dictionary to determine the meaning of "art" but because we share a much more vague and broad pretheoretical understanding of what art is. Although there may be any number of difficult cases, from the Lascaux caves to Andy Warhol's Brillo boxes to the amazing cattle markings Dinka herders so enjoy, there are also enough indisputable examples to give talk about art an intelligible place to begin. In this respect, art talk is like the sciences: physics, linguistics, or medicine. As mature disciplines these sciences have developed hard-won theories that cover phenomena remote from mundane encounters with physical objects, ordinary speech, or the experience of headaches, but they nevertheless begin with such common experiences. There was, for instance, human awareness of good health and physical well-being, and with it a contrasting acquaintance with broken legs, indigestion, and death, long before there was a germ theory of disease, double-blind placebo testing, or any *theory* of health at all. Medicine began from pretheoretical understandings of health and disease; as a de-

veloped discipline, medicine has produced sophisticated theories and clinically effective cures, but not in ten thousand years has it abolished the ordinary distinction between robust good health and feeling nauseated or bleeding to death.

A naturalism about art would therefore take us back to the broad intuitions we have about everyday experience, including cross-cultural and historical experience. In ironic confirmation of this claim, it is striking how even writers who would reject "our" intuitions as shot through with a bourgeois ideology or ethnocentrism, and who prefer to stipulate definitions for their own theoretical purposes, are themselves reliant on the very intuitions they repudiate. Overing's argument, by stressing "the hidden dangers" for anthropologists of bringing concepts of Western aesthetics "to the task of understanding and translating other people's ideas about the beautiful" is reduced to contradiction and incoherence. She cannot have it both ways: on the one hand denying that aesthetics is a cross-cultural category, while on the other hand affirming that "other people" also have "ideas about the beautiful" that we can get wrong.

Overing discusses a focus of her fieldwork, the Piaroa people of the Amazon. She says variously that the "Piaroa notion of beauty cannot be removed from productive use . . . objects and people are beautiful for what they can do . . . beautification empowers . . . the beautiful and the artistic . . . are all considered to be aspects of the one and the same process." These factors, she concludes, make the Piaroa sense of beauty "offensive to our aesthetic sensibility." Hardly. Clearly, the Piaroa have a sense of beauty perhaps as different from ours as the Victorian sense is from that of the Sung Dynasty. But either beauty for the Piaroa is a recognizable kind of beauty—a distinctly Piaroa beauty, to be sure—or it is not. If it is not, then Overing ought not to call it "beauty" in the first place. If it is, then aesthetics is a cross-cultural category that she, despite her theoretical bent, must recognize and appeal to.

III

Similar claims have been made by the anthropologist Lynn M. Hart. She has written of large decorative paintings on mythological themes, *jyonti* paintings, made as a part of marriage celebrations by Hindu women in

Uttar Pradesh, sometimes working individually, sometimes in groups. She gives a full account of the women artists in their working environment, then goes on to describe the appearance of one such painting in a North American dining room and moves from there to the exhibition of another of these works in the *Magiciens de la terre* show in the Pompidou Center in Paris in 1989. Despite the fact that *jyonti* paintings are straightforward, colorfully stylized depictions of Hindu mythological themes (Ganesh, Lakshmi and Vishnu, sun and moon, lovebirds, etc.), Hart insists on using "producer" instead of "artist" and "visual image" instead of "art" to refer to this work (if it is "work"). Hart is determined, she explains, to avoid "inappropriate Western terminology." Otherwise, she imagines, Westerners might have trouble appreciating that "the images and patterns themselves are based on religion, ritual, and mythic themes and derive their meaning—and their power—from the religious contexts of their production and use." The indigenous aesthetic principles for this art, or rather visual images, are "different from standard Western aesthetics." The excellence of the works from an indigenous perspective, she explains, "is seen to lie in the closeness of the central symbol's approximation to an ideal image, with special attention paid to the style, technique, and materials used. It is important to re-present the symbols used in an adequate way, not to improve upon them, though at the same time the image on the wall should be as beautiful and pleasing as possible," and so on, all "quite distinct from Western aesthetic canons."

Hart's claim that *jyonti* painting cannot be understood by applying concepts of Western art is either trivial or false. If she means that Western painting does not traditionally include elements of Hindu mythology and is not painted on whitewashed mud walls by fluent speakers of Hindi as part of marriage celebrations, then indeed *jyonti* painting does not fall within Western categories. But that is no help to Hart's position. She would rather have us believe that *jyonti* painting is not even art "in our sense." At one point she attempts to dramatize the cultural difference between *jyonti* image producers and European artists:

> The Western producer of a painting destined (he or she hopes) for the wall of an art gallery and possibly for the wall of a great art museum is conscious of him- or herself as "artist" making an object that is contrived, posed, set apart from everyday life, just as

the short stories and novels of contemporary fiction are contrived, posed, and separate from everyday life. These products proclaim, "Look at me, I'm art!" The producer of the ritual images in a Hindu village is not conscious of herself in this particular way. She is producing an image that derives its meaning from the part it plays in life, rather than as a contrived, posed object.

Leaving aside the adequacy of this as a general account of Western art, it is clear that Hart is comparing here two completely different categories of activity. We are presented with the image of the ambitious Western artist operating in a professional market of agents, dealer galleries, money, and museums. Against this familiar image she gives us humble Indian women who decorate the walls of their houses with conventionalized religious designs as part of making a village wedding special. In Hart's sentimental account, "a woman, a mother, lovingly creates beautiful, emotion-filled, auspicious, important images for her own children for the purpose of helping them, of supporting them so they can succeed and be happy in the next stage of their lives."

The contrast is nonsensical. The history of the West is replete with countless mothers and prospective mothers-in-law who have labored at embroidery, knitting, and sewing, "producing" beautiful artifacts for their children's weddings, either as part of a trousseau or as decorative elements (e.g., decorated cakes) for the wedding day. These beautiful— or beautified—objects can be as lovingly created by European as by Indian women. Much of this output is cloth or fiber art, but it would also include decorated ceramics and items of household furniture, such as cradles. Some of these objects make reference to religious themes of fecundity and protection. Why has Hart failed to cite comparable Western traditions of dowry or trousseau arts to place in relation to the *jyonti* paintings of Uttar Pradesh?

On the evidence of her text, she is guilty of the very ethnocentrism she so blithely accuses others of. She studies a genre of folk art in one culture and, seeing that it is *painting* of a type, looks within Western culture to discover an analogue in painting. But if you want a comparison for a *jyonti* painting, it is absurd to look at a Mark Rothko hanging in a New York gallery. *Jyonti* paintings belong with domestic and dowry arts of cultures worldwide, from beautifully woven Maori feather cloaks

for infants to embroidered samplers to knitted blankets in European folk traditions. Elsewhere in her essay Hart complains of the West's tendency to place a greater value on high-art traditions than on craft traditions. In fact, Hart is doing exactly that herself: she is so impressed by these Indian forms as *painting* that she fails to acknowledge the women's craft traditions associated with marriage celebrations and trousseaus in her own culture. They too display loving and devoted exercise of skill and aesthetic judgment.

IV

I turn next to Susan M. Vogel, whose writing on tribal arts displays an eloquence and intellectual sophistication unmatched by the previous authors. Yet her wonderful book *Baule: African Art, Western Eyes* contains analysis reflecting a point of view similar to theirs: "This book," she explains, "is inspired by my enjoyment of certain objects of Baule material culture as works of art in a Western sense, but it seeks to explore what 'artworks' mean in Baule thinking and in individual Baule lives." Vogel says that the Baule people "who made and used these objects do not conceive them as 'art,' and may equate even the finest sculptures with mundane things, devoid of any visual interest, that have the same function and meaning . . . 'Art' in our sense does not exist in Baule villages, or if it does villagers might point to modern house decorations, rather than famous traditional sculptures still made and used in villages and evoked by the term 'African art.'"

She supports this contention with the following observations. First, the Baule "merge and equate" (a) spirits and unseen powers, (b) ordinary physical objects in which they may dwell, such as a lump of clay, and (c) superb sculptures, which they may also inhabit. However, only the last are works of art in the Western sense. Second, the Baule "attribute great powers to their artworks—powers that Western culture would mainly relegate to the realm of superstition . . . Enormous powers of life and death are integral parts of the sculptures we admire in museums, and Baule people do not consider them apart from those powers." Third, many of the most important art works of the Baule are not meant to be seen by large audiences, or by just anybody, but are normally hidden

from view, "kept in shuttered or windowless rooms that few people enter" or wrapped in cloth and taken out only infrequently. This sharply contrasts with the Western ethos of aesthetic objects that invite "intense, exalted looking" from a large audience. Looking itself is for the Baule a privileged and risky act, as the very sight of a sculpture by the wrong person can be fatal. This shows the special place of sight in Baule culture, where "seeing something is potentially more significant, more dangerous and contaminating, than touching or ingesting something." (Thus, Vogel says, a woman inadvertently seeing a sacred man's mask might die from the event, whereas a blind woman who laid her hand on it but didn't realize what she was touching would not necessarily be so threatened; men might find the sight of a woman's genitals fatal.)

Do these considerations support the view that the Baule have a different concept of art from the West's; that "art" in our sense cannot be found in Baule villages? No, they do not, as Vogel's subsequent account repeatedly makes clear. She describes masks and figure sculptures that have intense spiritual and personal significance to the Baule. These include personal portrait masks and so-called spirit spouses. Among these pieces magical or personal meanings certainly loom larger in the minds of their owners than purely sensuous or technical qualities: some of these objects would have been made by superb local carvers, others by less competent artists, but this might have little bearing on the significance of the work to its owner. These distinctions, however, and the fact that this art genre is implicated in a spiritual world, are not uniquely Baule phenomena. Many Christians who have been inspired by Giotto's great frescoes at Padua might have been just as moved by similar frescoes that did not approach Giotto's high level of artistry; in other words, the original audience might have generally had little interest in their comparative *artistic* values and would have responded to them purely as religious narratives. Our own much later grasp of the importance of Giotto for his original audience requires knowing the place of his work in a specific economy of *religious* thought. Religion, though often intermingled with art, need not be confused with it. So it is perfectly valid for an art historian to discuss those aspects of Giotto's work that form part of *art* history—technique, formal excellence, modes of representation—rather than religious or social history. The aesthetic qualities of Giotto's paintings and frescoes are not accidental by-products of religion: they

fuse high skill, artistic expression, and religious tradition. The same goes for Baule masks and figures. In both cultures, the status of these works as art is not threatened by being regarded by their original audiences as religious objects—as biblical illustrations, perhaps merely colorful backdrops for religious ceremonies, in the case of Giotto, as powerful "inhabited" spirit objects in the case of the Baule. The Baule people are in many ways exotic, but this does not mean that their art possess no clear analogues in our traditions.

Vogel pursues another kind of exoticizing impulse in her discussion of Yoruba twin dolls. For the Yoruba, twins are minor deities, and there is a genre of wood carvings to honor deceased twins, whose spirits in traditional animist religion inhabit the sculptures, known as *ibeji*. As Vogel explains, however, this tradition is in decline, particularly among Muslim and Christian families. The older carvings, which were produced with magnificent care, are being replaced by cheap, simplified carvings of low relief, and sometimes by cheaper Taiwanese plastic dolls with European features. (Even more recently, there is no sculpture at all in the twin cult, but rather photographs, where a doubled print of the surviving twin often stands in for the deceased sibling.) Both Vogel and, following her, the philosopher David Novitz, are especially impressed by the alacrity with which Yoruba people have been willing to supplant traditional wooden sculptures with plastic dolls. Vogel conceives these practices as "an imaginative use of imported items as replacements for traditional artworks." Novitz draws a more radical conclusion: the *ibeji* sculptures, since they are so easily replaced by mass-produced dolls that "most assuredly would not be considered art in our culture," are therefore "appreciated not for their originality, nor for their beauty, nor yet for their proportions; they are appreciated primarily as quasi-religious artifacts that allow the beneficial influence of the deceased twin to persist in the parents' lives." The *ibeji* carvings, Novitz says, "occupy a social space in Yoruba society that is remote from the social space occupied by works of art in our society."

But leaving the plastic dolls aside for a moment, there are no features of this story that warrant claiming that the traditional or more recent *ibeji* carvings are not art—in our sense or any sense. Recalling the criteria for art discussed in the last chapter, we can say that the older *ibeji* sculptures are (a) skillfully made objects (b) produced in a recognizable, conventional style, and (c) subject to qualitative criticism. They are

treated as (d) very special objects—and making them available only for private, rather than public, display gives then an even more special aura. They are also (e) imaginative objects—that is, they stand for the dead child and are inhabited by its spirit, but do not literally replace it. Taken together, these features warrant calling *ibeji* carvings works of art.

The same features also argue against Vogel's bland acceptance of the recent adoption of Taiwanese trinkets as a creative updating of an old tradition. There may be many reasons for the acceptance of plastic dolls as *ibeji*. Certainly the Christianizing of Yoruba life is a major factor. Doubtless there are Yoruba mothers too poor to commission carvings, as well as mothers who are simply uninterested in *ibeji* statues as distinctly Yoruba art (thus, incidentally, showing in this case that the enrichment or enhancement of Yoruba identity with art makes no difference to them). The plastic dolls may even have sheer novelty appeal. But in general, that there are people in any culture who do not care for a local art form, or who lose interest in it long enough for it to die out, tells us little about whether it is or was an art. Like the replacement of Pueblo pottery by cheap (and more practical) tin pots in the nineteenth-century American Southwest, the invasion of the Yoruba *ibeji* cult by plastic toys does not constitute a new innovation in an artistic tradition but rather its very death.

Through much of her discussion, Vogel is attempting to defamiliarize Baule and Yoruba art in the minds of her Western readers, requiring them to stop and think about the presuppositions they bring to any appearance of the word "art." This demand for an "unlearning" of cultural habits is entirely laudable: it extends the Western reader's understanding and appreciation (and, by the way, it is a strategy that could with profit be more often applied to Giotto appreciation as well). However, it is a strategy that can also encourage the false notion that we are ethnocentrically mistaken in calling Baule or Yoruba sacred creations "art." That aspect of the strategy is yet another instance of confounding, exoticizing rhetoric in ethnographic aesthetics.

In the end, however, it seems that Vogel herself does not believe the rhetoric. Having tried to establish the strangeness of Baule art, she turns around at the conclusion of her book to assure readers of its familiarity: "Nothing described in this book is completely unique to the Baule. In fact, the greatest interest of a tightly focused art study like this one may

lie precisely in how much light it can shed on the place of art in other, distant cultures."

V

How much different from a familiar practice in our culture must an alien practice, *x*, be in order to support the claim, "They have a different concept of *x* from ours"? There is one extreme answer to this question, held earnestly and systematically to my knowledge by no anthropologist, though it is often hinted at or suggested informally: it is that version of cultural relativism that claims that since the meaning of any concept is constituted by the other concepts and cultural forms in which it is embedded, concepts can *never* be intelligibly compared cross-culturally. This so-called incommensurability thesis—stressing cultural uniqueness—is attractive to some ethnographers who have specialized in specific cultures: it affords them a privileged standpoint, as they alone possess superior knowledge of the conceptual world of "their" tribe. The cultural interpretations of an ethnographer who knows the local language of a tribe, and has a grasp of the tribe's web of rarefied or esoteric meanings, cannot easily be challenged by outsiders. And since concepts in this view are noninterchangeable among cultures, it follows that the translation of not only poetic language but any language—along with comparison of political forms or social structures, judicial procedures, cooking and eating practices, warfare, and especially works of art—would therefore be impossible.

In the daily work of the ethnographer, where comparison and the cross-cultural use of concepts are constantly practiced, such incommensurability is never actually regarded as fact. Nevertheless, ethnographers will occasionally claim that a tribe "does not have our concept" of some practice or other. It is my contention that the notion of "a different concept" is stretched beyond intelligibility in almost all such contexts, and I have yet to see it used validly in connection with art. In the first place, the claim that a cultural form is unique, or that the concept that denotes it in our culture is useless or inapplicable in another culture, requires that the person making the claim has a firm command of the potentially comparable practices or meanings in Western culture with which the

alien meaning might be analogized. This is not a purely theoretical issue, and any ethnographer claiming cultural uniqueness for an alien meaning needs to be asked, *Are you confident you know enough about your own culture to make an incomparability claim?* This problem is at the core of the essay by Hart: she fails to find the proper comparison for *jyonti* painting, which is not European gallery painting but traditional religious folk painting practiced in the context of trousseau arts. Broadly speaking, this is a frequent deficiency in the anthropology of art. The anthropologist who is very good at mapping out a kinship system might still be an insensitive oaf when it comes to appreciating an indigenous local art.

With the Baule examples presented by Vogel, the issue is different. The magical powers built into these arts do not find a close analogue in Western art practice (though they recall weeping or healing religious statues that periodically appear even today in Europe and the Americas, or in outposts of Christianity such as the Philippines). Nevertheless, we have no trouble appreciating the skill and aesthetic characteristics of Baule spirit-spouse sculptures; we can also comprehend, thanks to Vogel's insights, the psychological utility of the notion of the spirit spouse for the Baule. Combining our general ideas of art with these other aspects of a foreign artistic/magical/religious practice is hardly an insurmountable task for the Western intellectual imagination. Vogel in particular paints a lucidly coherent picture of the world of Baule art and belief. Understanding her does not require any stretching or adjustment of "our concept" of art, however much she tells us about art's place in Baule culture.

Consider the cross-cultural practice of cooking. Suppose there existed a tribe whose only way of cooking food—any food, ever—was to boil it in water. Everything this tribe ever prepared and ate was either raw or boiled. Would we say, "They have a different concept of cooking from us"? No; they cook food, though within a more limited repertoire of techniques than ours. But a greater range of techniques for a practice does not in itself change the concept of that practice. The invention of the microwave oven did not change the concept of cooking; it provided a new way to do it: our great-grandparents had our concept of cooking, even if they never used microwave ovens. Suppose, however, that we discovered a tribe that never heated food, had never heard of heating it, but always passed a spirit wand over it before eating it. Would we say they had "a different concept of cooking from ours"? Again, no; whatever

else they are doing—blessing food, sanctifying it, warding off poisons, authorizing the occasion of its being eaten—they are not *cooking* it with a spirit wand. (Nor could they be symbolically cooking it: the wand could act to cook symbolically only if they knew what cooking was, but that would mean they already had the concept.)

In parallel fashion, suppose some culture's concept of art included objects that, although sculpted out of wood, were *never* looked at with amazement, pleasure, or fascination of any kind, in public or in private (or were expected to be looked at even by nonhuman entities, as by gods), were the subject of no critical vocabulary, were never admired for their skill, did not represent anything, were crafted in no discernibly regular style, and, although employed as doorstops, were never accorded any attention beyond what was required to place them before open doors or to remove them in order to shut doors. Could we say that this tribe has "a different concept of art from ours"? No; on the evidence so far supplied, whatever else these objects are (doorstops, evidently), they are not "art in a sense different from the Western sense." *They are not works of art at all.* In order to qualify as a work of art, in whatever attenuated, distant, strange, or obscure sense we might want to capture, a mysterious object new to our experience would have to share in *some* of those aspects— giving sensuous pleasure in experience, being created in (or against) a traditional style, involving intense imaginative attention, being skillfully made or performed, being symbolic or representative, expressing emotion or feeling, and so forth—that art shares not only in Western culture but also in the great art traditions of Asia and the rest of the world, including tribal cultures of Africa, the Americas, and Oceania. If there is no discernible connection with this established complex of ideas, the mysterious object is not a new kind of art: it is not art at all.

VI

However illuminating or defective their interpretations, anthropologists at least fancy that they approach art from the standpoint of ethnographic evidence. Philosophers, on the other hand, are given professional leave to concoct purely imaginary thought experiments. Analysis in the mode of Wittgenstein, for example, often begins with a kind of make-believe an-

thropology: "Imagine a tribe . . ." One such thought experiment has been devised by Arthur Danto to test the question of whether an exotic tribe might have a completely different concept of art from ours. Could we imagine a set of aesthetic values in another culture—its aesthetic sensibility or aesthetic universe—that is *unavailable to our aesthetic perception, no matter how hard we apply our mind to it*? Might there exist in a foreign culture a whole genre of art that we could not directly perceive as such except by being told by a cultural insider that it is art?

Danto asks us to imagine two African tribes who live out of contact with each other on either side of a mountain divide. Each of these imaginary tribes produces both pots and baskets that are, whichever tribe produces them, indistinguishable to our eyes. Yet despite the external similarity of the two tribes' pots and baskets, there is all the difference in the world between them. In the culture of the Pot People, as one of the tribes is known, pots are rich with significance. God, in their cosmology, is a pot-maker, and pots for the Pot People express a whole cosmology; the potters who make them are honored as artists in their society. The Basket Folk, who live on the other side of the mountains, make baskets that, for them, "embody the principles of the universe itself." Their cosmology is built around the idea of the basket, and each of their baskets is an object of great meaning and spiritual power—a work of art.

Now as it happens, the Basket Folk also make pots, as the Pot People manufacture baskets. Though Basket Folk pots are admired by ethnographers, the Basket Folk attach no special importance to them: they are merely utensils, "of a piece with fish nets and arrow heads, textiles of bark and flax." Similar is the attitude of the Pot People to their baskets: the tribesmen who make them are regarded as artisans but not honored as artists in their homeland.

In Danto's narrative, a difficulty looms when objects acquired from the Pot People and the Basket Folk are put on display in a Fine Arts Museum and a Natural History Museum. As you would expect, Pot People pots and Basket Folk baskets, being works of art, are housed in the Primitive Wing of the Fine Arts Museum, while pots of the Basket Folk and baskets of the Pot People are displayed alongside other utilitarian artifacts in the Natural History Museum. The Natural History Museum does, however, present two dioramas of everyday life—tribesmen cultivating gardens, weaving, nursing babies—among the Pot People

and the Basket Folk: "A basket from the Basket Folk and a pot from the Pot People are given a kind of privileged place in their respective dioramas . . . standing apart, perhaps objects of rapt attention." A guided school group is shown both dioramas. A schoolgirl among them proclaims that she can see no difference between the baskets venerated in the Basket Folk diorama and the baskets strewn about, some broken, all used, in the Pot People diorama.

The child is fobbed off with assurances that experts can tell the difference, but her problem remains: if *we* can't see the differences that make one class of objects into works of art while leaving the other class as utilitarian artifacts, should the distinction make any difference *to us?* Physical scientific criteria are dismissed, and rightly so, by Danto: these cannot be the differences that matter. Yet the child's question will, I think, touch a nerve with anyone who has worried about cross-cultural aesthetic perception. Danto's example challenges at its very heart aesthetic criticism applied to the art of remote cultures because it raises the possibility that what a pot or basket meant to a tribe, or whether it meant anything at all, might be irrelevant to our aesthetic appreciation of it. No one who has admired a work of tribal art, or been moved or thrilled by a mask or carving, can avoid the awkward implications raised: Did it move its maker? Is it a good one in the tribe's eyes? Is it a piece of special spiritual significance? Is it a purely utilitarian object? A piece of tourist kitsch?

Danto never identifies the relevant experts whose supposed knowledge is (falsely) used to deflect the little girl's question; we are left supposing they would be museum scientists or curators, and in his thought experiment we are required to imagine that in reality not even they can tell the difference from visual inspection: the same visual inspection of works of art that ought to give aesthetic pleasure. But Danto has omitted from the discussion what seems to me a crucially important group of potential experts who might actually be able to see a difference. What about the Pot People potters themselves? Could we imagine Pot People culture just as Danto describes it—with its mythology, its significations, its sense of life packed into the concept of the pot, and incarnated in the individual pots of the tribe—and yet entertain the hypothesis that *Pot People potters would themselves be unable to distinguish their own creations from the utilitarian artifacts of another tribe over the mountains?*

Danto's story, after all, is not just about the foibles of curatorship; it is about the artistic life of the tribes themselves. And every aspect and element of my own experience of tribal art—both in museum collections and in fieldwork in the jungles of New Guinea—suggests that Danto's tribes are humanly impossible. They are, of course, not logically impossible, any more than a monkey who accidentally types out *Hamlet* on his word processor is logically impossible. But it isn't bare logical possibility that makes Danto's story so seductive. Anyone who was worked in the area of ethnographic art will tell you that in many individual cases there will be uncertainty about how to take a work: whether to cast it in the category of art or the category of artifact, or whether to consider it as a tourist piece made for sale to outsiders or as a work of significant spiritual value to the people who made it. Danto, however, is not presenting us with a mistake about some particular work. Rather, he describes a situation where *a whole genre or tradition of tribal art is to our eyes aesthetically indistinguishable from another genre or tradition of tribal artifact.* In point of fact, that a whole art tradition might in the real world be indiscernible from a utilitarian artifact tradition seems to me as about as likely a monkey typing *Hamlet.*

Could we imagine a persistent pattern of cultural behavior as odd as the situation Danto portrays? If pots with their mythology and spiritual dimensions have the place he ascribes for the Pot People, if pot-making is their most valued art, we would expert Pot People potters to be meticulous about the construction and decoration of their pots. They would work according to a critical canon of excellence in design and decoration—with thought and worry going into obtaining the perfect clay for making them, firing them for exactly the right kind of finish. That would explain why, in Danto's account, they would admire their best potters and treasure the finest pots.

Turn for a moment from philosophical thought experiments to a real-life example: the carvers of the Sepik River of New Guinea, where I have conducted fieldwork. Like Danto's pot- and basket-makers, Sepik carvers also produce both works of spiritual and magical significance and works for pure utility. Some of their utilitarian carvings are highly expressive. They make canoes with nothing more than a "nice line," and undecorated earthenware pots, and wooden carving tools. But you'll also find gliding up the Sepik River canoes with elaborately decorated prows in the form

of crocodiles' heads, and elegantly embellished cooking pots and carving mallets. There are ancestor figures and healing charms whose significance is limited to appeasing some spirit. And finally, with immense areas of overlap and ambiguity, there are carvings done simply to sell to tourists; some of these are very fine, while most are quite tawdry.

Europeans new to Sepik art will naturally miss subtle distinctions that are there to be detected in it. But persevere and you may discover the intrinsic differences between a carving of a human form done to sell to a tourist and one made with the utmost seriousness to please the spirit of an ancestor. The tourist, for example, will see the initiation scars carved on the front of the figure but won't notice if they are omitted from the back. The ancestor spirit will notice the absence of dorsal scars, and also know if the carving is painstakingly fashioned from a hard wood, such as garamut, or is produced in a soft, easy-to-carve wood: spirits don't like shortcuts, which tourists won't notice. The spirit may prefer a very large carving, and is not concerned whether it taxes a twenty-kilo luggage limit. The Sepik carver who is working to please a spirit will therefore bring to the job a sense of intense purpose that will show itself in perceptible qualities of the finished art work. To the educated Sepik eye, to the Sepik connoisseur, such inner qualities are as plain to see as passionate intensity is evident to Westerners in the painting of van Gogh. Anyone, Sepik or not, can be skeptical about the seriousness of supernatural intent of a particular carving; but in most cases questions will no more naturally arise than they do in questioning van Gogh's seriousness of purpose. Moreover, Sepik criteria of artistic excellence are in principle available to anyone with the time and will to learn to perceive; they are not monadically sealed in Sepik culture. (If they were somehow unlearnable, they couldn't even be taught to the next generation of Sepik carvers.)

With Danto's challenge in mind, here is another philosophic thought experiment, one of my own. It is an imaginary pastiche, although it is derived in part from my experience of New Guinea. It may be caricature, but it describes in every one of its details facts and events observed by me and by ethnographers who have worked in the Pacific region. Imagine again two peoples (the word "tribe" is not technically correct in Oceania). The first, I shall call them the Jungle People, produce carvings that when seen at night in flickering firelight in the cavernous Spirit House

come alive as the souls of the dead enter into them. Jungle People master carvers, who use tools of stone and bone, are specially revered by their fellows, with a few individual carvers known for their remarkable works. These men (they are strictly men in this culture, as women are strictly weavers) produce a great variety of carving, mostly involving human and animal forms. The Jungle People particularly value carvings made of the hardest old woods of the ancient tropical rain forest they inhabit; they believe too that the gods respond especially favorably to carvings that are difficult to make. Now and again their carvings are produced in secret and hidden in the jungle, where they are found by children, with the word put about that they were left there by the gods. The Jungle People pray to these carvings, and cover them with pig fat, or blood, or semen, in order to energize them spiritually to bring about healing or luck in hunting expeditions. As they are still isolated from modern civilization, the Jungle People have no access to representational images other than those their own carvers produce: they have never seen either pictures or carvings of other cultures, except the vaguely similar carvings of nearby cultures. They themselves have no tradition of two-dimensional painting or drawing. Their carvings, even when realistic to our eyes, are indelibly stylized in their peculiarly elongated Jungle People manner. Occasionally, the Jungle People form raiding parties to steal especially powerful carvings from neighbors. Over generations, many people have died in these raids. The carvings are very important to them.

As it happens, there is another tribe, historically and culturally closely related to the Jungle People. We know they are related because their language and system of mythology share many elements with the Jungle People's, as did their sacred and decorative carving prior to their first contact with an Australian patrol officer in the middle 1930s. They live where they have always lived, near the mouth of a river on their large South Pacific island. In the 1960s, a Club Med was built next to their village, and although they still have their traditional name, they now whimsically call themselves the Tourist People. They no longer pray to their carved idols and would be terribly embarrassed at the idea of smearing carvings with blood or semen, because they have all become devout, somewhat prudish, Methodists. They still, however, produce their "traditional" carvings, all of which they sell to the Club Med visitors. Using carving tools of German steel on soft woods, they are able quickly to

manufacture large numbers of carvings, which they usually shine with polyurethane varnish. The Tourist People are able to live comfortably on a government welfare benefit (the government is supported by mining royalties, as parts of the country are rich with gold deposits), so much of the extra money earned through carving goes into the purchase and rental of movies for their video players. (No broadcast television reaches the Tourist People's settlement, but every household has a video play-back device. Old Hong Kong kung-fu movies, dubbed into Melanesian pidgin, are a perpetual delight.)

Now let us stop and try to imagine, in the manner of Arthur Danto, that *no one can tell the difference between the carvings of the Jungle People and the carvings of the Tourist People.* But wait: how is it possible to imag-ine that carvings produced in such completely different contexts, for such completely different aims, could turn out to be indistinguishable? We might well suppose that an occasional Tourist People carving produced by an old carver in the traditional style, or by a clever young carver using a traditional model, might, at least to a tourist, look like an ancient Jungle People carving, or might be to most eyes indistinguishable from Tourist People carvings produced before the days of Club Med. Individual cases, perhaps; but general indiscerniblility between whole genres of Jungle People and Tourist People carving? Step out of the philosopher's study and into the real world of human values and artistic creation, and the prospect seems about as likely as a monkey-authored *Hamlet.*

Danto insists on a conceptual distinction between art and utilitarian artifact that would seem on the face of it to be in agreement with what I have described so far about both the (real) Sepik peoples and the (imaginary) Jungle/Tourist People. Artifacts are not problematic for Danto: they are simply nicely made useful objects. Art works are alto-gether something else, "a compound of thought and matter," as he puts it. A utilitarian artifact "is shaped by its function, but the shape of an artwork is given by its content . . . To be a work of art, I have argued, is to embody a thought, to have a content, to express a meaning, and so the works of art that outwardly resemble Primitive artifacts embody thoughts, have contents, express meanings, though the objects [i.e., arti-facts] they resemble do not."

Applying Danto's way of speaking to my thought experiment, the Jungle People's carvings are used by them to express deeply held ideas

about their lives, their mythic history, and their values. The Tourist People's carvings are mere items of merchandise and express little or nothing. Art is opposed either to utilitarian artifacts or tourist kitsch: all parties can agree so far that art objects are those apparently formally significant objects that express or embody ideas. The difference between my imaginary story and Danto's is that Danto—under the spell of Duchamp's readymades and Warhol's Brillo boxes, and affected by the particular fallibility of naive Westerners in spotting distinctions between authentic masterworks of primitive art and mere artifacts (or kitsch)—has tried to construct a picture of art in which perceptions do not count at all, in which interpretation and institutional status determine aesthetic value *tout court*. In Danto's Pot People/Basket Folk world, the cultural outsider can never know an artistic masterpiece unless and until some insider comes along with the information that, yes, that's a work of art.

In contrast to Danto, the implication of my thought experiment is that trained perception, the ability of tribal peoples themselves to see systematic differences between expressive art and utilitarian artifact—and the ability of the informed eyes of Westerners also to learn to perceive differences—is fundamental. Tribal art works are more often than not works of skill that are intended to delight (or dazzle or frighten) the beholder; there are no local Duchamps or Warhols in New Guinea or elsewhere in the realms of indigenous, ethnographic arts. Danto is taking the ignorance of the outsider and trying to parlay it into a principle according to which perception would not count at all.

Danto has elsewhere argued that the very existence of art objects depends on interpretation. He claims that "interpretations are what constitute works." Interpretations identify what it is that artists have made: "The interpretation is not something outside the work: work and interpretation arise together in aesthetic consciousness." This is a fine way to describe a modernist experiment such as Marcel Duchamp's *In Advance of the Broken Arm*, which was just a hardware-store snow shovel until Duchamp leaned it against the wall of a gallery and "interpreted" it as a work of art. The conceptual adventures of European modernism are a world away from African artists who, along with Sepik artists, and countless other artists of tribal societies, create works for the eye as well as the mind. That these tribal objects are intended to amaze, amuse, shock, and enchant is part of the artistic interpretation that constitutes

their very being as works of art. Danto's constituting interpretations in his ethno-aesthetic fantasy stand, like Duchamp's readymades, independent of perception: for all their artistic differences, the works of the Pot People and the Basket Folk end up as indiscernible. In contrast, the actual constituting interpretations of real tribal artists normally entail perceptual distinctions.

Learning a primitive art genre is thus not a matter of acquiring knowledge of a cultural context into which objects can be set (and distinguished as artifact or art); it is a matter of gaining cultural knowledge in order to see aesthetic qualities which have intentionally been placed in the objects to be seen. An obvious empirical corollary to all this would be that the genres or objects that mean the most to a tribe will usually be the very ones in which the most perceivable content is packed; sacred ancestor carvings will be richer in their connections to a cultural background, and provide a more powerful visual experience, than digging sticks or cooking pots (unless, of course, they are special pots or magical sticks). This is true of every so-called primitive culture of my acquaintance.

Since Danto is willing to give primacy to the artist's interpretation as constitutive of art in the Western tradition, the same courtesy ought to be extended to his two imagined tribes. His failure to interrogate the indigenous artists and connoisseurs of these tribes as to whether they can perceive differences that escape Western curators and schoolchildren might be construed as ethnocentrism. But this would be fatuous: it is hard to know what it would be for a philosopher to be ethnocentric about an example that is the product of his own fertile imagination. Danto, after all, is the chief colonial administrator and exclusive ethnographer of the territory that includes the Pot People and the Basket Folk. Nevertheless, I am certain that if he would allow a few more alert anthropologists into the area, these tribes would have another story to tell.

CHAPTER 5

Art and Natural Selection

⊷

I

Charles Darwin was not the first thinker to suggest that living organisms evolved through time. The pre-Socratic philosopher Anaximander said as much 2,500 years ago, and the concept had become widely accepted by Darwin's own time. Nor did Darwin's originality lie with the idea that all animal life is related, or that parts of organisms or their behavior patterns are conducive to survival: by Darwin's time, such facts were constantly being appealed to by theologians as evidence for God's hand in nature. Darwin's theory of evolution triumphed because it proposed a physical mechanism to make evolution both intelligible and possible: the development of species by a process of *random mutation and selective retention*, known forever after as natural selection.

At a stroke, natural selection deprived religious naturalism of its greatest single support beam. Darwin discovered a purely physical process that could generate biological organisms that function *as though* they had been consciously designed. Indeed, they were "designed," but in a new sense: design by blindly causal rather than knowingly intentional processes. Today, biblical creationists still insist on the necessity of divine intention to account for at least some features of the natural world, for instance, the intricate purposiveness of a weaver bird's nest or the human eye. Anyone with a clear grasp of evolution is unlikely to find the creationist position interesting. But when it comes to applying evolution to the human mind and to cultural and artistic life—prime examples

all of rational, intentional human planning and action—the issues of design and purpose reemerge all over again, though in ways not always appreciated even by sophisticated defenders of Darwinism. It is one thing to connect the structure and function of the immune system or inner ear to evolutionary principles. It is quite another to suppose that evolution might be linked to the paintings of Albrecht Dürer or the poetry of Gérard de Nerval. Darwin believed there were important connections between evolution of human artistic practices. We shall look at his ideas on this subject later, particularly in chapter 7. First, though, I want to examine an important question: *are the arts in their various forms adaptations in their own right, or are they better understood as modern by-products of adaptations?*

Evolutionary psychology is the study of the developmental history and adaptive functions of the mind, including the ways those functions shape the mind's cultural products. Evolutionary psychology holds out the hope, as Steven Pinker puts it, "of understanding the *design* or *purpose* of the mind"—its individual features, biases, capacities—"not in a mystical or teleological sense, but in the sense of the simulacrum of engineering that pervades the natural world." The engineering in question must strictly speaking have as its goal *survival or reproduction*; it cannot be something that, say, merely improves the quality of life for an organism, or is seen as desirable by it. This fundamental fact severely limits the scope of evolutionary explanation. As Pinker puts it, "Evolutionary biology rules out, for example, adaptations that work toward the good of the species, the harmony of the ecosystem, beauty for its own sake, benefits to entities other than the replicators that create the adaptations (e.g., horses that evolve saddles), functional complexity without reproductive benefit (e.g., an adaptation to compute the digits of pi), and anachronistic adaptations that benefit the organism in a kind of environment other than the one in which it evolved (e.g., an innate ability to read or an innate concept of *carburetor* or *trombone*)." In other words, it is never enough for an evolutionary explanation of a biological or mental phenomenon to point out the phenomenon's putative benefits for individuals, for society, or for humanity as a whole.

The arts, for instance, are commonly thought to be good for us in any number of ways, giving us a sense of well-being or feelings of comfort. Art may help us to see deeper into the human psyche, aid convalescents

in hospitals to recover more quickly, or give us a better appreciation of the natural world. It may bind communities together, or alternatively show us the virtues of cultivating our individuality. Art may offer consolation in moments of life crisis, it may soothe the nerves, or it may produce a beneficial psychological catharsis, a purging of emotions that clears the mind or edifies the soul. Even if all of these claims were true, they could not by themselves validate a Darwinian explanation of the arts, unless they could somehow be connected with survival and reproduction. The problem here is a temptation to bask in warm feelings about the arts and then to trip over a stock fallacy of classical logic: "Evolved adaptations are advantageous for our species. The arts are advantageous for our species. Therefore, the arts are evolved adaptations."

Whoa! Antibiotics and air-conditioning are advantageous for us, but unlike the eye, which is also advantageous, they are not evolved adaptations. Our lives are filled with contrivances and benefits designed by us or bequeathed to us by our culture's traditions and technologies. These advantages are endlessly open-ended and variable. Evolved adaptations, however, are a relatively small though crucially important subclass of the long list of things that we may enjoy or benefit from. These adaptations may give us pain or pleasure, may provoke emotions, and may or may not work to our advantage today, but they form part of our nature and personality because they possessed survival and reproductive advantages in the ancient past of *Homo sapiens*. They constitute a stable, finite list that has not changed significantly since the savannas of the Pleistocene. They are the source of general human predilections and desires that act as givens, the origin points of causal chains that motivate and validate the goods and practices (including technologies) that constitute our culture.

Why do I like chocolates? In part, because they are sweet and fat. Why do I like sweet and fat? There is no obvious answer to that question available to introspection: think about it as hard as you like, but soul-searching and self-analysis can never by themselves tell you why you enjoy sweet and fat. Evolution, thankfully, gave us capacities and yearning to help us survive and reproduce in the ancestral world—but an explanation from evolution of why we have them was never part of the deal.

II.

Chocolates, however, are not merely appealing delivery mechanisms for sucrose, fructose, and lipid compounds. They are culturally sanctioned, economically conditioned, and technologically enabled ways not only to satisfy hunger but to serve as gift or love tokens, or to demonstrate a candy-maker's artistry. Using a standard terminological distinction for evolutionary psychology, hunger and a craving for sweets are the *proximate cause* of my eating chocolate, while my genetically evolved nutritional need for sweet and fat is the *ultimate cause*. Although this is clear enough in a simple physiological case of a food, applying such an explanatory model to social and cultural practices raises complicated new issues. Sweet and fat are one kind of evolutionary ultimate cause, and certainly help explain the existence of chocolates in the modern world, but they are not the only cause at work in this case. There might, for instance, be other ultimate causes at play—connected in this case with generosity, or an impulse to give pleasurable gifts in courtship contexts, or a desire to display and appreciate confectionary skill or to enjoy a familiar food. The conventional approach to such issues for the last half century has been to treat the desire for sweet and fat as the ultimate biological cause for the existence of chocolates, and everything else mentioned as a mere cultural overlay on the biological demand. A Darwinian approach says, no, there may well be a whole array of innate instincts at play here: gift-giving and skill-display instincts, for example, which may have evolutionary origins. These evolved interests and behavior patterns will in their turn be subject to cultural forming and modification, but they too may draw on innate sources as much as the desire for sweet and fat. When we turn from chocolates back to the arts, we encounter an even richer combination of psychological adaptations and cultural traditions out of which emerge the worlds of the arts.

In order better to understand how innate instincts interact with cultural traditions, I want to turn to another powerful, universal instinct that has clear cultural implications: incest avoidance. Here the ultimate cause of the instinct (keeping the gene pool sound by minimizing the effects of DNA copying mistakes) is far removed from the proximate cause, being at least uninterested in and at most repelled by the idea of sexual intercourse with a close relative. This instinct was first systematically described by

Edward A. Westermarck, the nineteenth-century Finnish anthropologist whose research is cited by E. O. Wilson as providing an exemplary case of the interplay between instinctual nature and historical culture in human social behavior. The cravings of hunger are immediately clear: they make food attractive. In contrast, the Westermarck effect is based more on a distinct absence of a craving or interest in an area where cravings and interests are so central: sex. It applies to close blood relatives but has a side effect in the general anthropological rule that children who live together between the ages of three and six, blood relatives or not, are unlikely to form a sexual bond in later life. This fact is confirmed by studies of the Israeli kibbutzim, where children raised together from an early age have a very low marriage rate, and in China, where a study has shown that when a little girl goes to live in the house of her intended husband, a little boy of similar age, the failure rate of the subsequent marriage is much higher than with marriages that are arranged in adolescence or later. As Wilson described it, the Westermarck effect delivers to people an unconscious command: *Have no sexual interest in those whom you knew intimately during the earliest years of your life.*

Incest avoidance is an instinct that humans share with other sexually reproducing animals, including all of the other primates, whose young, like *Homo sapiens*, often disperse at the point of sexual maturity. But with humans there is also a cultural packaging for incest avoidance. In all but a small minority of cultures, incest avoidance is explained, elaborated, justified, and codified by mythology, folktales, laws, or superstitions: it is transformed into the incest taboo. Such narratives may be ways of rationalizing the Westermarck effect, but they may also arise from a completely different source: the fact that people sometimes can directly observe the effects of inbreeding—the greater frequency of a variety of deformities, including dwarfism and mental retardation, as well as early mortality. One study of sixty nonliterate societies indicates that about a third were directly aware that deformities result from incestuous unions. Not all nonliterate cultures show such awareness, presumably because their prohibitions on incest are successful enough that they have not had available to them the comparative observations of the results of inbreeding. Other societies, generally the ones that have literacy and formal legal systems, may codify incest prohibitions and justify them explicitly in terms of inbreeding effects.

Here, then, is a complex situation of innate, heritable dispositions (the Westermarck effect), given formal expression by a variety of cultural rules and meanings (incest taboos) that can be empirically connected to observable outcomes (deformed children). In Wilson's account, what he calls these "enhancements" of incest avoidance look like benighted justifications of an instinctual impulse. But the taboos might in some cases be entirely rational: a directly observed, though infrequent, deadly effect produced by inbreeding might require, if it is to be avoided, being made into a taboo by the vivid drama, superstition, or mythological story—a supernatural theory of incest, so to speak. The taboo structure, in other words, might be originated by a perfectly rational familiarity with deformed children. So we have a spectrum: the pure operation of unconscious, innate drives, preferences, and capacities at one extreme, and behavior based on rational observation, independent of drives, as well as purely learned behavior, at the other. Between these natural limits are the constructions of local and traditional culture that combine with inherited nature, channeling it, using it, exploiting it, resisting it.

Sometimes superstitions and mythologies validate the impulses that come from within; on other occasions, they may plainly validate empirical observation observed from without. Most of human life is in a middle territory, conducted in light of the overlapping effects of instinct, custom, authority (shamans in the Pleistocene, "experts" and the media today), and personal rational choices based on the evidence experience provides. It is useful to apply such analytical categories to facts of everyday life—hunger and thirst, fear of snakes (or electrical outlets), sex and reproduction, incest avoidance, a sense of fairness, language, sociality, and so forth. It is especially important to keep this analysis in mind when describing the evolved sources and innate impulses that drive something as culturally freighted as the arts.

III

The gold standard for evolutionary explanation is the biological concept of an adaptation: an inherited physiological, affective, or behavioral characteristic that reliably develops in an organism, increasing its chances

of survival and reproduction. But how can we characterize the relationship between adaptation and the innumerable features of human biology and mental life that are not adaptations? If we follow standard evolutionary theory, anything produced by an adaptive process that is not an adaptation must fall into one of two categories: it can be either (1) a one-off random or accidental effect of gene combination—noise, we might say, a mutation—or (2) a causally related by-product of an adaptation or arrangement of adaptations. To connect evolution and the arts, we concern ourselves with ancient, persistent patterns of human interests, capacities, and preferences. Random one-off mutations or the chance effects of mutations are therefore ruled out as explanations; these are dependable drivers of evolution, to be sure, but they are not the patterned features that are its end result.

By-products are a much more plausible class of possibilities for the arts. Might the arts be best understood as by-products of adaptations? A textbook example of a nonfunctional by-product of an evolved adaptation is the whiteness of bone. Skeletons make use of calcium, which is available to animals in their food and confers structural strength. As it happens, the insoluble calcium salts in bone are white, and so, therefore, is bone. There are adaptive reasons why bone should be strong, but no such reasons dictate that it should be white or any other color. Whiteness is a consequence of the chemical composition of bone; were calcium salts another color, bone might be green or pink. Other examples of by-products include the navel, essentially a scar that in itself has no adaptive function, and male nipples, which are by-products of the process that in females leads to mammary glands.

When we move from evolved organic features to an evolved psychology, we enter a field where the line dividing putative adaptation from by-products has been the subject of extended, sometimes hot dispute. One unacknowledged source of strong feelings in this area involves the connotations of the very term "by-product" itself. In ordinary parlance, "by-product" means a secondary, perhaps minor or irrelevant side effect of something more primary. The very idea of a by-product implies an effect that does not have a life of its own but is essentially "about" the thing that produced it. Try telling the believer or the patriot that religious convictions or patriotic feelings are by-products of Pleistocene adaptations. Even in areas closer to pure physiology, to treat important

effects—phenomena significant in the lives of individuals—as mere by-products can lead to controversy, as Elisabeth Lloyd found out when she published her research on the female orgasm.

Beginning her work in the 1980s, Lloyd evaluated twenty-one different theories of the female orgasm and came to the conclusion that the most plausible was Donald Symons's 1979 view that while the orgasm has a primary reproductive function with human males, in females it is, like nipples in males, a by-product of a shared embryonic physiology. In the first eight weeks of life the human embryo develops the neural pathways that, once sex is determined, become either the penis or the clitoris. Lloyd allows that the highly pleasurable male orgasm is an adaptation for reproduction. She argues, however, that the female orgasm, which is for many women not even a regular feature of sexual intercourse, is not an adaptation but a by-product of an effect designed by evolution for male pleasure. She shows that thirty-two studies undertaken over seventy-four years indicate that fewer than half of women regularly experience orgasm in intercourse. If you remove from these figures orgasm aided by manual clitoral stimulation during intercourse, then the percentage is lower still. Lloyd's feminist credentials and her criticism of what she regards as sexism in the history of male-agenda-driven research on the female orgasm did not shield her from being herself subjected to a shower of attacks, especially from feminists who regarded her as trivializing women's experience and—shades of Adam's rib—making it derivative of male experience.

Lloyd was encouraged in her research and speculations on the female orgasm by Stephen Jay Gould, who picked up her by-product thesis and used it as a topic for one of his essays in *Natural History* magazine in 1987. This connection with Gould is fitting, because of his systematic attempt to downgrade the importance of adaptation in evolution, replacing it with his notion of by-products. In fact, so far as psychology was concerned, Gould came to regard the whole realm of human cultural conduct and experience as a by-product of a single adaptation: the oversized human brain. "Spandrels" is his chosen metaphor for what he calls the "nonadaptive side consequences" of adaptations. The word is taken from architecture: it describes the triangular space that is created inside a building where rounded arches or windows meet a dome or ceiling. Spandrels can be useful spaces for paintings, mosaics, or other orna-

ments, but arched windows are not by-products of buildings designed to have spandrels; the spaces called spandrels are a by-product of having designed into a building arched or rounded windows.

For Gould, "spandrels define a major category of important evolutionary features that do not arise as adaptations." His supporting examples for the spandrel analogy are taken from animal physiology: clams, snails, and the tyrannosaurs. His application of spandrels to human affairs, however, is claimed only for by-products of the evolution of one particular human organ: the brain—which, he remarks, is "replete with spandrels." In fact, it "must be bursting with spandrels that are essential to human nature and vital to our self-understanding but that arose as nonadaptations, and are therefore outside the compass of evolutionary psychology." These epiphenomena, he simply proclaims, may account for "most of our mental properties and potentials." Gould is given to a punch-pulling use of "may," "most," and "might" in making his claims, and while he fluently details a variety of spandrels in evolved animal physiology, he is exasperatingly vague when he turns to patterns of human behavior. In fact, on the question of which behavior patterns *are not* spandrels but adaptations, he is entirely silent, except for a concession late in his career that some possible differences in the mental proclivities of the two sexes might be adaptations. On the question of which universal human behavior patterns *are* spandrels, he drops a few suggestions—the early Holocene invention of writing and reading is one—but he analyzes none. Gould feels no need to defend himself on this issue: "I am content to believe that the human brain became large by natural selection, and for adaptive reasons—that is for some set of activities that our savanna ancestors could only perform with bigger brains." The spandrels are just there, "often co-opted later in human history for important secondary functions." About the primary adaptation, the big brain, that produced these secondary manifestations, nothing is said, and in fact Gould's whole stance suggests that nothing can be said about it. His spandrel-laden brain turns out in the end to be a behavioral and cultural equivalent of the blank slate—an array of blank spandrels, actually: unutilized, but ready to be picked up and decorated with whatever values, interests, and capacities history and culture have in mind.

This remarkable, not to say brazen, attempt by the most famous Darwinian of his generation to prohibit evolutionary explanations for

psychological features does not jibe with facts that were available to him then or to us today. As noted, one example Gould does mention as a spandrel is the practice of writing and reading, since it is only about five thousand years old. But what about a reality he conspicuously fails to mention: spoken language? Writing and reading contrast markedly with the general capacity from which they derive. Speech is not a by-product of a big brain but a genuine adaptive capacity. It is not remotely plausible to suggest that our ancestors on the savannas or anywhere else developed a big brain with lots of all-purpose intelligence and nothing else save plenty of empty spandrels, some of which in due course came to be filled by language as we now know it. That *would be* a just-so story.

In actual fact, language appears in human beings as universally as sweat glands or fingernails. The complex mental processes it makes use of appear spontaneously and develop reliably toward mature linguistic competence with the same regularity everywhere. Moreover, language had obvious and decisive survival and reproductive value in the Pleistocene. The pan-cultural features of language are structurally uniform in ways that show adaptive design; they are not explainable except as innate. Even factors that interfere with the development of language and the mental equipment associated with it, such as autism and aphasia, do so in regular, diagnostically predictable ways. For Gould to have claimed that such an intrinsic component of human conduct and mental experience as language could be a by-product of brain attributes that mysteriously arose in the savannas for unknown purposes ignores everything we know about language. It is unimaginable that something as structurally complex and astoundingly functional as language could have appeared in the Pleistocene as a by-product of a brain that was growing in size to solve other, non-language-relevant problems.

Gould's anti-adaptationism, his disparaging attempts to minimize or actively deny connections between psychology, cultural forms, and evolved capacities, is at the far end of a continuum. We could imagine his bizarre position reflected at the opposite extreme by an equally strange hyper-adaptationism that posits configurations of specific genes to explain every feature of mental life you care to name: genes for composing or appreciating fugues, for badminton, for square dancing, and for a tendency to take too much carry-on luggage onto airplanes. No one, of course, actually believes that this could constitute a plausible evolution-

ary psychology. It is once again in the middle ground between the extremes of adaptation-denial and hyper-adaptationism that the truth about an evolved human nature will be found.

A persuasive middle position is staked out by Steven Pinker in *How the Mind Works* and *The Blank Slate*. As a major proponent of understanding the human condition by analyzing evolved psychology, he naturally opposes Gould's psychological anti-adaptationism. As we saw earlier in this chapter, Pinker is also cautious about claiming that just because some forms of human life are important to us, even "momentous activities like art, music, religion, and dreams," they are therefore adaptations. With the single exception of fictional narrative (which we shall discuss in the next chapter), Pinker argues that the arts are by-products of adaptations, rather than "adaptations in the biologist's sense of the word," meaning beneficial for survival and reproduction in the ancestral environment: "The mind is a neural computer, fitted by natural selection with combinatorial algorithms for causal and probabilistic reasoning about plants, animals, objects, and people. It is driven by goal states that served biological fitness in ancestral environments, such as food, sex, safety, parenthood, friendship, status, and knowledge. That toolbox, however, can be used to assemble Sunday afternoon projects of dubious adaptive significance."

"Sunday afternoon projects"—harmless, pleasurable, time-killing—is a pretty stiff way of dismissing the arts. Rather more famous is his suggestion that the arts are a kind of cheesecake for the mind. Cheesecake, his argument goes, is a food of recent invention: "We enjoy strawberry cheesecake, but not because we evolved a taste for it." What we have evolved and now carry with us from the ancestral environment is neural circuits that give us "trickles of enjoyment from the sweet taste of ripe fruit, the creamy mouth feel of fats and oils from nuts and meat, and the coolness of fresh water. Cheesecake packs a sensual wallop unlike anything in the natural world because it is a brew of megadoses of agreeable stimuli which we concocted for the express purpose of pressing our pleasure buttons."

By insisting that "some of the activities we consider most profound are non-adaptive by-products," Pinker is trying to steer well clear of any hint of hyper-adaptationism: "it is wrong to invent functions for activities that lack [adaptive] design merely because we want to ennoble them

with the imprimatur of biological adaptiveness." The issue, however, is not one of sentimentally attempting to dignify things we like—chamber music or cheesecake—by turning them into adaptations. For a Darwinian aesthetics, the question is how genuine adaptations might produce or explain capacities and preferences even for rarefied experiences. In this respect, I think it is misleading for Pinker to describe cheesecake as a by-product of evolved, and presumably adaptive, Pleistocene tastes. Rather say that cheesecake *directly satisfies* those very tastes. Pinker calls cheesecake "unlike anything in the natural world," but it is no more un-natural than most other foods, including many that our ancestors might have whipped up with honey, ripe fruits, nuts, and mastodon fat during the eighty thousand generations of the Pleistocene. Would we say that the sweet, fatty confections of the Upper Paleolithic were by-products of tastes already evolved by the Lower Paleolithic? It would make more sense to say that Pleistocene foods appealed directly to Pleistocene tastes in the Pleistocene and that in our day cheesecake, even though it is not a Pleistocene food, still appeals to those tastes. Cheesecake, in other words, is not a by-product at all but one of countless food varieties produced today to satisfy our present tastes, which originated long ago.

The explanatory power of evolutionary psychology lies foremost in identifying adaptations. But its job can also include explaining the character and features of any persistent human phenomenon, in part or in whole, by connecting it to the properties of adaptations. A Darwinian account of food preferences (for fat, sweet, piquancy, protein flavors, salt, fruit aromas, etc.) need not treat as by-products the items on a present-day restaurant menu; those items directly satisfy ancient preferences. Similarly, a Darwinian aesthetics will achieve explanatory power neither by proving that art forms are adaptations nor by dismissing them as by-products but by showing how their existence and character are connected to Pleistocene interests, preferences, and capacities.

Instead of architectural spandrels and cheesecake, consider as an analogy yet another human invention: the internal combustion engine. Imaginatively applying Pinker's reverse-engineering rule, we could readily infer that the engine's purpose is to produce torque in order to drive wheels. Along the way, we will also notice that the engine produces excess heat. We are entitled to regard this excess heat as a pure by-product, a side effect: if the engine functioned to produce torque without excess

heat, it would make little difference to us—or might even be considered advantageous, since the excess heat of internal combustion engines normally requires a cooling mechanism, in most cases a water pump and radiator. So is the cooling system, then, a by-product of the engine? Not exactly. The cooling system is a feature intrinsic to the design of internal combustion engines: it functions to disperse excess heat, and our reverse-engineering understanding of it would see it as part of the whole functionally interconnected mechanism. It is as much an intrinsic part of the design of the engine as, for instance, the heating and cooling systems of the human body. These involve life-protecting homeostatic reactions such as perspiration, shivering, and fevers. They are intrinsic elements of the body's physiological system and not by-products of adaptation—spandrels or epiphenomena. Like the body, internal combustion engines could not function at all without specialized cooling systems: on the engine analogy, cooling systems are adaptations.

Let us push the analogy a step farther. Suppose water used to cool a car engine is diverted into a second, smaller radiator with a fan in order to heat the driver/passenger compartment. Are we now justified at least in calling the car heater a by-product of the system? The answer again is no: rather than being an extraneous epiphenomenon, the heater is an entirely calculated way of using what really is a by-product (excess engine heat) for the benefit of the driver, satisfying his desire to stay warm. The mobility human beings want from cars and the desire for warmth are in any event neither parts nor design features nor by-products of the engine: they explain rather the very existence of the car, with its engine and heater. The car heater, like any designed artifact that makes use of and depends on a by-product, does not itself necessarily become for that reason a by-product. That engines give off heat is an inconvenient contingent fact, which in this case human ingenuity turns into an asset. (If engines gave off light instead of heat, engineers might well figure out how to make productive use of the excess light, and devise alternative methods to heat cars in cold weather.) It is true that people do not design and manufacture cars in order to create car heaters, but that is like saying that evolution did not produce eyes in order to produce eyelids. Eyelids are an adaptation too (a further, man-made enhancement of the eye would be spectacles). When the parts of a whole mechanism— artifact or evolved system—are functionally interconnected, understanding

the machine, or the organ, becomes a matter of seeing how and why the parts are interrelated and what they accomplish.

Grasping such functional interrelationships requires more than sorting features into the two categories of adaptation and by-product. It's a matter of grasping a range of bedrock adaptations—but then, on top of that, by-products of adaptations, utilizations, enhancements, and extensions of adaptations, combinations of enhancements of adaptations, and so on. In this sense, Darwinian explanation is always looking back into the past to adaptations that come to us from the ancestral environment, but then also toward the effects of history and culture on how evolved adaptations, strictly conceived, are modified, extended, or ingeniously enhanced—or even repressed—in human life. In mentioning the fact that internal combustion engines might have given off light as a by-product instead of heat, I meant to emphasize the contingency of both adaptations and their by-products: this as a matter of fact is how we turned out—beings who take pleasure in cheesecake and Chopin. We might have turned out differently if conditions had been slightly altered in the ancestral environment.

This contingency—a dependence on historical accidents we shall never fully know and prehistoric conditions about which we can only speculate imperfectly—makes the whole field of Darwinian psychology dependent not only on a general command of evolutionary theory but also on close empirical observation of the human mind and its adaptive features today—especially as viewed cross-culturally. Putting all of these factors together, along with such knowledge as we have of hunter-gatherer groups that survived into the modern age, is how we can achieve the best possible understanding of the human mind and its products, from primitive adzes to comedies of Shakespeare. At the same time, we can gain a better understanding of the limitations of the mind: those domains in which it is destined always to work imperfectly, with tendencies toward, for example, useless emotional reactions or counterproductive biases. Here too, a good procedural model is reverse engineering. Just as the person who knows that it is excess heat from the engine that supplies the car heater will understand why the heater does not immediately work on cold mornings, so the person who understands the evolutionary origins of artistic preferences has a better chance of understanding why the history of the arts plays out the way it does.

Neither writing nor reading nor cheesecake nor Cadillacs are Pleistocene adaptations. But no adequate grasp of their genesis and popularity can be achieved by ignoring the evolved interests and capacities that they serve or extend. Human beings derive pleasure from travel, the "freedom of the open road"; they are a social species that likes to communicate, and a relatively omnivorous species that enjoys sweet and fat: such factors explain technologies and cultural forms both prehistoric and modern. Exploring such connections is a job for evolutionary psychology and, in the case of the arts, a Darwinian aesthetics. As pointed out earlier, E. O. Wilson describes incest taboos not as by-products of the Westermarck effect but as enhancements and codifications of it. I have spoken of "extensions." Wilson's choice of words is entirely correct, as is Pinker's further description of the arts as ways that human beings achieve pleasure by catering to cognitive preferences that were adaptive in the ancestral environment. Cheesecake speaks to innate pleasure preferences, but so does Wagner's *Der Ring des Nibelungen*, though in ways that are rather more emotionally and intellectually complex.

IV

On the basis of this argument, I therefore side with opponents of the Symons/Lloyd/Gould view of the female orgasm as a nonadaptive by-product of an adaptive male process. A direct link between female orgasm and pregnancy, Lloyd demonstrates, cannot be established, and she uses this fact, in agreement with Gould, to conclude that the female orgasm is not an adaptation. But this analysis implies, in my opinion, a paltry, limited view of human sexual experience. In this regard, it is directly parallel to arguments about whether artistic pleasures might be adaptive. Lloyd makes much of the fact that clitoral pleasure is so often self-induced and experienced in the absence of a partner. But the same might be said of most male orgasms over a lifetime—and this presumably does not call into question the status of the male orgasm as an adaptation. Biologist John Alcock has attacked Lloyd's thesis by arguing that an adaptation such as the female orgasm does not have to be present in every act of intercourse in order for it to be adaptive, and surely he is right. In fact, to insist on the presence of a female orgasm, clitoral or not, in every

act of intercourse as a criterion of adaptiveness would be to measure it against a standard set by the ejaculative orgasm of the male—exactly the kind of masculinist agenda Lloyd elsewhere rails against.

Consider for a moment the huge repertoire of mental imagery and sensual feeling women and men are capable of in erotic experience. Any of these elements can contribute to sexual pleasure, and virtually all are heritable, that is, persistently present in certain percentages of populations but unlikely to be found in every individual. So for some women the breasts are a sensitive erogenous zone, a welcome object for male fondling, for others not. Some women achieve so-called vaginal orgasm, others clitoral, others both, and still others take pleasure in sex but never experience an orgasmic peak. Consider the variety of sexual positions, or orality in sex, including first and foremost the kiss. While erotic kissing does not cause pregnancy, and is not even a reliable cross-cultural universal, who would say that the kiss is a nonadaptive by-product of sexual intercourse? The erotic excitement of human lips meeting is an evolved adaptation. Only an impoverished view of erotic sex could grant adaptiveness exclusively to the male orgasm and suggest that everything else that happens in sex, from flirting to foreplay to affectionate aftermath, is only an incidental accompaniment, an extraneous by-product—like the whiteness of bone or the heat of an engine.

Erotic passion is saturated with intense sensations, bottomless emotions, fantasy, concord, danger, conflict, and the adventure of every kind of human intimacy and estrangement. The connections between eroticism and reproduction are obvious. The aesthetic realms of natural and artistic beauty are not so clearly connected to reproduction. But art too can create sublime pleasure and excitement, and expand our understanding of the humanly possible. The aesthetic, like the erotic, arises spontaneously as a source of pleasure in cultures across the globe, which means that no curious Darwinian ought to ignore it. Given their evident universality, the pleasures of the arts should be as easy to explain as the pleasures of sex and food; that they are not is a central problem for anyone wanting to broaden the relevance of evolution to the whole of human experience.

In chapter 1, I showed how innate interests and emotional reactions to natural landscapes impinge on tastes many people have assumed to be merely cultural. The Pleistocene heritage affects landscape painting, cal-

endar choices, and the design of parks and golf courses. It is wrong, however, to regard these modern phenomena as by-products of prehistoric impulses or emotions: rather, they directly address and satisfy ancient, persistent interests and longings. Pinker is justified in his doubts about trying to validate the arts, to make them seem even more deep or important, by inventing adaptive stories about them. However, no validation in either direction is required: what evolutionary aesthetics asks for is to reverse-engineer our present tastes—beginning with those that appear to be spontaneous and universal—in order to understand where they came from. It is as legitimate to do this with the arts as we experience them today as it is with sex or food.

As examples of pleasures conceived as by-products, Pinker has on more than one occasion referred to recreational drugs: chemicals that we ingest to directly excite the pleasure circuits of the brain. He has described recreational drugs on the analogy of keys that open shortcuts to pleasure centers: they give us pleasure without the toil that might have been required to achieve it by natural means. Here we may be able to agree that the term "by-product" is appropriate. If some chemist ever invents a pill that would give us the feeling of pleasure we get from having climbed a mountain without the bother of having to climb it, I suppose many people might be tempted by this pharmacological shortcut. But there would be no intrinsic connection between the emotion you might feel standing on a mountain peak, having climbed it, and the emotion you would feel having taken the pill.

An emotionally moving landscape painting, however, cannot be said to affect us in the same manner. The connection between a Salvator Rosa landscape and our Pleistocene feelings about landscapes is not a by-product relation. Rosa painted the work precisely to excite those feelings: the connection is therefore intrinsic. Nor is painting a pill that alters brain chemistry and gives us "beautiful landscape" feelings. Pinker says in the context of explaining the arts that they can be seen as "a way of figuring out how to get at the pleasure circuits of the brain and deliver little jolts of pleasure without the inconvenience of wringing bona fide fitness increments from a harsh world." True, the painting might in some sense be conceived as a convenience. ("Let's drive out to the country and enjoy the scenery." "No, it'll take too long. I'd prefer we sit here and look at some pretty landscape pictures.") But a by-product it is not.

My arguments are built on the idea that a vocabulary of adaptations versus by-products cannot make sense of the ancient origins and present reality of aesthetic and artistic experience. To be illuminated by evolution, the arts do not all need to be glorified as Darwinian adaptations similar to language, binocular vision, or the eye itself. Neither should the arts be dismissed as by-products of a collision of human biology with culture. The arts intensify experience, enhance it, extend it in time, and make it coherent. Even when they replace it, they do not jump to a pleasure-moment of the human organism and provide that as a surrogate for everything else. In the 1973 movie *Sleeper*, Woody Allen imagines a future in which people step into a telephone-booth-sized cylinder called an "orgasmatron" where they achieve instantly the desired pleasure-moment of sex without all the tiresome and time-consuming preliminaries (needless to say, a pleasure-moment for the moviegoer occurs when Woody gets accidentally locked in the orgasmatron). For the artistic equivalent, we would have to imagine an "aesthetetron." Step into it, push the correct button, and you can achieve a pleasure-moment of a kind produced by *Sense and Sensibility* or *Lucia di Lammermoor* without having to actually read the book or sit through the opera. What makes this joke funny (if it is) is the absurdity of trying to imagine that there exists any particular pleasure state, like an orgasm, that a work of art produces. Every great work of art is, like climbing a mountain, about the specific process of experiencing it—it is not about inducing some momentary pleasure experience that results from experiencing it. Were that the case, pills really would do the trick.

To borrow a less comic but certainly charming analogy from the German aesthetician Eckart Voland, we might think of a moth circling a lantern at night. With the arts, perhaps we should regard ourselves like moths who have "succeeded in inventing a lantern in order to have fun circling it." If the arts are like the lantern, the Darwinian question is why we worked so hard to invent them and why we have such fun circling them in the first place. The evolved adaptations are there to be discovered, and so are their extensions into our artistic and aesthetic lives.

CHAPTER 6

The Uses of Fiction

I

Of the twelve cross-cultural criteria for art given in chapter 3, the last, *imaginative experience*, is arguably the most important. Works of art may be embodied as physical objects—stone sculptures or painted canvases, dark squiggles formed by ink on paper or pixels on computer screens, or waves of vibrating air that musical instruments produce to excite mechanisms of the inner ear. But considered strictly as objects of aesthetic experience, works of art happen not in the world but in the theater of the human mind. The phrase "theater of the mind" is an apt metaphor, suggesting drama, stage sets, actors, and above all the sense of a make-believe world.

Life and the world could make no sense to us if all experience were make-believe in the way that the experience of art is. Smelling smoke and feeling the emotion of fear in an instantaneous recognition that there may be a fire in the house requires precisely that a threat be understood as palpably real. Understanding that a fiction about someone smelling smoke and feeling fear is not an occasion for action is fundamental to the most ordinary experience. How this distinction between make-believe and reality plays out in art and the experience of beauty is a complex and ancient question.

In *The Critique of Judgment* (1790), Immanuel Kant puts forward the most influential theory of art to be published between the Greeks and our own day. This rich compendium of grand abstraction and individual

comments on the arts presents an interlocking set of ideas that capture basic human intuitions about the arts, beauty in nature, and aesthetic responses to both. Of all the concepts central to Kant's aesthetics, the one that gained the most currency in its day and remains central to contemporary aesthetic theory is his idea of *disinterestedness*.

A judge who presides in a court of law is not supposed to be *uninterested* in the proceedings: the job requires listening with careful attention and engagement. The judge is obliged, however, to be a *disinterested* observer with no vested interests in the outcome of the case. A judge's attention is characterized by objectivity and detachment. Kant's use of the idea of disinterestedness in the opening paragraphs of *The Critique of Judgment* extends the idea of judicial impartiality into the contemplation of works of art.

The opposite of disinterested contemplation for Kant occurs when we have an interest in the existence of an object of experience, particularly when the pleasure we receive from the object satisfies a personal desire. In order for us to take pleasure in a meal, his argument goes, the food must actually exist and assuage our actual hunger. Imagined food will never satisfy a real hunger. But in the case of a beautiful thing that is subject to disinterested contemplation, the situation is entirely different. In the first place, the content or subject of a work of art need not exist, or ever have existed. The beauty of the *Iliad* is independent of whether the events it narrates ever actually happened. Nor must a beautiful painting depict existential reality.

At another level, even the physical existence of a work of art itself is discounted by Kant, in the sense that when we appreciate the beautiful, we respond only to what he calls the *presentation* of the object—how it looks or sounds to us in the imagination, how it comes to us in, again, the theater of the mind. A perfect hologram of a sculpture could therefore for Kant be as beautiful as the actual sculpture visually reproduced in the hologram. A Mozart symphony is beautiful heard performed live by an orchestra, but it is no less beautiful heard on the radio or from a high-quality recording made years ago. Paintings are physical objects that hang in museums, but as objects of beauty, as aesthetic objects, they only come into existence in the realm of what Kant calls the "free play of the imagination." Properly experienced, a work of art is bracketed off, detached, disengaged—not from close attention but from immediate personal needs, desires, and practical plans.

The experience of beauty might best be characterized for Kant by the dictum "Existence is suspended." This phrase, however, is not a translation from Kant but comes from an explanation of the requirement of disinterestedness in artistic experience presented by the evolutionary psychologists John Tooby and Leda Cosmides. Where Kant claimed that a suspension of interest in the existence of an object was fundamental to a proper imaginative response to art, Tooby and Cosmides argue more broadly that our imaginative lives are fundamental to our humanity, integrated into our nature by evolution. In particular, narrative art is for them an intensified, functionally adaptive extension of mental qualities that largely set us apart from other animals.

That mental involvement in the imagined worlds of fiction is a cross-cultural universal already suggests that fiction-making is an evolved adaptation. This idea is further supported by the fact that people everywhere find stories intellectually and emotionally arresting, and that they take immense pleasure in hearing them, reading them, or seeing them acted out. The few hunter-gatherers left today will recount narratives—fictional, mythological, historical, or daily-experience reports—around campfires, and there is no reason to doubt that such stories were told in caves through the Paleolithic. The brute fact of the pleasure and universality of storytelling, Tooby and Cosmides observe, is a solid first step in a potential chain of explanation: "Evolutionary researchers want to know why the mind is designed to find stories interesting."

II

The ability to imagine scenarios and states of affairs not present to direct consciousness must have had adaptive power in human prehistory, as it does in today's world. We imagine where we were last month, or what we plan to do tomorrow or next year. We imagine what it might be like to visit that restaurant, or what it would have been like had I taken that job or married that person. We try to imagine where we left that prescription or what the rough distance between Boston and New York must be. Imagination allows the weighing of indirect evidence, making chains of inference for what might have been or what might come to be. It allows for intellectual simulation and forecasting, the working out of

solutions to problems without high-cost experimentation in actual prac-
tice. Pentagon strategists engage in elaborate war games, in which imag-
ined plans of action are proposed and outcomes induced. In this respect,
war-gamers are in a line that extends back to the Pleistocene hunter-
gatherer band that imagined what food was likely available in the next
valley and weighed heading in that direction against envisioned risks and
opportunity costs of doing so. This capacity for strategic, prudential,
conditional thinking gave to such bands a vast adaptive advantage over
groups that could not plan with imaginative detail.

By allowing us to confront the world not just as naive realists who
respond directly to immediate threats or opportunities (the general con-
dition of other animals) but as supposition-makers and thought-
experimenters, imagination gave human beings one of their greatest
evolved cognitive assets. For Tooby and Cosmides, "It appears as if hu-
mans have evolved specialized cognitive machinery that allows us to en-
ter and participate in imagined worlds." They call this capacity *decoupled*
cognition. Like Aristotle, who in his *Poetics* refers both to the universal-
ity of children's imitative play and to the universality of the pleasure felt
in seeing imitations, Tooby and Cosmides lay stress on the genesis of
this mental process in children's pretend play. Pretend play, exhibited
as a part of normal child development, requires breathtakingly subtle
mechanisms to decouple the play world from the real world, and from
other play worlds. It is not that the true/false distinction is abandoned in
play but that the play world is bracketed off, and truth becomes truth-
for-the-play-world.

Adults stereotypically think of small children as prone to confuse
fantasy with reality, pretend play with the real world. The research by
psychologist Alan M. Leslie places such widespread belief in a more
accurate context by stressing the spontaneous, innate sophistication of
small children in pretending. Consider this charming account of Leslie's
experimental work by the evolutionary psychologist Pascal Boyer:

> Children pretend-pour pretend-tea out of an empty teapot into
> several cups. (They are careful to align the spout of their teapot
> with the cup, because in the pretend-scenario liquids fall down-
> ward as they do in the real world. This aspect of the scenario is
> handled by intuitive physics as if there were real liquid in the

pot.) Then an experimenter knocks over one of the cups, laments the fact that the pretend-tea is spilled all over the table, and asks the child to refill the empty cup. Now three-year-olds faced with this situation, that is, with two (actually) empty cups only one of which is also (pretend-)empty, do not make mistakes and pretend-fill only the pretend-empty one, not the actually empty one that is still pretend-full. This kind of virtuoso performance is involved in all situations of pretense. The child's cognitive system can handle the non-actual assumptions of the situation and run inferences of the intuitive ontology that makes sense in that imagined context but not in the real context.

The intricate imaginative capacities of small children should impress us not simply in terms of creative range—the ability to have pretend-games around any domain of the child's real experience. At least as remarkable is the way children can invoke consistent rules and limitations within freely invented yet coherent fantasy worlds. What's more, children are also able with remarkable accuracy to keep fantasy worlds separate from one another, and to quarantine multiple imaginary worlds from the actual life of the real world. They can "tag" the play-world facts for separate play-worlds, and distinguish them from real-world activities. In this way, the natural appearance of pretend play is accompanied with an equally natural ability to distinguish fantasy from reality. If human beings did not possess this capacity, which develops spontaneously in very young children, the mind's ability to process information about reality would be systematically undercut and confused by the workings of imaginative fantasy.

In this respect, children's pretend play is of a piece with another realm of spontaneous pleasure, the adult experience of fiction. In Tooby and Cosmides's account, fictions, not unlike tea-party scenarios, are made up out of "sets of propositions" that are all tied together but are walled off from what the child knows to be true of the real world and thus prevented from migrating into factual knowledge and corrupting it. Thus, a child knows what is true or false of the real world of her bedroom or her school and knows what is true or false of the fictional world of *Goldilocks and the Three Bears*. The child who has independently learned about bears is unlikely to generalize from "Goldilocks" to, for instance, the notion that real bears have furniture in their caves and cook porridge.

The same capacity for pretend play we instinctively developed as children is exercised every time we pick up a novel or sit down to watch a television drama: we then enter into an imaginative set of coherent, internally related ideas, including ontologies and rules of inference, that make their own world. The imagined world may be as gritty as that portrayed by a Scorsese movie, as remote as the wine-dark seas of Odysseus, or as comically surreal as a Road Runner cartoon. But overt resemblance to the world of mundane experience is not the issue: many compelling examples of that most adult of art forms, grand opera, present scenes and events that are no more "real" than a tea party with teddy bears.

Pretend play predictably occurs among children of all cultures at around eighteen months to two years—about the time that they begin to talk and engage socially. This fact, along with the high sophistication of decoupling mechanisms that isolate real from pretend worlds, stands as evidence that pretend play and fiction-making are isolable, evolved adaptations, forms of specialized intellectual machinery.

The evolutionary basis for these mechanisms is also supported by another fact: the universal human fascination with imagined fictions is not what we should predict as a properly evolved function for the human mind. Suppose for a moment that human beings only and exclusively took pleasure in what they took to be true narratives, factual reports that describe the real world. Evolutionary theory would then have no difficulty in attributing adaptive utility to the pleasure: the human love of the true, we would say, had survival value in the Pleistocene. We might further argue that just as early *Homo sapiens* needed to hew sharp adzes and know the ways of game animals, so they needed to employ language accurately to describe themselves and their environment and to communicate facts to each other. If humans loved *only* true stories, there would be no philosophical "problem of fiction," because there would be no intentionally constructed fiction in human life: the only alternatives to universally desired truth would be unintentional mistakes or intentional lies. Such Pleistocene Gradgrinds, as evolution might have developed them, would have been about as eager to waste their narrative efforts creating fables and fictions as they would have been to waste their manual labor in producing dull adzes. If this strict devotion to the truth, and with it a revulsion for fantasy and fiction, had developed and had shown clear adaptive value in the Pleistocene, making the Gradgrinds our direct ancestors,

then we would not be the people we are today. We could be expected to react to known-to-be-untrue stories and made-up fantasy much as we react to uselessly dull knives or, worse, the smell of rotting meat.

Clearly, such Gradgrinds could not possibly have been our most genetically contributing ancestors, given the present makeup of the human personality. Human beings across the globe expend staggering amounts of time and resources on creating and experiencing fantasies and fictions. The human fascination with fiction is so intense that it can amount to a virtual addiction. A government study in Britain—likely typical of the industrialized world—showed not long ago that, counting time spent going to plays and movies and watching television drama, the average Briton spends roughly 6 percent of all waking life attending to fictional dramatic performances. And that figure does not even include books and magazines: further vast numbers of hours are spent reading short stories, bodice-rippers, mysteries, and thrillers, as well as so-called serious fiction, old and new. Stories told, read, and dramatically or poetically performed are independently invented in all known cultures, literate or not, having advanced technologies or not. Where writing arrives, it is used to record fictions. When printing shows up, it is used to reproduce fictions more efficiently. Wherever television appears in the world, soap operas soon show up on the daily schedules. The love of fiction—a fiction instinct—is as universal as hierarchies, marriage, jokes, religion, sweet, fat, and the incest taboo.

III

For evolutionary aesthetics, the problem is to reverse-engineer the improbable but manifestly human urge to both make fictions and enjoy them. Any solution to this problem must take into account Steven Pinker's caution discussed in the previous chapter: it is easy but empty to observe that fiction, for instance, helps us to cope with the world, increases our capacity for cooperation, or comforts the sick, unless we can plausibly hypothesize that such coping or cooperation or comfort evolved as an adaptive function, conferring survival advantages in the ancestral environment. A thoroughgoing Darwinism makes a specific demand: nothing can be proposed as an adaptive function of fiction

unless it explains how the human appetite for fictional narratives acted to increase, however marginally, the chances of our Pleistocene forebears surviving and procreating.

Keeping this requirement in mind, here are three interconnected kinds of adaptive advantage that might explain the pervasiveness of fictions in life, now and as far back as history can record. "Fictions" includes oral story traditions and preliterate mythologies in the ancestral environment and, by implication after the invention of writing, such enhancements, extensions, and intensifications as novels, plays, operas, movies, and video games.

1. Stories provide low-cost, low-risk surrogate experience. They satisfy a need to experiment with answers to "what if?" questions that focus on the problems, threats, and opportunities life might have thrown before our ancestors, or might throw before us, both as individuals and as collectives. Fictions are preparations for life and its surprises.

2. Stories—whether overtly fictional, mythological, or representing real events—can be richly instructive sources of factual (or putatively factual) information. The didactic purpose of storytelling is diminished in literate cultures, but by providing a vivid and memorable way of communicating information, it likely had actual survival benefits in the Pleistocene.

3. Stories encourage us to explore the points of view, beliefs, motivations, and values of other human minds, inculcating potentially adaptive interpersonal and social capacities. They extend mind-reading capabilities that begin in infancy and come into full flower in adult sociality. Stories provide regulation for social behavior.

Although he generally regards the arts as by-products of adaptations, Pinker nevertheless grants that in all likelihood fictional storytelling directly evolved as an adaptation. The mind uses fiction to explore and solve life problems in the imagination: "The cliché that life imitates art is true because the function of some kinds of art is for life to imitate it."

Pinker's most striking metaphor for this function of storytelling is drawn from chess. We might expect that the countless potential situations and possibilities of chess would require a reliance by chess grand masters on strategic rules—maxims and algorithms—for play. This, however, is not the case. "Keep your king safe" or "Get your queen out early" are not much help beyond beginner's chess, and experienced players do not have available to them higher-level algorithms to rely on: chess games become too complicated too fast for mere maxims to be of much use. So instead, expert players study the published moves in countless actual games, building up a mental catalogue of the ways good players have reacted to challenges and situations. These games, studied and memorized in part or in whole in their thousands by chess grand masters, provide the templates and heuristics that make chess victory possible in uniquely new games. "Chess experience" for a mature player does not consist only in what the player knows from games personally played; it is rather what the player knows from all the games the player personally played or studied or observed.

Although thirty-two pieces on sixty-four squares provide an enormous number of combinatorial possibilities—untold trillions of moves—they would be dwarfed in range by the contingencies served up by daily experience in a human lifetime. Here too, rules and maxims such as "A penny saved is a penny earned" or "Look before you leap" have their elementary uses but provide about as much utility as "Try to control the center of the board" has to an experienced chess player. Imaginative stories, pleasurably experienced and remembered by both maturing and adult human beings, provide a far more complex and useful set of templates and examples to guide and inspire human action. To a large extent, they are built into life experience.

The chess analogy for the adaptive value of fiction and storytelling is richly suggestive. Chess, after all, is not a game that the human mind engages at the level of considering all possible moves for any one situation. That, in fact, is exactly how computers have classically treated chess: they use brute computational force to outcalculate a human opponent, including eliminating huge numbers of moves so bad a human being would never consider them. Chess has an intrinsic teleology not found in a computer's combinatorial bad-move elimination; the game has as its object that each player purposively tries to outsmart an

opponent—taking into account the opponent's assessment of each situation—in order to achieve checkmate. This, in any event, is how the human mind engages chess, and it is how the human mind engages the strategic teleology of life, except that instead of the single checkmating purpose, in life it must engage an indefinitely large number of purposes.

In the Darwinian scheme, this begins with reproduction and survival, and it is therefore not a coincidence that these fundamental imperatives precisely mirror the familiar literary/dramatic themes of sex and death. Around these deep imperatives cluster the main topics of literature and its oral antecedents. "Life," as Pinker puts it, "has even more moves than chess. People are always, to some extent, in conflict, and their moves and countermoves multiply out to an unimaginably vast set of interactions." To remind us of the complexities, he tosses out some possibilities:

> Parents, offspring, and siblings, because of their partial genetic overlap, have both common and competing interests, and any deed that one party directs toward another may be selfless, selfish, or a mixture of the two. When boy meets girl, either or both may see the other as a spouse, as a one-night stand, or nei- ther. Spouses may be faithful or adulterous. Friends may be false friends. Allies may assume less than their fair share of the risk, or may defect as the finger of fate turns toward them. Strangers may be competitors or outright enemies.

Warming to the subject, Pinker continues by pushing his hypothesis a step too far: "Fictional narratives supply us with a mental catalogue of the fatal conundrums we might face someday and the outcomes of strategies we could deploy in them. What are the options if I were to suspect that my uncle killed my father, took his position, and married my mother? . . . What's the worst that could happen if I had an affair to spice up my boring life as the wife of a country doctor? . . . The answers are to be found in any bookstore or video shop." But the specific fictions he mentions do not actually provide their audiences with sets of instruc- tions in the way he seems to suggest here, and his account invites the re- sponse of Jerry Fodor, having fun with this passage in a review of *How the Mind Works*: "Or what if it turns out that, having just used the ring that I got by kidnapping a dwarf to pay off the giants who built me my

new castle, I should discover that it is the very ring that I need in order to continue to be immortal and rule the world? It's important to think out the options betimes, because a thing like that could happen to anyone and you can never have too much insurance."

The adaptive value of storytelling in the ancestral environment would lie neither in deriving and applying relatively vacuous advisories such as "The early bird gets the worm" nor in specific instructions about avoiding road-rage incidents, lest I kill my father and end up inadvertently marrying my mother. Adaptiveness derives from the capacity of the human mind to build a store of experience in terms of individual, concrete cases—not just the actual lived and self-described life experiences of an individual but the narratives accumulated in memory that make up storytelling traditions: vivid gossip, mythologies, technical know-how, and moral fables—in general, what would have been the lore of a hunter-gatherer society. Whatever the brain processes that enable it, the human mind acquires and organizes a vast knowledge-store in terms of dramatic episodes of clan history, war stories, hunting anecdotes, near misses, tales of forbidden love, foolhardy actions with tragic outcomes, and so forth. These cases are used analogically and in terms of shared and differentiated features to make sense of new situations and to interpret past experience. (In this connection, it is worth noting that the ability to recognize and use analogies effectively remains a staple basis of contemporary intelligence tests.) As Pinker has put it, in this kind of case-based reasoning, an "entire configuration of relevant details is spelled out and recorded in memory, and the reasoner, when faced with a new scenario, searches in memory for the stored case whose constellation of details is most similar to the current one."

Fictional storytelling is not, therefore, a capacity uniquely cut off from nonfictional ways of describing and communicating facts but is an extension that was adaptively present in the human mind early on. In terms of the larger picture of human history, one of the most significant steps in the evolution of the mind was the achievement of sophisticated counterfactual information processing: the ability of human beings to extend themselves by representing in their minds possible but nonexistent states of affairs—situations that were-true-in-the-past or are-not-true-in-the-present or are-possibly-true-in-the-next-valley or might-be-true-in-the-coming-winter. This faculty for imaginative practical reasoning obviously

had immense survival value in the ancestral environment, enabling hunter-gatherer bands who were especially adept at it to exploit opportunities, cope with threats, and outplan and outcompete less articulate and imaginative groups and individuals. Fictional storytelling, which likely came later, does not function separately from this faculty but is an enhancement and extension of counterfactual thinking into more possible worlds with more possibilities than life experience could ever offer up to an individual. To the ability to think counterfactually, case-based reasoning adds a capacity to interpret and so gain knowledge by drawing analogies and identifying dissimilarities in richly complex situations that are confronted in reality and contemplated in imagination.

I earlier stressed the spontaneous capacity of even small children to tag facts according to whether they belong to one or another pretend world, or to the real world, and moreover to be able to cross imaginatively between worlds without confusion. This is a fundamental human faculty with, again, crucial survival value: an imaginative species whose members could not distinguish seeing a tiger in the forest from daydreaming about a tiger in the forest would have been at a distinct competitive disadvantage. But the manifest evolved ability to discriminate between what is true or valid in one world from what is fantasy does not mean that everything in a make-believe fantasy world is a make-believe fantasy fact. Just as the pretend tea in a doll's tea party obeys the same laws of gravity as real tea, so the facts and background information in fictions can be validly useful for living in the real world. To convey accurate facts and teach lessons for life is an ancient function of fiction and very likely part of its adaptive importance.

Going about today, as we do, in a world of factual knowledge taught and learned through nonfiction books and other media, we can lose sight of the power of fiction to convey information and so extend an individual's knowledge-store. For example, I fancy that I possess a fair understanding of life and society in nineteenth-century Russia—the serf system, the basic economics of everyday life, the position of the czar and his court, the country estates of the rich, the cultural admiration (and envy) of more advanced Europe, the vast distances and sense of psychological isolation of the provinces, and so forth. But come to think of it, I am not sure if I have ever read a history of czarist Russia. Like many of my contemporaries, I have built up this body of information through

reading Dostoyevsky, Tolstoy, Gogol, Pushkin, Lermontov, and Turgenev, seeing performances of Chekhov, and experiencing film and opera versions of these writers' works. The Russian writers provide such information only as background for their own fictional purposes, which are mainly plot- and character-driven. Nevertheless, the background information is accurate, and is not tagged in memory as fictional in the way that the background setting for fantasy and science-fiction novels are.

Whole shelves of stories and novels, particularly in the nineteenth century and up to the present, are in fact essentially travelogues or tales of exploration presented behind a plot involving fictional characters. For many Europeans, for instance, the adventure novels of Karl May, and before him the fact-laden picturesque stories of Jules Verne, were essentially dramatic and memorable ways to present exotic information about the South Seas, darkest Africa, or the Wild West. This genre persists today in many airport novels, as well as at a higher literary level in the popular sea adventures of Patrick O'Brian, which are read as much for their detailed nautical settings as for their dramatic content. And it goes almost without saying that a major element of the appeal of modern cinema resides in its capacity to transport audiences to faraway places and to locations in the distant past or future. Especially if they are exotic for the viewer, the setting and background for a film can be vividly remembered long after the characters and plot are forgotten.

This use of fiction as an information resource beyond its entertainment value goes back to the content of the earliest known oral traditions. The classicist Eric Havelock argued that providing cultural grounding and even technical knowledge was a major purpose of the *Iliad* and the *Odyssey* for the early Greek tribes where these epics originated. This in turn explains the vehement objections to Homer that Plato gives in such dialogues as the *Republic*. In the Homeric epics, as in much of Greek mythology and later in comedy and tragedy, the gods are human beings with all the human frailties writ large: they quarrel, scheme against each other, are bitterly jealous, make passionate (and adulterous) love, take cruel revenge on each other and on mortals, and feed their massive appetites. Plato regarded the whole Greek literary tradition, but especially the Homeric epics that lay at its heart, as setting the worst possible moral examples. That is why in the *Republic* he describes an ideal state in which the arts are strictly controlled to place

before the populace nothing but worthy and edifying examples of human and divine values and behavior.

If Plato's worries seem eccentric to the modern reader, Havelock says, it is because moderns, lost in the color and beauty of the Homeric epics, do not realize the extent to which they functioned as an oral encyclopedia of customs, status designations, religious history, and even nautical advice for their original audience. We tend to imagine the Homeric rhapsodes as entertainers for their age, but Havelock argues that they were essentially preservers of a "magisterial tradition": teachers, in fact, providing lessons in how a priest ought to be addressed, how classes of people—women and men, kings and warriors—ought to behave with respect to one another, how the social structure is maintained though such agencies as the intervention of Nestor, how kings (and gods) are petitioned for favor, how ritual sacrifices are to be carried out, how captured concubines are to be treated, and even how one should comport oneself at table. In an oral culture, Havelock argues, "much of social behavior and deportment had to be ceremonial," which explains the intricate descriptions of ritual behavior—essentially a practice of skilled technique for the early Greeks. The repeated references to what is "fitting" or "proper" demonstrate the level of customary or moral instruction in the epics, and the narrative of the first book of the *Iliad* even gives specific instruction on docking a ship at harbor: furl the sail, lower the mast, row to the beach, anchor the stern in deep water, disembark by the bow, and unload the cargo, and so forth. The bard, says Havelock, "is at once a storyteller and also a tribal encyclopedist."

Psychologist and literary theorist Michelle Scalise Sugiyama argues that information transmission, including methods of problem-solving, was a central adaptive benefit of imaginative storytelling for our ancestors, most succinctly expressed in the Boy Scout motto, "Be prepared." Hunter-gatherer life was "a never-ending stream of tasks, obstacles, and hazards, the local solutions to which the individual is not born knowing." The folklore of contemporary foragers, she observes, uses stories to enable "people to acquire information, rehearse strategies, or refine skills that are instrumental in surmounting real-life difficulties and dangers." She cites the case of the Kalahari hunters, who sit around the campfire describing recent hunts and those from the distant past. This is shoptalk, with anecdotes about the habits of animals, how to read tracking signs, and techniques for

the final chase and kill. But the kind of information exchange she describes need not come in the form of strictly factual accounts: it can be culled from fable and mythology too, and in fact may be more memorable when so presented. As an example of the latter, Sugiyama cites a Yanomamo folktale about how Jaguar is chided by Millipede for walking so noisily through the jungle. Millipede rounds and softens the soles of Jaguar's paws and teaches him to walk softly, without breaking branches. The story is replete with information and advice: about jaguars (predators of humans), about the importance (for humans) of walking quietly when far from a village or camp, and by analogy also about strategies for ambush and measures to avoid attack by other tribes. The tale is about local threats and strategies (both jaguars and humans) but also makes vivid more universal issues, emphasizing "our vulnerability to predation and a concomitant safety rule: whenever potential predators may lurk (be they human or nonhuman), it pays to tread lightly and be vigilant."

Conceived in this way, the problem-oriented thought experiments, information, and analysis of problem situations that storytelling addresses are directed at an outer environment of resources, dangers, and opportunities. But just as important in the social context of hunter-gatherer bands is the inner psychological experience of one's fellows, the shared emotional and intellectual world of the tribe. It is here that fiction comes into its own in terms of its particular artistic potential to portray and examine inner experience and demonstrate an adaptive relevance that extends beyond the issues so far discussed. Stories, now and presumably in prehistory, are about *human* life—the desires, emotions, calculations, struggles, frustrations, and pleasures that are the stuff of human experience. Animals as characters in stories—from the Yanomamo folklore to Aesop's fables to European fairy tales to Kipling to the fantasy literature of Tolkien to *The Lion King*—are invariably stand-ins for human beings. Physical objects or phenomena—the sun and moon, the wind, clouds— are humanized in stories all over the world as imaginary people. But a *purely natural history*—the "story" of the earth's geological history, for example—is a recent, and from a narrative perspective rather peculiar, idea. Rocks are passive recipients of action, not initiators of it. Stories are essentially about agency and emotion, which generally rules out a central place for rocks as main characters, unless they can be converted metaphorically or symbolically into humanlike entities.

Mere human agency and feeling are not, however, enough to make a story. Again, cross-culturally today and through all of known cultural history, stories are about problems and conflict: competing human interests for power or love are prime topics, as well as natural threats to life and limb (in which case a dangerous animal may well be an animal and not a surrogate person). In this way, the most abstract characterization that can be given of stories is that they involve (1) a human will and (2) some kind of resistance to it. That is why "Mary was hungry, Mary ate dinner" narrates a sequence of events that does not yet seem like a story, while "John was starving, but the pantry was empty" does sound like the beginning of one. Obstacles—to life, wealth, ambition, love, comfort, status, or power—are one central element in the fundamental idea of a story; the other element is how a human will triumphantly overcomes— or tragically fails to overcome—obstacles. Stories are intrinsically about how the minds of real or fictional characters attempt to surmount problems, which means stories not only take their audiences into fictional settings but also take them into the inner lives of imaginary people.

Just as there would have been a major adaptive advantage in learning from stories to deal with the threats and opportunities of the external physical world, so for an intensely social species such as *Homo sapiens* there was an advantage in the ancestral environment in honing an ability to navigate in the endlessly complex mental worlds people shared with their hunter-gatherer compatriots. The conclusion of chapter 2 reviewed the extent to which the features of a stable human nature revolve around human relationships of every variety: social coalitions of kinship or tribal affinity; issues of status; reciprocal exchange; the complexities of sex and child rearing; struggles over resources; benevolence and hostility; friendship and nepotism; conformity and independence; moral obligations, altruism, and selfishness; and so on. As we shall presently see, these issues constitute the major themes and subjects of literature and its oral antecedents. Stories are universally constituted in this way because of the role storytelling can play in helping individuals and groups develop and deepen their own grasp of human social and emotional experience. The teller of a story has, in the nature of the storytelling art, direct access to the inner mental experience of the story's characters. This access is impossible to develop in other arts—music, dance, painting, and sculpture—to anything like the extent that it is

available to oral or literary narrative. As Sugiyama points out, pictures can represent single views of a subject matter, and music can express emotions, but neither of these arts can unambiguously portray the complicated causal sequences of linked events and intentions that is natural to storytelling in its most rudimentary forms. Storytelling is a mirror of ordinary everyday social experience: of all the arts, it is the best suited to portray the mundane imaginative structures of memory, immediate perception, planning, calculation, and decision-making, both as we experience them ourselves and as we understand others to be experiencing them. But storytelling is also capable of taking us beyond the ordinary, and therein lies its mind-expanding capacity.

To understand, intellectually and emotionally, the mind of another is a distinct ability that emerges spontaneously in children around the age of two and is normally fully developed by the age of five. That it is a distinct, evolved adaptation—and not simply a generalized application of intelligence—is shown by the effortless reliability with which it develops. Its specific functional character is also demonstrated, incidentally, by the unhappy fact that there exists a particular affliction that can inhibit its development alone without affecting other intellectual capacities: autism. To varying degrees, the autistic child suffers from a neurological impairment in the ability to engage imaginatively the minds of other people—a problem that extends to an inability to enjoy fictions, experience ordinary empathy, and appreciate irony and jokes. Autistic children can be highly intelligent by many measures: tasks such as mathematics or mechanical manipulation, which are separate from reading the thoughts and emotions, may not challenge them. That autistics can be otherwise intellectually normal and yet have a special difficulty in learning how to communicate with others in terms of a shared mentality demonstrates that the capacity for empathy that we take for granted as central to pretend play and the enjoyment of stories (not to mention ordinary human empathy) is not learned but is rather a particular innate faculty.

The vicarious mind-reading function of literature is of particular interest to the literary theorist Lisa Zunshine, who argues that it is utilized to a high degree in modern writing but is characteristic also of literature's oral antecedents: in fiction, we exercise our ability to read the minds of literary characters, especially with regard to multiple perspectives nested in levels of intentionality. Fictional narratives, Zunshine argues, "rely on,

manipulate, and titillate our tendency to keep track of *who* thought, wanted, and felt what and *when*." Fiction "engages, teases, and pushes to its tentative limits our mind-reading capacity." In her view, the fact that there are cognitive constraints on how we can disentangle relationships between characters and their mental states is an opportunity for fiction to push these constraints to puzzle-making limits. For the record, the capacity of human readers to keep track of nested intentionality is severely challenged much beyond the fourth level: "John knew that Jane believed that Bill thought that Betty wanted to marry George" is normally as far as we can take it. Part of the pleasure of literature, at least for many readers, may well come from working out levels of intentionality. Whether this is adequate to explain the evolved origins of storytelling is another question. ("Telemachus wondered if his mother had considered that Odysseus dreaded the possibility that he would return home to find that she believed he no longer loved her" does not have an especially Homeric ring to it, and Zunshine herself allows that the levels of mental representation are not anything like as complex in early epics such as *Beowulf* as those found in Henry James.) But Zunshine is at the very least correct that a vicarious exploration of the minds of other people, individually and in relation to the storyteller, is a significant pleasure of fiction, in literature and oral storytelling as well.

The conception of literature and its ancient antecedents as an imaginative exploration of the larger possibilities of human intellectual and emotional life has been carefully worked out by the literary scholar Joseph Carroll. His position is in line with ideas espoused by Tooby and Cosmides and with a hypothesis proposed by E. O. Wilson in *Consilience*: that the arts in general, and perhaps most especially storytelling and literature, serve a particular adaptive feature for a species that, thanks to its huge brain and the complex situations it came to face (particularly in dealing with other human beings), has risen well above the more simple, routinized responses to the environment characteristic of other animals. The fact that human beings in the Pleistocene outgrew automatic animal instincts created problems of its own: confusion and uncertainty in choices available for action. "There was not enough time for human heredity to cope with the vastness of the new contingent possibilities revealed by high intelligence," Wilson says: "the arts filled the gap," allowing human beings to develop more flexible and sophisticated responses to new situations.

For his part, Carroll is in partial agreement with Pinker in regarding fictional thought experiments as a useful way to explain the origins of storytelling. But he dismisses the notion, which traces back to Freud, that fictions can also be understood as pleasurable fantasies, Pinker's mental cheesecake. Fiction goes deeper than pleasure, Carroll argues, "to regulate our complex psychological organization, and it helps us cultivate our socially adaptive capacity for entering mentally into the experience" of others:

> The experience of reading—or the auditory equivalent in the oral antecedents to literature—has some parallel with the experience of dreaming and also with the experience of "virtual reality" simulators. It is an experience of subjective absorption within an imaginary world, a world in which motives, situations, persons, and events operate dramatically, in narrative sequence. Unlike dreams, most literary works have a strong component of conscious conceptual order—a "thematic" order. But like dreams, and unlike other forms of conscious conceptual order—science, philosophy, scholarship—literature taps directly into the elemental response systems activated by emotion. Works of literature thus form a point of intersection between the most emotional, subjective parts of the mind and the most abstract and cerebral.

Part of the attractiveness of Carroll's account is its potential to explain *emotional saturation*, a notable yet curious property present in virtually all the arts that has already appeared on the list of cluster criteria for art in chapter 3. Works of art in every form—certainly stories and drama, but also music, poetry, and dance performances, as well as painting and sculpture—can incite or manipulate quick emotional responses at various narrative or dramatic junctures. But with works of art, emotion characteristically does not just break out, say, halfway through a narrative, even though swings and swells in emotion will be felt at many points in a story (as in a piece of music). Emotional feeling is normally *coextensive with the experience of a work of art*. Stated another way, fictions do not provide narrative content, then add emotion: they tend rather to establish a tone, mood, or feeling immediately and make continuous use of emotion. A play, for example, might present a dramatic

reversal, or a piece of music a jarring modulation from minor to major, and such moments might well be emotional peaks. But works of art are emotionally saturated in the sense that they express and explore affective experience within a coherent range throughout their totality. If we think, for instance, of any Chekhov play, the sense of an emotional world will be established almost immediately in the opening scene. The same can be said for much poetry and nearly all music: emotion is not added to the narrative or developmental structure of the work but is a mood that imbues the whole.

It is worth remarking that emotional saturation in this sense seems to be readily understood and accepted by audiences for art everywhere; so far as I have been able to ascertain, it is as much a spontaneous feature of art cross-culturally as mimesis or the admiration of skill. Indian aesthetics uses the Sanskrit word *rasa* to describe the specific emotional "flavor" of a work of art, and I have certainly seen the very marked emotional tones achieved in the sing-sing dance performances of New Guinea. This ready acceptance of emotion as coextensive with art, intrinsic to it, appears to be a bedrock fact of human nature and the nature of art; it could in principle have been otherwise, but it is not. For example, audiences worldwide find it natural and fitting that movies have musical scores to underline or interpret the emotions implicit in the story; even the earliest silent films were given musical accompaniment. I doubt if there exists a people anywhere that would find musical soundtracks for movies a strange or pointless practice; everyone immediately understands the presence of music in film. The naturalness of music for films goes along with the idea of opera but is just as well represented by love songs from the troubadours through Schubert to the Beatles to the present day. Finally, that it makes sense to fuse narrative and music to enhance emotion can be demonstrated by the fact that some of the most disconcerting aesthetic experiences involve situations where the emotional expression of different aspects of a work are at cross-purposes (anyone who doubts this should try reading Emily Dickinson with Beethoven on in the background).

Fiction provides us, then, with templates, mental maps for emotional life. These maps, Carroll argues, must be "emotionally saturated, imaginatively vivid." Art, therefore, is at least in this respect an adaptation for individuals because it helps them to know their own—i.e., characteristi-

cally human—emotions, and therefore helps them to navigate life in control of their emotions rather than being controlled by them. As Carroll puts it, "Evidence for this can be derived from every cultural corner of the earth, for the way literature and preliterate storytelling enters into the total motivational life of individuals, shaping and directing their belief systems and their behavior."

Although he does not refer to Aristotle or to the psychological research on children's imaginative play, Carroll does remind us of Dickens's persistent attention to the role that pretend play, or its unnatural absence, has in the lives of abused and neglected children. Tom and Louisa Gradgrind in *Hard Times* are tragically deprived of art and literature by their father, a utilitarian ideologue, and are left emotionally and morally stunted. Esther Summerson, the protagonist of *Bleak House*, grows up in a world without affection. She survives by creating an imaginative world of her own. It is a private, imaginary place where she talks with her doll and creates normal human affection, keeping her emotional nature alive, till the plot turns in her favor and she moves to a better environment: "The conversations she has with her doll are not fantasies of pleasure; they are desperate and effective measures of personal salvation." Carroll also mentions the abused David Copperfield, who discovers next to his bedroom dusty, forgotten books that had belonged to his dead father: *Tom Jones, Humphrey Clinker, Don Quixote*, and *Robinson Crusoe*. Beginning with a swipe at Pinker, Carroll argues his case thus:

> What David gets from these books is not just a bit of mental cheesecake, a chance for a transient fantasy in which all his own wishes are fulfilled. What he gets is lively and powerful images of human life suffused with the feeling and understanding of the astonishingly capable and complete human beings who wrote them. It is through this kind of contact with a sense of human possibility that he is enabled to escape from the degrading limitations of his own local environment. He is not escaping from reality; he is escaping from an impoverished reality into the larger world of healthy human possibility . . . He directly enhances his own fitness as a human being, and in doing so he demonstrates the kind of adaptive advantage that can be conferred by literature.

Anyone might be forgiven for questioning a theory of fiction that uses fictional characters to support itself. But it would be wrong to criticize Carroll for this. After all, whatever the melodramatic character of his novels, Dickens is a most penetrating observer of human nature, and his portraits of children are especially complex and insightful. Even if Dickens is unfair with Mill and the utilitarians, there is nothing ideologically driven in what he says about childhood and youth. And the exploration and cultivation of the emotions that Carroll finds in Dickens also goes on today worldwide when children turn on televisions or slip video discs into players to see—not once, but for the twentieth time—an animated version of a Dr. Seuss classic or a Disney animal fable.

The meaning of a literary work is not in the events it recounts. It is how events are interpreted that makes meaning. Interpretation, in turn, involves necessary reference to a *point of view*, which Carroll defines as "the locus of consciousness or experience within which any meaning takes place." Following the critic M. H. Abrams, he argues that an interpretive point of view is constituted by three elements: the author, the represented character, and the audience. These three elements come together in the experience of the reader. It follows that part of the significance for David Copperfield of discovering his father's books is that the youth is being introduced, as Carroll says, to "the astonishingly capable and complete human beings who wrote them." The importance of fiction depends in part on a sense of a communicative transaction between reader and author—understood as a real, not an implied or postulated, author. Zunshine and other more cognitively oriented theorists have described mind reading and distinguishing levels of nested intentionality as a transaction between the reader and the characters of a story, since within a story there will be multiple points of view. But there is also the transaction between reader and author—the latter understood by the reader as an actual person, the creator of the story, who negotiates between the various points of view of fictional persons (the characters), the author's own point of view, and the point of view of the reader. These three elements are present in every experience of fiction; in fact, they exhaust the list of operative elements.

This isn't to deny that audiences change (hence, as we shall see in chapter 8, our interest in recovering the meanings and values of the original audiences of historic works). Moreover, authors may contrive to

hide themselves behind narrators or implied authors. Nevertheless, the author remains the prime mover, the one who is trying to control the show—the interpretation of characters, their actions, and the events that befall them. Authors attempt this by persuading, manipulating, wheedling, planting hints, adopting a tone, and so forth: whatever will appeal to the reader and create a convincing interpretation, including interpretations of ambiguous events. This makes the experience of a story inescapably social. The story is not just about an imaginary social life: rather, the author's palpable presence means that stories are essentially communicative, and therefore social, events.

An example adduced by Carroll for a slightly different purpose can illustrate my point: the delightful episode in *Pride and Prejudice* in which Mr. Collins introduces himself to the Bennet household in a letter that is read by the family. This letter is, as Carroll nicely puts it, "an absolute marvel of fatuity and of pompous self-importance," and much about the characters of the family members is revealed in how mother, father, and the Bennet sisters react to it. The excessively sweet-tempered oldest sister, Jane, is puzzled by it, though she credits Mr. Collins with good intentions. The dull middle sister, Mary, says vapidly that she rather likes Mr. Collins's style. The mother, in her typical manner, only reacts to it opportunistically, in terms of a potential advantage in the situation. It is up to Elizabeth and her father to see clearly what a clownish performance the letter represents: their joint understanding marks an affinity of temperament and a quality of perceptiveness the others lack. But it is clear that there are two more people—not characters in a Jane Austen novel, but actual breathing human beings—who are in on the agreement between Mr. Bennet and his second daughter. These two further individuals are also members of what Carroll calls their "circle of wit and judgment." First, there is Jane Austen, the author of *Pride and Prejudice*. She was a real person, and a palpable sense of her lively, judicious personality animates every page of the writing. (Of course, academics have taken pride in stressing that this palpable sense too may be a clever invention of Jane Austen, but outside of the literary theorist's seminar, real stories with named authors are read as having been written by real people.) Second, there is you, the reader of *Pride and Prejudice*. The creation of *Pride and Prejudice* and the reader's experience of it unite all of these points of view: the novelist creates a feeling of shared sensibility not

open to everyone; by giving the reader a sense of achieved intimacy, it sharpens and cultivates perspective. It is no small pleasure for the reader to be included in this exclusive circle.

If this makes literature sound like imaginary gossip, so be it. Much of what audiences have gotten from storytelling in popular entertainment, naturally including soap operas and popular romance novels, is a vicarious extension of the pleasure of gossip: discovering people's hidden motives, revealing life's dirty laundry, and so forth. This fact need not be regarded as reflecting poorly on either Jane Austen on one side or on Harlequin romances on the other. Gossip is not always malicious or time-wasting but can be a means of acquiring useful skills and information. It is pleasurable for many people because it had adaptive value in the ancestral environment, sharpening human perceptions and understanding. Shakespeare, Tolstoy, Dickens, and George Eliot do make use of such natural pleasure to create great literature, extending it beyond what might be talked about over the back fence. In some respects Jane Austen too is giving us gossip—possibly the most elegant, insightful, witty gossip even committed to print. Carroll, with his high-art orientation, may object to Pinker's account of fiction in terms of fantasy, escapism, and sheer entertainment pleasure, and indeed Carroll provides powerful arguments for seeing fiction in a different, more cultivated way, in the older German tradition of *Bildung*, of the arts as crucial to create a flourishing human personality. But he has not so much refuted Pinker as shown that storytelling can do even more than Pinker acknowledges, and that this may well have had adaptive value.

Pinker's regard for fiction is more plausibly applied to aspects of contemporary popular arts—including Marvel comics, splatter video games, and most movies—than to *Middlemarch*. But there is no reason to deny that Harlequin readers and moviegoers today are also provided by their preferred fictions with cognitive maps and regulative templates. The general thesis about the deeper, long-term edification fiction can give us is not seriously challenged by new delivery mechanisms for storytelling. If there was adaptive survival value in ancient, Stone Age storytelling, it ought to extend to our own time and explain somehow the pleasure we get from any fictions—from effects-driven blockbuster movies, TV, and cheap thrillers all the way to classic literature that presents, in Matthew Arnold's words, "the best that is known and thought in the world."

IV

If the storytelling traditions of the world express pleasures and capacities that evolved long before the invention of writing—a storytelling instinct—can anything be further said about innate tendencies in the structure of stories? This is a vexed question throughout the history of criticism. Aristotle identified plot (Greek *mythos*) as the "structure of incidents" in a story; he claimed that of all the elements of drama, plot was the most important and the hardest to achieve effectively: it was the first principle and "soul" of tragedy. The German poet Friedrich Schiller and the Romantics were interested in the idea that there might be a manageably finite number of plots for fictions, and the nineteenth-century French writer Georges Polti, inspired by a remark made by Goethe, listed plot types to describe "the Thirty-six Dramatic Situations." Polti's list, which became popular among writers and is still in circulation (even among video-game creators) is not, strictly speaking, a set of plots but a catalogue of situations that might be useful in constructing plots: "Erroneous judgment, "Loss of loved one," "Fatal imprudence," "Self-sacrifice for an ideal," and so forth. Polti brought the whole idea of plots as outlines into disrepute, but it remains a tantalizing fact that seen as a whole and across cultures, stories do seem to fall into recognizable patterns. Might these patterns tap into innate tendencies?

The critic and journalist Christopher Booker has recently argued that human beings have a cross-cultural predilection for stories built on seven basic plot templates, which he draws from folktales of preliterate tribes, early epic poetry, novels, operas, and movies. He begins his account in the summer of 1975, when moviegoers flocked to theaters to see a tale about a predatory shark that terrorized a little Long Island resort. *Jaws* told how three brave men go to sea in a small boat and, after a bloody climax in which they kill the monster, return peace and security to their town—not unlike a tale enjoyed by Saxons dressed in animal skins and huddled around a fire some 1,200 years earlier. *Beowulf* also features a town terrorized by a monster, Grendel, who lives in a nearby lake and tears his victims to pieces. The hero Beowulf returns peace to his town during a bloody climax in which the monster is slain. *Beowulf* and *Jaws* are examples of the first of Booker's plot types. His list begins with seven plots, but he later adds two more for a total of nine:

"Overcoming the Monster" is found in countless stories from *The Epic of Gilgamesh* and *Little Red Riding Hood* to James Bond films such as *Dr. No*. This tale of conflict typically recounts the hero's ordeals, including an escape from death, and ends with a community or the world itself saved from evil.

"Rags to Riches." Booker places in this category *Cinderella*, *The Ugly Duckling*, *David Copperfield*, and other stories that tell of modest, downtrodden characters whose special talent or beauty is at last revealed to the world for a happy ending.

"Quest" stories feature a hero, normally joined by sidekicks, traveling the world and fighting to overcome evil and secure a priceless treasure (or, in the case of Odysseus, wife and hearth). The hero gains not only the treasure he seeks but also the girl, and they end as King and Queen.

"Voyage and Return" is exemplified by *Robinson Crusoe*, *Alice in Wonderland*, and *The Time Machine*. The protagonist leaves normal experience to enter an alien world, returning after what often amounts to a thrilling escape.

In "Comedy," such as *A Midsummer Night's Dream*, *The Importance of Being Earnest*, or *It Happened One Night*, confusion reigns until at last the hero and heroine are united in love.

"Tragedy" portrays human overreaching and its terrible consequences in the *Oresteia*, Sophocles' Oedipus plays, *Hamlet*, and innumerable Hollywood productions.

"Rebirth" stories center on characters such as Dickens's Scrooge, Snow White, and Dostoyevsky's Raskolnikov.

To this template system he unexpectedly adds at the end of his book two more plot types: "Rebellion" to cover the likes of *Nineteen Eighty-Four* and "Mystery" for the recent invention of the detective novel.

Booker illustrates his plot types with Greek and Roman literature, fairy tales, European epics, novels, plays, familiar Arabic and Japanese tales, operas from Mozart to Richard Strauss, American Indian and Australian Aboriginal folk tales, and movies from the silent era on. He makes a plausible case for his typology, at least as applied to literary traditions before the last two hundred years: he observes that the ambiguities and cynicism of modernism have driven literature away from the moral edification seen through most of storytelling history. Booker regards this as a failing: contemporary literature, he says, has "lost the plot." By offering up too many antiheroes and focusing on the moral ambiguities of life, modern fiction has in his opinion lost its moral bearings.

Booker believes the psychology that underpins his project is Carl Jung's theory of symbolism and archetypes, which he describes in a way that almost makes it sound like evolutionary psychology: "Carl Jung moved on to the much wider question of how, at a deeper level, we are all psychologically constructed in the same essential way . . . , in much the same way as we are genetically 'programmed' to grow physically: and it is only on, as it were, the more superficial levels of our psyche that our individuality emerges, and that each of us finds our own individual problem in coping with the 'programme' of development that our deeper unconscious has laid down for us."

Booker, however, is essentially interested in why "certain images, symbols and shaping forms recur in stories to an extent far greater than can be accounted for just by cultural transmission." This requires that we look deep into the unconscious, to discover what Jung designated as *archetypes*, "the ancient river beds along which our psychic current naturally flows," in Jung's own words. It is in these archetypal structures that Booker thinks can be found the "basic meaning and purpose of the patterns underlying storytelling."

Booker's project is a reminder of the odd place Jung occupies in intellectual history. Against the prevailing social constructionist givens of the last few generations, Jung looks downright prescient: he at least championed the idea of some kind of innate psychological content, and with it a human nature, which lies under the endless diversity of cultural expression. In the tradition of Jung, Booker is right to insist that transmission between cultures cannot explain the similarities in stories around the world. However, it is delusion to imagine that in Jung's theory of archetypes and

symbols we will find the "basic meaning and purpose" of patterns of sto-
rytelling. A plausible account of meaning and purpose—why these puta-
tive archetypes should exist in the first place—is precisely what Jungian
theory lacks, except in its vague emphasis on self-realization as the ulti-
mate goal of human thought and action. Jungian psychology and arche-
type theory hold nothing comparable to the explanatory power and rigor
we find in Darwin's appeal to selection for survival and reproduction.

In fact, a Jungian reading of fiction conflicts with Darwinian readings
in ways that are worth considering. For example, in his Jungian mode,
Booker interprets malevolent characters in stories as selfish "Dark Fig-
ures," who symbolize overweening egotism, the selfishness of the individ-
ual. The dark power of the ego is the source of evil, along with another
Jungian idea, the denial of the villain's "inner feminine." A Darwinian
could agree that egotism might explain the wickedness of someone like
Edmund in *King Lear*. But Grendel? The shark in *Jaws*? It is not clear that
egotism is an index of villainy. Oedipus is arguably a more egotistical
character than Iago, who in his devious cruelty is still far more evil. The
malevolence of the dinosaurs in *Jurassic Park* or the Cyclops in the *Odyssey*
does not lie in their selfishness or egotism. Who would ever think to call
Godzilla selfish? "Selfish" is a term we apply to people, and perhaps ani-
mals when they represent people in folktales. But in Darwinian terms,
the persistence of large, hungry, dangerous beasts as dramatic threats in
fiction is explainable as a straightforward Pleistocene adaptation. In an
evolutionary context, appeals to an arcane system of symbolism are an ex-
planatory fifth wheel: human beings are taught with no difficulty to be
wary of snakes or growling animals with large, exposed teeth. As for the
theme in fiction of egotism—the individual will against the needs of
others—that too is much more amenable to a straightforward Darwinian
account than to any system of symbols or archetypes.

Plots organize fiction, and while they can be reasonably sorted into a
manageable number of types, that in itself does not explain why plots
exist. A plot is a structure of actions and events, Aristotle's "structure of
incidents." The events may be fortuitous, but the actions must be moti-
vated, produced by the causality of human intention. Everything that
Oedipus or any other fictional character does is done for a reason
(known, unclear, or unknown), whether or not the results of the actions
are foreseen. It is therefore normal in criticism to disparage an author

for portraying a character's action as "unmotivated." In fact, a story wholly without motivation would test the very idea of a story in the first place. A play in which a man brews a cup of tea, throws it down the drain without tasting it, makes another and throws it out too, and another repeatedly on to the end, might be a Dadaist experiment, or an illustration of an obsessive disorder, but it would be better described as an anti-story rather a story. A character's motivation, as I indicated earlier in this chapter, involves the expression of will, normally toward the fulfillment of a desire, and against resistance or obstruction of some kind.

That a plot was a causal structure, an arrangement of motivations—in essence, desire against obstruction—was grasped by Aristotle, who was not much interested in plot types beyond comedy and tragedy. Write a story about a character, Aristotle argued, and you face only so many logical alternatives. In tragedy, for instance, either bad things happen to a good person (unjust and repugnant) or bad things happen to a bad person (just, but boring). Or good things happen to a bad person (unjust again). Tragic poignancy requires that bad things happen to a good but flawed person: although he may not have deserved his awful fate, through his arrogance Oedipus was asking for it. In the same rational spirit, Aristotle works out dramatic relations. A conflict between strangers or natural enemies is of little concern to us. What arouses interest is a hate-filled struggle between people who ought to love each other—the mother who murders her children to punish her husband, or two brothers who fight to the death. Aristotle knew this for the drama of his age as much as soap opera writers know it today.

Aristotle's thoughts on stories and drama endure because of his basic insight that the substance of drama is action and the emotions that animate it. The themes of Greek drama are built on such emotions as erotic and familial love, a sense of honor, civic loyalty, the inevitability of death, and so forth. For his part, Booker has not discovered archetypes in the Jungian sense, hardwired blueprints, for story plots: what he has identified is the deep themes that fascinate us in fictions. An analogy may make this clear: survey the architectural layout of most people's homes and you will find persistent patterns amid the variety. Bedrooms are separated from kitchens. Kitchens are close to dining rooms. Front doors do not open onto children's bedrooms or toilets. Are these patterns Jungian room-plan archetypes? Hardly. Life calls for the logical

separation of rooms where families can sleep, cook, store shoes, bathe, and watch television. Whenever life becomes prosperous enough for families to dwell in buildings with separate rooms, they will do so, and patterns of use and relationship begin to emerge. These room patterns follow not from mental imprints but from the functions of the rooms themselves, which in turn follow from other values of family relationships, preferences in food preparation, attitudes toward sex, possibilities of privacy, and so forth.

So it is with stories. The basic themes and situations of fiction are a product of fundamental, evolved interests human beings have in love, death, adventure, family, justice, and overcoming adversity. "Reproduction and survival" is the evolutionary slogan, which in fiction is translated straight into the eternal themes of love and death for tragedy, and love and marriage for comedy. Stories are populated with character types relevant to these themes: beautiful young women, handsome strong men, courageous leaders, children needing protection, and wise old people. Add to this the threats and obstacles to the fulfillment of love and fortune, including bad luck, villains, and mere misunderstanding, and you have the makings of literature. Story plots are not, therefore, unconscious archetypes but structures that inevitably follow, as Aristotle realized and Darwinian aesthetics can explain, from an instinctual desire to tell stories about the basic features of the human predicament.

V

Modern technologies for creating and enjoying fictions are a long way from sitting around a Pleistocene campfire listening to the storyteller's tale. However, these technological developments don't mean as much as we might imagine. The first ancient innovation in storytelling was probably the decision of a single creative storyteller to imitate various voices for different characters in a narrative. Later on, dramatic acting, with different people taking the parts of characters, would have been a natural development. Moving forward some thousands of years, the next great innovation for fictional entertainment would have been the invention of writing. To be able to write down a story frees it from the limits of a storyteller's memory; this enormously increased the variety and

complexity of fictional narratives. It was another five thousand years af-
ter the invention of writing that the growth of literature in our modern
sense was accelerated by Gutenberg's printing press. Reading and acting
were therefore the essential means of telling stories in literate cultures
from before *The Epic of Gilgamesh* through the nineteenth century, and
with movies on into the twenty-first. Nonliterate cultures continued to
rely—as they had for many thousands of years—on telling and acting as
their means of enjoying fiction.

Because film and video loom so large in our experience today, it is easy
to overestimate their importance. People who are enchanted by movies
and electronic media but are strangers to traditional live theater usually
have little idea of the visual spectacle theatrical production could offer
audiences as far back as the Renaissance, let alone after the introduction
of electric lights in the nineteenth century. Visual extravaganzas did not
begin with Hollywood but very likely amazed audiences in Paleolithic
caves, with firelight and cave echoes providing their special effects.

Fans today also overrate the contribution of video games to story-
telling as an art form. Video games are complicated and visually arrest-
ing forms of make-believe that allow viewers to jump onto the stage and
participate in the action. This is regarded by video-game enthusiasts as
an earthshaking advance. In a way, it is less an extension of storytelling
art than a regression to its precursors. While the themes and content of
video games may be complex and adult, the logic of viewer participation
in the story reverts back to the child's tea party with teddy bears. Video
games are first and foremost *games*, with rules for participants and the
attention-maintaining quality of uncertain outcomes. They somewhat
resemble fiction, but so do chess, poker, and Monopoly, by giving players
a defined creative role in a rule-governed, imaginative world. Video
games do not produce a new kind of make-believe entertainment, or
much improve on the older kinds of games and fictions, except by the
addition of intense visual or virtual-reality effects. (Someday, a video-
game version of *King Lear* may allow players to step into the action,
even to save poor Cordelia if they play skillfully enough. Whatever the
fun, this will not be an enhancement of Shakespeare.)

Some 2,500 years before the first stop-action King Kong made his
way up a model of the Empire State Building, Aristotle argued that
"spectacle"—the eye-popping effects of scenery, costumes, and stage

machinery (the deus ex machina) that were already in use in the theaters of Greece—was despite its popularity the least important aspect of drama. The most important aspect was an arresting plot, which was the hardest thing for a dramatist to achieve—ahead even of interesting characters and the poetic use of language. In cinema today, it is still the story told that makes the greatest films. In this respect, little has changed since our ancestors sat around a fire listening to a storyteller. Hollywood is engaged in a special-effects arms race; every movie has to have bigger explosions, uglier villains, more frenzied, realistic violence, ear-splitting noises, and ever-expanding battle scenes. No computer-generated crowd, according to current rules, is allowed to be smaller than the crowds in last month's blockbuster.

Such effects can give pleasure to many, but they do not replace the fundamental attraction of a rational, coherent story well told. The appeal of the story is an evolved, innate adaptation: universal, intensely pleasurable, emerging spontaneously in childhood in ways that (like the deep structure of speech) are so already so logically complex even in children's play that they require an explanation in terms of innate capacities. That it remains possible today to be engaged, amused, or moved by a story told by a single speaker—next to a campfire, around a watercooler, or across a dinner table—shows us that we are with regard to fiction the same people as our prehistoric ancestors. Good stories compel our attention. So do good storytellers. It is to that topic that we turn next.

CHAPTER 7

Art and Human Self-Domestication

I

The argument of this book has focused so far on the ways in which natural selection throws light on our understanding of natural and artistic beauty. My approach has tended to model the human mind on the analogy of a multipurpose tool—a Swiss Army knife fitted by evolution with an assortment of mental blades and implements for solving specific problems of survival in prehistory. Conceived in this way, our minds evolved for causal and probabilistic reasoning about the normal furniture of the Pleistocene environment: other people, animals, plants, and physical objects. The model brings into the light inclinations and strategies that were selected for in such areas as food preference and avoidance, self-defense, safety, habitat selection, and imaginative planning. In all these respects, the multitool pocket knife is an apt analogy, since it stresses the practical survival benefits of specialized interests, passions, dislikes, pleasures, skills, phobias, and intellectual aptitudes.

Conceived in this way, our Pleistocene inheritance gives us an explanation for underlying tendencies in landscape painting and garden design as reflecting deeply ancient habitat preferences. Similarly, the remarkable imaginative capacities of *Homo sapiens*—along with a persistent fascination with subjects such as physical dangers, competition for power, love, or exploration—are crucial to understanding the universality of storytelling. But there is more historically to landscape painting and literature than these factors of natural selection alone can explain.

In particular, my approach has till now has ignored one of the most important features given in the list of criteria for art in chapter 3: skill, style, and a sense of accomplishment—values we admire in art. It is human intelligence and creativity that transforms appealing landscape scenes and plot outlines into works of painterly or literary art.

Natural selection stresses survival in a hostile environment as fundamental to the prehistoric evolution of any adaptation. But if art is an adaptation, mere survival is a completely inadequate explanation for its existence. The reason is clear: artistic objects and performances are typically among the most opulent, extravagant, glittering, and profligate creations of the human mind. The arts squander brain power, physical effort, time, and precious resources. Natural selection, on the other hand, is economical and abstemious: it weeds out inefficiency and waste. The organs and behaviors of animals are designed by natural selection to allow a species to survive and reproduce, making the most effective use of local resources. Evolution by natural selection is a severe accountant in the way it sorts out potential adaptations in terms of costs and benefits. How strange, therefore, to argue then for a Darwinian genesis of the arts of man, which so often tend toward lavish excess, costly far beyond any obvious adaptive benefits for survival.

This problem is not unique to understanding human evolution but is a general issue in Darwinian theory. The classic case is the peacock's tail, as both Darwin and his early critics well understood. Some initial reluctance by otherwise sympathetic scientists to accept the *Origin of Species* stemmed from Darwin's failure to explain nature's excesses: for example, the plumage and songs of birds. Darwin was acutely aware of this difficulty. In a letter written to Asa Gray the year after the *Origin of Species* was published, he remarked on it. Before he developed the theory of evolution by natural selection, Darwin wrote to Gray, "the thought of the eye made me cold all over." He had eventually resolved the puzzle of how eyes can evolve, but he was then faced with a new obstacle. Now, he confided, the "sight of a feather in a peacock's tail, whenever I gaze at it, makes me sick!" As well it might, because the peacock's tail throws up a defiant challenge to the fundamental principles of natural selection. It is expensive to grow, requiring energy that could be otherwise utilized by the organism. The weight alone of this panoply of feathers with their iridescent eye-spots makes peacocks more vulnerable to predation in the

wild, significantly reducing peacock survival in the Asian habitats where the bird evolved. Natural selection ought to have long since eliminated the peacock's tail; in fact, natural selection should never have allowed it to develop in the first place.

In addition to its costliness and danger, another aspect of the peacock's tail is inconsistent with principles of evolution as Darwin originally mapped them out. Given the ways in which environments, food sources, and predators present themselves to animals, natural selection actually pushes toward uniformity, with the constant reinvention of the same general adaptations. As Geoffrey Miller puts it, "Natural selection for ecological utility tends to produce convergent evolution, where many lineages independently evolve the same efficient, low-cost solution to the same environmental problems—traits such as wings, eyes, teeth, claws, hearts, and lungs." Natural selection should lead us to expect birds that evolved in the same environment to have much the same coloration, for example, and to differ in such respects as size or beak shape only in terms of the particular niche each species occupies. But animal species frequently violate this pattern. Birds can exhibit in the same habitat an endless variety of striking, colorful plumage arrays.

In the nineteenth century this variety was usually explained as a matter of males signaling to females that they were members of the same species. (This is implausible: members of the same species need to recognize each other, but nothing like the feathers of an oriole or a peacock is needed for that.) As with the central thesis of the *Origin of Species*, Darwin worked slowly over years developing his solution to the riddle of the peacock, which he published in its most developed form in his last book in 1871, *The Descent of Man, and Selection in Relation to Sex*. In this work he puts forward a new, powerful, versatile principle, the second great driving force in the evolution of animal physiology and psychology: sexual selection by mate choice.

Sexual selection is, like natural selection, easily described, and its gross effects on the appearance and behavior of animals are often obvious to human observation. The peacock's tail, according to sexual selection, is a fitness indicator, a signal of health and high-quality genes. A large, colorful, symmetrical tail functions as an advertisement to peahens, proclaiming, "See what a strong, healthy peacock I am." The difficulty of growing and getting by with such a splendid monstrosity proves that the peacock

who sports one is fit; weak or diseased peacocks cannot grow adequate tails and will not, therefore, readily find mates. Indeed, the accuracy of peahen preferences in terms of fitness has been experimentally demonstrated: peacocks with the finest tails do possess relatively better genes. In addition to being a fitness indicator for the bird that has one, a tail that is attractive to peahens points toward another reproductive virtue: the male offspring of a union with a splendidly outfitted male will themselves be more likely to have splendid tails, which will in their turn be attractive to the next generation of peahens—thereby ensuring that the couple's genes will be passed through to future generations. At the same time, this process ensures that peahen preferences in male plumage are also passed on: that, in essence, is how sexual selection engraves mate-preference traits into the genetic makeup of a species.

Sexual selection is ubiquitous in the animal kingdom and throws light on curious features of animals that natural selection is powerless to explain. Not only striking plumage but such characteristics as body symmetry, healthy skin, shiny fur, agility, tireless courtship dancing, intricate aerial maneuvers, musculature, and gross strength are in part or in whole products of sexual selection. The typical pattern is that some trait of an animal that evolved by a straightforward process of natural selection is commandeered by sexual selection and either greatly accentuated or completely transformed into a fitness signal. Thus birds evolve feathers for warmth and for flight. But feathers are susceptible to coloration, can be grown in an immense variety of forms, and can act as visible signs of health and genetic fitness. Natural selection can produce drab feathers exactly to match a habitat background and achieve near invisibility in a nest. Sexual selection classically eschews camouflage strategies, going in exactly the opposite direction to produce gaudy, flamboyant shapes and colors. This ostentation—both dangerously conspicuous and wasteful—is not an incidental by-product of some evolutionary process but is the very point of sexual selection and fitness display.

Sexual selection is sometimes regarded as a special case of natural selection, since both processes in the most general sense increase gene propagation, the survival of a genetic line. However, as Darwin himself fully appreciated, the intrinsic mechanisms of natural and sexual selection are fundamentally different. In natural selection, random mutation and selective retention work together to improve the functions of organs and body

design required for survival: pancreas, kidneys, bone joints, blood-clotting capacity, sperm production, binocular vision, and so forth. Still within the realm of natural selection are evolved dispositions, emotions, and behavior patterns that have direct bearing on survival or the will to reproduce: fear of heights, wariness of growling animals, finding poisonous plant alkaloids bitter and repellent, a taste for sweet and fat, and sexual pleasure. A well-functioning liver and a general fear of snakes are both "healthy" in the sense that they were naturally selected for in prehistory and so remain with us today. For each one of us, our grandmothers and grandfathers tens of thousands of generations removed form a continuous line of people who were fit to live long enough to reproduce. These survivors passed their traits on to us, unlike their less fit siblings who died—of liver failure or snakebite, for instance—before they could reproduce. The unlucky siblings are our aunts and uncles thousands of generations removed; they are not our direct ancestors. These were joined in death by other of our more distant relatives, countless people and proto-people who did not find high places scary nor snakes particularly alarming, for whom fat and sweet were not especially tasty, and who in their reproductive prime took little pleasure from sexual adventures.

However, a distinctly new factor is introduced into the logic of evolution by sexual selection. Where natural selection pits a slowly mutating species against opportunities and demands of an external environment, sexual selection shifts the focus to the relation of members of a species to each other. These relations fall into two broad classes of competition. First, members of the same sex compete against each other for either the best mate or the largest number of mates. This kind of sexual selection still somewhat resembles natural selection: it typically involves aggressive fighting among males for females in a winner-takes-all situation. With elephant seals, sheer body size and constant guarding can give a large, mature male access to 80 percent or more of the females in an extensive beach territory. This kind of male competitive struggle, also observed among such animals as elk and bighorn goats, can lead to fights to the death for access to females.

Although they are a frequent topic of fictional literature worldwide, dramatic duels to the death for the hand of a lady are statistically rare among human beings. Monogamy demands assortative mating by pairs, rather than winner-takes-all, harem-building scenarios. This means that

men and women tend each to choose the highest-quality, highest-status mate attainable for them according to a variety of criteria. These criteria are part of a human mating system that aims not at crushing competing members of the same sex but at *attracting and seducing members of the opposite sex*. This second kind of sexual selection takes place in courtship, and it has affected the evolution of the human body and, more importantly for our purposes, done more to create the human personality as we know it today than any other single evolutionary factor. Just as sexual rivalry in animals is concentrated in males, and has tended to perfect offensive and defensive combat weapons such as teeth, claws, and antlers, mate choice in courtship is dominated by females, and especially in *Homo sapiens* by female feeling and discrimination. It is directed toward more subtle and charming qualities of body but also of mind; in fact, sexual selection is the driving force that has defined the very meaning of "charm" in how human beings tend to regard each other.

The reason females tend to dominate sexual selection is built into the logic of evolution. The burdens of conception are much heavier for females than for males. A girl arrives at puberty already possessing approximately four hundred eggs; she will issue one or occasionally two per month until menopause, never producing any others. When conception occurs, it is followed by a nine-month gestation, with sickness and weakened mobility. Then on to months of lactation, with the mother nurturing a hungry, mewling infant that in the end will require more years to achieve maturity than the young of any other species of animal. Men, on the other hand, may produce around twelve million sperm per hour and, in principle, may inseminate large numbers of women—and then abandon them at will. Thus the biggest recorded number of children born of one woman, an eighteenth-century Russian peasant, is reported to be sixty-nine, but that included many multiple births in twenty-seven pregnancies. The largest number of children fathered by one man, Mulai Ismail Ibn Sharif, a contemporary of Louis XIV, is said to be 1,042, naturally involving hundreds of mothers in a harem. (This number is on the low side: it is merely when they stopped counting.) A man who inseminates a low-quality, irresponsible mate still enjoys the chance of his genes being passed on at very little cost—indeed, at no cost whatsoever, if he abandons the woman and baby. For the woman, carrying and raising even one child is a very costly project. This enor-

mous difference between the situations of the sexes means there is a deep, innate propensity for women to be far more cautious and discriminating than men in choosing a mate for procreation: women not only need a mate who is healthy, they need one who will stick around, provide, and protect. (That the higher degree of female discrimination is a product of the lopsided costs of child-bearing is demonstrated by the fact that in each of those few species where the costs of gestation are borne by males—pipefish sea horses, for instance—it is males who become the more discriminating sex. This role reversal, however, is rare and occurs in no species of mammal.)

Again, the very idea that one man might, elephant-seal style, control hundreds of women in a harem is a reminder of how far some religious and political structures of the last ten thousand years have drawn us away from the prehistoric scene in which hunter-gatherer sexual preferences evolved. The small, mobile bands of human beings that came to flourish in the Pleistocene developed mate preferences based on their conditions, not ours. These tastes persist in our preferences in flirtation, courtship, and mating. They reveal themselves in experiences of pleasure and revulsion, including the physical features and qualities of personality we regard as attractive and charming—or, indeed, as beautiful—in human beings.

II

What, to begin with, are some of the outer, physical features that may make a member of the opposite sex eye-catching? One of the most famous studies of sexual attraction involves the waist-to-hip ratio. Healthy premenopausal women will have a ratio of .67 to .80—hardly an hourglass, but possibly a Coke bottle; this body shape is regarded as "feminine" and attractive by men. Women know this, and the history of fashion therefore includes methods to accentuate it with corsets and bustles. Devendra Singh, who originally studied the effect of this ratio using simple line drawings, noted that (outside of extremes of obesity or skeletal thinness) it was the *ratio* that men preferred, rather than any absolute weight or size. There is good statistical evidence for this preference being adaptive, as women who display a waist-to-hip ratio in the .7 or .8 range are significantly more fertile than women closer to the

healthy male ratio of around .9. In fact, .9 is close to both prepubescent girls and postmenopausal women. Singh has noted the extreme ratio found in depictions of Hindu goddesses (near to .3), whose supernormal waist-to-hip ratios match their supernormal fertility and sexuality, and of course the ratio also occurs in sexy women in art from Botticelli's *Birth of Venus* to Modigliani nudes.

Women, on the other hand, find men attractive who have wide shoulders and muscular upper-body mass, including pectoral muscles and biceps. This proportion is opposed to the least-liked pear shape created by narrow shoulders and fat in the abdomen and hips. Outside of primary sexual organs, upper-body musculature is one region where we see the biggest general differences between male and female bodies. Women have around three-quarters of male strength in their legs but only a third of the bench-press strength that requires arm and chest muscles. When it comes to the hand grasp, men are on average fully twice as strong as women, justifying all of those requests to husbands to twist off difficult jam lids. Nicely configured muscles over a relative absence of abdominal fat remain for women a significant potential feature in defining a beautiful man. Such beefcake may not be the best mate choice for a woman today, but along with other Pleistocene tastes, the attraction remains.

Two "mirror" asymmetries between women and men persist across cultures. One is the preference of women for older men, which mirrors the preference of men for younger women. The difference is just short of three years worldwide for actual marriages, and the averages of aspiration for the age of a spouse varies from culture to culture. The evolutionary psychologist Donald Buss records that in Zambia men prefer a wife seven years younger, while women want a husband four years older. In the United States and Canada, women indicate that they want men between two and three years older, while men want women about two years younger. In no culture are these average preferences close to equal, let alone reversed.

This age-preference psychology is explained by the fact that women seek status and resources in their mates, and these tend to accrue to relatively older males. In the Pleistocene context, the female preference for older men may have involved other factors difficult now to determine with certainty: knowledge, patience, and perhaps the more mature male's greater willingness to stick around, provide for his mate, and protect their children. For their part, men are less interested in status and resources in women and

more concerned with fertility, which is consistent with their preference for younger wives. A small survival and reproductive advantage for this age differential has engraved these preferences in the species. This has many implications and by-products today, stretching from the insurance industry to the use—overwhelmingly female—of cosmetic wrinkle creams and hair dyes against graying. The Pleistocene, it seems, was in respect of female desirability as much a "youth culture" as anything we see today.

Another persistent mirror asymmetry is the strong preference of individual women for men who are taller than they are, which is coupled with a much weaker preference of men for shorter women. While the age differential might still have uses both for men and women in choosing mates today, the height differential is obsolete for survival in the modern world, and in fact may be counterproductive, inconveniently closing off pairings that might otherwise have been excellent for both parties. Yet women's preference for height remains especially powerful, as the psychologist Nancy Etcoff has entertainingly described, showing itself in both the appeal relatively tall men have for women, whatever the heights of both, and also in the absolute appeal of male height from any female perspective. Women in personal ads openly search out tall men. Etcoff quotes *New Yorker* editor David Remnick as describing the normal situation in the lobby of a hotel where an NBA basketball team is staying as "resembling the waiting room of a modeling agency," with lithe beauties practically auditioning themselves for the players. Brian Hansen has shown that European royal portraiture tends systematically to exaggerate height by distorting normal head-to-torso ratios. The statistics on the above-average heights of American presidents reflect the situation of both tribal societies and corporation boardrooms. (I know from personal experience growing up around the film industry of Southern California that one of the most common remarks made by people who encounter a movie star on the street is "I was surprised how short he is." We tend involuntarily to envision high-status people as tall.)

Men are on average taller than women, so you would expect by that fact alone that most marriages would be of a woman to a taller husband: but in fact, marriages that reverse this norm are far less frequent than a random statistical distribution would predict. A conventional feminist interpretation of the "male taller rule" is that it stems from the desire of dominant males to tower over their subordinate mates. This flies in the

face of the fact that the preference is far more marked in women than it is in men. (This does not surprise the critic Daniel Nettle, who argues that since males are more interested in assessing fertility than females, and moderate height is a cue for both sexual maturity and fertility, men should be expected to be much less averse to feminine height than women are to male shortness. Indeed, it seems that for many short, rich men, a tall, beautiful wife is a trophy.)

Both sexes, however, agree on one of the most salient features that mark personal attractiveness: symmetry. Taking up with an unhealthy mate was a bad strategy for survival in the Pleistocene. Left-right symmetry is a statistical indicator of physiological and psychological health and so-called developmental stability, defined as an individual's capacity to grow in a normal way despite mutations and environmental deficits, such as poor nutrition, parasites, or injuries. Part of what makes it such a powerful indicator of fitness is that it is so easy to see, particularly in the face. We tend to take symmetry for granted and notice its absence more than its presence. While left-right symmetry in a face or a body does not guarantee beauty, marked asymmetries—a withered arm, a face that droops down one side—will severely diminish it.

III

Visible physical traits form an innate bedrock for the countless transformations and fashions of how the body has come to be altered, made up, decorated, and clothed. Our initial impulse to "think physical" about the opposite sex is, however, still a long way from the actual criteria that men and women use in mate choice. While physical features will cause heads to turn, if we examine a list of the top seven most-desired traits appealed to by both sexes for establishing relationships, we find that it includes only two bodily traits: physical health and physical attractiveness (which come to nearly the same thing). On the serious question of choosing a mate, both men and women on average place *kindness* first on their respective lists, with both naming *intelligence* as number two. Men will then choose *physical attractiveness*, including the qualities mentioned earlier, as well as other factors such as clear, smooth skin and bright eyes, while women will tend to turn their priorities toward the man's *wealth or resources*. Other

criteria on the list for both sexes are *exciting personality, adaptability, generosity, dependability, industriousness, creativity,* and a *sense of humor.* These personal characteristics—Aristotle would have numbered some of them among the prime human excellences, and religions worldwide identify many of them as basic moral qualities—are also bedrock features of humanity. Religions may claim credit for bestowing these moral qualities on the human race, and philosophers may seek to justify them rationally or demonstrate their logical necessity, but the fact that far-flung shamans, priests, and philosophers so often agree on what they are in the first place is in itself decisive evidence of their ancient, prereligious, prerational origins. The ensemble of mental qualities included in the mating criteria is, just as much as bodily features, the result of millions of years of mating decisions made by our prehistoric ancestors.

Darwin well understood that such mental qualities had been affected—some variously honed and accentuated, others diminished—by a process of sexual selection similar to the selective modifications brought about by animal breeders in domesticated species. His comparison, which has hardly been noticed by later commentators, is not as odd as it might at first seem: he argues in *The Descent of Man* that the domestication of originally wild animals in human prehistory was largely "unintentional," a process in which man "preserves during a long period the most pleasing or useful individuals, without any wish to modify the breed." Our pastoral ancestors, in other words, had no conscious plan for how species they herded or worked with would look or behave in a hundred generations. A Pleistocene hunter might feed and tolerate near his camp a wild dog that is docile toward him and his family but fierce in confronting strangers or other animals. An early Holocene herder would keep for milking submissive beasts that tended not to stray far from camp, and slaughter more independent or troublesome stock. Selective domestication of animals by humans occurred over many thousands of generations of deciding which animals were more desirable to keep than to eat.

In a manner that Darwin calls "closely analogous," human beings in prehistory *practiced selective breeding on themselves* by their own mating choices—essentially, it is accurate to say, domesticating their own species. Take, for example, the evolution of language. Speech as a medium of communication and practical planning would have been highly adaptive in prehistory. Speech is also one of those areas where natural selection

gave the capacity a start, but sexual selection led to its full and powerful flowering as the distinctly human phenomenon. Darwin himself suggests that the oldest evolved roots of human speech were expressive warning cries used to signal when the primate group is under threat: this capacity would improve survival and would have been enhanced by natural selection. However, sexual selection would have extended this ability of early man, Darwin argues, to use "his voice in producing true musical cadences, that is singing, as do some of the gibbon-apes at the present day":

> We may conclude from a widely-spread analogy, that this power would have been especially exerted during the courtship of the sexes,—would have expressed various emotions, such as love, jealousy, triumph,—and would have served as a challenge to rivals. It is, therefore, probable that the imitation of musical cries by articulate sounds may have given rise to words expressive of various complex emotions.

Darwin is not denying the factual communicative utility of language and its role in natural selection. He does, however, find its potential to express emotions in courtship contexts a plausible source of part of its early evolution. By suggesting the work of sexual selection on the evolution of language, Darwin is also suggesting another possibility: over and above its utility for Pleistocene survival, *language use became a fitness signal*—a marker of health and intelligence.

Any hunter-gatherer band that could communicate within the group on the whereabouts of water or of game, or could pick over the past in detail and plan raiding sorties, would possess an extraordinary advantage over competing groups without language (this is one of the persistent hypotheses about why our forebears may have exterminated the Neanderthals). But it is inadequate to analogize language only to a tool—say, a bread knife or the assorted blades of a Swiss Army knife. If knives are the analogy, language is better thought of as a saber with a jewel-encrusted hilt and a blade with intricate gold inlay. You are free to whittle a stick or cut bread with such a knife, but its meanings and uses extend far beyond utility for survival.

Consider vocabulary. Nonhuman primates have perhaps twenty distinct calls. The average speaker of a modern language, on the other hand,

knows sixty thousand or more separate words, learned spontaneously at an average of ten to twenty every day between the ages of about three years to eighteen. Would survival in the Pleistocene have required and thus enabled the acquisition of such a stupendous vocabulary? Certainly not; and in fact, 98 percent of our speech even today uses only about four thousand words. I. A. Richards and C. K. Ogden's Basic English for international communication made do with only 850 words; as Miller points out, textbooks in biology and astronomy have been written in Basic English. It is clear that no more than a couple of thousand words at most would have been adequate for communication in the Pleistocene.

The excess vocabulary of sixty-thousand-plus words is explained by sexual selection: the evolutionary function of language is not only to be a means of efficient communication but to be a signal of fitness and general intelligence. The best single health index, outside of obvious disease symptoms, is body symmetry, but the correlation between body symmetry and intelligence is only about 20 percent. Vocabulary size, and how effectively and creatively vocabulary is used, is much more clearly correlated to intelligence, which is why it is still used both in professional psychological testing and more generally by all of us automatically to gauge the cleverness of another person. Vocabulary accurately used is a handy quantitative measure with a potential to reach into the psyche in order to ascertain a person's mental powers. Our sensitivity to vocabulary grasp goes hand in hand with a general sensitivity to the ignorant or unintelligent misuse of language, which explains why audiences enjoy popular comic characters such as Mrs. Malaprop, or those unlettered police constables in Shakespeare who make such an entertaining mess of trying to use legal terminology that is beyond their grasp. Just as the evolutionary implications of good-sized biceps or a youthful complexion ensure that body-building centers and the cosmetic industry will not soon be going out of business, so the fitness-signaling functions of language use mean that books and audio programs for "vocabulary building" are bound to have a permanent market.

Vocabulary is but one aspect of language that gives us a view into another human mind: grammar, syntax, word choice, appropriateness, coherence, relevance, speed of response, wit, rhythm, ability to toy with words, and originality all play a part. Taken together, these skills and qualities of mind constitute *eloquence*, and the admiration of eloquence is solidly on

the list of human universals. This shows itself in a cross-cultural approval of the capacity to speak well publicly, but it is also critical in the most intimate context of courtship—a theme trenchantly explored by Edmund Rostand in *Cyrano de Bergerac*. Qualities such as vocabulary size, accurate syntax, and linguistic creativity are, despite the fame of Rostand's play, not often remarked as appealing to profound mating preferences. In fact, excellence in speech is treated almost as an embarrassment by many professional linguists who, perhaps out of a sense of political/linguistic egalitarianism (or a fear of being perceived as grammar-enforcing schoolmasters), have tended to dismiss high linguistic skill and "correctness" as a mere social class marker. But the human interest in sophisticated and original language use is much deeper than any social convention.

Miller remarks that it would be surprising to find a personal advertisement that read, "Single female seeking man who knows fifty thousand useless synonyms." However, he reports that couples in long-term relationships do tend to have approximately the same size vocabulary and that this pairing-equality among couples is indicated more strongly than are other traits. Vocabulary size and skill in language use are therefore further aspects of assortative mating, whereby individuals choose the best available mates who will stoop to their level—"the best I can get who'll settle for me." Thus a linguistically sophisticated lass may shudder to hear a chap say, "My criteria for a decent car is that it gets good mileage," and tell him that, alas, she is very busy next weekend. Note that this is emphatically not a failure of communication: she understands perfectly well what he means by the sentence. However, what he has signaled—as opposed to intentionally communicated—is that he has not caught up with Greek plural and singular forms that have migrated into English, and that he is therefore perhaps not her kind of guy. He can be consoled, whether he knows it or not, that there are any number of young women out there who, having no idea themselves of the difference between "criteria" and "criterion," will be impressed by his sound opinions on the subject of gasoline mileage. Each to his own level of competence: that is how assortative mating works.

In terms of sexual selection, vocabulary size—competently using not just the words "green" or "blue," but being able capably to employ "navy," "jade," "azure," "ultramarine," "cerulean," "sea green," "lime," "turquoise," "chartreuse," "cobalt blue," "forest green," "sapphire," "aquamarine," and so

on—is an ornamental capacity analogous to the peacock's tail. Such enhanced, decorative language use was pointless for Pleistocene survival, but it is as intrinsic to human life as other mental traits that have been created and enhanced by sexual selection. These include the virtues of being able to make and appreciate jokes, being able to spot and make use of metaphors and original analogies, having a good memory, or being able to tell a narrative story characterized by relevance, coherence, and drama. These features of language use are noticed and prized by human beings as direct signals and displays of mental quality (and indirect, though weaker, indicators of physical health). Even while natural selection was refining the human species against a background of "nature red in tooth and claw," improving the function of the heart valves or instilling physical pleasures and phobias, sexual selection was building a more interesting human personality, one that we have come to know as convivial, imaginative, gossipy, and gregarious, with a taste for the dramatic. Much of this mental and linguistic talent is directed to the human social group, but it is also a central area of interest in courtship contexts, a point that Darwin grasped in his first text on the subject. Miller rightly observes what follows from this: the number-one topic for poetic and sung language worldwide and through history is love. This is exactly what you would predict if poetry recited or sung had evolved in the context of courtship as a kind of cognitive foreplay. In the sense bequeathed to us by sexual selection's effects on the evolution of speech, love is poetry's natural subject.

The picture that sexual selection paints of our Pleistocene ancestors may seem unfamiliar, but there are important reasons for this. Archaeology gives us a history that is largely one of stones and bones, written in terms of fossilized skeletal remains and hard objects that accidentally survived in garbage heaps and fireplaces, or in a few cases were saved from destruction in untouched caves or the odd grave. It is a wondrous record of artistic achievement, however tiny it is. Luckily, we have the cave paintings from such important sites as Altamira, Lascaux, and Chauvet going back perhaps thirty thousand years. There are carvings of animals, a few human figures, such as the Venus of Willendorf, or the incredible Löwenmensch from Swabia that may be thirty two thousand years old, and shell necklaces and traces of cosmetic ocher use that go back as far as eighty thousand years. Some of the animal representations are astonishingly sophisticated, and there is Pleistocene jewelry that looks as though it might

have been bought last weekend at a local craft fair. There are bone flutes from the Pleistocene that are the earliest musical instruments. The so-called Ice Man, nicknamed Ötzi, hacked out of an Alpine glacier in 1991, is 5,300 years old. Ötzi lived just before the start of the Bronze Age, but he may represent older forms of life that stretch back to the Pleistocene. He was wearing meticulously tailored clothing of animal hides and a bearskin hat with chin strap and had snowshoes, a sewn bag with hunting acces-sories, and a fire-starting kit. These artifacts plus his many tattoos show skill and style in their construction. But of Ötzi's language, singing, po-etry, or dancing, we know nothing whatsoever.

Yet if we combine what we can reconstruct about Pleistocene exis-tence with the large ethnographic literature on hunter-gatherer societies in the nineteenth and twentieth centuries, we can deduce a fairly clear picture. The lives of many Pleistocene peoples were doubtless brutal and short. But for others, especially in Europe in the period of the receding glaciers and global warming at the end of the last Ice Age, there was abundant food and leisure—free time that was spent not only painting caves but presumably singing, telling stories, making jokes, improvising poetry, dancing, and making love. If Pleistocene communal life was similar to recent hunter-gather existence, there would have been a ten-dency for men's artistic artifact production to concentrate on carving hard materials, such as stone, hardwood, and bone, while women would have channeled their efforts into cloth and fiber artistry. Outside of some surviving jewelry, we know little of personal adornment, but it is likely that Ötzi's tattoos continue a persistent tradition of face and body painting. Elaborate hair styling would have likely been a feature of Pleistocene life, but again we know almost nothing of it. Piecing to-gether the whole picture of the fifty thousand years or so immediately preceding the invention of cities and agriculture, it is inconceivable that Pleistocene people did not have a vivid intellectual and creative life. This life would have found expression in song, dance, and imaginative speech—skills that matched in complexity and sophistication what we know of Pleistocene jewelry, painting, and carving.

Darwin's concept of sexual selection offers to us a startlingly new metaphor for the mind, one that has at least as much to say about the origin of the arts as natural selection does. The ancients understood mind on the analogy of a mirror or a blank writing slate. Descartes

followed the traditions of his own religion in offering a picture of mind as an embodied ghost. For Hume it was a bundle of perceptions, while in Freud's view the mind came to resemble a high-pressure hydraulic system. More recently, the analogy of the computer chip has come to dominate discourse about the mind. If we combine the computer model with Darwinian natural selection, we so far have a picture of the mind as a strategizing, planning, problem-solving machine that cleverly survived in the savannas with well-honed computational algorithms.

Darwinian sexual selection, however, presents a radically different model of mind. As Miller so nicely puts it, the mind in sexual selection is best seen as a gaudy, overpowered Pleistocene home-entertainment system, devised in order that our Stone Age ancestors could attract, amuse, and bed each other. Of course, bed was not the only objective, since the qualities of mind chosen and thus evolved in this process of human self-domestication made for enduring pairings, the rearing of children who themselves might survive, and thus the creation of robust social groups. But the gadgets and gizmos of the home-entertainment model of mind—in electronics stores they are even called "modules"— are designed for much more than just recording accurate knowledge or planning hunting parties. They are about telling stories or inventing ideologies that will captivate an audience. This sexually selected mind has its record and playback functions, along with a library of stories and anecdotes in audio format, and a dictionary with an impressive thesaurus (for meanings and synonyms and not, needless to say, for spelling in Pleistocene). Better even than any modern home-entertainment unit, the human version not only archives and reproduces funny stories or metaphors but makes them up on the spot, demonstrating wit and originality of a sort yet to be matched by any computer. Provide this sexually selected mind with a piece of wood and it can use its hands and tools to carve an animal; for it, a cave wall can be a perfect place to paint a whole menagerie. It has penchants for the oddest activities—such as its liking for jokes, which it uses to induce strange but highly pleasurable temporary convulsions in itself and others.

From the Greeks through the Enlightenment and on into the computer age, every prevailing analogy for the mind has captured some important aspect or function of it. But none even begins to explain the mind as the creative, exuberant, imaginative, romantic, wasteful, storytelling,

witty, loquacious, poetic, ideology-inventing organ it also is. Darwin's *Descent of Man*, by regarding the mind as a sexual ornament, presents us with a first step toward explaining those features of the human personality that we find most charming, captivating, and seductive. Adding sexual selection to natural selection, we begin at last to see the possibility for a complete theory of the origin of the arts.

<div align="center">IV</div>

An essential requirement of Darwinian fitness indicators is that they function reliably and honestly: they must pose authentic tests. If they can be faked, they are useless as indicators. If unhealthy peacocks can grow massive symmetrical tails, the tail loses its value as an indicator. With *Homo sapiens*, a big vocabulary skillfully used only works as a signal of intelligence or competence if it is difficult for less intelligent and capable people to attain it. Sexual selection thus creates a psychological arms race in which the signaling capacity of one sex is pitted against the critical, discriminating powers of the other. That is why we have elevator shoes and push-up bras. That is what the cosmetic, body-building, and vocabulary-building industries are largely about: accentuating, highlighting, or faking desirable signals.

Sexual selection theory sees urges to improve or enhance fitness signals by any available means as utterly natural strategies: they are straightforward Pleistocene adaptations. In this, sexual selection theory goes dead against many forms of cultural constructionism that have prevailed in intellectual discourse for the last half century. For instance, it has for years been widely argued that women dye their hair and apply wrinkle creams only through cultural pressure, and that wrinkles and gray hair are "natural." A Darwinian view maintains that, on the contrary, a woman's desire to look younger, like a man's desire to appear stronger, taller, or more wealthy, is adaptive and innate. Such strategies will take different forms in different cultures and epochs, but they are prehistoric in their origins. Contrary to gender theorists who have tried to argue that women's use of creams and dyes makes them dupes of the cosmetic industry, the converse is more the case: industries that produce lipsticks, mascara, and hair colors only exist because the values of youthfulness and "looking

good" are products of evolution. Approve of them or not, these values persist because they represent our deeper, innate nature.

The general rule is that skeptical sensitivity to detail and nuance about a sexually selected signal is bound to arise if the signal is open to any degree of fakery. Whatever the limitations of their avian intellects, peahens are unquestionably more severe and perceptive critics of peacock tails than any human observer could hope to be; those tails are important to peahens in ways they can never be to us. Similarly, human abilities to make critical distinctions in responding to evolved cues and signals are effortless and acute. Human critical discrimination in signals requires very little training to get it going: it is spontaneous, often a component of gossip, and even pleasurable—always the mark of an evolved capacity. "That suit's an Armani? I don't believe it." "I can't tell if she dyes her hair, but it's gorgeous." "How can I take seriously a so-called professor who keeps saying 'ekcetera'?" "She shouldn't try to get rid of those crow's feet—they give her face character." "I wonder if that's a real tan?" "Terrific! It makes you look twenty years younger!" "Did you notice his elevator shoes?" "It was a nice meal, but she made it out of packaged food." "He actually only knows a few French phrases." "Sure, she's a doctor—of homeopathy."

Human obsessions with what is fake and what is genuine in skill, eloquence, beauty, and intelligence merge into another fitness indicator that we have already encountered high on the female list of mate-selection indicators and rather lower on the male list: wealth, along with its closely associated feature of social status. Women normally cannot help paying attention to how rich a man is—or how potentially rich, if he has not yet set out on a career—as well as his conscientiousness, social standing, and generosity. As a fitness indicator, wealth is open to dishonest signaling, and women are especially keen to distinguish honest wealth signals from faked or exaggerated ones. From the standpoint of sexual selection, whether that really is a Rolex watch or an authentic Princeton diploma is not trivial. Selective pressures in the Pleistocene seem to have combined with cultural expressions from the Holocene to put in place elaborate systems of resource-demonstration rules that are intuitively recognized by females—and ignored by males at their reproductive peril.

How does resource-demonstration work in courtship? Here is where the spontaneous, universal characteristics of an adaptation make themselves apparent. One of the best ways for the boy to prove he has

resources is to give the girl something that is both expensive and useless. Hence flowers: they wilt, and except to look pretty have no use. They can communicate "I love you," but more important is what they signal: "I have the resources to buy thoughtful and beautiful but completely useless things for you, my dearest. And please also enjoy these fine, expensive Belgian chocolates." Consider the alternative: if natural selection governed courtship, the boy would show up at the girl's apartment clutching, instead of flowers and chocolates, a lovely potato, or perhaps a couple of thick steaks, or, being even more inventive, a new ratchet wrench set for her. After all, natural selection favors practicality and efficiency. (The young couple would then go out to a serve-yourself, all-you-can-eat restaurant, since natural selection also favors economy.)

That we smile at this indicates how counterintuitive it is. The real world, operating according to the imperatives of sexual selection, works very differently. If the male is serious, he will take the female to a lavish, overpriced restaurant serving mere smidgens of food. He will order champagne and make sure she notices his large tip. (The all-you-can-eat cafeteria comes later: after they've married and have to feed the children.) With respect to proving access to resources and commitment, nothing beats the gift of a diamond, particularly as an engagement ring. Diamonds, since they are both expensive and useless, are indeed a girl's best friend. They prove one of two conclusions: either he has the resources he claims—money to waste on useless minerals—or, if he does not, he is so committed that he has gone into debt (or robbed a bank, which must also be attractive, since Mafia chieftains do find their gun molls). Any way a woman looks at it, the gift—not just the promise—of a diamond marks a significant step in a courtship situation. (The De Beers slogan, "A diamond is forever," is widely regarded as the most inspired single advertising statement of all time, and Darwinian theory explains why: it connects serious wealth display with the loving commitment women seek in establishing a household.)

V

Thorstein Veblen, the economist who a century ago coined the phrase "conspicuous consumption," argued that wealth display, including squan-

dering money on pointless possessions, was a major component of human cultures from the ancient world to the present. He also argued, more controversially, that high cost and waste are intrinsically mixed with our concepts of art and beauty. Veblen's central claims about people's responses to beauty are most forcefully (and cynically) expressed in the chapter entitled "Pecuniary Canons of Taste" in *The Theory of the Leisure Class* (1899). Here, in a move that foreshadows Arthur Danto's favorite argumentative strategy, he has us imagine two nearly identical artifacts: a pair of spoons, one of solid silver, appearing to be handmade, and costing perhaps twenty dollars (a lot of money in 1899), the other machine-made out of silvery base metal and costing twenty cents. As eating utensils, each is as serviceable as the other. We can also imagine, Veblen proposes, that as sheer visual objects (seen in terms of "intrinsic beauty of grain or color"), the spoons are identically attractive. Now suppose, Veblen says, we discover on careful inspection that the signs of having been wrought by hand are in the case of the silver spoon actually faked: the spoon, though made of silver, turns out to be a machine-made object that cleverly imitates the small irregularities of a handmade artifact. Immediately, he observes, its value will decline by as much as 90 percent. Moreover, even if the spoons were visually indiscernible and only the weight of the cheaper utensil gave it away, our sense of the overall beauty of the objects would still be affected by knowing that one was mass-produced, the other handmade.

With regard to the concept of beauty itself, Veblen is not entirely clear or consistent on what his analysis means. Sometimes he seems to be saying that costliness and beauty, while logically distinguishable concepts, are inevitably bundled together by human nature in our minds: when an observer realizes that what he thought was handmade silverware is actually something stamped out by a machine, the gratification he derives from "its contemplation as an object of beauty" is instantly diminished. But Veblen also says that our regard for something beautiful "is, commonly, in great measure a gratification of our sense of costliness masquerading under the name of beauty." This is a somewhat different idea: if the association of beauty and expensiveness is just a masquerade act, then we would be right to reject expensiveness as a regrettable— indeed, reprehensible—confusion that pollutes our sense of beauty. Most theorists of beauty from Kant through the twentieth century would heartily agree: to think that our response to a work of art should

depend on its market value is today regarded as gross vulgarity. However, if we are looking back not only through history but also to the prehistory of art and decoration, we might come closer to an understanding of uncomfortable facts that are bound to irritate this modern aesthetic sensibility. The very idea that costliness and art are intrinsically connected in our aesthetic psychology may be a disagreeable possibility, but if it turns out to be true, it is a fact that is better faced than buried.

Veblen's example of costliness in this case involves monetary value. Costliness in hunter-gatherer societies would have been measured not with money but in terms of time, resources, and the expenditure of labor. In sexual selection, these factors involve what Amotz and Avishag Zahavi have called in the realm of animal ethology a manifestation of the "handicap principle." According to this way of formulating sexual selection, an animal shows its genetic fitness to a mate by squandering resources that a less fit animal could not afford to waste: the endless singing of a mockingbird and the intense red of a healthy stickleback, not to mention the peacock's tail, are handicaps, proving, so to speak, that "I can take on the world with one hand tied behind my back." Extended to human behavior, the Zahavis' handicap principle throws into clear relief the conspicuous wastefulness described by Veblen. The best way for an individual to demonstrate the possession of an adaptive quality—money, health, imagination, strength, vigor—is to be seen wasting these very resources.

The Zahavis' way of describing sexual selection has been supported in economic terms by the anthropologist Eckart Voland, who contrasts the useful traits evolved by natural selection with the fitness signals of sexual selection: "For useful traits, their production costs are disadvantageous, but unavoidable. With signals [in sexual selection], however, the additional costs are what count. Contrary to long-held economic rationality, demand increases together with its price. Useful traits do not lose utility if their price falls. Signals, on the other hand, lose their function if their production becomes cheap." It follows that in the human realm, people will be ever on the lookout for ostentatious ways to squander wealth: building impractical mansions, driving pointlessly expensive cars, or carrying three-thousand-dollar handbags.

If we extend the various suggestions of Darwin and his followers into the realm of art, we can see ways in which costliness and waste impinge on beauty. I would summarize the implications as follows:

- Works of art will frequently be made of rare or expensive materials: silver and gold, clear jade, marble that is difficult to transport, jewels, fine hardwoods, unusual pigments, and rare dyes, such as the Tyrian purple of classical antiquity.

- Works of art should be very time-consuming to create. In that sense, they may demonstrate that the maker has leisure—conspicuous leisure—in a way that indirectly indicates that he possesses wealth or status.

- Even if a work of art is quickly executed, the skills to make it should have been time-consuming or difficult to acquire. (Admired skills are often manual, showing fine motor control or dexterity: "He'd painted every hair" or "She never missed a note.")

- The created work of art may be more impressive if it is remote from any possible use. Expensive and useful can be very pleasant, but expensive and useless might well be much better.

- A sense of waste, and therefore handicap, can be emphasized by channeling resources into work that is this fleeting: the perfect centerpiece for an expensive dinner party may be a poignantly lovely ice sculpture. Marble is fine, but ice can be even better from the standpoint of signal theory.

- In addition to time, works of art will have required special intellectual or creative effort to create. The sheer brains and energy needed to produce Picasso's or Wagner's oeuvre is bound, like the Pyramids, to impress us. (Speaking of handicaps, consider the awe inspired by Beethoven's deafness.)

Imagine with me for a moment that our world was just as it is today, except that the earth had a slightly different geology: diamonds were as common in my imaginary world as beach sand is in ours, while jade was as scarce as diamonds. In such a world, would diamonds—normally used as ship ballast or as in-fill for building foundations—be laboriously cut and employed in jewelry? This is unlikely: sexual selection theory would suggest that in such a world a "sublimely beautiful diamond tiara" would be an absurdity, something like a "sublimely beautiful plywood-and-sequin

tiara." If jade were so rare, however, we could well imagine that a tiara of jade inlay in gold might be regarded as exquisitely beautiful. Diamonds in our imagined world might be used in children's toys or reflective road signs, but they would never figure in magnificent jewelry. As it so happens in our real world, diamonds are both rare and capable of being used for dazzling jewelry. (This, incidentally, is in line with what little is known about the early history of bodily adornment. Kathryn Coe observes that some of the earliest known jewelry incorporates materials that were transported—perhaps in trade—over long distances.)

When Veblen says, "The marks of expensiveness come to be accepted as beautiful features of expensive articles," however, he is not only talking about costliness of materials: the sense of an object's cost, and therefore its beauty, is increased also by awareness of a slow, painstaking means of production. "Handmade" will therefore always be an honorific designation, superior to "machine-made" in the beauty stakes, irrespective of the fact that the industrial product may be smoother, more symmetrical, or error-free. Error-free machines are much less interesting to us than error-free hands. In trying to connect the concept of beauty with technical show, the anthropologist Alfred Gell recounts an early personal experience. As a child, he was deeply impressed by a two-foot-high matchstick model of Salisbury Cathedral. This was "a virtuoso example of the matchstick modeler's art . . . calculated to strike a profound chord in the heart of any eleven-year-old." The young Gell well understood the nature of the materials—glue and matchsticks—"and the idea of assembling these materials into such an impressive construction provoked feelings of the deepest awe." He says that from a "small boy's point of view it was the ultimate work of art, much more entrancing in fact than the cathedral itself." Many of us have experienced similar moments of awe as children and, yes, later on as adults. That it is regarded as unsophisticated to find beauty in such humble skill displays as matchstick construction shows how contemporary art-theoretical thinking has estranged us from deep sources of aesthetic satisfaction, including the admiration of craft.

There is an enchantment in objects meticulously crafted by the human hand, but at the same time we should not forget that in the nineteenth century, the Gilded Age when Veblen was writing, conspicuous waste in art included piling on pointless and to us today grotesque ornamentation:

think of the high-labor investments in decorating Victorian furniture with meticulous floral carvings, inane but complicated wood inlays, and the extensive use of gold, silver, and ivory detailing. That kind of ornamental excess today is largely out of fashion, but conspicuous waste is still an important factor in the art world—just like every evolved interest, whether we philosophically approve of it or not. It can take many forms. For instance, it is present in the postwar tendency toward the production of gigantic paintings that practically need to have new museum wings built around them. If the wall space taken up by the huge canvas in a museum is in an expensive area of a large city—instead of being in, say, a defunct linen factory in the provinces that has been turned into an art museum—so much the better. None of this denies that the painting might otherwise be a fine work of art; it is only to acknowledge that the work's size and the costs of display already proclaim its seriousness and beauty. If this application of Veblen's thinking and the handicap principle to recent art history is correct, we may expect that, just as many pieces of ornate Victorian furniture have ended up as white elephants in the eyes of later generations, too heavy and awkward even for junk shops, it may be that curators of the future will be left wondering how to dispose of those 1970s mega-canvases, such as the gigantic portraits by Chuck Close that take up so much space in New York's Metropolitan Museum.

Thorstein Veblen's view of modern social life encroaches on aesthetic theory in ways that the modernist sensibility is bound to find uncomfortable. Kant set the direction for modern art-theoretical thinking in explicitly wanting to expunge from "pure" aesthetic experience, as he called it, such degrading factors as "finery," mere ornamentation: "if the ornamentation does not itself enter into the composition of the beautiful form—if it is introduced like a gold frame merely to win approval for the picture by means of its charm—it is then called *finery* and takes away from the genuine beauty. "Kant even rejected as proper constituents of aesthetic form such values as color and emotion. His philosophical followers—through Clive Bell and Clement Greenberg up to the present—may not have gone that far, but they have continued to regard pure form as what counts in art and anything else as a mere cultural excrescence to be scraped off with the intellectual equivalent of a wire brush. Bell not only insisted that represented content was irrelevant to a proper aesthetic response to painting, he claimed that proper aesthetes

don't even see content: "You will notice that people who cannot feel pure aesthetic emotions remember pictures by their subjects; whereas people who can, as often as not, have no idea what the subject of a picture is. They have never noticed the representative element, and so when they discuss pictures they talk about the shapes of forms and the relations and quantities of colours."

Have you ever met anyone who, having seen a painting, could only remember blue rectangles, green mottled areas, and pinkish brown smudges but couldn't recall if they were cars or trees or people? Neither have I, but then Bell would just say that we move in the wrong circles. This loopy quotation—which describes people who "feel pure aesthetic emotions" as aphasics who might be entertainingly explained by Oliver Sacks—shows how far aesthetic formalism has been willing to go in trying to shame people out of admitting to such pleasures as enjoying the represented content of a work of art.

Rejecting modernism's tendency to scold naive taste, however, does not entail that we must champion the cause of popular values or embrace those aspects of the art world so cynically described by Veblen. Clive Bell knew painting much better than Veblen, and his wonderfully astute essays repay study by anyone who cares about art, even when their conclusions reduce to absurdity. While evolutionary psychology and prehistoric economics nicely explain why someone would stroll through a museum crassly remarking on how much the paintings are worth, they do not justify such behavior. We are still entitled to teach our children that although the money of the art market and the beauty of art works are connected, it is mainly the rare beauty of a Rembrandt portrait that causes it to be worth a lot of money, rather than its market price causing it to be beautiful—that understanding immediate visual beauty is the key. And that, yes, quite lovely jewelry can be made of materials more modest than gold and diamonds.

Still, if even to the smallest degree, rarity and expense add to beauty and cheapness detracts from it, it is important that we understand this psychological fact, rather than deny it or try to pretend it is merely social. The familiar Müller-Lyer illusion is worth recalling in this respect. The two lines—one with arrow points at the ends, the other with the arrows opening out from the ends of the line—look to be of different lengths even though they are exactly equal. A fascinating aspect of this

illusion is that even after it is explained and fully understood, *one line still looks longer than the other.* The "angles out" configuration corresponds to the line being farther away, and our three-dimensional vision therefore insists on telling us that the line must be longer: our cognitive system evolved to make this jump in visual reasoning, and it will not be denied. In the same way, we might be aware of how rarity or cost plays into our pleasurable response to the specialness of a necklace or a painting, and still be unable to ignore this component of experience, even if we believe it to be rationally unjustified. The point is to know why such deep feelings persistently appear in aesthetic life, without either grimly suppressing or blithely accepting them.

Veblen's economic and aesthetic insights have been regarded by many commentators over the last century as being essentially about capitalism and the distortions it imposes on human life. This is wrong. His examples are drawn as much from early European history and tribal ethnography, such as the Kwakiutl potlatch, as they are from the hypercapitalism of the Gilded Age. His chapter on aesthetics contains admiring references to Hawaiian feather cloaks and the elaborately carved handles for Polynesian adzes, both of which he adduces to support his case that uselessness is connected to beauty. Veblen wrote not about local or historically unique situations but about the general human condition as he understood it. He put much research into analyzing cultural constructions, but his target is the human nature that underpins them: persistent innate tendencies that are spontaneously manifest in widely separated cultures and historical epochs.

Seen in this light, however, there is no reason to accept that we are doomed forever to respond to art in terms of costliness, conspicuous waste, or its bearing on social status. Pleistocene landscape preferences are just as innate but need not control our tastes in landscape painting or even our choice of a calendar. Once we understand and know an impulse, we can choose to go along with it or we can resist it. There are elements in the art world as described by Veblen—for instance, the intimate association of art with money—that ought to disturb us. But better we should know this devil than deny it or pretend it is but a product of capitalism.

In the same way, there is no reason to deny the sense of wonder we derive from a demonstration of special skill or painstaking labor, whether

occasioned by a cathedral built of matchsticks, a soprano's high E-flat, or a photorealist painting of a bowl of ice cream. Our innate aesthetic tastes have many constituents, including not only awe at skill displays but intrinsic connections with wealth and therefore with social status. Like our innate moral sentiments, these tastes ought to be open to endless rational reconsideration and judgment. Kant had it right: the experience of art is a practice of contemplation—in it, we need not be slave to our innate proclivities, our passions. Even in free play, our intellect counts.

VI

In a curious but oft-quoted utterance, Wittgenstein said, "The human body is the best picture of the human soul." Unless this is intended as some kind of gnomic defense of psychological behaviorism, it's certainly wrong. The best picture we can have of the human soul is gained by listening to what a person says and how he says it. Language—the human voice, and writing—is not only a communication medium ("Looks like rain today"; "There's game over the next hill") but is an expressive and creative instrument, revealing the peculiar insights, individual interests, humor, and special talents of an individual. As a form of cognitive foreplay in courtship, language can give us, in Geoffrey Miller's words, "a panoramic view of someone's personality, plans, hopes, fears, and ideals." If Darwin himself was right in his own speculation about the origins of language, foreplay of a sort is indeed where it began: as a means for first arresting the interest of members of the opposite sex and then demonstrating something to them. On this speculation, ordinary descriptive communication would have come later. Language originated in grabbing attention and expressing something compelling. Miller argues that this aspect of language, verbal courtship, spreads throughout cultures and has come to be associated with many social skills and capacities: "Language puts minds on public display, where sexual choice could see them clearly for the first time in evolutionary history."

But what began in the courtship context seeped into areas of human life far removed from sex. Art in the most general sense is also an extension of this capacity into imaginative realms of storytelling, picture-making, crafting artifacts, music, poetic language, joke-telling, dance,

and ordinary banter. Art is not the only extension of displays of human skill and expressiveness: areas as diverse as politics, sports, and science have all taken human expressive intelligence in radically different directions.

Explaining these developments by connecting them with sexual selection and the rise of language does not make them at root "all the same," or all about sex. This was one of Freud's many errors. He sensed, as many of us do intuitively, that at some deep level much art is somehow connected with sex. He thought it could be found in his libidinal drives, in which surplus energy is the source of sexual display or, even more improbably, in those Freudian systems of symbolism in which everything convex stands for some tumescent body part. Many "letting off steam" theories of art make the same kind of error: they fail to see that running around the block is a better way of letting off energy than composing a string quartet. What sexual selection in evolution does is give us an explanation of why so much human energy has been exhausted on objects of the most extreme elegance and complexity—not just the massive symmetry of the Pyramids, but the poignancy of Shakespeare's sonnets or the Schubert Quintet in C.

Sexual selection explains the will of human beings to charm and interest each other. At the same time, it explains why we can regard each other now and again as so charming and interesting. We find beautiful artifacts—carvings, poems, stories, arias—captivating because at a profound level we sense that they take us into the minds that made them. This sense of communion, even of intimacy, with other personalities may be erroneous—even systematically delusional—but the self-domestication of sexual selection was not about truth; it was about living the richer sociality that would carry on the human species and allow it to flourish. That too defines success, for the survival not just of the physically strongest but of the cleverest, wittiest, and wisest. If along the way this amazing process has given us Lascaux, Homer, Cervantes, Chopin, Tolstoy, Stravinsky, and *The Simpsons*, as well as minds to appreciate and take pleasure in them, then so much the better.

CHAPTER 8

Intention, Forgery, Dada: Three Aesthetic Problems

I

Much of the appeal of Darwin's theory of evolution—and the horror of it, for some theists—is that it expunges from biology the concept of purpose, thereby converting biology into a mechanistic science. In this respect, the author of *On the Origin of Species* may be said to be the combined Copernicus, Galileo, and Kepler of biology. Just as these astronomers gave us a view of the heavens in which no angels were required to propel the planets in their orbs and the earth was no longer the center of the celestial system, so Darwin showed that no God was needed to design the spider's intricate web and that man is in truth but another animal. Had Darwin ceased his research and theoretical speculation with the publication of the *Origin of Species*, he would still be honored as the greatest biologist of history. But he went on to extend his thinking into the evolution of the mental life of animals, including the human species, work that culminated in *The Descent of Man*. I have explained Darwin's account as a claim that the human race domesticated not only dogs and alpacas, roses and cabbages, through selective breeding, but that it also domesticated itself through the long process of mate selection.

Describing sexual selection as human self-domestication should not seem all that strange. Every direct prehistoric ancestor of every person alive today at times faced critical survival choices: whether to run or hold ground against a predator, which road to take toward a green valley,

whether to slake an intense thirst by drinking from some brackish pool. These choices were frequently instantaneous and intuitive, and, needless to say, our direct ancestors were the ones with the better intuitions. But there was another crucial intuitive choice often faced by our ancestors: whether to choose this man or woman as a mate with whom to rear children and share a life of mutual support. It is inconceivable that decisions of such emotional intimacy and magnitude were not made with an eye toward the character of the prospective mate, and that these decisions did not therefore deeply affect the evolution of the human personality—with its tastes, values, and interests—in the broadest sense. Our ancestors, male and female, were the ones who were chosen by each other.

Sexual selection theory as developed in *The Descent of Man* has disquieted and irritated many otherwise sympathetic evolutionary theorists because, I suspect, it allows purposes and intentions back into evolution through an unlocked side door. The slogan memorized by generations of students of natural selection is *random mutation and selective retention*. The "retention" here is strictly nonteleological, a matter of brute physical survival. The retention process of sexual selection with human beings is, however, in large measure purposive and intentional. In this context, puzzling about whether peahens have purposes in their mating choices is an unnecessary distraction: other animals aside, it is absolutely clear that with the human race, sexual selection describes a revived evolutionary teleology—the reintroduction of intentional, intelligent design into the evolutionary process. The designer, however, is not a deity but human individuals themselves. Though it is directed toward other human beings, it is as purposive as the domestication of those wolf descendants that became familiar household pets. Every Pleistocene man who chose to bed, protect, and provision a woman because she struck him as, say, witty and healthy, and because her eyes lit up in the presence of children, along with every woman who chose a man because of his extraordinary hunting skills, delightful sense of humor, and generosity, was making a rational, intentional choice that in the end built much of the human personality as we now know it. Natural selection aside, it is an evolutionary fact that available individuals who were less witty and intelligent, had poorer hunting skills, were indifferent to children, or were less generous in the right situations stood poorer chances of attracting a

mate. This Darwinian process of self-domestication introduces a place for consciousness and purpose that is absent in principle from natural selection. To that extent, *Homo sapiens* is a self-designed species.

Human evolution is therefore structured across a continuum. At one end are purely natural selective processes that give us, for instance, our internal organs and the autonomic processes that regulate our bodies. At the other end are rational decisions—intentional, and yet adaptive and species-altering if they include a bias, however tiny, in favor of repro-duction over tens of thousands of generations in prehistoric epochs. It is at this end of the continuum, where rational choice and innate intu-itions can overlap and reinforce one another, that we find important adaptations that are relevant to understanding the human personality, including the innate value systems implicit in morality, sociality, politics, religion, and the arts. Decisions made by women and men over hun-dreds of millennia have honed the human virtues as we now understand them: the admiration of altruism, skill, strength, intelligence, industri-ousness, courage, imagination, eloquence, diligence, kindness, and so forth. Not all of these evolved human excellences (they run roughly par-allel to the list of universal mating criteria) are implicated in a general understanding of art and beauty. But some of the virtues clearly are, and connecting them with natural selection and sexual selection gives us a powerful means not only to talk about the origins and universal charac-ter of the arts worldwide but also to throw light on issues and paradoxes that have bedeviled theoretical aesthetics since the Greeks.

The philosophy of art as an academic discipline has long thrived on paradoxes and the insights that come from taking them to pieces. Its normal procedural mode is, like many other branches of philosophy, to analyze conflicting ideas and either to show how one or the other side is correct, or to demonstrate how a new understanding of a paradox can make it evaporate. Aristotle invented aesthetics as the logical analysis of the arts, and Kant perfected the genre by treating art and beauty as a self-subsistent realm with an integrated rational structure. In this spirit, contemporary philosophers of art have been given to publishing books and articles with titles like "The Logic of Criticism," "The Concept of Art," or "The Structure of Aesthetics." If we look at much of this work, however, we find that the paradoxes on which aesthetics as a discipline depends—the conflicts that generate incisive analysis instead of bland

description—are manifestations of varied and conflicting feelings about art that lie deep in the psyche. The logical analysis requirement that is part of the standard job description for philosophers is unable, as it turns out, to explain where these competing feelings and intuitions come from. For this level of explanation, we need to turn to evolution.

Three of the hottest continuing topics in aesthetic theory are (1) the role of artists' intentions in understanding art, (2) the aesthetic implications of forgery and authenticity, and (3) the aesthetic status of Dadaist works such as Duchamp's *Fountain*. My purpose in what follows is to explain how arguments about these issues erupt from deeply held but conflicting intuitions that we all share about the nature and value of art. Evolution, I will demonstrate, is the key to understanding why these issues are so contentious in the first place.

II

Outside academia's cloistered halls, most people would be surprised that the idea of artistic intention should be controversial at all. What could be more reasonable than the notion that authors and artists have purposes and intentions in producing their works and that understanding these is decisive in understanding their art? Common sense tends to take it for granted that the artist is to some degree a communicator and that whatever meaning the artist's work possesses—though not its quality—is largely determined by the artist. Artists tend to agree: how many painters or novelists have responded to bad reviews with the bitter complaint, "The critic didn't understand what I was trying to do"?

According to this view, the work of art is a bridge to the mind of the artist, a public object that may unlock the secrets of the artist's inner life. And since the artist may be a woman or man of special gifts and insights, those secrets will be well worth knowing. To get the most from a work of art, we will want to understand it "properly," in terms of what its creator intended.

This complex of ideas, known as "intentionalism," came under a decisive attack in the middle of the last century by the critic William Wimsatt and philosopher Monroe C. Beardsley in a famous 1946 paper, "The Intentional Fallacy." They argued that "the design or intention of

the author is neither available nor desirable as a standard for judging the success of a work of literary art," or indeed any art. Authors' intentions are not available in the sense that we can never be sure what is in another person's mind across the breakfast table, let alone when that person is an author who might have lived hundreds or thousands of years ago. Intentions are not desirable in the sense that the meaning of a work of literature will always be larger, more saturated with coherent and contradictory meanings, than any artistic intention could account for.

In *The Possibility of Criticism*, Beardsley went on to put forward three principal arguments against the idea that the meaning of a specifically literary text must be the meaning that it had to its author. First: we can understand texts that have meaning independent of an author's intention; this is shown by the fact that computer-generated texts are meaningful, and that texts with significant (sometimes hilarious) typographical errors are meaningful. These texts have meaning, but, as he puts it, "nothing was meant by anyone." In the second place, the meaning of a text can change after the author has died (or, by implication, we may suppose, an hour after he wrote it). Beardsley observes, "And if today's textual meaning [of a line of poetry] cannot be identified with any authorial meaning, it follows that textual meanings are not the same thing as authorial meanings." Finally, Beardsley argues that because a text can have meanings an author was not aware of, it again follows that textual meanings are not identical with authorial meanings.

Wimsatt and Beardsley's dismissal of intention as a standard for interpretation was in support of the New Criticism, the modern movement in critical theory that came to dominate Anglo-American scholarship of their generation. But by the 1960s the attack on artistic intention was coming from a different direction and was taking a different, more politicized form in France. Roland Barthes announced "the death of the author," and Michel Foucault called for abandoning the "author-function" in criticism. The French critique of intentionalism treated literature as texts produced by ideological systems which were in control of the writer and any intentions he might have. This opened the door to interpretations in which the forces identified by Freudian psychology or, say, historical materialism accounted not only for the nature of the text but for its reception in culture. Libidinal forces, culture, economic determinants: the meanings of texts were controlled by anything but the indi-

vidual mind of the author. Jacques Derrida's famous formulation was somewhat different: there is nothing outside the text, he said, except more texts, of course. From every direction, these ideas, pushed with Gallic bravado, were seen as freeing criticism from the dead hand of the author. Barthes said, "It is language which speaks, not the author," an interest in whom is "the epitome and culmination of capitalist ideology." Writing must therefore be regarded as the "destruction of every voice, of every point of origin." The removal of the repressive author liberates criticism, making it a kind of free play, even placing the critic in the controlling position as creator of literary meaning.

But while anti-intentionalist arguments have preoccupied academics for the last half century, intentionalism itself has stubbornly persisted in most thinking about art and literature. This is because the intentionalist position is backed by powerful arguments. One of these involves how we assign works of art to categories. Consider as an example ethnographic work on Hopi pottery undertaken in the 1920s by the anthropologist Ruth Bunzel. In her well-known study of Pueblo pottery decoration, she came to notice that although Hopi potters (all women) condemned copying and were convinced that their work was in fact original and creative, close inspection revealed that their designs were very similar, exhibiting only tiny variations. Bunzel's interpretation of what she saw forced her to conclude that Hopi potters suffer from some kind of general delusion about their originality. She reported that when this "sterility of imagination" was brought to their attention, they failed to see their plagiarism. Bunzel regarded this as a "very simple and rather amusing" failure to align their ideals of creativity with their actual practices of rote copying.

Has Bunzel given us an adequate account? Perhaps not. Bunzel left New York and traveled to Arizona to study Hopi pottery. Suppose a Hopi anthropologist were to leave Arizona for New York to study the art of piano playing as carried on by some of the more famous exponents. He goes to Carnegie Hall one night and hears Leif Andsnes play a Schubert sonata; the next night he returns to hear Hélène Grimaud, who as luck would have it happens to be performing the very same Schubert work. As he walks out of the hall, our Hopi social scientist exclaims that despite the enormous claims that are made for the artistic originality of Grimaud, it is clear that she merely "copied," with "only tiny variations," Andsnes's piano playing of the night before.

Ruth Bunzel misunderstood Hopi pottery decoration practices in a way that is very close to our fictional Hopi anthropologist. In the artistic genre she describes, inventing entirely new designs is simply not what counts as "being original" in painting pots; rather, what matters is the inventive use of designs and motifs already in an established decorative repertoire. In this sense, painting a Hopi pot may be more like performing from a score than it is like composing a new work.

The essential problem is that Bunzel has assigned pot decoration to the wrong category of activity. This is a mistake that can only be rectified by a direct understanding of artists' intentions. Anthropological examples like this one are useful because in ethnographic contexts we are less tempted to evaluate work in terms of ready-made, familiar conventions that we use in, say, evaluating nineteenth-century novels. In cross-cultural situations, we are forced to ask directly, *What are these people up to?* Having grasped that, we can move on to judge the work.

Irony is an area where artistic intentions are crucial to aesthetic understanding, and the problems it creates are not just relevant to literature but occur across all the arts. Consider Richard Strauss's only work for piano and orchestra, his *Berleske* of 1885. The innocent listener who supposes the piece to be a straightforward attempt to compose a one-movement piano concerto will no doubt find it attractive and rewarding. But the meaning of Strauss's mad double-octave passages, which evaporate at the top of the keyboard (rather than leading into big cadences), or the long runs that go nowhere, will elude such a listener. In this instance the composer has helpfully provided a title that gives a hint that the work is intended in part as a send-up of the Romantic virtuoso piano concerto. But authors are not always so helpful; and in any event, whether they are is immaterial so far as the purely conceptual question is concerned.

Literary irony makes ridiculous Barthes's grand claim that writing is the "destruction of every voice." The very possibility of irony—of understanding it or of getting it wrong—shows that artistic creation inescapably involves a specific human voice: the voice of an author. Naturally, skillful ironists may supply their readers with few conventional clues of ironic intent, and to that extent may seem to be letting their texts "speak for themselves." The ironist unsure of his audience's sophistication, on the other hand, may be required to lace his text with obvious cues indi-

cating how they are to be taken (one thinks of Jonathan Swift, but also Art Buchwald).

The anti-intentionalist may still insist that it is the business of criticism to provide an interpretation under which the work, intentions aside, is seen as the richest, the most rewarding, the most profound. The philosopher Laurent Stern has claimed that if we agree that a text is a work of art, "then among two competing interpretations that may equally fit the text, the one which assigns greater value and significance to the text will be preferred." Stern is attempting to discredit the idea that ironic works are decisive in proving the need for author's intentions in textual interpretation. Thus he tells us that Daniel Defoe's "Shortest Way with the Dissenters" admits of two interpretations, literal and ironic, but it is a far better work understood as a piece of irony, even without any external evidence. Similarly, he recommends reading Jonathan Swift's "Modest Proposal" as ironic because it would be difficult to understand at all if taken literally.

These examples support Stern's argument: they are fine works, and much better seen as what they are, as ironic. But turn things around for a moment and consider bad art, works like Richard Bach's *Jonathan Livingston Seagull*. There is no doubt that Bach intended this little book (think of it as a very long greeting card) to be a serious work of literature with important messages for the human spirit. But it arguably would have had greater value and significance had he meant it as a lampoon, a send-up of inspirational literature: then one could genuinely laugh with it, instead of at it. Yet even if it is seen in the best light when taken as ironic, we cannot do so if we have sufficient evidence that Bach did not intend it to be so taken. To do so would be to endow the work with an illusory significance and value.

It is not up to interpreters arbitrarily to impose conventions in order to produce an interpretation that puts the work in the best possible light: this stretches charity beyond the limit. To describe such literary notables as William McGonagall ("the World's Worst Poet") and Julia A. Moore (more affectionately known as "the Sweet Singer of Michigan"), the Canadian humorist Stephen Leacock coined the term "supercomic." Ogden Nash and Edward Lear are comic poets. To be supercomic, a poet must write stunningly bad verse and do so with great earnestness. It is a category that depends for its very existence on an author's having

intentions of a certain sort, specifically not ironic. As it is, there are no conventions at all peculiar to supercomic verse: seriousness of purpose and sublime ineptitude are its only requirements.

Finally, there remains on the pro-intentionalist side one more area of relevance for authorial intention: anachronism. In his defense of "the authority of the text," Beardsley cites some lines written in the eighteenth century: "Yet, by immense benignity inclin'd / To spread about him that primeval joy / Which fill'd himself, he rais'd his plastic arm." "Plastic" has not completely lost the meaning it had for the poet, Mark Akenside, in 1744, but it has gained an additional meaning since then. "Consequently," Beardsley says, "the line in which it occurs has . . . acquired a new meaning . . . Of course, we can inquire into both meanings, if we will; but these are two distinct inquiries."

Yet how many readers would have any interest in an interpretation of the poem that took "plastic" in this case to refer to that polymer material that came into general use only in the twentieth century? It is not that such an anachronistic interpretation is out of line with Akenside's intentions so much as that it cannot accord with any possible intention he might have had. Whimsy might occasionally enable an amusing or illuminating remark about Akenside's use of "plastic" in relation to the modern sense of the word as "polymer," but simply and ignorantly to read his "plastic" as our "polymer" doesn't go.

The "intentional fallacy" and the "death of the author" have been a main intellectual dish at many a feast for philosophers, critics, and literary theorists for fifty years. Not just conferences and anthologies but whole research careers have been fashioned around teasing out the implications of arguments for and against appeals to intention. From an evolutionary psychological standpoint, however, all the disputation seems overwrought. As with other areas in aesthetics, theorists who write about these problems pit against each other conflicting intuitions about storytelling, audiences, and authorship. From an evolutionary perspective, it is these basic intuitions that have to be explained.

Paradoxes of authorship begin with the uneasy coexistence of three distinct functions for language in human social life. These functions are deep, are doubtless prehistoric, and appear spontaneously in human language-using experience. Identifying these three functions can demon-

strate why aesthetic theory finds itself locked in perpetual arguments about the status and importance of authorial intention.

1. *The communicative/descriptive function.* Asked why we have language at all, most people will jump first to this reason. We tend to regard language seen as a tool for ordinary descriptions of the world and personal communication: "Looks like rain tomorrow," "Pomegranates have doubled in price," "Don't forget to bring home bread," "Madison was a great president," "I'm in love with Eloise." Descriptions of the world—including speakers' descriptions of themselves, their speculations, exhortations, and value judgments—are in such usages normally intended to be taken by hearers as true; this is how communication about matters of fact works. We call narratives in this mode nonfiction. This is language used in history, science, gossip, and daily communication, from "God made the world in six days" to "A ten-gallon hat only holds three quarts" to "Please pass the Tabasco sauce."

2. *The imaginary function.* This is language as a creative medium for telling fictional tales, including expressive stories composed in stylized forms such as poetry. "Decoupling" is the term used by Tooby and Cosmides to describe this function. As I have already indicated in chapter 6, children at a very young age spontaneously grasp in their play the differences between descriptive uses of language for the real world and decoupled uses in a make-believe or storytelling world. The distinction between descriptive and decoupled uses of language is universally understood, even when the status of any narrative is disputed. The *Iliad* was once regarded as a true history. Now it is viewed as "just a story," and people argue about whether the Old Testament is history. But the ability to distinguish reality from make-believe has not changed. Cues indicating fictional intent are sometimes needed for clear understanding and are instantly processed. We know we are about to hear a fiction when a speaker begins, "Once upon a time . . ." or "A priest and a rabbi walk into a bar . . ."

3. *The fitness indicator function.* Whereas the first two functions often exclude each other, this third function of language coexists

with both. It is language use as a show of skill, style, and intelligence. We admire clarity, accuracy, and relevance in realistic, descriptive uses of language and regard these qualities as showing that a speaker possesses desirable intellectual qualities. Fictional creations—stories, jokes, and ornamented speech, such as poetry—are similarly judged. Behind every act of speaking, descriptive or artistic, looms the idea of a fitness test. Human beings are continuously judging their fellows in terms of the cleverness or banality of their language use. Skillful employment of a large vocabulary, complicated grammatical constructions, wit, surprise, stylishness, coherence, and lucidity all have bearing on how we assess other human beings. Intentionally artistic uses of language are particularly liable to assessment in terms of what they reveal about the character of a speaker or writer.

Every speech act has the potential for all three of these functions to be present, overlapping in different ways. *Pride and Prejudice* is a fiction, but that does not mean that it cannot represent realistic elements. It tells about how lives were lived in Regency England, including descriptions of physical conditions, housing, diet, class relations, and so on. We will find in it also a variety of moral and factual views expressed by characters in the novel; these represent the kinds of views—foolish or wise, informed or ignorant—one would have been likely to hear in the day. Unless authors write in genres allowing nonrealistic elements (such as the gothic novel or science fiction), they will be judged by their authenticity—or lack of it, as when, for instance, a movie that takes place in the 1940s has a character talking anachronistically about his "lifestyle."

But whatever their factual accuracies or unintended gaffes, fictional performances are untethered from practical, descriptive communication. Like every other story, *Pride and Prejudice* is play, make-believe for grown-ups. The notion of Kantian disinterestedness, contemplation of the aesthetic object, is a philosopher's abstract way of describing the deep and spontaneous human capacity to disengage the worlds of storytellers from ordinary communicative and descriptive acts. At its heart, the general doctrine of aesthetic autonomy, so much debated by theorists since the eighteenth century, is about how to deal intellectually

with this innate human capacity for decoupling, for purely imaginative experience.

Implicated in this whole sphere, however, we find the third function, already identified as a product of sexual selection. Speech performances, especially artistic speech performances, are Darwinian fitness indicators: ways of judging the wit, originality, or general cleverness of a person. This does not mean that anyone normally picks up *Pride and Prejudice* to learn about Jane Austen's health, mental or physical, at the time she wrote the novel. It does mean that it is impossible for any sophisticated, informed speaker of English to read her novel without feeling twinges of admiration for her extraordinary skill and style. Our intense interest in artistic skill, as well as the pleasure that it gives us, will not be denied: it is an extension of innate, spontaneous Pleistocene values, feelings, and attitudes. History and culture give us the artistic forms (epics, novels, paintings, poems) in which we evaluate skill and virtuosity, but our admiration of skill and virtuosity itself is an adaptation derived from sexual selection off the back of natural selection.

The conflict between the function of communicative speech and decoupled imaginative speech is the source of the intentional (so-called) fallacy. In one way or another, this basic distinction—factual versus fictional speech acts—is widely recognized by theorists. What is not appreciated is the way the fitness indicator function impinges on the relation between a work of literary art and its audience. In factual communication, truth matters. In fiction it does not, except normally to provide an accurate or deft backdrop for a story. But the third, fitness indicator function is an ever-present voice whispering to us that one kind of truth always matters: the truth about the sobriety, knowledge, intelligence, seriousness, or competence of the fact-teller or the fiction-maker.

This is a truth we are unable to ignore. It is fitness evaluation that therefore makes it impossible to take bad poetry and transform it into good poetry by willy-nilly claiming that the author meant a bad poem ironically. While it is generally a good policy in criticism to find the interpretation under which a literary work is seen in the best light, critics still have to invoke some notion of a real author. Readers can see meanings in literature that authors themselves may not have realized were there, and it is fair to ascribe these to a larger coherent intention of an

author rather than to regard them as mere accidents. But where the evidence for an interpretation involves imputing to a work meanings an author could not possibly have entertained (such as Akenside's "plastic" meaning "polymer") or where the ascription of irony simply takes merely incompetent work and transforms it into witty and intelligent art—in these cases our awareness of the fitness function requires that we draw a line. In such situations, a correct assessment of the talent of the creators will mean more than an illusory "getting more pleasure" from the work. Seeking authorial intentions is therefore no fallacy: it is from an evolutionary standpoint psychologically impossible to ignore the potential skill, craft, talent, or genius revealed in speech and writing. This in turn cannot be achieved without having some idea of authorial intention.

The fitness function of writing explains, incidentally, why "postulated author" or "implied author" theories of literary intention are bound to fail. Alexander Nehamas, for example, allows that texts must be understood as the products of human agents, but then takes back what he seems to have granted when he says that "just as the author is not identical with a text's fictional narrator, so he is also distinct from its historical writer. The author is postulated as the agent whose actions account for the text's features; he is a character, a hypothesis which is accepted provisionally, guides interpretation, and is in turn modified in its light. The author, unlike the writer, is not a text's efficient cause but, so to speak, its formal cause, manifested in though not identical with it." In this view, the intentional fallacy is solved by making the author yet another character for our imaginative delectation.

Unfortunately, postulated-author theory is far too clever for literary reality: the fitness function must in the nature of things pull us back to assessing the capacities of a historical writer. For example, I suppose it is fair to say that I idolize Anton Chekhov, author of some of the most poignant and profound plays of dramatic history. My idolatry, however, is not directed to a formal cause within Chekhov's texts, whatever that might mean, or to some kind of "provisional hypothesis" I accept. No, as evolution demands, my feelings are about a certain doctor who died tragically young, a man whose bones now lie in Novodevichy Cemetery in Moscow. His genius, not the genius of another postulated figure, animates those plays. There is no getting around the fact that historical works of art are created by historical people. Whatever the intellectual

peculiarities this fact creates for theory, as readers and critics of real works of art we are continuously captivated by the talents of the real people who make them.

III

Han van Meegeren

In 1937, the Boymans Museum in Rotterdam unveiled what it regarded as one of the most spectacular art finds of the twentieth century: *Christ and the Disciples at Emmaus*, an early work by Johannes Vermeer. This discovery stunned connoisseurs and the ordinary public alike. The painting had recently come to light when it was put on the market, apparently by an impoverished Italian family that had owned it for generations. Professor Abraham Bredius, reigning historian of Dutch painting, was deeply moved by the rediscovery, suggesting that the painting was perhaps Vermeer's greatest work. While its large size and religious theme made it unusual for the Delft artist, it was, Bredius insisted, "every inch a Vermeer." Bredius wrote of the "splendid luminous effect" of the painting's colors, which he called "magnificent—and characteristic: Christ in a splendid blue; the disciple on the left whose face is barely visible a fine grey; the other disciple on the left in yellow—the yellow of the famous Vermeer at Dresden, but subdued so that it remains in perfect harmony with the other colors." Bredius also praised the sense of human expression in the work: "In no other picture by the great Master of Delft do we find such sentiment, such a profound understanding of the Bible story—a sentiment so nobly human expressed through the medium of the highest art."

In its first weeks on exhibit, the new Vermeer attracted crowds to the Boymans Museum. Among them could be found a thin gentleman who seemed to enjoy challenging visitors who reacted to the painting with gasps of admiration. "I can't believe they paid half a million guilders for this," he would say, "it's obviously a fake." The indignation his comments provoked must have given the man, Han van Meegeren, a thrill. For he was the very forger who the year before had scraped pigments off an old canvas, perfected seventeenth-century paint formulas, and created *Christ and the Disciples at Emmaus*. Van Meegeren went on over the next few

years to produce a dozen or so more fake Vermeers that sold for immense prices to museums and private collectors. It was only a few days after the Second World War that he was finally arrested: not for forgery, but for having sold a Dutch national treasure to the enemy, since one of his Vermeers had ended up in the personal collection of Reichsmarschall Hermann Göring.

Van Meegeren confessed, and his forgeries were consigned to basement storage. But why? Here is the basic problem of forgery in the arts: if an aesthetic object has been widely admired, has given delight to thousands of art lovers, and is then revealed to be a forgery or a copy, why reject it? The discovery that it is a fake does not alter the perceived qualities of the work: the colors of the *Emmaus* should have been just as "magnificent" and "luminous" after van Meegeren's confession as before. An object's status as original or forged is extraneous information, incidental to its intrinsic aesthetic properties. It follows that the individual who pays an enormous sum for an original but who would have no interest in a reproduction that he could not tell from the original (a Picasso pen-and-ink drawing, for instance) or, worse, who chooses an aesthetically inferior original over an excellent and superior forgery (or copy), is confused or, as Arthur Koestler once suggested, a snob. If you can't see a difference between two aesthetic objects, so this line of argument goes, there can be no aesthetic difference between them.

The problem of forgery has provoked some ingenious responses by philosophers. Nelson Goodman, for example, called into question the whole idea of basing an argument on there being no discernible difference between an original and a copy or forgery. His question is, "Discernible to whom?" Differences between the *Mona Lisa* and a so-called exact copy of it may be indiscernible to an amateur but obvious to a professional curator. Even if the curator cannot tell the difference between the original and the copy, that does not prove that noticeable differences will never emerge and, later on, appear glaring not only to the curator but to more innocent eyes as well. The most careful inspection of a work of art—original or forged—cannot rule out that future inspections will reveal something important we don't notice today. Goodman's idea is that aesthetic perception, in becoming more informed by artistic knowledge over time, can sharpen and mature.

Goodman's response is to some extent backed up by the van Meegeren episode. Even at the unveiling of the *Emmaus*, there was skepticism about its authenticity. The local agent for the New York dealer Joseph Duveen saw the painting and quietly wired back to his employer that it was a "rotten fake." It may be that, among other things, Duveen's agent had noticed a feature that became more widely remarked after van Meegeren's confession: there is a photographic quality to the faces that looks less like seventeenth-century portraiture than like black-and-white movie stills; one of the faces, in fact, displays a striking resemblance to Greta Garbo. On the one hand, this "modern" feel of the painting almost certainly gave it a subtle appeal to its initial audience. On the other hand, the very same quality reveals to our eyes the painting's dated origin, as much as any 1930s movie betrays its origins with its hairstyles, makeup, gestures, and language.

Goodman pointed out another general characteristic of forgery episodes relevant to the van Meegeren case. Any supposed new discovery of a work by an old artist will be assessed and authenticated in part by the extent to which its features conform to the artist's known oeuvre. But once incorporated into the artist's oeuvre, a new work—maybe a forgery—becomes part of that oeuvre, or what Goodman calls the "precedent class" of works against which further new discoveries will be assessed. In the case of van Meegeren, the *Emmaus* was stylistically the closest of all his forgeries to the precedent class of authentic Vermeers. Once it was authenticated by Bredius and hung on the wall of the Boymans Museum, its stylistic features—e.g., heavy, drooping eyes with walnut-shell lids—became an accepted aspect of the Vermeer style. Van Meegeren's next forgery could therefore move farther from the original precedent class of Vermeers. As van Meegeren continued to forge, the "Vermeer style" became more and more disfigured—to the point where his last fakes, including the one Göring came to own, looked more like mediocre German Expressionist paintings than anything the seventeenth century, let alone Vermeer, ever produced. (Van Meegeren was also aided by the fact that most of his activity was carried out during the Second World War, with actual Vermeers in protective storage and unavailable for direct comparison.) In the end, all of his forgeries were enough alike to each other, and different stylistically from authentic Vermeers, that it

is certain their status would eventually have been revealed even without van Meegeren's confession.

Eric Hebborn

It is so easy for anyone to spot van Meegeren fakes that it can leave a false impression that forgery is not a serious problem for art history and connoisseurship. Eric Hebborn was a far more brilliant faker than Han van Meegeren, and some of the damage he did to art history will likely never be undone. Hebborn was born into a cockney family in 1934. While still a student, he went to work for a London picture restorer named George Aczel. Restoration, it developed, meant much more than cleaning and retouching, and soon Hebborn was repainting large areas of old works, cleverly "improving" them. An insignificant landscape became, with the addition of a balloon in its gray sky, an important (and expensive) painting recording the early history of aviation. As Hebborn wrote, "A cat added to the foreground guaranteed the sale of the dullest landscape . . . Popular signatures came and unpopular signatures went . . . Poppies bloomed in dun-colored fields." Such "improved" pictures went straight into gold frames and the plush surroundings of a dealer gallery where sales often netted Aczel a 500 percent profit.

Before long Hebborn realized that there is little need to begin with an old painting: talent along with old inks and paper was enough, and talent was something Hebborn had in abundance. He began to produce works that showed up in the collections of the British Museum, the Pierpont Morgan Library in New York, the National Gallery in Washington, and innumerable private collections. These were not trifles but mainly Old Master drawings authenticated by noted art historians, such as Sir Anthony Blunt, and sold through Christie's, Sotheby's, and especially the respected London dealer Colnaghi.

By the time his career as forger concluded, Hebborn had produced by his own account approximately a thousand fake drawings, purportedly by such hands as Castiglione, Mantegna, Rubens, Breughel, Van Dyck, Boucher, Poussin, Ghisi, Tiepolo, and Piranesi. But that isn't all: there has been sculpture, a series of "important" Augustus Johns, and works by Corot, Boldini, and even Hockney. A Renaissance bronze Narcissus was authenticated by Sir John Pope-Hennessy, and a "Parri

Spinelli" drawing was purchased by Denys Sutton, editor of *Apollo*, for £14,000.

In 1978, Colnaghi's realized that they had been selling fakes when informed that a curator had noticed that a Pierpont Morgan "Francesco del Cossa" was on paper identical to a "Savelli Sperandio" in Washington's National Gallery. Since both of these drawings had been obtained from Hebborn, his reputation as a source of drawings crashed, and so temporarily did the London market in Master drawings. Hebborn might at this point have decided to retire, or at least lie low, but instead he vowed to flood the Old Master market with five hundred more drawings, which he claims to have accomplished between 1978 and 1988. Given the quality and diversity of his known output, there is little reason to distrust this general claim.

Unlike van Meegeren's Vermeers, many of Hebborn's fakes are disarming in their liveliness and grace. They are, simply as basic visual objects, beautiful to look at. His *Temples of Venus and Diana*, by "Breughel," or his *Christ Crowned with Thorns*, by "Van Dyck," would in my opinion have done credit to their purported artists. There is no doubt that between scores and hundreds of his forged Master drawings reside in private and museum collections. The actual number is uncertain and is bound to remain so for the foreseeable future, since there is no incentive for the owners of these works to find out whether or not they are by Hebborn. This charming rogue died from a hammer blow to the back of his skull received in a dark alley in Rome in 1996. Police were never able to make an arrest for the murder. But his splendid fakes live on.

Joyce Hatto

Indisputably lovely fakes of a very different kind were produced by the pianist Joyce Hatto over an approximately seventeen-year period beginning around 1989. Born in 1928, she was the daughter of a music-loving London antiques dealer. As a teenager, she kept practicing during the Blitz, hiding under the piano when the bombs were falling. She claimed later to have known the composers Ralph Vaughan Williams, Benjamin Britten, and Carl Orff, to have studied Chopin with the French virtuoso Alfred Cortot, and to have taken advice from the pianist Clara Haskil. She was Arnold Bax's favored interpreter for his *Symphonic Variations*.

Hatto made recordings from the 1950s until 1970, some Mozart and Rachmaninoff, but tending toward light-music potboilers: the *Cornish Rhapsody* and the *Warsaw Concerto*. Her career was already in decline when she was given—so she claimed—a cancer diagnosis in the early 1970s. She retired to a village near Cambridge with her husband, a recording engineer named William Barrington-Coupe, and a fine old Steinway that Rachmaninoff himself had used for prewar recitals in Britain.

Then came what seemed at the time to be one of the strangest turns in the history of classical music. Joyce Hatto began in her retirement to record CDs for a small record label run by her husband. She began with Liszt, went back to cover Bach and all of the Mozart sonatas, and continued with a complete Beethoven sonata set. Then on to Schubert and Schumann, Chopin, and more Liszt. Her Prokofiev sonatas (all nine) were tossed off with incredible virtuosity. In total she recorded more than 120 CDs—including many of the most difficult piano pieces ever written, played with breathtaking speed and accuracy. This was more than the entire recorded output of Arthur Rubinstein, and his included many repetitions.

Intriguingly, she gave to the music a developed although oddly malleable personality. She could do Schubert in one style, and then Prokofiev almost as though she were a new person playing a different piano—an astonishing, chameleon-like artistic ability. We normally think of prodigies as children who exhibit some kind of miraculous ability in music. Joyce Hatto became something unheard of in the annals of classical music: a prodigy of old age, the very latest of late bloomers, "the greatest living pianist that almost no one has heard of," as the critic Richard Dyer put it for himself and many other piano aficionados in the *Boston Globe*.

Little wonder that when she at last succumbed to her cancer in 2006 at age seventy-seven—recording Beethoven's Sonata no. 26, *Les Adieux*, from a wheelchair in her last days—the *Guardian* called her "one of the greatest pianists Britain has ever produced." What a nice touch: playing Beethoven's farewell sonata from a wheelchair. It went along with her image in the press as an indomitable spirit with a charming personality—always ready with a quote from Shakespeare, Rubinstein, or Muhammad Ali. She also claimed to have a clear vision of the mission of musical

interpreters, proclaiming, "Our job is to communicate the spiritual content of life as it is presented in the music. Nothing belongs to us; all you can do is pass it along."

It soon became brutally clear that "passing along" is exactly what she was up to. When, a few months after she died, a buyer of one of her CDs slid her recording of Liszt's *Transcendental Études* into his computer, it immediately identified the track as a recording by the Hungarian pianist László Simon. Since then, analysis by professional sound engineers and piano enthusiasts across the globe has confirmed that the entire Joyce Hatto oeuvre recorded after 1989 is without exception stolen from the CDs of other pianists—mainly young, lesser-known, vigorous artists.

Joyce Hatto was not a pianistic forger. In order to forge a piano performance, she would have had to record Beethoven's *Waldstein Sonata* herself and sell it to the world as a lost recording by, for instance, William Kapell. She was instead a plagiarist: she stole other pianists' work and with only a few electronic alterations—usually speeding up difficult pieces to make them sound more brilliant—sold it as her own. Plagiarism is hard to bring off with any public art, because sooner or later any generally available source is likely to be noticed. (This explains why most plagiarism occurs not in the area of public art but in private, largely perpetrated by students against their teachers.)

In retrospect, the critics who praised van Meegeren's Vermeers look foolish. The same cannot be said of the critics who were entranced by Hatto's performances, which were culled from the more obscure corners of the CD catalogue. The only serious embarrassment was experienced by those few magazine critics who had given unenthusiastic reviews to an original performance but had fallen all over themselves in praise for the same recording when they thought the pianist was the seventy-five-year-old lady who had for years been battling cancer. But in that respect, every listener who was thrilled by this artistry was to some extent affected—some would say suckered—by the appealing idea of an aged pianist at the end of her life producing such dazzling virtuosity. I include myself, since I'd heard a radio documentary on her before her death and found her Liszt and Schubert recordings stupendous for a woman of her age.

IV

Goodman's approach to the problem of forgery throws light on the psychological dynamics of historical responses to fakes and copies, but it does not explain exactly why we object to forgeries in the first place. A broadly social-constructionist answer to that question is given by the musicologist Leonard Meyer. We may imagine that we can separate the aesthetic criteria we use to evaluate forgery from other cultural norms and criteria, Meyer says, but this is a mistake: it is actually impossible to pry apart our aesthetic and our cultural values. It follows that insisting it should make no difference whether a work is forged or not is simply naive: it asks us to turn our backs on our cultural heritage and the value our culture places on originality. The understanding of any human product requires, Meyer writes, "understanding how it came to be and what it is and . . . if it is an event in the past, . . . being aware of its implications as realized in history." We can no more rid ourselves of these presuppositions of perception than, as he puts it, we can breathe in a vacuum. Meyer's position implies that if our culture set less store by inventiveness and originality, we might come to accept forgery as a normal practice.

If Meyer's position is correct, it would follow that in another culture someone like van Meegeren might be lauded as being as fine an artist as Vermeer: this is at least in principle imaginable, whatever we happen now to think of van Meegeren's fakes. It would certainly follow that there should be no principled aesthetic objection to Eric Hebborn's better forgeries, only a cultural or legal objection. As for Hatto, if you enjoy fine piano playing, her recordings are as good as anyone else's—in fact, they *are* anyone else's—made all the better as displays of virtuosity for being speeded up by as much as 20 percent.

But claims on behalf of Meyer's position are trickier than they may at first seem. Suppose someone hypothesizes, "We just disapprove of van Meegeren because of our overweening cultural interest in originality and the cult of genius. If we were not so constrained by such cultural values, then van Meegeren would have been praised rather than condemned for his 'Vermeer' paintings." But this hypothesis only thinks through half the issue: if we didn't have these cultural values, then we would never have so valued—or perhaps even heard of—the work of

Vermeer in the first place. Were that the case, van Meegeren would never have wasted time painting his forgeries. It is not as though forgery would be tolerated in this hypothesized world: it could not exist as a practice in the first place. The hypothesis is rather like saying, "Bank robbery is only a crime because of the cultural value we place on money." It is not that if we didn't place value on money, then bank robbery would be okay: if we didn't value money, banks wouldn't even bother to keep it, nor would people rob it from them.

Again, take an ordinary work practice requiring the competent but routine application of methods to solve problems: plumbing. Plumbers are not prohibited from "forging" each other's work. If the very idea of forgery in plumbing strikes us as outlandish, it is not because our culture tolerates forger-plumbers but not forger-artists. Plumbers do not sign their work or take any particular personal credit for it ("Architecture by Frank Gehry, plumbing by Herman O'Reilly"); forgery therefore has no relevance in plumbing. Nor is this just a question of money, since many plumbers are better paid for their work than artists. It rather has to do with something special that distinguishes art from other productive human practices. It is that something special that makes the issue of art forgery arresting in a way that other forms of fraud are not. If Joyce Hatto had figured a way to embezzle money from other pianists' bank accounts, it would have been an interesting story in the annals of crime. But her plagiarism was a peculiarly *artistic crime*, fascinating to us in ways that go beyond ordinary fraud. Her victims are not just other pianists, any more than the victims of van Meegeren or Hebborn are the buyers of their paintings. For all three of these fraudsters, *their audiences are their victims*.

V

My own first attack on this problem, published in 1979, used what was at that time a wholly imaginary example:

> Consider for a moment Smith and Jones, who have just finished listening to a new recording of Liszt's *Transcendental Études*. Smith is transfixed. He says, "What beautiful artistry! The

pianist's tone is superb, his control absolute, his speed and accuracy dazzling. Truly an electric performance!" Jones responds with a sigh. "Yeah, it was electric all right. Or to be more precise, it was electronic. He recorded the music at practice tempo and the engineers speeded it up on a rotating head recorder." Poor Smith—his enthusiasm evaporates.

Rotating head recorders are a 1960s technology for changing speed without altering pitch (by the 1990s, Joyce Hatto's husband was able to tweak the speed of her recordings by digital means). My example, however, was intended to point to a general fact about aesthetic response, relevant both to plagiarism and electronic alteration: all art—and not just the so-called performing arts—incorporates at some level the idea of *performance*. Every artistic act—composing a fugue, writing a sonnet, weaving a basket, painting a portrait—is a performance, and is undertaken against a backdrop of normal expectations for producing work of one kind or another. Some of these expectations involve the technical properties of artistic media: what you can normally accomplish molding wet clay, applying pigments to a canvas, carving oak, or drawing a horsehair bow across a taut string. But artistic performances also take place against stylistic or historical backdrops: works of art are created in genres and during stylistic epochs that condition what will count as inventiveness, audacity, timidity, eloquence, banality, wit, or vulgarity in a work of art.

To understand a work of art we must have some idea of the limitations, technical and conventional, within which the artist works—a sense of the challenges an artist faces. For example, it may be perfectly true to remark that in a painting of the Madonna the pale pink of the Virgin's robe contrasts pleasantly with the light blue-gray of her cloak. But it is also relevant to know that an artist is working within a canon (as fifteenth-century Italian artists did) according to which the robe must be some shade of red and the cloak must be blue. The demand to juxtapose fundamentally warm and cool colors poses difficulties for creating harmony between robe and cloak, in the face of which Ghirlandaio may reduce the size of the cloak and tone it down with gray, and Perugino may depict the cloak thrown over the Virgin's knees and allow a green shawl with red and yellow stripes to dominate the composition,

while Filippo Lippi may simply cover the robe completely with the cloak. To say that the resulting arrangement of colors is pleasing may be true enough. But a fuller appreciation and understanding of these works of art would involve recognizing how the pleasing harmony is a response to a problem, a demand convention places on the artist.

To know whether an artistic performance succeeds or fails requires that we know what counts as success or failure in any performance context. Music critics will consider a pianist's tone, phrasing, tempo, accuracy, and ability to sustain a line or build to a climax. Speed and brilliance may be important considerations, which is not to say the fastest performance will be the best. But behind these considerations is an unstated assumption: that is it one person's *ten unaided fingers* that produce the sounds. The excitement a virtuoso pianist generates with a glittering shower of notes is intrinsically connected with this fact. An aurally identical experience that is electronically synthesized can never dazzle us in the same way: sound synthesizers can produce individual notes as fast as you please, while pianists cannot. Built into the thrill of hearing a virtuoso is admiration for what the performance represents as a human achievement. Forgery and other forms of fakery in the arts misrepresent the nature of the performance and so misrepresent achievement.

Of course, technologies change, and what might be a performance of one type can develop into something different. There might come a time, for instance, when electronically produced prestissimos will become accepted and be what will count as achievement in a recorded piano performance. When that day arrives, we will no longer say things like, "Didn't she play that run beautifully?" but rather, "Doesn't Sony do marvelous tempo engineering?" We may expect that engineers will be given credit on recordings, not for having faithfully reproduced the sounds the artist has produced, but for having altered the sounds in ways previously left to the performer. There is no principled reason to oppose this, any more than we ought to oppose recording *Götterdämmerung* in separate sessions on various days. But just as we ought to know that the resulting recording will feature voices that sustain their power throughout the whole work in ways that would be impossible in any live performance, so we ought to know that the manipulated piano recording is a collaboration of pianist and engineer, one that may feature double

octaves going down the keyboard at speeds human nerve and muscle alone could never produce. This may well be a music world of beautiful sounds, but it will no longer be a world of thrilling keyboard virtuosity.

VI

The example of the faked piano recording nicely illustrates a striking psychological effect: a shock, a sense of deflation and betrayal, in finding out that what you thought was brilliant virtuosity was only an engineer twiddling a dial. Aesthetic theory can trace out the implications of such aesthetic intuitions for critical discourse, but it typically says nothing about the sources of the intuitions themselves. For this, we must turn to our evolved interests and emotions toward works of art. As with the intentional fallacy, the paradoxes of forgery are generated by conflicting adaptive functions of works of art. On the one hand, we have the natural impulse to treat the work of art in a disinterested or decoupled manner, as an object that gives pleasure in the imagination. On the other hand, and in ways that conflict with this first aspect, works of art are skill displays, Darwinian fitness tests, and dependent on an innate information system that emerged in sexual selection.

The Kantian standpoint of disinterested contemplation, which has its parallel more recently in the decoupled function of art that Tooby and Cosmides identify, treats aesthetic experience as something cordoned off in the theater of the imagination from practical means/ends calculation. From this point of view, whether a glittering shower of notes was produced by a pianist or a computer, it will be just as beautiful and exciting. Whether a painting was created in the seventeenth century with a badger-hair brush or the twentieth with an airbrush is immaterial: it is how that lovely soft shading strikes the eye that counts. Or whether that enormous crowd is five thousand extras hired to film the scene or five thousand humanlike, pixelated figures produced by a computer is beside the point: it is simply thrilling to see. From a disinterested, decoupled perspective, questions of how something is produced make no difference to aesthetic effect.

It is interesting to note that Kant himself found this position ulti-
mately unsustainable. Although he begins his *Critique of Judgment* by
claiming that art ought to be subject to free and disinterested contem-
plation, he later abandons this by distinguishing what he calls *free* from
dependent beauty. Beauties of nature, such as flowers, are free beauties,
appreciated "without any concept," as he puts it, without any notion
what they are supposed to be. Works of art are dependent beauties. The
beauty of a church, for instance, depends on its being in accord with
the purposes of a church as a dignified place of worship. A church that
looked like a summer house or an arsenal, he says, could never be prop-
erly beautiful.

Later still, in the same book, Kant argues that even the experience
of the beauty of nature requires that we accurately understand exactly
what we perceive. He asks us to imagine visitors to a country inn who
are sitting on a verandah enjoying "a quiet summer evening by the soft
light of the moon." What the scene needs to make it perfect is a
nightingale, and since there are none in the vicinity, the innkeeper
hires a boy with a reed in his mouth to hide in the bushes and imitate
the bird. No one who catches on to the ruse, Kant says, "will long en-
dure listening to this song that he had before considered so charming."
The same thing would happen, he says, were we to try to make the
path through a forest more beautiful by sticking artificial flowers
among the shrubs or perching "artfully carved birds" on the branches
of trees. A direct response to the beauty of nature, Kant insists, re-
quires that it be authentically natural.

Kant does not extend to what he called the fine arts the idea that an
art performance must be accurately represented in terms of achievement,
but his positions on both dependent and natural beauty have clear impli-
cations for forged, copied, misattributed, or plagiarized works of art and
artistic performances. Disinterested contemplation may be Kant's default
stance toward art objects, but even he has to allow that the origins of an
object—whether or not it is artificial, or what it is intended to be—can
make a crucial difference to aesthetic perception. The logic of the Kant-
ian position may even seem to open the door for the claim that works of
art are skill displays that require us to intuit the capacities involved in
their creation.

VII

Even before the Pleistocene, many animals, as well as our proto-human ancestors, would have assessed potential mates with an eye toward their abilities to acquit themselves adequately, or better than adequately, in fitness tests. The sexual selectionist view is that performance in fitness tests may have begun in courtship contexts, but it eventually came to spread out and saturate the whole of human social life. Fitness displays for modern humans are not, in a word, just about mating: they have been extended into our regard for human achievement more broadly conceived. Beyond this, there is very likely an adaptive advantage that we could see today in any human grouping that valued displays of skill by any of its members, whether for courtship purposes or not. This helps explain why, in something like the Hatto case, we can be so awestruck by a pianist who had enjoyed only a modest success, but who in her seventies seemed miraculously to have achieved greatness. It was not just her consummate technical prowess, it was a sense of musical authority she brought to "her" interpretations. It would have been an awe-inspiring achievement, had it not been a fraud.

But then, awe followed by a sense of indignation and betrayal are not feelings limited to music or the arts. Watching someone win the New York Marathon or break a world record in the pole vault can also bring tears to the eyes—and when it turns out the winner had taken a subway shortcut or had a used mechanically augmented pole, it is not just that the athlete has cheated in a game: we the audience also *feel cheated*. The key to this psychological effect is, I am now certain, an evolved emotion, one long familiar to common sense but assumed to be merely cultural or conventional by many theorists. There is no one word to describe it, but it includes feelings of *awe*, *admiration*, *esteem*, and *elevation*.

The structure of emotional life is not easy to analyze cross-culturally, which is why most psychologists are content to stick close to Paul Ekman's basic list, emotions that have clearly evolved origins and are in some cases shared with other animals: *happiness*, *surprise*, *anger*, *sadness*, *fear*, and *disgust* or *contempt*. Other emotions that are namable in European languages can be closely related to each other and thus hard to distinguish in some cultural contexts: envy and jealousy, for example, or guilt and shame. Beyond these, Jonathan Haidt of the University of

Virginia has, with colleagues, identified a complex association of universal emotions that he regards as innate responses—presumably adaptations, although not as ancient as *fear* or *anger*—that are built into human sociality. He calls them "other-praising" emotions. They are not local manifestations of such basic affects as *joy* or *curiosity* or pleasure in *amusement* but are a specific and irreducible family of human emotions in their own right. These emotions are, I would add, deeply implicated in Darwinian aesthetics. They include *gratitude* for the actions of others, *admiration* for excellence in another person, particularly for the displayed skills, and a heightened sensibility Haidt calls *elevation*.

Haidt observes that while psychologists have studied "other-criticizing" emotions such as contempt or disgust, and emotions of self-praise (pride, self-satisfaction) or self-criticism (embarrassment, shame), very little research has been directed to other-praising emotions. What work has been done on gratitude has been in the context of economic exchanges, while the literature on admiration is almost nonexistent. Darwin himself actually defined admiration as an emotion: "surprise associated with some pleasure and a sense of approval." Haidt sees it as a pleasurable "response to a non-moral excellence," including extraordinary displays of skill, talent, or achievement. The experimental evidence he supplies confirms what most people would intuitively guess: that feelings of admiration motivate people to want to improve themselves, or to emulate the admired person. But leaving this empirical outcome aside, admiration is also a *distinct feeling of pleasure*, one that we may guess is profoundly ingrained in our psychology as an adaptation for social living.

If we bring together three facts about human skill displays, we can use them to make a prediction. The facts:

1. Human interest in high-skill activities—particularly those with a public face, such as athletic or artistic performances—derives at least in part from their ancient status as Darwinian fitness signals.

2. High-skill performances are normally subjects of freely given admiration; in fact, achieving the pleasure of admiration is a reason audiences will pay to see high-skill exhibitions.

3. As signals, high-skill performances are subject to keen critical assessment and evaluation—the fastest or highest in athletics,

the clearest, most eloquent, deepest, or most moving in the case
of the arts.

The prediction entailed by these facts is this: highly skilled perfor-
mances that excite admiration will be a focus not only of critical evalua-
tion but of continual inspection and interrogation about potential for
cheating. A sports star may beat his children and evade his income tax,
but such issues will never match in the public imagination the question
of whether he used anabolic steroids to break a home-run record or win
the Tour de France. The modern obsession with drugs in sport is a com-
pletely predictable result of the evolved basis for sport as a public skill
display; the money involved in sports cheating is secondary in overall
importance. For exactly the same reasons, Joyce Hatto's faked recordings
came as a shock to her admirers.

The sport and athletic analogy is, however, of limited use in its appli-
cation to art forgery. Many of the physical achievements of sport stars
are one-dimensional, judged according to a single criterion. No one much
cares if a sprinter or weight lifter wins an Olympic gold medal grace-
fully or awkwardly, just as soccer fans want to see their team win the
World Cup, whatever it takes: an ugly win is normally preferred to any
loss, no matter how brave or elegant.

Indisputably, works of art are pretty things suited to disinterested
contemplation. It is naive, however, to treat them exclusively in this way,
because works of art are also windows into the mind of another human
being. We are likely to find a Mathew Brady photograph of Lincoln
touching because it lets us see directly into the sad, knowing eyes of a
great and doomed man. But Rembrandt's portraits of his son Titus or
his mother reading the Bible provide a completely different experience.
We do not look through them to see the little boy or the old woman.
Rather, these paintings take us into Rembrandt's mind. They express,
and therefore reveal, his love—as father, as son—for his subjects. The
history of painting is not a history of what the European Alps once
looked like, or how people dressed in the fifteenth century, or how the
summer sun can dry out a hayfield in Languedoc. It is a history of innu-
merable human visions of the world. Creative arts inexhaustibly give us
ways of looking into human souls and thus expand our own outlook and
understanding. In this respect, Han van Meegeren's conceit that he was

as great a painter as Vermeer misses the point. Even if the claim were not palpably absurd as a claim to technical skill (for the record, it is absurd), our interest in Vermeer lies in wanting to know how that particular Dutch genius saw his seventeenth-century world, including the human beings that peopled it. Eric Hebborn might well have done a plausible job of a Rembrandt Titus, but it could never be Rembrandt's loving vision of his son: it would be just be one clever criminal's attempt to convince us that this is how Rembrandt saw his little boy.

Since forgery episodes so often involve the foolishness of curators and critics as well as the financial misfortunes of the rich, it is easy to dismiss them as amusing sideshows in art history. Tracing our objections to forgery down to their Darwinian roots, however, puts the subject in a different light. Authenticity, which in the arts means at the most profound level communion with another human soul, is something we are destined by evolution to want from literature, music, painting, and the other arts. This sense of communion exhilarates and elevates the spirit. How odd that this ancient ideal should should be explained by a theory pioneered not by some great historian of the arts, but by a nineteenth-century naturalist, an expert on pigeon-breeding, barnacles, and the finches of the Galápagos Islands. It is evolution that tells us about the some of the deepest longings and needs that works of art touch.

VIII

In the run-up to the 2004 Turner Prize, the most prestigious contemporary art prize awarded in Britain, the sponsor of the award, Gordon's Gin, polled five hundred of the most powerful people in the art world. Leading dealers, critics, artists, and curators were asked what in their opinion was the most influential work of art of the twentieth century, taken from a list of twenty nominations. When the votes were tabulated, well back in second place was Picasso's *Les Demoiselles d'Avignon*, ahead of Andy Warhol's *Marilyn Diptych*, Picasso's *Guernica*, and Matisse's *The Red Studio* in fifth place, with works by Joseph Beuys, Constantin Brancusi, Jackson Pollock, Donald Judd, and Henry Moore bringing up the rear. The winner by far, with 64 percent of the vote for number one, was an object whose very status as a work of art remains in dispute, a

work that no longer exists because the artist's sister tossed it into the trash long ago: *Fountain*, the men's urinal put forward for exhibition in 1917 by Marcel Duchamp.

Gordon's Gin initiated the survey of experts "in order to identify key art pieces to help the public understand more about the inspiration and creative process." To that end, the corporation hired a former Tate curator, Simon Wilson, to clarify it all. As he explained, "The Duchampian notion that art can be made of anything has finally taken off. And not only about formal qualities, but about the 'edginess' of using a urinal and thus challenging bourgeois art." Of those polled, it was artists in particular who plumped for *Fountain*, he pointed out: "it feels like there is a new generation out there saying, 'Cut the crap'—Duchamp opened up modern art."

If a better understanding of the creative process was the purpose of the Gordon's Gin exercise, it seems to have failed. CNN couldn't get the story straight, wrongly reporting that the art experts voted *Fountain* "the world's best piece of art," while visitors to the BBC Web site predictably railed against the art experts' choice. "Insulting!" "Pretentious idiots!" they wrote. "If true artists like Leonardo da Vinci saw this they would turn in their graves." "These people go their own elitist disdaining way, society goes another," wrote one reader. "Finally," said another, "a piece of modern art to receive my opinion of it."

Going by that comment, as well as Simon Wilson's, you'd think that Duchamp had only just come up with *Fountain*, rather than having presented it to the art world eighty-seven years earlier. *Fountain* was not the first instance of a type of art Duchamp called "readymades," ordinary objects manufactured for industrial or consumer use but presented to the world as works of art. Having already established himself as an important modernist artist with his remarkable painting *Nude Descending a Staircase*, Duchamp moved on to a new and radically different idea: that it might be possible for art to be a form of expression purely for the mind, rather than the eye. His first experiment in this direction, toward pure ideas and away from "retinal art," as he termed it, was *Bicycle Wheel*. (Like *Fountain*, this 1913 work is lost, although many years later Duchamp reconstructed it for the Museum of Modern Art.) It is a bicycle wheel that turns in a fork mounted on a wooden stool. Because it was assembled by the artist from manufactured parts, Duchamp called it an "as-

sisted readymade," and many people now consider it the first important piece of kinetic sculpture. Then came two celebrated quintessential readymades: *Bottle Rack* (1914), a galvanized rack for drying bottles, also thrown out by his sister, and *In Advance of the Broken Arm* (1915), which was a snow shovel purchased at a hardware store and signed. (The original versions of these also disappeared.) Next, Duchamp came up with *Comb*, a flat, heavy dog-grooming comb with a suitably Dadaist inscription, "Three or four drops of height have nothing to do with savagery."

At last he produced his most notorious achievement, something strikingly ugly in the eyes of many people: a porcelain urinal that Duchamp purchased at the J. L. Mott Iron Works in Brooklyn. He inscribed the work on the side "R. Mutt 1917" and entered it in a show of the Society of Independent Artists, of which he was a founder. It was rejected for exhibition, and Duchamp resigned from the society. Although the original piece is lost, it was recorded in a famous photograph by Alfred Stieglitz, and in the 1950s Duchamp "re-created" it by purchasing urinals and then inscribing them with the same 1917 name, almost like a series of signed prints. Duchamp later wrote that *Fountain* "sprang from the idea of making an experiment concerned with taste: choose the object which has the least chance of being liked. A urinal— very few people think there is anything wonderful about a urinal. The danger to be avoided lies in aesthetic delectation."

As *Nude Descending a Staircase* and his later mixed-media work *The Bride Stripped Bare by Her Bachelors, Even* both demonstrate, Duchamp was an artist of unusual talent in a purely traditional sense. But his creatively jumpy mind was also that of a mathematician, high-level chess player, theorist, and jokester. He could not be satisfied with painting and was looking for ways to go beyond it, to negate the "cleverness of the hand" that was so important in the history of aesthetics. He had been brought to this point from a question he had already asked himself in 1913: "Can one make works that are not works of art?"

This question raises a thicket of issues. What can the verb "make" mean in relation to a readymade, since the artist does little or nothing to the object, which was made elsewhere? (Responding to Arthur Danto's view of readymades as a "transfiguration of the commonplace," John Brough has argued that buying a urinal from a plumbing manufacturer and exhibiting it in a gallery has nothing of transfiguration about it—it's

rather a matter of the *transportation of the commonplace*.) Perhaps
Duchamp's question is about the possibility of the artist making a work
of art that at the same time denies its status as work of art. Such a work
would force its audience to say, "No, no, that cannot be a work of art."
Any such object—intended to baffle or frustrate its audience—will be a
kind of anti-art, described by P. N. Humble as "the antithesis of some-
thing created primarily with the intention of rewarding aesthetic con-
templation." Anti-art, Humble suggests, "reflects and embodies the
intention to produce something that does not, and *could not*, satisfy the
criteria we employ in classifying things as art."

This is a perfect description of *Fountain*, yet philosophical aesthetics
for the last third of the twentieth century has been bent on trying to
find a justification for this object not as anti-art but as art. So is *Fountain*
a work of art? Most art intellectuals say yes, it clearly is; a smaller group
of theorists argue that it is not. One way to throw light on the question
is to analyze *Fountain* against the list of cluster criteria for art proposed
in chapter 3.

*1. Direct pleasure. The art object is valued as a source of immediate expe-
riential pleasure in itself, often said to be "for its own sake."* In this respect,
Duchamp precisely chose an object that—at least for its first intended
audience in 1917—would supply no pleasure in perception, direct or in-
direct. *Fountain* is a disagreeable piece of plumbing. As a Dadaist ges-
ture, on the other hand, the object can be a source of great pleasure.
This pleasure is dependent on its being exhibited as a work of art and—
like the pleasure of a joke, an artistic shaggy-dog story—it requires
knowledge of context and intentions. The urinal did not supply this
kind of pleasure over at the J. R. Mott company in Brooklyn, where it
was just a piece of plumbing, a stock item.

*2. Skill and virtuosity. The making of the object requires and demon-
strates the exercise of specialized skills. The demonstration of skill is one of the
most deeply moving and pleasurable aspects of art.* Again, *Fountain* is a di-
rect assault on the notion that a work of art requires skill. With a ready-
made, the skill is someone else's, in this case the foundry workers'. Skill
nevertheless remains highly relevant to Duchamp's readymades. Today,
when the my-kid-could-do-that brigade challenges the skill involved in
producing some readymade descendant in a gallery—preserved shark,
unmade bed, whatever—the response by curators is often to insist that

the skill of the artist is present in knowing exactly what unusual, however minimal, act will be admired by a sophisticated art-world audience: your kid doesn't know that! As a Dadaist gesture in this sense, *Fountain* is not just skillful, it has to be regarded as a work of genius.

3. Style. *Works of art are made in recognizable styles, rules that govern form, composition, or expression. Style provides a stable, predictable, "normal" background against which artists may create novelty and expressive surprise.* Once more, *Fountain* is not opposed to any particular style, as Bauhaus might pit itself against Victorian ornament, but is implicitly against the whole idea of style. *Fountain*, *Comb*, and *In Advance of the Broken Arm* are all objects that come as close to pure utility as you might find. White porcelain may in some minds suggest a bathroom-fixture style, but if we understand the nature of the surface primarily as having a hygienic function (no-stick, easily cleanable), then the object is devoid of style. Combs and hairbrushes are usually designed with stylized handles, but Duchamp probably chose a practical dog-grooming comb as *Comb* because it shows no hint of design or style whatsoever.

4. Novelty and creativity. *Art is valued for its novelty, creativity, originality, and capacity to surprise its audience. This includes both the attention-grabbing function of art and the artist's less jolting capacity to explore the deeper possibilities of a medium or theme.* In this respect, *Fountain* is a wondrous object, so surprising that it was even turned away from an avant-garde exhibition. That it is being constantly rediscovered nearly a century later and treated as shockingly new is testament to its visionary nature. It is as though Duchamp saw the future history of modernism before him and, like a chess player who can grasp a necessary progression of moves well into the future of a match, he jumped straight to the endgame. A urinal set on a plinth: checkmate!

5. Criticism. *Wherever artistic forms are found, they exist alongside some kind of critical language of judgment and appreciation.* If the amount of discourse generated by an art object were the sole criterion for arthood, then *Fountain* would pass at the top rank. With this reservation, however: the discourse centered on *Fountain*, unlike other art works, has almost nothing to do with its directly perceivable qualities—no loving descriptions of that white, gleaming surface, nothing about the object's form. *Fountain* stands apart from a work such as *Les Demoiselles d'Avignon* in that by the artist's intention it makes no difference what it looks

like. Also, because there is no direct craftsmanship involved, *Fountain* is unlikely to encourage the kind of critical shoptalk we expect from artists. (We don't imagine readymade artists swapping tips on the best deals at Plumbing Depot, or spring close-out sales on snow shovels.) *Fountain* was sure to win a "most influential" poll among critics, curators, artists, and theorists, because it has produced nearly a century of endless art talk.

6. Representation. *Art objects, including sculptures, paintings, and fictional narratives, represent or imitate real and imaginary experiences of the world.* Ordinary representation in any plain Aristotelian sense is clearly absent from *Fountain*. Duchamp's readymades even resist the way in which some of their close relatives, such as Andy Warhol's Brillo boxes and his Campbell's Soup cans, can be read as symbolic. Warhol was delivering oblique comments on consumerist society and economy, and his works can be interpreted as symbolic, even if they are not imitative. *Fountain* is different. It is not about urine or about the commodification of plumbing in modern society. It is not even about ugliness. It is at heart a Dadaist critique of the art world and art idolatry. This meaning, however, is indirect (some would call it a "meta-meaning"); it is not to be read off the appearance of the object in the way that Warhol invites by replicating popular-brand consumer merchandise.

7. Special focus. *Works of art and artistic performances tend to be bracketed off from ordinary life, made a separate and dramatic focus of experience.* The intended appearance of *Fountain* on a plinth in an art exhibition is central to the idea of a readymade. A resolutely not-special object that is made special—by being given a title, being signed by the artist, or inscribed with poetry—and then put on display in a gallery: this is Duchamp's, and Dada's, most notable contribution to art history. Later conceptual artists tried with less success to extend the idea, for instance, making a coffee stain on a carpet in the artist's apartment in 1968 into a work of art. Since the carpet no longer exists, however, the stain cannot be made special in the way that is accomplished by a gold frame or a plinth under spotlights.

8. Expressive individuality. *The potential to express individual personality is generally latent in art practices, whether or not it is fully achieved.* There is no doubt that *Fountain* is expressive of the artist's individuality, so long as we are referring to his gesture in putting forward a urinal as a

work of art. Readymades are premanufactured objects and so cannot express artistic individuality in the way that canonical painting does. As much as canonical painting, however, *Fountain* and the other readymades have generated a literature on Duchamp and what he meant by these works. In that sense, they are as open-ended and vague as traditional art objects, and subject to endless interpretation. They provoke curiosity among critics and historians about the qualities of the artistic mind that produced—or presented—these objects.

9. Emotional saturation. In varying degrees, the experience of works of art is shot through with emotion. While there is no doubt that *Fountain* has often provoked or incited emotions—of delight from the cognoscenti, of disgust from traditionalists or from the man in the street—the object itself embodies and expresses no emotion. That indeed is again part of the whole idea of a readymade. Because it is so disagreeable, *Fountain* is even less successful in being emotionally neutral than other readymades, a fact recognized by Duchamp himself in remarks on *Comb*: "During the 48 years since it was chosen . . . this little iron comb has kept the characteristics of a true readymade: no beauty, no ugliness, nothing particularly aesthetic about it." To the extent that we normally expect a work of art to somehow express emotion, *Fountain* once more frustrates expectation.

10. Intellectual challenge. Works of art tend to be designed to utilize a combined variety of human perceptual and intellectual capacities to a full extent; indeed the best works stretch them beyond ordinary limits. By setting itself as a puzzle, *Fountain* clearly seems to fulfill this criterion. Note, however, that this object does it in a way that is different from the puzzles of large, complex works, such as *The Waste Land* or *Finnegans Wake*. *Fountain*'s intellectual challenges are entirely external to it: they are not about its characteristics as a piece of plumbing but about its status as a work of art. The object stretches the imagination, to be sure, but entirely away from the object itself and into philosophy and art history.

11. Art traditions and institutions. Art objects and performances, as much in small-scale oral cultures as in literate civilizations, are created and to a degree given significance by their place in the history and traditions of their art. This single feature is the basis of the so-called institutional theory of art, which argues that once any object has met this criterion it need meet no others on the list: institutional validation alone can make absolutely

anything (or any artifact, in some versions) a work of art. The opposed view, one generally championed by this book, is that any artifact that has all, or nearly all, of the other twelve features on the list does not need to have this one to be a work of art; such an object could not fail to be a work of art in the absence of only this feature. (Some works of tribal art or outsider art—e.g., the traced and colored narrative illustrations of the recluse artist Henry Darger—might be examples of such objects.) In any case, *Fountain* and the other readymades are obviously objects that support the importance of this criterion; indeed, institutional theory was formulated in the first place largely to settle disputes about such objects as readymades. Used alone, this criterion would make of art a pure institutional construction.

12. Imaginative experience. *Art objects essentially provide an imaginative experience for both producers and audiences. Art happens in a make-believe world, in the theater of the imagination.* By Duchamp's very intention, *Fountain* barely qualifies as an imaginative object. The plinth, the place in an art gallery, promises that the object will be something for the imagination, and yet the object itself denies it. It is not at an imaginative or theatrical level about plumbing, urination, or any larger human issue. It is intended to leave the imagination dead and therefore to provoke meditation and lively argument about what a work of art is. This is a wholly admirable intention, but it is not in itself an artistic intention. Many theorists have over years confused the pleasures of argumentative discourse, which is in its way imaginative too, with the pleasures of art, and therefore conclude that *Fountain* fulfills this last criterion. If they were right, then any stimulating book on aesthetic theory would be a work of art.

In his defense of readymades as art, even Arthur Danto expresses queasiness about the art value of the Mott/Mutt urinal: "*Fountain* is not to every artlover's taste, and I confess that as much as I admire it philosophically, I should, were it given me, exchange it as quickly as I could for more or less than any Chardin or Morandi—or even, given the exaggerations of the art market, for a middling chateau in the valley of the Loire." But *Fountain* is indeed a philosophical gesture specifically intended *not to be of any artlover's taste*, and Danto ought to feel no shame in being less than attracted to it. Duchamp himself was asked about the origins of the readymade as a type of object: "Please note that I didn't

want to make a work of art out of it," he said. "It was in 1915, especially, in the United States, that I did other objects with inscriptions, like the snow shovel . . . The word 'readymade' thrust itself on me then. It seemed perfect for these things that weren't works of art, that weren't sketches, and to which no art terms applied. That's why I was tempted to make them." The philosopher John Brough, who quotes this remark, asks, isn't it high time to take Duchamp at his word?

On a numerical calculation of items on the cluster criteria list, not to mention the overwhelming agreement of generations of art theorists and art historians, the answer is a resounding "Yes, *Fountain* is a work of art." Duchamp's readymades nevertheless incite fierce debate because they so deeply and effectively challenge our evolutionary response-system for art: where's the emotion, the individuality, the skill, the beauty? Duchamp set himself not only against culture but against the adaptive structure of art. Yet there it is on a plinth, an object of no special interest made into an object of the most special attention. Can this be art? Of course not, and yet it must be, as the experts continue to insist. As philosophical provocations about art, the readymades are intellectual masterpieces. For its part, *Fountain* may not be pretty, but as an art-theoretical gesture, it is a work of incandescent genius.

Fountain is also inimitable, which puts in a curious light Simon Wilson's comment that the readymade "has finally taken off." To the contrary, it took off long ago with Duchamp, who flew it with wit and style. In historical perspective, his readymades have in their po-faced neutrality a definite humor and charm. But like jokes that can only be laughed at once, having been done, they cannot be done again with anything like Duchampian impact. Haydn invented the string quartet, and it could "take off" in the hands of Beethoven and Schubert: that's what it is to pioneer an art form. It is a mistake to think of the readymade in the same way.

This hasn't stopped any number of lesser artists from trying to perform again and yet again Duchamp's subversive act. The imitations reached rock bottom in 1961 with *Merda d'artista*, a series of works produced, in every sense of the word, by the Italian conceptual artist Piero Manzoni. In fact, in 2002 the Tate Gallery paid $61,000 to add to its collection Can 004 from Manzoni's series of ninety cans of his own feces. Can 004 is signed and labeled on the English side, opposite the

Italian, "Artist's Shit. Contents 30 gr net. Freshly preserved, produced and tinned in May 1961." Manzoni had undertaken many other projects, including signing hard-boiled eggs and declaring Umberto Eco a work of art, but even he may have been surprised by the success of selling his own excrement. As Manzoni explained, "If collectors really want something intimate, really personal to the artist, there's the artist's own shit. That really is his."

According to Manzoni's friend Enrico Baj, the ninety cans were "an act of defiant mockery of the art world, artists, and art criticism." Manzoni was also opposed, Baj claimed, to "empty and formal manifestations of the dominant culture" of art, of a bureaucracy of the beautiful. The trouble is that by now such gestures as *Merda d'artista* have long since been accepted by the institutional bureaucracy of art. This is nowhere more clear than in the Tate Gallery's official response to journalists' questions about the 2002 Manzoni acquisition. Can 004 was a "very important purchase for a very small amount of money," a spokeswoman said. Manzoni "was an incredibly important international artist. What he was doing with his work was looking at a lot of issues that are pertinent to twentieth-century art, like authorship and the production of art." She then added, without a hint of irony, "It is a very seminal work." *Not that too!*

The Tate's humorless defense of its acquisition contains a sad lesson in the decline and fall of the readymade. The readymades were objects perceptively presented by Marcel Duchamp to an art world that was itself incapable of appreciating their wit or his irony; the solemn reaction made them all the more amusing and effective. Since 1917, the originally clever idea of the readymade has spread through the art world, but the same dull values prevail from the institutional side. In Manzoni's case the only humor to be found is in the messy fate of many who acquired works in the *Merda d'artista* series: quietly, but knowing exactly what he was up to, Manzoni had improperly autoclaved the cans. At least half of those bought by museums and collectors eventually exploded.

The Contingency of Aesthetic Values

I

Immanuel Kant, a man with a capacious and hungry intellect, regarded himself as a modern, eighteenth-century cosmopolitan—from the Greek *kosmopolitês*, "world citizen." Although he never left his hometown of Königsberg, his mind roamed through the entirety of human knowledge and experience. Beyond philosophy, he studied and wrote extensively across subjects scientific and humane. In astronomy, he proposed a still-plausible process for the formation of the solar system and suggested that blurry nebulae seen among the stars might well be distant galaxies like our own Milky Way. He wrote substantial physical geographies of North and South America and entertaining accounts of the national characters of the Dutch, the Arabs, the Spanish, the English, the French, the Italians, and the Germans. He had little taste for music, but he possessed a sense of visual form (though, oddly, not color), understood poetry, and enjoyed English novels. In formulating his grand theory of aesthetics in the *Critique of Judgment*, he repeatedly refers to the arts of tribal peoples—the Carib Indians, the Iroquois, the Maori—in an effort to shake his readers out of their Eurocentric prejudice and so present a more universal conception of what art is for the human race as a whole.

For Kant, Hume, and their Enlightenment inheritors, intellectual sophistication is achieved in part by recognizing that our most cherished values and interests may be products of local cultural contingency—they

are "ours" only through accidents of when and where we were born. Parochialism, in contrast, treats the values learned at your mother's knee as necessary givens and as indisputably superior to the values of other people (and their mothers): my religion is the only true religion, my customs are the only refined or civilized customs, my language is the only one fit for writing great poetry, my music is the only beautiful music, and so forth. That all cultures regard themselves as special and privileged in their values and beliefs was something noted by the Greeks, but it became a theme for objective investigation in the Enlightenment. The result for European intellectuals was an inevitable progress toward cultural relativism, and by the time we get to the twentieth century, it is cemented in place as the prevailing ideology in the humanities and social sciences.

Charles Darwin's discoveries brought into biology and the study of human psychology the sense of contingency that the Enlightenment had already recognized in the cultural world. The eighteenth-century thinkers had contrasted the endless variety of beliefs and values across cultures with a permanent, unchanging, God-given human nature that lay underneath it all. Human nature is permanent, so the thinking went, but human culture is created. Darwin agreed on the historic contingency of culture. His theory of evolution, however, now added a radically new element to thinking about cultural values: just as they are to an extent products of historic contingency, so the unchanging, innate instincts, interests, and preferences that underlie cultural values are also to some degree accidents—*products of prehistoric contingency*.

Most culture and art theorists in the twentieth century have extended earlier ideas of cultural relativism into an all-embracing ideology of social construction: it is not just that *some* of our artistic meanings and value ascriptions arbitrarily derive from accidents of history and culture, so the general view went, *all* of them do. For the usual culture theorist, the picture came to look like this: to be sure, the biological structure of the body—the corpuscles of its blood, its organs, its musculature—were dictated by DNA and RNA. Darwin and the biologists were credited with that much. Culture, however, was completely different. It was a realm of free creativity that engraved itself on a mental blank slate: culture was the uncontested domain of the humanities, untouched by biology. Even such a committed Darwinian as Stephen Jay Gould argued

that cultural life derived from history and could not be understood in terms of prehistoric adaptations. This blank-slate picture of the mind as a relatively unconstrained culture generator therefore ceded to Darwinian evolution all of biology, and perhaps simple puzzles of perceptual psychology, while keeping within the humanities meaning, emotion, and aesthetic experience.

Intellectual history has played itself out in this way in part because the blank-slate view of culture and meaning meshes perfectly with important aspects of modernist ideology. From the start of the last century, modernist painters, writers, composers, and art theorists consoled themselves that audience resistance was a mark of worthwhile creative endeavor. Modernists looked back at the nineteenth century and saw that bourgeois listeners had found Beethoven ugly and dissonant, Manet and Baudelaire obscene, Wagner nonsensical, and Flaubert offensive but had come in time to appreciate their genius. In fact, all great art of the avant-garde is rejected until a larger public comes to understand it. The story of the premiere of the *Rite of Spring* is therefore modernism's most enduring morality tale: what once was so outrageous, so unintelligible, that it could cause a riot, came eventually, through knowledge and familiarity, to be accepted as a masterpiece. Modernism thus extrapolated from such incidents a general rule: *our ability to adapt to new kinds of music or art has no limit whatsoever.*

Allied with blank-slate psychology, promoters of modernism cited Dadaist experiments to insist that beauty could reside in any perceptual object, that people could be "taught" to take aesthetic pleasure in any experience whatsoever. Once this fact was understood, so modernist hopes went, we would all become free to enjoy pure abstraction in painting, atonality in music, random word-order poetry, *Finnegans Wake*, and readymades, just as much as we enjoy Ingres, Mozart, or Jane Austen. "Difficult" modernist art, literature, and music could become popular—culturally dominant, in fact—given enough time and familiarity. As Anton Webern longingly imagined, the postman on his rounds might someday be overheard whistling an atonal tune.

The Darwinian claim, on the other hand, is that at the heart of all such arguments lies a fatal non sequitur: while it is true that culture sanctions and habituates a wide variety of aesthetic tastes, it does not follow that culture can give us a taste for just anything at all. Nor,

conversely, does it follow that if in the future no postman is ever found whistling one of Schoenberg's tone rows, the reason must be that the postman's culture deprived him of the chance to appreciate the beauties of atonality. Human nature, so evolutionary aesthetics insists, sets limits on what culture and the arts can accomplish with the human personality and its tastes. Contingent facts about human nature ensure not only that some things in the arts will be difficult to appreciate but that appreciation of them may be impossible.

Any sophisticated and worldly observer in the eighteenth century could already see the ways aesthetic taste was informed or determined by historic conditions. But an enlarged or broadened way of thinking about the arts is extended by Darwinian evolution from the realm of culture into the domain of human nature itself: the vast realm of cultural constructions is created by a mind whose underlying interests, preferences, and capacities are products of human prehistory. Art may seem largely cultural, but the art instinct that conditions it is not.

II

We are all happy to acknowledge the haphazard contingency of our cultural values. Think how different our lives or our cultures might have been if, to cite a few random examples, the Greeks had lost at Marathon, the Library of Alexandria had not burned, German had been installed as the official language of the American colonies (it almost was), Shakespeare had died as a child, Schubert had lived to be seventy, or Hitler had invaded Britain instead of the Soviet Union. Human history and culture are subject to countless accidents or decisions, known and unknown. It follows there is very little inevitability in human history.

If there is anything fated in human history, it is owed to the persistent influence of a genetically determined, unchanging human nature. If *that* had been different, for instance, if human sociality developed in different ways, then history would have gone in unimagined directions. Until Darwin, most thinkers regarded human nature as God-given and immutable. Darwin explained that human nature has a history too— more precisely a prehistory—that has been subject to historical accidents

and chance influences, although they are too remote to reconstruct except speculatively. Many aspects of the human body result from evolution having taken arbitrary byways. We can follow back the structure of the human hand with its four fingers and an opposable thumb through predecessor species. It is not impossible to imagine that we might have ended up with five fingers plus thumb, or (like Mickey Mouse) three plus a thumb. Lost in the darkness of our evolutionary past is the forking path in the evolution of some predecessor species that brought us to the hand we possess, but it might have been otherwise. The same goes for the instincts that make up our psychological human nature, including the art instinct.

In order to understand the art instinct and reverse-engineer probable functions for its general features, we also have to understand its prehistoric contingency—understand in that sense its mysteries and the limits of what we can possibly know about it. To that end, I will compare two kinds of sensory experience—smells and pitched sounds—in terms of what they offer as potential art forms. This discussion will show two important features of evolutionary aesthetics: first, that not every human sense organ provides a sensory basis for a developed art form, and, second, that why some sensory experiences developed into high arts may remain forever unknown to us.

Smell

Philosophers of art Larry Shiner and Yulia Kriskovets have argued that olfactory art is unjustly ignored by art theorists but that smell art is "in its infancy" and is set to develop a solid place for itself in the future of art. If this idea seems surprising, Shiner and Kriskovets attribute the surprise to "a longstanding philosophical prejudice against the so-called lower senses of smell, taste, and touch that has often led to the denial of their suitability for aesthetic reflection," a prejudice many moderns share. Philosophers, going all the way back to Plato and Aristotle, have regarded smell as "far beneath vision and hearing in dignity, intellectual power, and refinement." As the sense closest to humans' animal nature, it has traditionally been disqualified from serious aesthetic or artistic consideration.

But is there, as Shiner and Kriskovets put it, a "prejudice against

smell" that keeps us from taking it seriously as an artistic medium? Looking around at the general culture, I find it hard to discern any bias against smell purely as a sense. Perfume is a widely advertised and sold luxury commodity; the food pages of magazines and newspapers continuously tout and critically discuss the aromas of foods and wines. Car manufacturers worry about the exact showroom smell of their new vehicles, and a hotel chain even injects into the lobbies and hallways of all its facilities a pleasant but peculiarly distinct odor to stimulate the olfactory memories of its regular customers. Drugstores and groceries sell countless products to add, enhance, or remove smells in daily life, sprays and potions that come out of a gigantic international industry of research into and manufacture of smell products.

Moreover, the human sense of smell is acute and highly discriminating. It is said that human beings can distinguish thousands of different odor molecules, which makes the nose at least as discriminating as the eye or the ear for distinguishing different sensations. Many smells are intrinsically pleasant to humans, such as those emanating from some fruits and flowers—especially cultivars that have been domesticated precisely to appeal to human olfaction. Shiner and Kriskovets claim that the "purely sensuous, noncognitive character of scents" counts against smells in art-theoretical thinking, but this cannot be true. If anything, there is for human beings more potential cognitive information in a single smell than you'd normally expect from a single color or a single sound. Smells function as important cognitive signals, as in the attractive aroma of roasting meats, the subtle attractions of sexually implicated pheromones, the peculiarly pleasant smell of a baby, or the nauseating odors of rancid foods. Although the sense of smell did not develop in the human brain to levels of sensitivity seen with other mammals (we have only forty thousand olfactory receptors to the bloodhound's two billion), and indeed, the human smell sense may have atrophied as our proto-human ancestors' brains grew to give us language, the olfactory sense remains important in human life today.

Long tradition is certainly correct in seeming to recognize that sight and hearing are historically, and doubtless prehistorically, far more important than smell to human beings as survival tools. We imagine our upright-walking hunter-gatherer ancestors gazing across the savannas in search of game or predators, or listening intently for the faint sound of a

breaking twig in the forest at night: these are examples of the survival value of eyes and ears. The nose too afforded knowledge, and therefore survival value, but not to the same degree. To this day, we use "I see" for "I understand," and the vocabulary of knowledge is shot through with metaphors of light and vision. "I hear . . . ," on the other hand, implies secondhand information, while "I smell" is almost absent from the vocabulary of knowledge, except to denote suspicion or to suggest mild irony ("I smell a rat"). Unlike colors and sounds, smells are largely built around attraction and aversion: single smells can be "mouthwatering" or "sexy" or "repulsive" in ways that no single color or sound can be. In particular, in terms of raw survival, smells associated with revulsion are very likely the most important in evolution: unlike that of the the African hyena and other scavenging mammals, the human digestive system did not evolve to cope with the bacterial dangers of rotted meat; extreme averse reactions to it are therefore a crucial evolutionary survival tool.

Nevertheless, given the vital importance of the sense of smell, the discriminative capacities of human olfaction, and the fact that many fragrances are pleasurable in themselves, you might think that smell would have become the medium for a grand art tradition—that it would have developed into an art form to stand beside the big three of visual arts, language arts, and music and dance. The fact that this has not happened ought to strike any philosopher of art as curious and counterintuitive, but it has been the subject of remarkably little scientific or philosophical speculation. One worthwhile stab at the subject is found in a passage by Monroe Beardsley in his *Aesthetics: Problems in the Philosophy of Criticism*. He claims the fundamental problem with smells as an artistic medium is that, unlike musical tones, they cannot be ordered by "intrinsic relations" among themselves. With musical pitches, one note is always higher or lower than another, they stand in scales with octaves, and they can be arranged in serial order with regard to loudness or duration. Smell defies any such rational arrangement. Beardsley has us imagine "a scent organ with keys by which perfume or brandy, the aroma of new-mown hay or pumpkin pie could be wafted into the air." How, Beardsley asks, could such an instrument be built?

> On what principle would you arrange the keys, as the keys of a
> piano are arranged in ascending pitch? How would you begin to

look for systematic, repeatable, regular combinations that would be harmonious and enjoyable as complexes? . . . Some smells are certainly more pleasing than others. But there does not seem to be enough order within these sensory fields to construct aesthetic objects with balance, climax, development, or pattern. This, and not the view that smell and taste are "lower senses" compared with sight and hearing, seems to explain the absence of taste-symphonies and smell-sonatas.

Beardsley may have identified part of the problem with smell as an artistic medium, but there seems to me to be more to it than a lack of systemization. Smells are certainly disanalogous to sounds in forming what appears to be a rational system—with octaves and fifths, consonances and dissonances—but they are actually not so far from colors: the visual spectrum is systematic, to be sure, but the use of mixed colors in the history of painting has always been intuitive and singular, and never especially depended on observing the rainbow or on Newton's demonstration of the spectrum (the discovery of perspective did far more for the history of painting than the discovery of spectral ordering). Like colors and also sounds, harmonious complexes of smells are possible, and the progression of foods through a meal or the experience of good wine depends on them. Still, few are willing to class the best culinary or oenological experiences alongside the *Iliad* or *Guernica*—even if experiences of meals and fine wines are some of the most prized and pleasurable moments life can offer. Why?

Memory plays a crucial role in creating an aesthetic structure in an experiencing mind. Beardsley speaks of repeatability, balance, and pattern. In order for repetitions and pattern to be grasped in music, poetry, or fiction, you have to be able to remember individual elements—words, notes, sequences, melodic fragments, fictive events, names, etc.—over long periods. Events that happen at the end of a five-hundred-page novel can echo events from its very beginning, or throw into new light passages in its middle chapters. Even ordinary, untrained perception of music may require being able to remember and arrange in the imagination hundreds of elements for an individual piece. Normal human memory is filled with a stupendous quantity of coherently arranged and articulated musical notes—melodies, chords, rhythms—picked up over

a lifetime. In general, the impact of narrative, musical, and other temporal arts depends on an ability to discriminate elements and see how they are arranged in the imaginative experience of a work.

Smells resist this kind of imaginative arrangement. You can hear fifty words or fifty musical notes and understand how they carry forward as a complete imaginative experience. If these elements are the beginning of a poem or a musical work they will be discrete, and yet unified in a single experience that is more meaningful than any one element itself. Try, then, to imagine an experience of fifty successive smells—whether individual aromas or mixtures—presented as a work of art to the imagination. Since smells tend to obliterate each other in ways that the semantic fields of words do not, making experiential distinctions would be very hard indeed. Could you remember sequences seven, eight, and nine by the time you were at smells forty-one and forty-two? Could the human mind be trained to place these separate experiences into an imagined whole, one that is available for disinterested contemplation?

It seems impossible: we did not evolve to process olfactory information in the way we process the meanings of notes, words, or even colors in particular artistic contexts. I acknowledge that professional perfumers can make smell distinctions that would defy normal perception and that such an extraordinary nose and olfactory memory as that possessed by the wine expert Robert Parker are within the realm of human possibility. I also accept that smell can powerfully incite memory: virtually everybody—not just Marcel Proust—knows foods and aromas that will transport the mind back to childhood experience. This intense and singular capacity is not, however, what is required to reconstruct and present in the mind an imaginative work of art. It is far too crude to suggest that words and tones are somehow of the mind, while aromas are associated with the body, and that this is the reason smell will therefore never provide the material for high art. Rather, it is our ability to remember smells and arrange them into aesthetic wholes that is the issue.

There is yet another problem with smell as an art medium: its failure to evoke or express emotions beyond those of personal association and nostalgia. Smells, unlike colors, do not have names of their own: they are always identified by what they are smells of (vanilla, orange blossom, bakery, wet dog, burnt match, tar, rosemary, pine smoke, strawberry,

garlic, etc.). Any person may associate a smell with other experiences or feelings (burning incense with one's religion, for instance). But smells are oddly without the intrinsic emotions of the sort that seem to inhere in the structures of music or the expressively colored forms of painting. The philosopher Frank Sibley appears to agree with this point when he says that smells and flavors "are necessarily limited: unlike major arts, they have no expressive connections with emotions, love or hate, grief, joy, terror, suffering, yearning, pity, or sorrow." Thinking back to the cluster criteria listed in chapter 3, the absence in olfactory experience of either emotional saturation or expressive individuality seems to count decisively against smell as the medium for a self-subsistent art form that might someday stand with music, painting, drama, and literature. This despite the fact that the creation of smells may be a demanding skill and the result—from perfumes to foods—extremely pleasant.

I think it likely that every known medium that can be manipulated, utilized, or adapted to the basic requirements of an art form has already been turned toward making art. Human ingenuity and creativity, coupled with the relentless desire to turn pleasures into arts, has guaranteed it. Academic pleading at this late stage on behalf of smell arts is much less interesting than trying to answer the question of why smell, despite its importance in evolution and the pleasure it can provide, has never by itself been the stuff of art. Moreover, despite artistic experimentation and academic theorists' hopes, smell shows no solid signs of becoming the basis for a high art tradition.

Sound

Music, on the other hand, did become one of the supreme art forms: universal across cultures and history, a focus of spontaneous interest from infancy, and for many individuals a source of consuming, lifelong pleasure. All this despite the fact that the ability to perceive its medium—pitched sound—has almost no imaginable significance for survival in natural selection. The sounds of nature—wind in the trees, crack of lightning, breaking waves and rushing waters—are predominately variations on white noise. It is a feature of music cross-culturally, however, that it uses relatively pure, pitched tones. The only common natural source of pitched tones in human experience is birdsong, along with the

howls and cries of a few mammals and reptiles. Many animal sounds are inaudible to the human ear, and, in any event, there is nothing in the potential adaptive advantages of knowing birdsongs and animal cries that can remotely explain the deep and pervasive hold of music on the human mind in almost every culture.

Charles Darwin himself counted the "capacity and love for singing or music" among "the most mysterious" features of the human race, and in *The Descent of Man* he devotes a substantial passage to the origins of music. The very uselessness of music in terms of natural selection, along with its flamboyance, forces Darwin to see it as a product of sexual selection, descended from mating and rivalry cries of our prehuman ancestors. In the course of presenting his case, Darwin also makes two observations that go beyond overt issues of sexual selection while still cutting to the heart of music as a potential art form. First, Darwin stresses the relation of music to emotion:

> Music arouses in us various emotions, but not the more terrible ones of horror, fear, rage, etc. It awakens the gentler feelings of tenderness and love, which readily pass into devotion. In the Chinese annals it is said, "Music hath the power of making heaven descend upon earth." It likewise stirs up in us the sense of triumph and the glorious ardour for war. These powerful and mingled feelings may well give rise to the sense of sublimity.

Darwin would not deny, presumably, that a musical soundtrack could be appropriate for a horror movie; he is only claiming that the raw horror a dramatic story might incite could never be produced by music, any more than anger or fear could be produced by music. Music's natural ground is—as you would expect for an adaptation of sexual selection—romance. Indeed, he remarks, "Love is still the commonest theme of our songs."

A second connection Darwin describes is music's ancient tie to language, in particular to oratory—that is to say, language in public performance. He observes that "when vivid emotions are felt and expressed by the orator, or even in common speech, musical cadences and rhythm are instinctively used." The sensations and ideas "excited in us by music, or expressed by the cadences of oratory, appear from their vagueness, yet

depth, like mental reversions to the emotions and thoughts of a long-past age." Darwin's speculations have for me a ring of truth:

> All these facts with respect to music and impassioned speech become intelligible to a certain extent, if we may assume that musical tones and rhythm were used by our half-human ancestors, during the season of courtship, when animals of all kinds are excited not only by love, but by the strong passions of jealousy, rivalry, and triumph . . . We must suppose that the rhythms and cadences of oratory are derived from previously developed musical powers. We can thus understand how it is that music, dancing, song, and poetry are such very ancient arts. We may go even further than this, and, as remarked in a former chapter, believe that musical sounds afforded one of the bases for the development of language.
>
> The impassioned orator, bard, or musician, when with his varied tones and cadences he excites the strongest emotions in his hearers, little suspects that he uses the same means by which his half-human ancestors long ago aroused each other's ardent passions, during their courtship and rivalry.

This is genuinely plausible. Song—speech rhythmically expressed in pitched tones—is universal and obviously the simplest musical form. But there is an important feature instrumental music also shares with language, a feature that tends to go unnoticed. The language-recognition machinery of the human brain fundamentally distinguishes vowel sounds—pure, simple tones—from consonants, which are more complex, and combined with vowels create a gigantic realm of linguistic possibility. This enables us not only to distinguish human speech from other noises but to make countless subtle aural differentiations. Music exploits the ability to perceive such minute and subtle distinctions, not only with the singing voice but in instrumental music as well. Musical pitches are the equivalent of vowels—"supervowels," they have been called—that stand in systematic relation to each other: the fifth, the octave, diatonic tuning, and so forth. The attack of an instrumental note, the first tenth of a second or less, is picked up by the ear in the way that a consonant at the beginning of a word is acoustically perceived; it con-

ditions how its vowel sound is heard: the acoustic differences between the spoken "play," "bay," "ray," "stray," "day," and "stay" are minute, happening in the first milliseconds of the words. Anyone who has played with digital editors or even magnetic tape may know that, in exactly the same way as removing the consonant, snipping off the attack of a note can make it impossible to distinguish whether it is being played by an oboe or a violin or a clarinet.

If you add rhythm to the quasi-speech of vocally or instrumentally produced pitched sounds, and load tonal harmony and melody onto that, you have music as we know it. Music is a peculiar art form in a few respects that are worth paying attention to. First, it tolerates repetition in a way no other art does. The music psychologist David Huron has studied work from fifty widely scattered musical cultures across the globe—Navajo war dance, Gypsy, flamenco, Punjabi pop, Estonian bagpipe, and so on—and found that on average "94% of all musical passages longer than a few seconds in duration are repeated at some point in the work." With many European classical works that figure would be higher, with repetitions embedded in repetitions. Not only is repetition intrinsic to musical composition and expression, musical works bear wholesale repetition in a way found in no other art. I must have heard the Beethoven and Brahms symphonies hundreds of times, and yet could with pleasure listen tonight to another performance of these works. No other art encourages repetitive experience quite so much: poetry does to some extent, but reading a novel or story hundreds of times is unlikely. Drama allows repetitions, but our willingness to see Shakespeare performed over and over depends on new productions and actors. Even among the most devoted movie fans, there is no appetite for repetition in film experience that matches the eagerness to hear the same music recordings over again, from Haydn to Leadbelly, Sarah Vaughan to Glenn Gould.

As mentioned earlier, most of us walk the streets with thousands of fragments and whole pieces of music available in memory. We can hear the initial notes of pieces and often sing through them completely in our minds. Pieces of music can get "stuck in your head," repeating over and over again to the point of annoyance, and in a manner that is seldom experienced with scraps of poetry, prose, or visual sense. Memory tasks can be made easier with music (children learn to sing the alphabet), and

stroke sufferers who struggle with speech can often still sing. The immediate, spontaneous accessibility of music, its clear association with pleasure, and our memory for it should strike us as uncanny.

Memory and repetition make it possible for musical works—from pop ballads to Mahler symphonies—to have structural form, melodies, development, suspense, climax, and surprise, all of which generate pleasure. The capacity to appreciate music requires that the listener be able to plausibly predict at each moment what the next note, chord, transition, or cadence is going to be. Music arrests attention and keeps it focused by continuously positing possibilities for the next few seconds of a piece and then either giving the listener the pleasure of having expectations confirmed or the (often pleasant) surprise of having expectations thwarted or subverted. Listening to music, the mind is instant by instant absorbing what has gone before and anticipating what is yet to come— with the greatest composers, like the greatest storytellers, usually playing a masterful game of setting up expectations that are then foiled with something even more interesting than you had imagined.

In music theory, aesthetic modernism has shown little interest in such musical psychology. It has instead placed its hopes in the malleability of aesthetic taste, preferring a picture of genius composers ultimately overcoming resistance from the closed-minded conservatism of audiences. I do not think the picture is justified, as the case of Arnold Schoenberg demonstrates. With his invention of the twelve-tone method to replace traditional melody, Schoenberg is said to have brought atonality to music. But as Huron points out, Schoenberg's twelve-tone music is not so much atonal as *contratonal*. If Schoenberg had set out with a randomizer to create his tone rows, tonal relations would now and again occur simply by chance. His tone rows, however, are built on a principle of reverse musical psychology: he wrote them precisely to avoid even as much tonality as would occur probabilistically with a throw of a composer's dice.

More than that, the intervals in the tone rows are, Huron shows, "more than double the average for music from around the world." The notes of most melodies—Mary Had a Little Lamb or the choral theme from Beethoven's Ninth Symphony—are either contiguous or for the most part fairly close to each other. In creating tone rows with extraordinarily wide intervals, Schoenberg achieved something remarkable in

any global comparison. Huron has been able to show that Swiss yodeling is the only music that routinely contains "wider melodic intervals than twelve-tone music." No wonder audiences have tended to find Schoenberg's twelve-tone compositions "senseless" or "excruciating."

Schoenberg, in my opinion, wrote some extraordinary music—*Transfigured Night* and *Moses and Aron* are impressive creations. But the general failure of his contratonality to catch on with the musical public is evidence that it is not just another conventional musical schema for the blank slate that is the human mind. World music grows out of natural, evolved interests, however puzzling their origins. The aesthetic effects of music universally depend on listeners being able to anticipate climaxes, resolutions, suspensions, or cadences—and then hear the music fulfill or foil those anticipations. Completely unpredictable music—which is what Schoenberg's atonality comes to, unless you memorize the sequences—can no longer surprise the mind: if just *anything* can be expected, nothing can enter experience as unexpected. It follows that nothing can surprise, jar, fulfill, shock, or in other ways please the listener. At their self-serving worst, modernist theorists have blamed the failure of audiences to appreciate atonality on stupidity, laziness, or musical naïveté. But composers too can err in producing work that, for all its intellectual interest, is unable to draw from the wellsprings of musical pleasure in the mind.

III

Darwinian theory, particularly when it involves sexual selection, does not propose that we can adduce from evolutionary theory itself exactly how or why the arts have come down to us in the ways we now experience them. Evolution remains a kind of natural history—in truth, an unrecoverable prehistory—with twists, turns, and genetic bottlenecks we shall never know about.

Olfaction, with its intense sensation, marked pleasure, discriminative capacity, and connections with personal memory, ought to have been the basis of a high and abiding art form. But for reasons we do not fully understand, this did not happen. I have put it down to the inability of the human mind to arrange smells into meaningful formal gestalts, to

remember them in structures that are then savored in the imagination as objects of disinterested pleasure. In actual experience, smells obliterate each other, while in memory they cannot be recalled in discrete sequences as words or musical notes can. I've also pointed out that smells, despite their personal importance in creating moments of nostalgia, in jogging memory, are not able to evoke or express strong emotions of the sort we require from drama, music, literature, or painting. Despite its obvious survival value, smell therefore never became the basis for a high-art tradition—except that the "therefore" denotes no logical entailment but a series of contingent evolutionary events in human prehistory. If our quirky prehistory had taken different paths, smell might have a different place in modern human culture.

Pitched sounds, however, became the basis for a great art form despite having no survival implications whatsoever. While I am persuaded by the plausibility of Darwin's speculations about mating cries being somehow involved in the origins of music, to trace a continuous route from primordial calls to *The Art of the Fugue* will never be possible. Moreover, annexing music wholly to the procreative interests in the way that sexual selection suggests misses a great deal of the art itself as we understand it today. Yes, music and dance have clear relevance to courtship. Yes, lovers do sing for each other in some folk traditions, though today lovers sing mostly as characters in opera, musicals, and Bollywood gush: the love song appears in dramatic performances rather more often than in direct, one-on-one acts of seduction. Much music-making is communal on a large scale (chorus or orchestra before a large audience), whereas love-making remains cross-culturally a private transaction. (In fact, today I'd guess that lovers are more likely to speak a pseudo baby talk among themselves, or trade poems, than to sing to each other.)

To further complicate matters, for many music minds, a major attraction of music today lies not in its communal dance potential or connections with love but in the emotionally staggering ways that it shifts harmonically. Admittedly, I speak here for myself and my own deepest experiences with music—beginning as a child listening over and over again to my parents' Toscanini recording of Beethoven's Seventh Symphony, especially the allegretto with its captivating key modulations. Yet key modulations of the sort I refer to—the ones that make the transi-

tions in Vaughan Williams's *Fantasia on a Theme by Thomas Tallis* or the closing pages of *Götterdämmerung* or Beethoven's Ninth Symphony so sublime—are very late inventions in musical culture. How these acoustic phenomena came to so stir the mind—spontaneously, pleasurably, effortlessly—is another mystery of evolution.

Our aesthetic tastes and interests do not form a rational deductive system but look rather more like a haphazard concatenation of adaptations, extensions of adaptations, and vestigial attractions and preferences. They evolved to delight and captivate human eyes, ears, and minds—not to form a logical system or make intellectual life easy for aesthetic theorists. Of course, many would prefer to believe that whatever we find beautiful is beautiful everywhere and for all time. In that spirit, the pianist Louis Kentner once observed that if a Martian were ever to visit us, he ought to be presented with the Beethoven piano sonatas, as proof of what our civilization is capable of. A lovely thought, but it does not survive a moment's critical scrutiny. Had Kentner considered the density of air on Mars and its effect on the evolution of ears? Would the Martians have any conception of arranging pitched tones into meaningful sequences? On the other hand, who can say that, given how they evolved, Martians might not be enraptured by the smells of Earth, succumbing to the charms of perfumers, the distinct odors of an insecticide factory, or a slaughterhouse? We may think that we made music for the whole universe. In truth, we made music just for ourselves.

CHAPTER 10

Greatness in the Arts

I

The arts are not the only sources of pleasure in our lives, or even for a majority the most important ones. People take joy in their hobbies, their families and pets, spectator sports, food and wine, political causes, and collectibles. They get high on drugs and find deep rewards in religion or the company of good friends. The desire, however, to combine sources of feeling—an enthusiasm for rock climbing with the pleasure of travel, a love of children with the enjoyment of woodworking—while perfectly predictable at an ordinary level, has led to many a muddle in art theory. You may love poetry and be fascinated by fine porcelain; it does not follow, however, that the greatest work of art is a plate with a poem painted on it.

Because (1) so many activities require skills that, if they have any inventive or expressive potential at all (cake decorating, lawn care), can be marginally turned into arts in some of the ways defined in chapter 3, and because (2) even the canonical arts overlap and interpenetrate with large, non-artistic domains of human enjoyment, there is plenty of potential to conflate artistic with other pleasures. Another factor also seeds misunderstanding: the desire of artists, writers, musicians, ordinary audiences, and academics to endorse or to validate the arts by associating them with their favorite enthusiasms—typically political or religious causes—or alternatively to dignify their non-artistic interests by reckoning them to be artistic too.

The disputes generated by this miasma of confusion—along with a century of tedious arguments about whether this or that tribal sculpture or modernist experiment is "art"—have for generations distracted attention from the fact this book is meant to explain: the universal appeal of the arts—from soap operas to symphonies—across cultures and through history. The principal way to make sense of the universality of art is, as I have argued throughout, to understand the arts naturalistically, in terms of the evolved adaptations that both underlie the arts and help constitute them. In this last chapter, however, I want to shift attention from the arts as general phenomena of wide appeal to the more rarefied pinnacles of artistic achievement: I want to examine the bearing evolutionary theory has on understanding the qualities of the greatest artistic masterpieces.

II

Clive Bell's classic essay "The Aesthetic Hypothesis," the first chapter of his 1914 book *Art*, defends his modernist formalism in what has always been for me one of the most evocative passages in the history of aesthetics. In explaining how most viewers miss the aesthetic point of painting, as he understands it, by concentrating their attention on the represented content of pictures, he describes his own limited, not to say dunderheaded, musical perceptions. Bell admits that he is not musical: the subtleties of harmony and rhythm escape him, he declares, and he has little sense of musical form. Once in a while, however, when he is feeling "clear and bright and intent," perhaps at the beginning of a concert, he can for a while appreciate music "as pure art with a tremendous significance of its own and no relation whatever to the significance of life; and in those moments I lose myself in that infinitely sublime state of mind to which pure visual form transports me." His normal state of mind at a concert, as he explained, was quite inferior:

> Tired or perplexed, I let slip my sense of form, my aesthetic emotion collapses, and I begin weaving into the harmonies, that I cannot grasp, the ideas of life. Incapable of feeling the austere emotions of art, I begin to read into the musical forms human

emotions of terror and mystery, love and hate, and spend the
minutes, pleasantly enough, in a world of turbid and inferior
feeling. At such times, were the grossest pieces of onomatopoeic
representation—the song of a bird, the galloping of horses, the
cries of children, or the laughing of demons—to be introduced
into the symphony, I should not be offended. Very likely I should
be pleased; they would afford new points of departure for new
trains of romantic feeling or heroic thought.

Such trains of agreeable thought, Bell explains, are a way of using art
"as a means to the emotions of life." He then concludes with a haunting
passage:

I have been using art as a means to the emotions of life and
reading into it the ideas of life. I have been cutting blocks with
a razor. I have tumbled from the superb peaks of aesthetic exal-
tation to the snug foothills of warm humanity. It is a jolly coun-
try. No one need be ashamed of enjoying himself there. Only no
one who has ever been on the heights can help feeling a little
crestfallen in the cosy valleys. And let no one imagine, because
he has made merry in the warm tilth and quaint nooks of ro-
mance, that he can even guess at the austere and thrilling rap-
tures of those who have climbed the cold, white peaks of art.

Bell is defending a particular theory of abstraction in painting by ap-
pealing to the commonly accepted idea that music is abstract. He is ask-
ing, if we accept abstraction in music, why not accept it in painting? His
description, however, of experiencing the highest art has a much broader
application: it is about how we are dragged down from what he regards
as the aesthetic heavens when we use art to reproduce comfortable emo-
tions or to exemplify our treasured beliefs. "Cold" may not be quite the
right word for all of the greatest art, but Bell's mountain analogy, sug-
gesting climbing, an exploration, the achievement of a vista, does make
the grandeur of the Himalayas a fine metaphor for the greatest works
of art.

III

Before turning to the aesthetic peaks, however, I want to deal with three areas of jolly aesthetic foothills and the intellectual quicksands that surround them. These are the widely held views that the arts evolved to build stronger societies or that they are intrinsically involved with religion, morality, or politics. I shall also draw distinctions between art and craft that have bearing on the question of what makes a masterpiece. I begin with four assertions:

1. The arts are not essentially social. If you look over a wide range of group experiences, today and through history, there are clear associations between artistic activities and social life. Painted Paleolithic caves were places for ceremonies, and the evidence points to group dancing as having been a prehistoric activity. There is a sense of shared pleasure in being in an audience enjoying a musical performance. Sacred music in religious services is for many people extremely moving, while on a rather different level there is a thrill to be found in the synchronized expressive dancing of a corps de ballet. More personal are the rewards for instrumental players in the creative coordination required to make chamber music, and I've been told by more than one choir singer that the intense pleasure in joining the single voice of a chorus is like nothing else in experience. I don't personally know about that, but I have studied and engaged in sing-sings—continuous rhythmic singing and dancing through the night—in New Guinea jungles and have looked in on raves of the kind that became popular in Europe and America in the 1990s. It is a serious understatement to describe these events as merely similar: they are, so far as I can tell, exactly the same activity, except that the age range of participants in sing-sings is wider and the electrical amplification in raves makes the music louder.

Described in this way, music and dance would seem to increase *empathy, cooperation,* and *social solidarity.* Human beings are an intensely social species, team players who trade ideas, relish each other's company, like to communicate, and create complex, integrated social groups to pursue common ends. Could it be that music, dancing, storytelling, and the other arts evolved specifically to strengthen the social health of hunter-gatherer bands, and that this survival value can explain the universality, persistence, and pleasure of the arts?

Many of the most thoughtful theorists in the evolution of the arts have

inclined toward this view. Over a century ago, Emile Durkheim described moral codes, rituals, and customs as functioning to increase social solidarity. His idea was widely adopted by social scientists as an explanation for many social activities, especially those of a ceremonial character. In this tradition, Ellen Dissanayake has argued that singing and dancing have their roots in the turn-taking, imitation, and mutuality of mother-infant play. The gestures and rhythmic movements of adult dances and other performances grow from childhood and create a sense of belonging for every individual, fostering social cohesion. Ceremonial activity stretches from hunter-gatherer prehistory to the subcultures—families, clubs, teams, religions—in mass society today. "Ceremony," Dissanayake says, is "a one-word term for what is really a collection or assembly of elaborations"— patterning and accentuations—"of words, voices, actions, movements, bodies, surroundings, and paraphernalia" that in the end constitute the arts: "chant or song, poetic language, ordered movement and gesture or dance, mime, and drama, along with considered and even spectacular visual display." The art-saturated ceremonies we see across human cultures display "supreme beauty, skill, extravagance, and impressiveness." They may be designed to impress the gods and convey messages about order and meaning in the cosmos, but they build stronger societies along the way.

Or so it can certainly seem. Yet not everyone is convinced by this "social cohesion" explanation for the arts. Steven Pinker associates it with the theory of *group selection* in evolution: the idea that strong groups evolved through systems of mutual reciprocity and that traits of the group—its size, structure, division of labor, and so forth—are selected for at a level above that of the individual. Leaving aside the technical objections to group selection theory as an evolutionary principle (personally, I find the idea of group selection attractive), the case for it providing an evolved function for the arts seems to me weak. To begin with, working communally to create an object of beauty does not always build social ties. Leo Tolstoy's *What Is Art?* provides a hilarious eyewitness account of an opera rehearsal. Tolstoy starts by describing dirty, tired stagehands scolding one another. Their ill-humor does not come close, however, to that of the conductor for the performance. As the tenor begins to sing, "Home I bring the bri-i-de," the French horn misses a cue. The conductor angrily raps his music stand and denounces the horn player. The tenor starts again. "Home I bring the bri-i-de," but the cho-

rus fails to raise their hands at the right moment. "Are you dead, or what? Cows that you are? You're corpses!" So they begin again, and stop again, and begin again, for six hours. "Home I bring the bri-i-de," repeated twenty times followed by raps with the stick, scolding, and corrections, the conductor shouting "asses," "fools," "idiots," "swine." Tolstoy, of course, has a larger intention: to argue that elite European arts such as opera are literally demoralizing, and are therefore not true arts, which by his definition must tie together the human community. He may be wrong in holding that opera is not a proper art, but he is surely right that the arts do not always create warm communities.

Music-making spans a spectrum from one extreme of Tolstoy's opera rehearsal to the other extreme of a choral singer submerging herself in the glories of the *Missa Solemnis* or to the intimacy that can come from the cooperative satisfactions of making chamber music. I was once discussing Beethoven chamber works with a colleague, a violin professor who had played extensively in Europe. I showed him an old LP recording of the Razumovsky quartets that had given me much delight. It had a photograph of the performing ensemble on the cover, four rather serious-looking gentlemen who together had made a successful career for themselves as a string quartet in the 1950s and '60s. Ah! My friend was acquainted with them, and he told me that this particular quartet was notorious. These four artists so despised each other that except for pure business, they avoided speaking, and where possible always stayed at four different hotels when traveling. Why should this have surprised me? After all, it is not just music: the worlds of painting and literature are equally riven with intense competition, feuds, jealousies for the success of others, and gnawing resentments of every kind.

Pinker objects in general to group selection because he thinks that in order for it to work as a valid evolutionary process, the actual structural characteristic of the group—its size, for instance—must be specifically selected for repeatedly across generations in the way that genes are. Instead, what group selection theory offers is "gluey metaphors": bonding, social cohesion, cementing relationships, and so forth. This account, Pinker argues, cannot "do justice to the ambivalent mixture of selfish, nepotistic, strategic, and self-advertising motives that really animate a person's feelings toward his or her group." It is entirely true that some of the most agreeable human experiences involve being members of a group,

including taking part in artistically creative group efforts or being a member of an appreciative audience. But just because the potential to feel warmth and satisfaction in communal experience is fundamental to the human personality, and therefore comes to the fore when people gather together to enjoy artistic performances, it does not follow that communal experience is itself fundamental to the arts.

Wondrous aesthetic experiences are possible in the absence of a sense of larger community: the response an individual has to a beautiful landscape, for instance, or to a private, silent reading of a novel or a poem, to a painting, or to a recording of the *Goldberg Variations* heard in solitude. If the arts were intrinsically social in the way that social-cohesion theory claims, we could expect that people would not only flock to hear authors' readings of their works (where the point is the presence of the literary artist), they would also take pleasure in attending readings of novels together. They would prefer standing in a crowd to see a painting in a museum, rather than standing alone, and musical friends would normally come together to hear recordings. To be sure, novel readers do form book clubs; but this is less a fact about novel reading than about the propensity of enthusiasts for any pleasure—dog breeding, gardening, politics—to form clubs.

My own view is that traces of sexual selection, the evolutionary process that pits suitors against each other in a competition with real winners and losers, undermines the communal spirit as having an intrinsic role in the arts. Because of sexual selection, the arts retain an incorrigible sense of being made by one individual person for another. Arthur Rubinstein's recitals were often experienced as great communal occasions of the audience paying homage to a fine pianist while both he and the audience honored the composers whose music was being performed. Yet Rubinstein said that what he really liked in a recital was to fix his eye on some lovely sitting near the stage and imagine he was playing just for her. The motives of art, as even Darwin knew, are ancient and complicated—directed toward a community, perhaps, but also created to captivate an audience of one.

2. The arts are not just crafts. I have argued that an often spine-tingling part of our ancient, evolved response to the arts is the appreciation of technical achievement. That does not mean, however, that every instance of skill or craftsmanship (for instance, in the work of a plumber or an accountant) will be in itself a candidate for art.

Most people understand craft in terms of its ordinary products: weaving, pottery, and furniture-making are regarded as crafts because they use fiber, clay, and wood to produce useful artifacts. Such craftsmanship requires genuine skill, in the sense of minimal competence, to yield passable results. But as usually conceived, crafts *only* require competence—unlike fine arts such as painting, musical composition, and poetry, which we think of as needing special talent. The British philosopher R. G. Collingwood accepted these commonplaces but, in the 1930s, formulated the difference between art and craft in a way that made the distinction independent of what an artifact was made of or whether it was useful.

Craft, Collingwood argued, is skilled work purposefully directed toward a final product or designed artifact; the *craftsman knows in advance* what the end product will look like. The craftsman's foreknowledge is required by the very idea of a craft. An experienced cook following a recipe to make vanilla ice cream can be described as a craftsman not because he can anticipate every problem he will meet along the way but because he clearly (not vaguely or generally) knows in advance what vanilla ice cream looks and tastes like and knows exactly how to whip it up. In craft, Collingwood says, the result in this way "is preconceived," fully understood before being arrived at. Thus a cook who tries to make ice cream and ends up with sweet cottage cheese may have inadvertently produced a delicious dish. But as pleased as we may be with the result, such culinary misadventures are not the competent exercise of craft.

Art is in this respect an entirely different domain. Like craft, art requires the exercise of skill and technique, but the artist does not have anything resembling the craftsman's precise foreknowledge of the end state—the finished art work—when he starts out. A proper art, Collingwood argued, is open during the creative process to a partial or complete change of direction or goal—open even to losing any sense of goal at all. The artist may change his mind, seize a new possibility, or make a surprising turn. If a poet begins to write a hymn in praise of Fidel Castro and ends—even against his initial intention—with a work about the odiousness of poems in praise of dictators, we do not see the poet as any less competent or the poem in that respect any less a work of art.

We pay craftsmen to paint houses or repair clocks because of the dependability of learned techniques: these people know what they are doing. But in the sense of using skill to produce a preconceived result, creative

artists strictly speaking *never know what they're doing*. Even Mozart, who could compose music faster in his mind than he could actually write it down, and might therefore look to a naive observer like he was transcribing a preconceived outcome, was fully an artist in the sense described: he did not, after all, compose his music before he composed it. The domain of craft is one of recipes, instruction books, formulas, methods, and routines. The arts, Collingwood argued, are always open to the unexpected; a change in a single word or note or brushstroke can alter or even reverse not only the meaning of the work but the artist's entire objective.

Collingwood applied this craft/art distinction to the feature that he considered central to the great historical arts as they have come down to us: the expression of emotion. He distinguished the artistic expression of emotion from the more craftlike practice of emotional arousal. For him, *arousing* an emotion is essentially a matter of trying to incite in an audience some kind of general, preconceived emotional response. Arousal is manipulative, which is why we speak of a formulaic movie or novel designed to elicit a predetermined sadness as a "tearjerker." People are aroused by patriotic music, melodrama, and sentimental poetry. Stage magicians can arouse surprised reactions from audiences with illusionistic skills, creating seemingly impossible spectacles.

The artist, on the other hand, probes the content of human emotional life with an eye toward articulating, or making clear, a unique emotion, an individual feeling. The endpoint may be a moment when the artist declares, "That's it, that's what I wanted." But when that moment is reached, it is, so to speak, discovered for the first time by the artist.

If an actress, for example, sets herself the task of arousing a kind of emotional reaction in an audience, then in Collingwood's terms she is exercising a craft. This craft is a perfectly honorable job, requiring learning lines, taking direction, and exercising a host of skills. However, if the actress sets out to plumb the emotional and intellectual possibilities of a difficult or ambiguous part, if she is, say, trying to make the character's particular motivations and emotions clear to her audience but at the same time clear to herself, then she is at that moment engaged in the creative work of an artist. She is not simply acting out a Shakespearean part for an audience, she is trying to discover what is in the soul of Lady Macbeth.

Kant said of the beautiful that it is something that "pleases without a concept," and that beautiful objects possess "purposiveness without pur-

pose." Good pickup trucks or good pencil sharpeners do well what we know in advance we want them to do. Kant meant that there can be no preconceived idea of a beautiful novel or a beautiful piece of music in the same way: the work of art is not an answer to a problem out in the world but an object of contemplation in the theater of the imagination that makes up its own problems and supplies its own solutions. That is why painting with a paint-by-the-numbers set yields, in the terms described, a craft outcome, while committing to a blank canvas an entirely new, imaginative rendering of the Mojave Desert is an art. As art, it cannot be cranked out according to a routine or plan.

This basic distinction, incidentally, explains the disquiet of many people about the inclusion in the Olympics of athletic performances whose appeal is partly artistic: ice dancing, synchronized swimming, gymnastic displays. The hundred-meter dash has a winner by a single criterion: whoever runs the fastest. A single success-criterion that is known in advance is the hallmark of a craft. Sports that include elements of grace and style, however, cannot have a single criterion for winning, so committees use complicated points systems to evaluate such events. The seeming objectivity of a points system is a facade, of course, that tries to hide the fact that winners in these events are decided in part by judgments of aesthetic taste, which invites inevitable disputes. What makes ice dancing and gymnastics among the most popular Olympic events is precisely that, unlike the long jump or weight lifting, they are highly virtuosic artistic displays not entirely assessable by preconceived criteria. It also makes their judging fraught with controversy.

3. The arts are not essentially religious or moral or political. The open, probing character of the arts also means that, while they are suffused with emotion and value, they will never stand comfortably alongside other human value systems. Religion, ethics, and politics all require to some degree adherence to a conceptual stability that even the most conformist artists may wish to test. The arts never quite fit with the moral demands on which any functioning society depends.

Religions have availed themselves of the arts since the Paleolithic caves. The attention-grabbing nature of art, its ritual and ceremonial potential, its ability to tell compelling stories, and the sense in which its complexities pleasurably tax the mind up to and beyond the limits of comprehension make it a suitable accoutrement for religious

practices—more suitable, for instance, than many other domains of human conduct, such as sports or cuisine. It is no wonder, therefore, that so much of the finest art of history has religious meaning, from the Parthenon and Chartres to the Taj Mahal and the Rothko Chapel, from the *Divine Comedy* and *Paradise Lost* through the *German Requiem* to *The Brothers Karamazov*. Religious feelings deeply affect millions of people, and the history of aesthetic theory includes assertions that the oceanic, transcendent feelings that the arts can induce are in essence the same as feelings derived from spiritual devotion. Very many religious believers who are art lovers feel that art is essentially religious.

Because moral values are seen across the world as issuing from religion, and because storytelling is such an important means to inculcate moral values, it is no surprise that morality becomes another element in the interplay of art and religion, along with politics. Governments use the arts to convey and bolster moral and political values. Artists for their part use art works to express moral sentiments and make political statements. Audiences in their turn make moral judgments about artists or works of art, as do politicians, prelates, and censors. The fictional heroes and villains in narrative art works invite moral evaluation. How art works stand in relation to traditions and the values they embody can be regarded as having a moral dimension.

In this endlessly complex set of interactions, there is no evidence that art is essentially religious, or that literary or aesthetic experience of any kind will improve us morally. The philosopher Martha Nussbaum has for years championed the notion that literature—and, by implication, films and other narrative media—has the capacity to broaden the imagination, expose us fictionally to exemplary moral conduct, condition the emotions, and provide us with moral guidance. In a well-known debate with her, Richard Posner, a federal judge and legal theorist, has responded that there is no evidence that literary critics and English majors are more morally refined than other mortals or that literary works in general have the edifying effects Nussbaum claims for them. Posner argues to the contrary that literature sets before readers many of the worst examples possible. Classic literature is full of moral atrocities that authors sometimes approve of and often present as the benign moral furniture of their world:

Rape, pillage, murder, human and animal sacrifice, concubinage, and slavery in the *Iliad*; misogyny in the *Oresteia* and countless other works; blood-curdling vengeance; anti-semitism in more works of literature than one can count, including works by Shakespeare and Dickens; racism and sexism likewise; homophobia (think only of Shakespeare's *Troilus and Cressida* and Mann's "Death in Venice"); monarchism, aristocracy, caste systems and other illegitimate (as they seem to us) forms of hierarchy; colonialism, imperialism, religious obscurantism, gratuitous violence, torture (as of Iago in *Othello*), and criminality; alcoholism and drug-addiction, relentless stereotyping; sadism . . .

Against Posner's hair-raising reminders (his list goes on) can be set examples of moral uplift found in literature and drama. The trouble is that many of the most influential of the edifying works—*Uncle Tom's Cabin* or *Pilgrim's Progress*, for instance—are not the best works of literary art. Posner's point, as Peter Lamarque has nicely put it, is not to deny that literature can have morally beneficial effects; it is rather that the benefits are so obscure, so diffuse and self-contradictory, that they are very poor evidence for the claim that moral edification is the main achievement of literature.

Art's encounters with morality and politics are made difficult by the fact that moral and social systems require rules to be observed and obeyed. Moral or legal systems essentially ask that people be good, and prefer (or require) narratives to promote that end. Art's most essential requirement is not that the characters it fictively portrays be good but that they be *interesting*: Oedipus, Richard III, Becky Sharp. I do not believe that this is a mere cultural convention: it is a natural outcome of the fact that fiction is imaginative (and therefore partly insulated from moral judgments) and intended to capture attention. That is why even the earliest examples of literature—the *Iliad* and the *Odyssey*, for instance—take their audience far beyond moral instruction. In so doing, they effectively undermine morality, which is one reason why Plato in the *Republic* wanted to have Homer banned from his ideal state.

Color and variety, the spectacle of human wills set against myriad obstacles, including each other, is the stuff of fiction, which is why

politicized or moralizing interpretations of literature so often flatten literary art. This is especially true in the regrettable way that much academic criticism has been carried out in the last generation. It may be an exciting discovery for some to know that Rudyard Kipling was a racist or that Jane Austen was not perhaps sufficiently bestirred by the slave trade, but besides being reminders that the past is a foreign country, such facts do not tell us much about their art. Politics is rightly about what must be done today in order to improve our lives. The arts as we confront them in Milton or the late Beethoven quartets are about features of the human condition that are not open to "improvement" by ethics committees or by legislatures. As the literary theorist Ihab Hassan has put it, politics, "when it becomes primary in our lives, tends to exteriorize all the difficulties of existence. It literally makes them superficial as Sophocles, Shakespeare, and Pascal are not. Tragedy is not injustice."

4. High-art traditions demand individuality. Why would anyone find it awkward when two women show up at a party coincidentally wearing the same evening dress? Where did we learn to react in this way? The answer is that we didn't simply learn it, as we learned the road code. The sense of awkwardness comes from an intuitive recognition that an evening dress—along with the coiffure, the makeup, the jewelry—ought in the context of a party to be the expression of an individual personality, ought to show the *originality* of a person. A party is an occasion for display—flamboyant or discreet—whether the woman is young and mingling with suitors, or happily married and just demonstrating her personal taste (and maybe her status). In social life generally, we expect to be presented with distinguishing differences in outlook and expression, especially on occasions involving display. Everyone in his or her way should stand out and be an individual. For a person of either sex, being "distinguished" is a compliment.

If personal distinction is a basic desideratum in social life, it is much more important in the life of art. The appetite for seeing a strong artistic personality stamp a distinctive individuality on an artistic performance or creation seems to be universal. The fascination, sometimes near obsession, with individual expression is evidence for its being an extension into the arts of an evolved adaptation relevant to interpersonal recognition and evaluation—something that has come about, no doubt, through a pathway in sexual selection. Some theorists have been tempted to imag-

ine that the emphasis on artistic individuality is a local convention in European culture—that art was less individualistic before the rise of capitalism, or that in tribal societies the fact that it is often unsigned shows that individuality of expression is not universally important. The evidence is heavily against this hypothesis. Just because there was no call for artisans who built and decorated the medieval cathedrals to sign their contributions to those great communal efforts does not entail that the work of especially skilled individuals was not admired in its day. My own research in remote New Guinea villages clearly shows that the work of individual dancers, poets, and carvers is a focus of fascinated attention. Of course, carvings were not signed until very recently—why should they be signed in a small society where everyone knows everyone else, knows who made what, and there is in any event no writing?

From New Guinea to New York, different cultures have varied ways of dealing with artistic individuality: in India, the classical tradition treats its most famous singers, dancers, and instrumentalists much as in Europe, while in China, artistic individuality has in different periods been relatively played down by a rhetoric of modesty and self-effacement. But there is no living artistic tradition where it can be said that art is produced with no regard for the individuals who do it. The whole Western performance tradition is one of powerful personalities producing performances that are uniquely their own. We call these people stars.

But the same goes for canonical creative arts, where desire to experience an individual's distinct and developed emotional tone, the manifestation of a personality, draws audiences to art. The artists whose work has survived and achieved wide cross-cultural appeal are people whose output is marked by a persistent, distinct emotional tone, within individual works and also across a whole output: Leonardo, Wagner, Jane Austen, Hokusai, Schiller, Cervantes, Sesshu Toyo, Cézanne, Homer, Brahms, Murasaki, Shakespeare, Basho, Monet, Dostoyevsky.

Here, it seems to me, we confront an innate, evolved potential that is particularly important to the arts. It is no more learned than any other basic, evolved potential for deriving gratification from food, love, or problem-solving. Like other evolved potentials for pleasure, it is heritable—that is, individual sensitivity to it varies in the population. With people for whom the arts are a source of continual enjoyment, it is bedrock: the emotional feeling, the tone, the sense of a distinct outlook,

the sense of entering into the feelings of a mind that is not your own. It is what we get in the atmosphere of the *Odyssey*, from looking straight through Monet's rough painted surface and into the waters of a lily pond, from the wit and sense of life in Jane Austen's account of the Bennet family gossiping, or from the yearning voice of Yeats's poetry.

The importance of the individuality of emotional saturation in art can be demonstrated with a philosopher's thought experiment. Consider a work with a strong and distinct sense of emotional expression, say, the Brahms Symphony no. 4 in E minor. That work is drenched with a certain melancholy, a feeling, or so it seems, that no other piece of music quite has, a feeling that is embedded in the notes and construction of that particular piece of music. Now suppose that in a hundred years' time, developments of the pharmacological manipulation of moods and emotions have become so sophisticated that you can buy a pill that will give you the specific emotional fix of the E-minor symphony: swallow it and you'll experience the exact same emotional feeling that you get from listening to the Brahms. Can you imagine taking the pill in order to save the expense of concert tickets, or even the cost of time spent in listening to a recording of the piece?

The answer is very likely to be no, and the reason tells us something about the nature of aesthetic expression. It is not just the emotion as a bare feeling we want from art, it is the individual artistic expression of emotion—how emotions are revealed in the art, though technique, structure, balance, and the blending of sounds. Works of music are not beautiful because they arouse emotions in us as a drug might; they are beautiful because of how the emotions are created by the total structure of the music itself. Someone once remarked that years after forgetting the characters and plot of a novel, you may still retain a memory of the emotional atmosphere of the work. This too is consistent with the idea that the emotional tone of art reaches deeply into the mind, not by manipulating general moods or kinds of feeling, but by creating the highly individual work of art from which unique feelings emerge.

Yes, we want feeling from art, but not as an end for which the art is a means: with art, the means is the end itself. It follows that emotion pills will never replace art, because nothing can substitute for a sense of emotional expression derived from the experience of a complex aesthetic

structure created by another human being. To speak in metaphors, the work of art is another human mind incarnate: not in flesh and blood but in sounds, words, or colors. If you are an artist, the most enduring way to achieve a lasting artistic success is to create works of aesthetic pleasure that are saturated with emotion, specifically expressing distinct emotions that are perceived as yours. Cheap sentimentality in art traffics in emotions that are everybody's: that is why soap opera is a genre art; consumers of soaps have little curiosity about who writes them. The greatest works of art—grand opera, for instance—are emotionally distinct, and if we love them, we can't help wondering who people like Mozart or Wagner really were.

Even for relatively minor artists, establishing an individual emotional tone is crucial. Staying with music for a moment, Sergei Rachmaninoff was composing at the same time as his friend Nikolai Medtner. While Medtner's music may deserve more exposure than it now receives, it does not stand up well beside Rachmaninoff's, despite being stylistically very similar. Rachmaninoff's music has an immediate way of establishing a strong and distinct mood in the mind of the listener, the mysterious sense of an individual musical personality. Medtner's music, in contrast, whatever its graceful finish and stylistic similarities to Rachmaninoff's, cannot express the same distinctly brooding personal atmosphere.

Extending Darwin's original suggestion, I believe that this intense interest in art as emotional expression derives from wanting to see through art into another human personality: it springs from a desire for knowledge of another person. When cynics disparage art criticism as "high-class gossip," they are on to something. Talking about art is an indirect way of talking about the inner lives of other people: that is, oddly, of artists. In the Pleistocene, outside painting and sculpture, almost any aesthetic expression we might enjoy would have come from a living person. After the invention of writing and, later, visual and sound recording, it became possible to enjoy art created by long-dead men and women. If art is a vestigial fitness marker for courtship, or a way of knowing another mind in social interchange, it follows that the love of art made by dead people is an evolutionary mistake. If so, it is a mistake that profoundly marks the pleasure we take in all of the arts today.

IV

From the very beginning of this book, my aim has been to elucidate general characteristics of the arts in terms of evolved adaptations. Although I have referred repeatedly to the standard canon, I have written with every intention of including in the analysis what might be dismissed as low-end popular art. If my analysis is correct, it should enable us to talk more intelligently about the arc of art that moves from bedtime stories and *Sesame Street* through young people's fictions and into television soap operas, romance novels, and formulaic Hollywood movies.

However, open-mindedness about including low-end amusements under the rubric of art ought not to distract us from paying attention to the rare but persistent qualities of art's most demanding, top-end excellence. In this conclusion, I want to sketch the central characteristics that inhere in the very greatest works of art, the masterpieces that have withstood Hume's Test of Time and show every indication of maintaining their hold on the human imagination. The relationship that these characteristics have to our evolved nature is murky at best, but it is real and it is worth meditating on. I focus attention on four primary properties: high complexity, serious thematic content, a sense of insistent or urgent purpose, and a distance from ordinary human pleasures and desires. I want finally to show how kitsch, by pretending to such values, presents us with the worst of all aesthetic worlds.

1. Complexity. Aristotle analogized works of art to animals in the sense that both have parts that are organically related to one another in a perceiver's experience. By saying that both could be beautiful, he was marking an important fact about all adequate works of art: their elements are meaningfully interrelated within a whole work. That is why we say of a Shakespeare sonnet or Schubert song that you "could not change" a single word or note without detracting from the aesthetic impact of the whole. If we turn to the greatest art with this in mind, it often incites pleasure by presenting audiences with the highest degree of meaning-complexity the mind can grasp. Of course, minds differ in their capacities to grasp meaning of high complexity: it will depend on age, maturity, memory abilities, familiarity with cultural referents, and general intelligence and reasoning ability. It also depends on the individual's sensitivity to a medium (even genius can be unresponsive to some art

forms, for instance, Vladimir Nabokov's inability to appreciate music or Kant's unresponsiveness to color in painting).

Complexity does not mean sheer complicatedness but rather the densely significant interrelations of, say, poetry, plotting, and dramatic rhythm in a play like Shakespeare's *King Lear*. And if understanding the intricacies of a work of art can be demanding for audiences, it requires superhuman capacities from artists. The psychologist and historian of scientific and artistic genius Dean Simonton argues that the most brilliant creators in the history of the arts were without apparent exception highly intelligent individuals, as they would have to be. If chess masters work out possibilities of thirty-two pieces on sixty-four squares, an opera composer has to be seen as playing an analogous five- or six-dimensional chess, making story, characters, poetry, action, plot, and above all music cohere into a unified whole—one where every move counts. Artistic masterpieces fuse myriad disparate elements, layer upon layer of meaning, into a single, unified, self-enhancing whole.

In this respect alone, works such as *Der Rosenkavalier* or *War and Peace* are not just achievements: they seem more like miracles. Above even the highest levels of chess, mathematics, or science itself, the greatest works of art unite every aspect of human experience: intellect and the will, but also emotions and human values of every kind (including ugliness and evil). Psychologically, some of the most staggering moments in aesthetic experience, the ones we may remember all our lives, are those instants where the events that make up the whole of a vast novel, an opera, or a poem, sonata, or painting fall meaningfully into place. The finest works of art draw us into them in order to yield up the deep, intricate imaginative experiences. They are marked by the utmost lucidity and coherence.

2. Serious content. The themes of great works are love, death, and human fate. The salvation of the soul and a happy ending in eternity loom as central to art in some religious traditions, but we also find even in the most religiously influenced texts, from *The Epic of Gilgamesh* to the present, tragic suggestions that salvation may not be the lot of man. Artistic masterpieces need not be solemn and can end joyfully (Jane Austen's are among the most delightful), but even when they do, they are not merely jolly and amusing, and offer an implicit nod, if not to a darker side of human existence, then at least to what might be termed a realistic view of the finitude of life and aspiration. Mozart has a capacity to

combine joy and sadness—think of *The Marriage of Figaro*—that strikes
many listeners as astounding. Among other uncanny attributes, Schu-
bert's ability to express sadness in a major key gives him a permanent
place in the artistic pantheon. Shakespeare's comedies end, as they must,
with marriages all 'round, except for some unhappy character—Shylock
or Caliban, for example—who exits bitter and disappointed as a re-
minder that in human life happy endings are not for everyone. Chekhov
insisted he wrote comedies, but a bleak, heartbreaking realism gives his
works a depth that places them among the highest artistic achievements
of the modern age.

That the arts do not attain greatness through prettiness or attractive-
ness can be illustrated by considering the ambiguous place of sexual acts
in art. Although love is the most pervasive theme for representative arts
everywhere, explicit eroticism does not tend to figure importantly in the
greatest masterpieces. It is far too easy, in my view, to attribute this
merely to social repression: even in artistic genres that allow a flourish-
ing erotic subculture, such as Japanese woodblock printing, openly erotic
works do not rate among the highest achievements. Nor, I think, is this
fact attributable to the innate, universal aversion to engaging in sexual
intercourse in public. This issue deserves comment from an evolutionary
standpoint.

The evolutionary psychology of art has to begin somewhere, and
some of the earliest speculations in the field going back for a decade or
more have involved straightforward observations such as the analysis
of female desirability in terms of waist-to-hip ratios. But as obviously
applicable as it is to representations of the female body through his-
tory, this centerfold theory of beauty tells us very little about the place
of love, with its intrinsic tensions and endless complexities, as a theme
for the arts. Sex itself is just too simple. In fact, eroticism is treated in
most art and literature as either a subject for comic interludes or an
offstage plot element for tragedy. Pure eroticism by itself is no more
likely as a theme for great art than purely green and pleasant Pleis-
tocene calendar landscapes are a likely theme for the greatest paintings.
An enduring masterpiece that presented a perfect, pretty landscape
would more probably use it as, say, a background for the Expulsion
from Eden than as a central subject in its own right. A portrait of a
withered old woman—for example, either of Rembrandt's loving de-

pictions of his mother reading the Bible—can be a much more beautiful work of art than an Alberto Vargas pinup, attractive waist-to-hip ratios notwithstanding. The evolutionary implications of waist-to-hip ratios for art history are not unlike the evolutionary implications for the presence of sweetness in food. That sugars are in all cuisines and that sweetness makes some foods more attractive for evolutionary reasons does not mean that a bowl of corn syrup and a plate of sugar will ever be dinner.

3. Purpose. As high complexity of structure and seriousness of themes and expression mark great works of art, so does authenticity of artistic purpose—a sense that *the artist means it*. In his remarkable study of the highest excellence in the arts and sciences, *Human Accomplishment*, Charles Murray puts forward the idea that the greatest art tends to be created against a cultural backdrop of what he calls "transcendental goods"—a belief that real beauty exists, there is objective truth, and the good is a genuine value independent of human cultures and choices. Taken together, Murray writes, these three kinds of good enable the "moral vision" that is characteristic of the most enduring art: "Extract its moral vision, and Goya's *The Third of May, 1808* becomes a violent cartoon. Extract its moral vision, and *Huckleberry Finn* becomes *Tom Sawyer*." Murray connects with this idea the claim that "great accomplishment in the arts depends upon a culture's enjoying a well-articulated, widely held conception of the good" and that "art created in the absence of a well-articulated conception of the good is likely to be arid and ephemeral."

This falls in line with Tolstoy's view that artistic value is achieved only when an art work expresses the authentic values of its maker, especially when those values are shared by the artist's culture or community. Tolstoy damned modern art as amusing but spiritually empty while lavishing praise on naive folk art, especially the Christian art of the Russian peasantry. Had he lived a generation later, he likely would have extolled the "primitive" art of tribal societies, not out of a desire to support the modernist agendas of Picasso or Roger Fry but to champion the notion that the honest art of noble savages expresses authentic spiritual values rejected by modern society. To put it as plainly as possible: Tolstoy and Murray both argue that the best art is produced in societies that believe in something.

Societies, however, do not generally make works of art; only individuals do. Authenticity as a truth of *personal expression*, so far as I have been able to tell, is found in the highest art everywhere—even, as in older Chinese and some American Southwest Pueblo cultures, where traditional modesty requires that individuality be downplayed. From the major art centers of the world today to small-scale societies where there is no place for a high/low art distinction as we would understand it, people recognize seriousness of purpose. From my own experience in New Guinea, I can say that in Sepik River cultures you will find a clear understanding among expert artists of the enormous difference between a carving made to sell to a tourist and one that is made for a god or an ancestor. If a carver is producing a decorated shield on which his very life depends, the protecting ancestor depicted on the shield's front will be accomplished with a seriousness of purpose you will never discover in a tourist trinket. To do proper carving, a New Guinea artist named Pita Mangal said to the ethnographer Dirk Smidt, "you must concentrate, think well and be inspired. You must think hard which motif you want to cut into the wood. And you must feel this inside, in your heart." No doubt many of the greatest African carvings are motivated by the same spiritual gravity. I imagine that the psychology of authentic expression in this context is identical to that of the medieval artisan who, knowing that his handiwork would be placed high on a cathedral out of human view, nevertheless lavished the most loving care on it. God, after all, would see it forever.

Murray's conclusion that artistic masterpieces will be more likely found in cultures and times committed to transcendental goods that are justified in religious faith is backed up by the phenomenal strength of the arts in the Italian Renaissance (as it is by the decline of great art in cynical, ironic ages, such as our own). Nevertheless, absolute seriousness of purpose comes ultimately from an individual, not just a culture, and most great artists, musicians, and writers demonstrate a rare and often obsessional commitment to solving artistic problems in themselves. With Shakespeare, Beethoven, Hokusai, and Wagner we have artists for whom the art itself is the transcendental good and not a reflection of anything else—an articulated religious or ethical ideal, or even a theory of beauty. The commitment of many of the greatest artists comes from within them and is addressed to their art, its problems and opportunities, and not to their philosophy or their religion.

4. Distance. Human beings make art works to please each other, to be sure. There is a cool *objectivity*, however, about the greatest works of art: the worlds they create have little direct regard for our insistent wants and needs; still less do they show any intention on the part of their creators to ingratiate themselves with us. In contrast, ingratiating itself with the audience is a main function of the polar opposite of authentic artistic beauty, which is not ugliness (which can be a important component in beauty) but kitsch. The word "kitsch" can describe harmless knick-knacks, or objects made to charm children, but the concept also has a more sinister place in the realm of high art as referring to a kind of bogus art that pretends to insight or achieved revelation but actually is made to flatter and reassure its consumers.

In his meditation on kitsch in *The Unbearable Lightness of Being*, Milan Kundera notes the essential self-consciousness kitsch promotes. The kitsch object, as he explains it, calls forth "the second tear." The first tear is what we shed in the presence of a tragic, pitiful, or perhaps beautiful event. The second tear is shed in recognition of our own sensitive nature, our remarkable ability to feel such pity, to understand such pathos or beauty. A love of kitsch is therefore essentially self-congratulatory. In a withering critique of Sir Luke Fildes's *The Doctor* (1891, Tate Gallery), Clive Bell says that this famous portrayal of a thoughtful physician with a sick child creates what he calls a "false" emotion. What the painting gives us "is not pity and admiration but a sense of complacency in our own pitifulness and generosity."

The kitsch object openly declares itself to be "beautiful," "profound," "moving," or "important." But it does not bother trying to achieve these qualities, because it is actually about its audience, or its owner. The ultimate reference point for kitsch is always me: my needs, my tastes, my deep feelings, my worthy interests, my admirable morality. Thus an expensive and ostentatious set of "great works of literature bound in hand-tooled leather" does not exist for the sake of the actual literary works it contains. Rather, it is displayed in a living room as confirmation of the sophistication and good taste of its owner. (Authentic literary sophistication would be better evidenced by a shelf of dog-eared, broken-spine paperbacks of *Moby-Dick*, *Middlemarch*, and the like. But that would require reading the books.)

Kitsch shows you nothing genuinely new, changes nothing in your

bright shining soul; to the contrary, it congratulates you for being exactly the refined person you already are. Depending on the subject (Dürer's *Praying Hands* as sculpture, a tapestry of *The Last Supper*, baby fur seals, whales), kitsch objects can function to display their owners' deep spirituality or elevated moral, not to mention environmental, sensitivity. Literature and philosophy too can offer kitsch by way of undemanding analysis of life's problems through trite insights into the secrets of the universe. In this respect, Hermann Hesse's pretentious mysticism and Khalil Gibran's little messages dressed up in pseudo-biblical cadences count as kitsch. And let us not forget glitzy Broadway productions that mimic serious opera (so boring!) but offer instead a morass of bad music, loudly miked, and dramatic clichés. These cold, white peaks are cardboard props.

Of course, honest reproductions of Renaissance masterpieces or Cézanne landscapes hanging in dorm rooms or homes are no more kitsch than recordings of great musical performances. Nor are simplified objects directed to the tastes of children. It's wrong for adults to turn up their noses at the *Pastoral Symphony* episode in Disney's original *Fantasia* (1940) with its gods and baby Pegasus; that sequence may be corny, but for many a young mind it was a first thrilling view of Mount Beethoven. Nor when we return to art works that touched us as children are we always disappointed: get hold of a copy of *Charlotte's Web* and you may find it an enchanting book still.

Marcel Duchamp is vilified to this day for having placed the most disagreeable object he could find, a urinal, on a plinth and called it art. But his witty gesture, while not much to look at, was an act of ironic genius, and irony of any kind is the great antagonist of kitsch. High kitsch demands solemnity and high seriousness—entirely fake and parasitic. It succeeds not by expressing deep emotions but by reminding you of them. This, incidentally, throws light on a curious recent development in art history: by insisting on taking Duchamp so seriously as an artistic innovator and overlooking the layers of irony in *Fountain*, Duchamp's contemporary followers and their art-theory champions have returned to the traditional, bourgeois art ideal of high seriousness. What next, a bust of John Cage on the piano? In this respect, readymade knockoffs such as Tracey Emin's unmade bed or Damien Hirst's shark in formaldehyde smell suspiciously of kitsch, as does the turgid prose of critics who take them so seriously. But then kitsch, money, flattery, and

careerism are inevitably linked in the art world. Kitsch as pretentious, self-serving tripe can show up anywhere, even in cutting-edge dealer-galleries. It is not just for the middle-class living rooms so despised by the art elite.

<div align="center">V</div>

The oft-described spirituality of artistic masterpieces, their otherworldly quality, is in contrast authentic, and involves a feeling—experienced by atheist and believer alike—that standing before a masterpiece you are in the presence of a power that exceeds anything you can imagine for yourself, something greater than you ever can or will be. The rapture masterpieces offer is literally *ecstatic*—taking you out of yourself. Theists may wish to attribute all this to the power of God, Darwinian humanists to the near miraculous power of human genius. Both will approach such works as suppliants: we yield to them, allowing them to take us where they will.

The artistic masterpieces of our age may seem a long way from the first daubs of red ocher on a human face or the first musical notes that echoed through ancient caves. Yet what our ancestors began spread across the globe, in art high and low. We remain like our ancestors in admiring high skill and virtuosity. We find stylish personal expression arresting, as well as the sheer wonder of seeing the creation of something new. Art's imaginary worlds are still vivid in the theater of the mind, saturated with the most affecting emotions, the focus of rapt attention, offering intellectual challenges that give pleasure in being mastered. And over all this, we still share with our ancestors a feeling of recognition and communion with other human beings through the medium of art.

Preoccupied as we are with the flashy media and buzzing gizmos of daily experience, we forget how close we remain to the prehistoric women and men who first found beauty in the world. Their blood runs in our veins. Our art instinct is theirs.

Acknowledgments

I owe much to the many people whose advice and inspiration have helped me bring this project together. Alexander Sesonske, Noel Fleming, and Herbert Fingarette incited interests in aesthetic theory. Sidney Hook was a fine teacher and a brilliant example of independent thinking. Ellen Dissanayake, a scholar far ahead of her time, showed the way to a Darwinian aesthetics, inspiring my early forays into this territory. In terms of outlook and temperament, Steve Pinker is in some respects a polar opposite of Ellen, but his lucid analysis and insistent interrogations have left marks all over this book, including its title. I owe much to both these thinkers, as well as to two other redoubtable scholars, Joseph Carroll and Brian Boyd, for invaluable knowledge and insight. Thanks also to Noël Carroll, Doug Dutton, Julius Moravcsik, Stephen Davies, Alex Neill, Brett Cooke, Thierry Lenain, Ray Sawhill, Richard A. Posner, Ihab Hassan, David Gallop, Elric Hooper, Geoffrey Miller, Joseph Palencik, Wayne Lorimer, Francis Sparshott, Wilfried van Damme, Chris Boylan, Bruce Ellis, Satoshi Kanazawa, Garth Fletcher, Graham Macdonald, Simon Kemp, Ian Steward, Ray Prebble, Jonathan Haidt, Geoff Carey, Ben Dutton, Sonia Dutton, Susan Vogel, and the late Leo Fleischmann. Katie Henderson helped sharpen the argument. Peter Ginna is a gifted editor who from acquisition to the final proofs has applied his extraordinary talent and care to this book. Like my friend and agent, John Brockman, Peter was an early believer in my approach to aesthetic questions. I am indebted to both of these men.

Above all, the support and collaboration of my wife, Margit Dutton, has been incalculable. Her keen editorial eye informs every page of this

book. More than that, my argument is animated by all I have learned from her over the years about art, music, literature, and life. This book is dedicated to her, and to our children, with love.

Christchurch, New Zealand

Notes

These notes include references to material available on the Internet. Long Web site addresses are tricky to transcribe, and specific sites often go dead. Web citations are therefore given here in brackets: "w/s," means "Web search," and is followed by a series of words that can be typed into any standard search engine. The desired Web site, and other relevant sites, should appear in the top two or three entries in your search results. Thus [w/s sailer golf courses] is an instruction to type "sailer golf courses" into a search engine in order to locate Steve Sailer's article relating golf-course design to prehistoric landscape tastes. An updated site for source material and discussion relevant to *The Art Instinct* can be found at www.theartinstinct.com.

INTRODUCTION

7–8 Thierry Lenain (1998) has written the most astute—sensitive but unsentimental—analysis of animal art in print. On "disruption" and the "pseudo-artistic play" of chimps, see Lenain (1998), pp. 169–72. For remarkable footage of a New Guinea bower bird's handiwork, see [w/s attenborough bower bird]. While aware of their limitations, Brian Boyd (2009) still makes very effective use of animal analogies to explain aspects of human artistic behavior.

10 Whorf (1956); Kuhn (1962). Through her books and magazine columns, Margaret Mead (1949) was highly influential through the whole postwar period, as was the eloquent Clifford Geertz (1973). On the urban legend about the Eskimo words for snow, see Pinker (1994), pp. 64–65 or [w/s eskimo words snow].

CHAPTER 1: LANDSCAPE AND LONGING

13 Wypijewski (1997) presents background on the Nation Institute study.
 More information, including the paintings themselves, is at [w/s komar
 melamid].

15–17 The long quotation from Melamid is in Wypijewski (1997), p. 13; the
 Danto quotations are from pp. 124–40, esp. 137. It was Ellen Dis-
 sanayake (1998) who first saw the connection between the Komar and
 Melamid paintings and prehistoric landscape tastes—yet another debt
 Darwinian aesthetics owes to her.

19–21 See Appleton (1975); Ulrich (1993); Kaplan and Kaplan (1982); Orians
 and Heerwagen (1992); Kaplan (1992). Steve Sailer has a wonderful
 illustrated article on the Web, "From Bauhaus to Golf Course," show-
 ing how golf course architecture appeals to Pleistocene tastes [w/s
 sailer golf courses].

22 For feelings of safety in landscape features, see Ruso et al. (2003); for age
 preferences, see Balling and Falk (1982). The Synek and Grammer study
 (undated) is on the Web only, [w/s synek grammer aesthetics]. Elizabeth
 Lyons (1983) discusses gender differences in landscape preferences.

23 The account of daily life for hunter-gatherers is in Orians and Heer-
 wagen (1992), pp. 556–57.

25 Tooby and Cosmides (1990) describe the adaptive utility of emotions.
 This article is on the Web [w/s tooby past explains present].

26 Wilson (1998) has an extensive discussion of reactions to snakes that
 relates the ancient and adaptive to the recent and cultural, pp. 71–81.

CHAPTER 2: ART AND HUMAN NATURE

29–30 Pinker (1994), p. 430. Jeremy Coote has written a description of Dinka
 taste in cattle marking, in Coote and Shelton (1992). For the notion that
 children "grow" language, as well as a general account of Chomsky's uni-
 versal grammar, see Pinker (1992), p. 35 and Pinker and Bloom (1992).

31–35 Plato's condemnation of the arts is found in books 3, 4, and 10 of the
 Republic. The Aristotle passages about imitations are from chapter 2 of
 the *Poetics*, Aristotle (1965). The quotation about the eternal discovery
 of culture is in the *Politics*, Aristotle (1984), at 1312b25. The passage on
 magnitude is in chapter 3 of the *Poetics*.

36–38 Hume's "Of the Standard of Taste" is widely available: [w/s denisdut-
 ton.com hume]. For Kant on personal taste, see sections 2–5 of *The
 Critique of Judgment*, Kant (1987). The *sensus communis* appears in sec-
 tion 40 [w/s denisdutton.com kant critique].

39–40 See Sibley (2001); Beardsley (1958); Sparshott (1982). The institutional theory of art is in Dickie (1974), although credit should be given to a very similar theory put forward by Diffey in 1969, collected in Diffey (1991). A general institutional viewpoint on art was also adumbrated by Danto (1964). The "need for art" remark is in Dickie (1974), p. 30.

42–46 See Pinker and Bloom (1992). The gloss on Hamilton is from Daly and Wilson (1997), in Buss (1999), p. 223. Pinker on Dawkins is at Pinker (1997), p. 44. Brown's entire 1991 list is on the Web [w/s donald brown universals], but the actual book is invaluable for its surrounding discussion. Brown's introduction is notable for its brilliant universalist redescription of events in Geertz's famous account of a Balinese cockfight, originally in Geertz (1973), pp. 412–53. The introduction to Barkow, Tooby, and Cosmides, *The Adapted Mind* (1992), is a clear explanation of the needs for universals to discuss human behavior, as is the book's first chapter, "The Psychological Foundations of Culture." Joseph Carroll's version of the list emphasizes universals in social relations; it is in Carroll (2004), pp. 187–206. My own list in the last paragraph of the chapter is inspired in part by reading Rubin (2002); for a review, see [w/s rubin dutton darwinian].

Chapter 3: What Is Art?

47–48 Quotations are from Julius Moravcsik (1991). See also Moravcsik (1988) and (1993). The ideas formulated by this Stanford University philosopher mark an important contribution to contemporary aesthetic thought. The Noël Carroll quotation is from Carroll (1994), p. 15.

51–52 The first philosopher to describe a "cluster concept" seems to have been John Searle (1958). An early application for art came from E. J. Bond (1975). Blocker (1994) provides what reads as a cluster concept for tribal art, and both Berys Gaut (2000) and (2005) and Stephen Davies (2004) discuss and defend the idea of a cluster concept. My own first cluster proposal was put forward in Dutton (2000), followed by a longer version in (2001). The present list is longer than either of the earlier variations. My friend and colleague the late David Novitz argued in Novitz (1998) that art is indefinable as a natural concept.

54 Francis Sparshott's classic treatment of criticism is in Sparshott (1999). A fresh approach to criticism can be found in Noël Carroll's *On Criticism* (2008).

55 See Dissanayake (1990) and (2000), but especially (1992), chapter 3, "The Core of Art: Making Special."

57 Paul Ekman (2003) is a central source for the psychology of "basic," universal emotions.

58 Levinson (1991) mounts an astute defense of the institutional theory, supporting Diffey (1991), Dickie (1974), and Danto (1981), (1986), and others.

60 For a superb discussion of art in tribal societies, see Blocker (1994), p. 148; for a review of Blocker, see [w/s denisdutton.com blocker]. Wilfried van Damme's *Beauty in Context* (1996) is a sophisticated account of cross-cultural aesthetics.

62 Another issue for which the cluster criteria list is helpful is the status of bullfighting as an art form. Bullfighting seems to meet enough of the criteria to justify the claims of Ernest Hemingway and others that it is a high and noble art. There is a problem, however, with the last item on the list, imaginative experience. There is no question that Goya's gory representations of bullfights qualify as high art, while many bullfight posters qualify as not-so-high. But *real* bullfights are not representations to the extent that they involve actually tormenting and killing an animal. The bull's palpable suffering pulls bullfighting down from the realm of art and into blood-soaked reality. The French version of bullfighting, where ribbons are artfully plucked from the head of the bull (which is never harmed), is wholly different, as are artistic practices that develop animal skills to beautiful effect, such as dressage. In this respect, the boilerplate message in movie credits "No animals were harmed in the production of this film" is important as an assurance that the art work can be enjoyed as something purely for the imagination. As art, a bullfight is like a production of *Hamlet* where some of the actors really are poisoned and stabbed to death at the end. Though it involves the fate of a nonhuman animal, bullfighting seems an aesthetic perversion nonetheless.

63 I owe the lovely Harlem Globetrotters example to Brian Boyd, who has also urged me to include (a) artifactuality and (b) having been made for an audience to my list of cluster criteria. I resist for the reasons given, but his may be the wiser view. Nigel Warburton, who is both a seasoned aesthetics specialist and a dedicated soccer fan, has tried to convince me that the capacity to appreciate a "beautiful game," irrespective of who wins, is much more widespread in the world of soccer than I credit. He may be right.

CHAPTER 4: "BUT THEY DON'T HAVE OUR CONCEPT OF ART"

64–65 See Fry (1923); Boas (1955); Bunzel (1929); Goldwater (1962). The Maurice Bloch remark expresses ideas rarely heard from anthropologists of his generation and is often quoted by evolutionary psychologists. It is in Bloch (1977).

65–67 The Manchester debate, with arguments from Overing and others, is transcribed in Weiner (1994).

67–69 See Hart (1995); "distinct from Western aesthetic canons" is at p. 131, and the longer quotation at p. 144.

70–71 The Baule "equate even the finest sculptures with mundane things," Vogel (1997), p. 80; on "intense, exalted looking" and danger, see pp. 83–86 and 110.

72 On the Yoruba *ibeji*, see Vogel (1991), pp. 88–90.

72–73 Vogel (1991); Novitz (1998), p. 27.

77–78 For the Pot People and the Basket Folk, see Danto (1988). The claim that interpretations "constitute art" is in Danto (1986), p. 45.

84 The Sudanese art theorist Mohamed A. Abusabib ends a detailed and insightful discussion of Danto on a note of exasperation about forever agonizing over whether primitive art is art: "Finally, one might wonder whether all these pains over the issue could have been avoided if before putting forward this question about primitive art, other similar questions such as 'Is Primitive Music Music?' or 'Is Primitive Dance Dance?' had been pondered" (1995), p. 41.

CHAPTER 5: ART AND NATURAL SELECTION

86–89 Pinker (1997), p. 20. For Wilson on Westermarck and incest avoidance, see Wilson (1998), pp. 173–80.

92 See Lloyd (2005) and Symons (1979). Gould's *Natural History* essay is reprinted in Gould (1992).

93–94 On spandrels, see Gould and Lewontin (1979). Quotations are from Gould (1997). A penetrating critique of Gould has been produced by Carroll (2004), pp. 227–45.

95–96 Pinker's "Sunday afternoon projects" wisecrack and the cheesecake mention are in Pinker (1997), p. 524–25.

99–100 Alcock's critique of Lloyd is in an interview with the *New York Times*, May 17, 2005. Many interesting discussions of the Lloyd thesis can be found on the Web [w/s elisabeth lloyd orgasm bias]. Her personal Web site at Indiana University collects reviews of her book. While I may disagree with Lloyd, I must remark on the way that she has been

viciously and unfairly abused for advancing a perfectly reputable scientific position in *The Case of the Female Orgasm*. There is no question in my mind that her book reveals implicit sexism not only in the history of science but also in the critical reception of evolutionary arguments, including hers. I expect no one will pan my book by saying that "he'd be no fun on a date."

101 Further quotations from Pinker (1997), p. 524.

108 The fable of the moth and the lantern is from a splendid article on sexual selection, beauty, and by-products by Eckart Voland in his anthology, Voland and Grammer (2003).

CHAPTER 6: THE USES OF FICTION

103–5 See the first five sections of Kant (1987), [w/s denisdutton.com kant third critique]. For "decoupling," see Cosmides and Tooby (2000), [w/s cosmides tooby evolutionary emotions] and Tooby and Cosmides (2001), [w/s tooby cosmides beauty build]. Yes, the name order of the authors reverses as shown here.

106–7 See Leslie (1987). Pascal Boyer's marvelous gloss on Leslie, including the tea party description given here, is very useful; see Boyer (2001), p. 130.

109 The British statistics are cited by Daniel Nettle in his contribution to Gottschall and Wilson (2005), p. 56.

111–13 The chess analogy is in Pinker (1997), pp. 542–43. The parody description of Wagner's *Ring* is Fodor (1998), available on the Web [w/s trouble darwinism fodor]. The subsequent quotation from Pinker is from his review of Gottschall and Wilson, Pinker (2006), p. 172.

115–17 See Havelock (1963), pp. 80–83. Quotations from Sugiyama are from Sugiyama (2005). Peter Swirski's *Of Literature and Knowledge* (2008) argues a convincing case for the adaptive value of fictional narrative thinking by placing it on a continuum with philosophical and scientific thought experiments.

119 On the particular effects of autism on empathic understanding, and therefore on the autistic's grasps of fictional narrative, see Baron-Cohen (1996).

119–20 Zunshine (2006); the quotations are in a response to Brian Boyd in *Philosophy and Literature*, Zunshine (2007).

120 Wilson is quoted by Carroll (2006), pp. 42 and 43. Brian Boyd's *On the Origin of Stories* (2009) argues an impressive case for the arts in general and storytelling in particular as a form of cognitive play.

121–24 Carroll (2006), p. 42. The quotation about the young David Copperfield is from Carroll (2004), p. 68. The three points of view, with the

example from *Pride and Prejudice*, are discussed in Carroll (2004), p. 208–10.

126 Barash and Barash (2005) use the plots of classic fictions to illustrate principles of evolutionary psychology. While their entertaining book says little about the nature of fiction, it does throw Darwinian light on the kinds of stories typically chosen by authors. For an appreciation and critique, see [w/s denisdutton.com barash].

127–30 Polti's list is not in print, but is available on the Web [w/s polti dramatic situations]. Quotations are from Booker (2004); the Jung remarks are at p. 12.

133 For a philosophical view of video games as an art form, see Tavinor (2005).

CHAPTER 7: ART AND HUMAN SELF-DOMESTICATION

136 For Darwin on why peacocks made him sick, see Cronin (1991), p. 113. The letter can be found on the Web [w/s darwin gray peacock sick]. Darwin's actual words are a lighthearted aside in a personal letter. I note that they are now idiotically quoted on creationist Web sites as evidence that Darwin was unable to explain the wonders of nature.

137 On convergent evolution, see Miller (2003).

141 On the waist-to-hip ratio, see Singh (1995) and subsequent discussions [w/s waist hip singh].

142–44 For male upper-body mass, see Etcoff (1999). Etcoff also discusses the female age lag and the preference for tall men, as does Buss in his very clear exposition (Buss 1999). The David Remnick quotation is in Etcoff (1999), p. 77. Brian Hansen's results (1998) on body ratios in portraiture were presented to the 1998 meeting of the Human Behavior and Evolution Society at the University of California, Davis. For the more accepting attitude men have toward taller women than women have toward shorter men, see Nettle (2002); this article is on the Web [w/s women height nettle]. On symmetry, see Buss (1999), pp. 118–20.

144–45 General mating criteria are discussed in Miller (2000) and (2001), as well as in Buss (1994) and (1999). For Darwin on "unintentional" domestication, see Darwin (1896), p. 614. *The Descent of Man* can be downloaded from the Web and searched with ordinary desktop search functions.

146 A word should be said on behalf of Friedrich Schiller, whose 1794 *Letters on Aesthetic Education* imaginatively suggest aspects of sexual selection eighty years before Darwin. Schiller found the concept of play central to art, which with his many comparisons to animals he tends to view as a natural phenomenon. He also regarded the emergence of

high culture out of barbarism as being largely a matter of females exercising mate choice. See Schiller (1967), especially Letter XXVII; on the Web [w/s denisdutton.com schiller]. Brian Boyd (2009) stresses the importance of cognitive play in the arts.

147–48 The issue of vocabulary size is emphasized by Miller in chapters 10 and 11 of *The Mating Mind* (2000). Miller's exposition of sexual selection is both eloquent and to my mind completely in line with Darwin's suggestions in *The Descent of Man*.

149–50 A provocative new look at surviving cave art has been produced by Guthrie (2005). Although there have been major discoveries since he wrote his book, Pfeiffer (1982) is still a fine summary. There is much material on the Web about Ötzi, [w/s otzi iceman].

154–56 Veblen's spoon example is at (1994), pp. 78–79; the Zahavis' book is now an established classic in sexual selection theory. Voland's quotation is at Voland (2003), pp. 241–42.

158 For Kathryn Coe on carrying materials for far distances, see Coe (2003). For Gell on the matchstick cathedral, see Gell (1992), pp. 48–49. Marek Kohn (1999) and Steven Mithen (2003) have argued that handaxes—difficult to make, symmetrical, smooth, and unchanged for around a million years—are the absolute earliest aesthetic artifacts in the archeological record. They regard handaxes as a product of sexual selection.

159–60 Kant disparages "finery" in section 14 of *The Critique of Judgment*, Kant (1987). Bell's weird remark about people of discernment not noticing representation in painting is in *Art* (1958), pp. 29–30.

162 Wittgenstein's comment about the human soul is in the *Philosophical Investigations* (1958), part 2, section iv. The Miller observation is in (2000), p. 356.

CHAPTER 8: INTENTION, FORGERY, DADA: THREE AESTHETIC PROBLEMS

165 Darwin's great two-volume work, *The Variation of Animals and Plants Under Domestication* (1896b) should, along with *The Expression of the Emotions in Man and Animals* (1896c), be much more widely known.

167–68 Wimsatt and Beardsley (1946), [w/s wimsatt beardsley intentional fallacy]; *The Possibility of Criticism*, Beardsley (1970), pp. 19–20. See Barthes (1977); Foucault (1969); Derrida (1983).

169–72 See Bunzel (1929); Stern (1980). A classic collection of bad verse is Wyndham-Lewis and Lee (2003). The Akenside quotation is in Beardsley (1970), p. 20.

176 See Nehamas (1981), p. 145; also Nehamas (1987).

177 Research discussed by Paul Bloom in *Descartes' Baby* shows that chil-
 dren aged three or four have a strong, spontaneous sense of the inten-
 tion behind representations and communicative acts. Whether a circle
 with a straight line coming down from it is a lollipop or a balloon de-
 pends for the child not on resemblance but on represented intent.
 Bloom adds that "a good way to make a child cry is to take a picture
 [drawn by the child] that is described as 'Mommy' and insist that it is
 a picture of someone else—the child's brother, say. Children resent
 this; they know it is a picture of Mommy because that is the person
 they intend it to depict." See Bloom (2004), p. 78.

177–79 For accounts of van Meegeren's career, see Werness (1983), Wynne
 (2006), and Lopez (2008). The best recent book on the subject is from
 Edward Dolnick (2008). The quotation from Bredius is in Dutton
 (1983), pp. 30–31; the van Meegeren quotation (obviously, to some de-
 gree an invention) is from Wynne (2006), p. 164. Mills and Mansfield
 (1979) provide a good general overview of forgery. For more on the van
 Meegeren episode, with plenty of illustrations, see [w/s meegeren Ver-
 meer fakes]. Koestler (1955) gives the earliest version of his argument;
 it appeared in other venues in subsequent years. Nelson Goodman first
 wrote on forgery in *The Languages of Art* (1968); the section on forgery
 is anthologized in Dutton (1983).

180 Hebborn's autobiography may include more than the usual quota of in-
 vention, but it is an entertaining book (1993). There is other material
 available on the Web, including my obituary of Hebborn, from which I
 have drawn for this discussion; see [w/s hebborn fakes forgery dutton].

181 The best general account of the Hatto affair to date is Mark Singer's
 New Yorker article (2007), see [w/s mark singer joyce hatto]. I have
 drawn on my own *New York Times* op-ed (2007) for this discussion.
 Andrys Basten has produced an extensive Web bibliography [w/s
 hatto hoax log]. The most absurd story still in circulation about the
 affair has it that Hatto's recording-engineer husband, William
 Barrington-Coupe, who had previously served prison time for fraud,
 faked the recordings out of love for his ailing wife. He now claims
 she was unaware of what was going on and believed she'd actually
 made the CDs. This is certainly false; there is not the slightest
 doubt that she was in on the hoax from the start. Hatto was a witty,
 intelligent woman in command of her faculties till the end. She knew
 full well that she had not recorded with a large symphony orchestra
 (at a local disused cinema!) the complete concertos of Brahms,
 Chopin, Mendelssohn, Schumann, and Rachmaninoff, plus three

concertos by Saint-Saëns, the Tchaikovsky B-flat minor, Grieg's A-minor, etc. As for whether Barrington-Coupe loved his wife, it is doubtless true. But that's entirely beside the point. I'm sure Clyde loved Bonnie too.

184–86 Meyer's views are in Dutton (1983). The faked piano recording example was originally published in the *British Journal of Aesthetics* in 1979; it is in Dutton (1983) and on the Web [w/s denisdutton.com meegeren].

188–89 See Tooby and Cosmides (2001). Free and dependent beauty is discussed in Kant (1987), section 16. The charming example of the boy who fakes the nightingale for the pleasure of the guests at the inn can be found in section 42. My own take on free and dependent beauty is in Dutton (1994), also on the Web [w/s dutton kant free beauty].

190–91 The list of basic emotions is in Ekman (2003). For Jonathan Haidt's important work on admiration and elevation as distinct, identifiable emotions, see Algoe and Haidt (2008).

193–96 For background on the 2004 Turner Prize, [w/s turner prize 2004 gordon's most influential]. For analysis of Duchamp and *Fountain*, see Humble (1982); Brough (1991); Danto (1981). Rubin (1984) provides a general history of Duchamp and modernism.

199–200 Duchamp's remark on *Comb* is quoted by Humble (1982). Information on Henry Darger is widely distributed on the Web [w/s henry darger].

200–201 Danto (1986), p. 35; the odd syntax is Danto's.

201–2 More can be learned about the exploits of Piero Manzoni by searching the Web: [w/s piero manzoni tate shit]. Don't miss the Tate podcast for young people entitled "What's Inside the Can?" Two Tate curators earnestly analyze the "problem the artist faced when trying to can his own shit." In the end, they are deeply moved: "It's a tribute to the artist that he's done something that is still impenetrable by science. So the idea lives on. It's a great idea." Completely, unintentionally hilarious [w/s listen what's inside the can manzoni].

CHAPTER 9: THE CONTINGENCY OF AESTHETIC VALUES

207 See Shiner and Kriskovets (2007). Among recent philosophical accounts that deal with food, and therefore to some extent smell, are Korsmeyer (1999) and Telfer (1996).

208 The figure 30,000 gets tossed about as an estimate for the number of individual smells the normal human nose can distinguish. Thanks to Avery Gilbert for trying to track down the source of this supposed fact, which turns out to be a rumor of uncertain origin. No researcher

has ever tried to bring together thousands of smells and apply them to a pool of human subjects. See Gilbert (2008), pp. 1–5. Gilbert recounts the history of attempts to inject smell into movies, culminating in Mike Todd, Jr.'s Smell-O-Vision of 1959. Smell was actually first introduced into a film in 1906: rose scent to accompany a newsreel of the Pasadena Tournament of Roses Parade; see Gilbert (2008), pp. 147–69.

209–12 Beardsley (1958), p. 99. Robert Parker's nose is legend. See the classic *Atlantic Monthly* article by William Langewiesche [w/s robert parker million dollar nose]. Sibley's account of smell is in Sibley (2001).

213–14 Darwin (1896). These passages can be found in any searchable version of *The Descent of Man*: [w/s darwin descent man gutenberg]. The "supervowel" suggestion is nicely put by Pascal Boyer (2001), p. 132. Other recent treatments of music can be found in Wallin et al. (1999) and Mithen (2006).

215–18 David Huron's overview of musical psychology (2006) in terms of anticipation and fulfillment is one of the most illuminating accounts of music I have ever read. The discussion of repetition is at pp. 228–29, and intervals in melodies at pp. 339–44.

219 Gary Marcus's *Kluge: The Haphazard Construction of the Human Mind* (2008) argues that any foibles of human thinking emerge from cobbled-together mental routines and algorithms that we evolved in the savannas: they are far from being rationally systematic or even suited to modern life. "Haphazard" is also my word for the adaptations that make up the arts as we have them today. The Kentner observation was quoted without further source by Martin Kettle in the *Guardian*, February 16, 2008.

CHAPTER 10: GREATNESS IN THE ARTS

221–22 All quotations are from the first chapter of *Art*, Bell (1958). For a Web version in which I have included illustrations of some of his most important examples, see [w/s denisdutton.com clive bell signficant].

224 Dissanayake makes a good case for the social value of ceremony, and therefore participatory arts (1992), pp. 43–63. In her latest book, *Art and Intimacy* (2000), she persuasively argues for a continuous line that leads from mother/infant interactions to the fully developed social arts of the human race.

225–26 The strongest proponent of group selection in evolutionary theory today is David Sloan Wilson, in *Darwin's Cathedral* (2002), *Evolution for Everyone* (2007), and the book he coauthored with the philosopher

Elliott Sober, *Unto Others* (1998). While I have reservations about applying group selection theory to explain the existence of the arts, as a general principle in evolutionary theory I regard group selection as very important—indeed, crucial to explain the origins of sociality and cooperation. The opera rehearsal description is in Tolstoy (1960), pp. 10–15. Pinker's discussion of "gluey metaphors" is in (2007); the quotation is at p. 177. I believe Rubinstein told anecdotes like this on many occasions. I am reporting from my memory of a version of it recounted in a radio interview years ago. I have heard the same story attributed to Frank Sinatra.

227–29 See Collingwood (1938), pp. 15–41.

229 Brian Boyd (2009) is especially acute in his analysis of the attention-grabbing character of the arts in general and stories in particular.

230–32 Nussbaum (1997); Posner (1997), quotation from p. 5; Hassan (2006), p. 225.

237 See Simonton (1999), pp. 78–79. I have written a long review of this book [w/s denisdutton.com genius simonton]

238 In his "Darwinian Aesthetics" entry in the *Handbook of Evolutionary Psychology*, Randy Thornhill (1998) lumps together a whole range of evolved responses to stimuli—sugar, language skill, lovely bodies, status, savannas, youthful looks, etc.—as "aesthetic adaptations" that induce pleasure. He quotes Donald Symons saying "Beauty is in the adaptations of the beholder." Art for Thornhill has "subliminal" utility, with "unconsciously perceived cues" that have an evolutionary source (p. 557). His rhetoric sounds almost Freudian, but his account is far too crude to begin to analyze complex, serious works of art.

239–40 Murray (2003), pp. 415–25; Smidt (1990).

241 Kundera (1984), p. 251. Over many years, the Franklin Mint has produced and sold what must amount to a small mountain—dare I say, a treasure trove—of kitsch, pitched at buyers in the most pretentious language possible. See [w/s franklin mint] and click on individual objects for a laugh.

Bibliography

Abusabib, Mohamed A. (1995). *African Art: An Aesthetic Inquiry.* Uppsala: Acta Universitatis Upsaliensis.

Aiken, Nancy E. (1998). *The Biological Origins of Art.* Westport, Connecticut: Praeger.

Algoe, Sara B., and Jonathan Haidt. (2008). "Witnessing Excellence in Action: The 'Other-praising' Emotions of Elevation, Gratitude, and Admiration." *Journal of Personality and Social Psychology,* forthcoming.

Appleton, Jay. (1975). *The Experience of Landscape.* New York: Wiley.

Aristotle. (1965). *The Poetics.* Trans. Richard Janko. Indianapolis: Hackett.

———. (1984). *The Politics.* Trans. Carnes Lord. Chicago: University of Chicago Press.

Balling, J. D., and J. H. Falk. (1982). "Development of Visual Preference for Natural Environments." *Environment and Behavior* 14:5–28.

Barash, David P., and Nanelle Barash. (2005). *Madame Bovary's Ovaries: A Darwinian Look at Literature.* New York: Delacorte Press.

Barkow, Jerome H., Leda Cosmides, and John Tooby, eds. (1992). *The Adapted Mind: Evolutionary Psychology and the Generation of Culture.* New York: Oxford University Press.

Baron-Cohen, Stephen. (1995). *Mindblindness: An Essay on Autism and the Theory of Mind.* Cambridge, Massachusetts: Bradford/MIT Press.

Barthes, Roland. (1977). "The Death of the Author," in *Image/Music/Text.* Trans. Stephen Heath. New York: Hill & Wang.

Beardsley, Monroe C. (1958). *Aesthetics: Problems in the Philosophy of Criticism.* New York: Harcourt, Brace & World.

———. (1970). *The Possibility of Criticism.* Detroit: Wayne State University Press.

———. (1984). "Art and Its Cultural Context." *Communication and Cognition* 17:27–45.

Bedaux, Jan Baptist, and Brett Cooke, eds. (1999). *Sociobiology and the Arts.* Amsterdam: Rodopi.

Bell, Clive. (1958). *Art.* New York: Capricorn. Originally published in 1913.

Bloch, Maurice. (1977). "The Past and the Present in the Present." *Man* 12:278–92.

Blocker, H. Gene. (1994). *The Aesthetics of Primitive Art.* Lanham, Maryland: University Press of America.

Bloom, Paul. (2004). *Descartes' Baby: How the Science of Child Development Explains What Makes Us Human.* New York: Basic Books.

Boaz, Franz. (1955). *Primitive Art.* New York: Dover. Originally published in 1927.

Bond, E. J. (1975). "The Essential Nature of Art." *American Philosophical Quarterly* 12:177–83.

Booker, Christopher. (2004). *The Seven Basic Plots: Why We Tell Stories.* New York: Continuum.

Boyd, Brian. (2005). "Evolutionary Theories of Art," in Gottschall and Wilson (2005).

———. (2009). *On the Origin of Stories: Evolution, Cognition, and Fiction.* Cambridge, Massachusetts: Belknap Press of Harvard University Press.

Boyer, Pascal. (2001). *Religion Explained: The Evolutionary Origins of Religious Thought.* New York: Basic Books.

Brough, John. (1991). "Who's Afraid of Marcel Duchamp?" in *Philosophy and Art*, ed. Daniel O. Dahlstrom. Washington: Catholic University of America.

Brown, Donald E. (1991). *Human Universals.* Philadelphia: Temple University Press.

Bunzel, Ruth. (1929). *The Pueblo Potter: A Study of Creative Imagination in Primitive Art.* New York: Columbia University Press.

Buss, David M. (1994). *The Evolution of Desire: Strategies of Human Mating.* New York: Basic Books.

———. (1999). *Evolutionary Psychology: The New Science of the Mind.* Boston: Allyn & Bacon.

Buss, David M., ed. (2005). *The Handbook of Evolutionary Psychology.* Hoboken, New Jersey: John Wiley.

Carroll, Joseph. (2004). *Literary Darwinism: Evolution, Human Nature, and Literature.* New York: Routledge.

———. (2006). "The Human Revolution and the Adaptive Function of Literature." *Philosophy and Literature* 30:33–49.

Carroll, Noël. (1994). "Identifying Art," in *Institutions of Art: Reconsiderations of George Dickie's Philosophy*, ed. Robert J. Yanal. University Park: Pennsylvania State University Press.

———. (1999). *The Philosophy of Art: A Contemporary Introduction.* New York: Routledge.

———, ed. (2000). *Theories of Art Today*. Madison: University of Wisconsin Press.

———. (2009). *On Criticism*. New York: Routledge.

Cascardi, Anthony J., ed. (1987). *Literature and the Question of Philosophy*. Baltimore: Johns Hopkins University Press.

Coe, Kathryn. (2003). *The Ancestress Hypothesis*. Piscataway, New Jersey: Rutgers University Press.

Collingwood, R. G. (1938). *The Principles of Art*. Oxford: Oxford University Press.

Cooke, Brett, and Frederick Turner, eds. (1999). *Biopoetics: Evolutionary Explorations in the Arts*. Lexington, Kentucky: ICUS Books.

Coote, Jeremy, and Anthony Shelton, eds. (1992). *Anthropology, Art, and Aesthetics*. Oxford: Clarendon Press.

Cosmides, Leda, and John Tooby. (2000). "Evolutionary Psychology and the Emotions," in *Handbook of Emotions*, ed. M. Lewis and J. M. Haviland-Jones, 2nd ed. New York: Guilford.

———. (2000). "Consider the Source: The Evolution of Adaptations for Decoupling and Metarepresentation," in *Metarepresentations*, ed. Dan Sperber. New York: Oxford University Press.

Cronin, Helena. (1991). *The Ant and the Peacock: Altruism and Sexual Selection from Darwin to Today*. Cambridge: Cambridge University Press.

Currie, Gregory. (2004). *Arts and Minds*. New York: Oxford University Press.

Daly, Martin, Catherine Salmon, and Margo Wilson. (1997). "Kinship: The Conceptual Hole in Psychological Studies of Social Cognition and Close Relationships," in *Evolutionary Social Psychology*, ed. J. A. Simpson and D. T. Kenrick. Mahwah, New Jersey: Lawrence Erlbaum.

Danto, Arthur C. (1964). "The Artworld." *Journal of Philosophy* 61:571–84.

———. (1981) *The Transfiguration of the Commonplace*. Cambridge: Harvard University Press.

———. (1986). "Appreciation and Interpretation," in *The Philosophical Disenfranchisement of Art*. New York: Columbia University Press.

———. (1988). "Artifact and Art," in the exhibition catalogue for *ART/artifact*. New York: Center for African Art.

———. (1997). "Can It Be the 'Most Wanted' Even if Nobody Wants It?" in Wypijewski (1997).

Darwin, Charles. (1896a). *The Descent of Man, and Selection in Relation to Sex*. New York: Appleton. Originally published in 1871.

———. (1896b). *The Expression of the Emotions in Man and Animals*. New York: Appleton. Originally published in 1872.

———. (1896c). *The Variation of Animals and Plants Under Domestication*, 2 vols., 2nd ed. New York: Appleton. Originally published in 1868.

————. (2003). *On the Origin of Species*, ed. Joseph Carroll. Peterborough, Ontario: Broadview Press. Originally published in 1859.

Davies, Stephen. (1991). *Definitions of Art*. Ithaca: Cornell University Press.

————. (2000). "Non-Western Art and Art's Definition," in Noël Carroll (2000).

————. (2004). "The Cluster Theory of Art." *British Journal of Aesthetics* 44:297–300.

Davies, Stephen, and Ananta Charana Sukla, eds. (2003). *Art and Essence*. Westport, Connecticut: Praeger.

Dennett, Daniel C. (1995). *Darwin's Dangerous Idea: Evolution and the Meanings of Life*. New York: Simon & Schuster.

Derrida, Jacques. (1983). "Signature Event Context," in *Margins of Philosophy*. Trans. Alan Bass. Chicago: University of Chicago Press.

Dickie, George. (1974). *Art and the Aesthetic: An Institutional Analysis*. Ithaca: Cornell University Press.

————. (1991). *The Republic of Art and Other Essays*. New York: Peter Lang. The essay "The Republic of Art" was first published in 1969.

Dissanayake, Ellen. (1990). *What Is Art For?* Seattle: University of Washington Press.

————. (1992). *Homo Aestheticus: Where Art Comes From and Why*. New York: Free Press; also in a new edition (2001) from University of Washington Press.

————. (1998). "Komar and Melamid Discover Pleistocene Taste." *Philosophy and Literature* 22: 486–96.

————. (2000). *Art and Intimacy: How the Arts Began*. Seattle: University of Washington Press.

Dolnick, Edward. (2008). *The Forger's Spell: A True Story of Vermeer, Nazis, and the Greatest Art Hoax of the Twentieth Century*. New York: HarperCollins.

Dutton, Denis. (1993). "Tribal Art and Artifact." *Journal of Aesthetics and Art Criticism* 51:13–21.

————. (1994). "The Experience of Art Is Paradise Regained: Kant on Free and Dependent Beauty." *British Journal of Aesthetics* 34:226–41.

————. (2000). "But They Don't Have Our Concept of Art," in Noël Carroll (2000).

————. (2001). "Aesthetic Universals," in *The Routledge Companion to Aesthetics*, ed. Berys Gaut and Dominic McIver Lopes. London: Routledge.

————. (2007). "Shoot the Piano Player." *New York Times*, February 26.

————, ed. (1983). *The Forger's Art: Forgery and the Philosophy of Art*, Berkeley and Los Angeles: University of California Press.

Ekman, Paul. (2003). *Emotions Revealed*. New York: Henry Holt.

Etcoff, Nancy. (1999). *Survival of the Prettiest: The Science of Beauty*. New York: Anchor Books.

Fodor, Jerry. (1998). "The Trouble with Psychological Darwinism." *London Review of Books*, January 22.

Foucault, Michel. (1969). "What Is an Author?" in *Textual Strategies: Perspectives in Post-Structuralist Criticism*, ed. Josué V. Harari. Ithaca: Cornell University Press.

Fry, Roger. (1923). "Negro Sculpture," in *Vision and Design*. London: Chatto & Windus.

Gaut, Berys. (2000). "*Art* as a Cluster Concept," in Noël Carroll (2000).

———. (2005). "The Cluster Account of Art Defended." *British Journal of Aesthetics* 45:273–88.

Geertz, Clifford. (1973). *The Interpretation of Cultures*. New York: Basic Books.

Gell, Alfred. (1992). "The Technology of Enchantment and the Enchantment of Technology," in Coote and Shelton (1992).

———. (1998). *Art and Agency: An Anthropological Theory*. New York: Oxford University Press.

Gilbert, Avery. (2008). *What the Nose Knows: The Science of Scent in Everyday Life*. New York: Crown Publishers.

Goldwater, Robert. (1962). *The Great Bieri*. New York: Museum of Primitive Art.

Goodman, Nelson. (1968). *Languages of Art*. Indianapolis: Hackett.

———. (1983). "Art and Authenticity," in Dutton (1983).

Gottschall, Jonathan, and David Sloan Wilson, eds. (2005). *The Literary Animal: Evolution and the Nature of Narrative*. Evanston: Northwestern University Press.

Gould, Stephen Jay. (1992). "Male Nipples and Clitoral Ripples," in *Bully for Brontosaurus*. New York: Norton.

———. (1997). "Evolution: The Pleasures of Pluralism." *New York Review of Books*, June 26.

Gould, Stephen Jay, and Richard C. Lewontin. (1979). "The Spandrels of San Marco and the Panglossian Paradigm: A Critique of the Adaptationist Programme." *Proceedings of the Royal Society of London* 205:281–88.

Guthrie, R. Dale. (2005). *The Nature of Paleolithic Art*. Chicago: University of Chicago Press.

Hansen, Brian. (1998). "Height-To-Head Ratio as a Marker of Status in Idealized Representations of Adult Human." Presentation to the Human Behavior and Evolution Society. Davis, California, July 11.

Hart, Lynn M. (1995). "Three Walls: Regional Aesthetics and the International Art World," in *The Traffic in Culture: Refiguring Art and Anthropology*, ed. George E. Marcus and Fred R. Myers. Berkeley: University of California Press.

Hassan, Ihab. (2006). "Postmodernism? A Self-Interview." *Philosophy and Literature* 30:223–28.

Havelock, Eric A. (1963). *Preface to Plato*. Cambridge: Harvard University Press, 1963.

Hebborn, Eric. (1993). *Drawn to Trouble*. New York: Random House.

Hogan, Patrick Colm. (2003). *The Mind and Its Stories: Narrative Universals and Human Emotions*. Cambridge: Cambridge University Press.

Humble, P. N. (1982). "Duchamp's Readymades: Art and Anti-art." *British Journal of Aesthetics* 22:52–64.

Huron, David. (2006). *Sweet Anticipation: Music and the Psychology of Expectation*. Cambridge: MIT Press.

Kant, Immanuel. (1987). *Critique of Judgment*. Trans. Werner S. Pluhar. Indianapolis: Hackett.

Kaplan, Stephen. (1992). "Environmental Preference in a Knowledge-Seeking, Knowledge-Using Organism," in Barkow et al. (1992).

Kaplan, Stephen, and Rachel Kaplan. (1982). *Cognition and Environment: Functioning in an Uncertain World*. New York: Praeger.

Koestler, Arthur. (1955). "The Anatomy of Snobbery." *Anchor Review* 1:1–25.

Kohn, Marek. (1999). *As We Know It: Coming to Terms with an Evolved Mind*. London: Granta Books.

Korsmeyer, Carolyn. (1999). *Making Sense of Taste: Food and Philosophy*. Ithaca: Cornell University Press.

Kuhn, Thomas S. (1962). *The Structure of Scientific Revolutions*. Chicago: University of Chicago Press.

Kulka, Tomas. (1996). *Kitsch and Art*. University Park: Pennsylvania State University Press.

Kundera, Milan. (1984). *The Unbearable Lightness of Being*. Trans. Michael Henry Heim. New York: Harper & Row.

Lamarque, Peter. (2009). *The Philosophy of Literature*. Oxford: Blackwell.

Lenain, Thierry. (1997). *Monkey Painting*. London: Reaktion Books.

———. (1999). "Animal Aesthetics and Human Art," in Bedaux and Cooke (1999).

Leslie, A. (1987). "Pretense and Representation: The Origins of 'Theory of Mind,'" *Psychological Review* 94:412–26.

Levinson, Jerrold. (1990). "Defining Art Historically," in *Music, Art, and Metaphysics*. Ithaca: Cornell University Press.

Lloyd, Elisabeth A. (2005). *The Case of the Female Orgasm: Bias in the Science of Evolution*. Cambridge: Harvard University Press.

Lopez, Jonathan. (2008). *The Man Who Made Vermeers: Unvarnishing the Legend of Master Forger Han van Meegeren*. New York: Harcourt.

Lyons, Elizabeth. (1983). "Demographic Correlates of Landscape Preference." *Environment and Behavior* 15:487–511.

Marcus, Gary. (2008). *Kluge: The Haphazard Construction of the Human Mind.* Boston: Houghton Mifflin.

Martindale, Colin. (1990). *The Clockwork Muse: The Predictability of Artistic Change.* New York: Basic Books.

Mead, Margaret. (1949). *Male and Female: A Study of the Sexes in a Changing World.* New York: William Morrow.

Meyer, Leonard B. (1983). "Forgery and the Anthropology of Art," in Dutton (1983).

Miller, Alan S., and Satoshi Kanazawa. (2007). *Why Beautiful People Have More Daughters.* New York: Penguin/Perigee.

Miller, Geoffrey F. (2000). *The Mating Mind: How Sexual Choice Shaped the Evolution of Human Nature.* New York: Doubleday.

———. (2001). "Aesthetic Fitness: How Sexual Selection Shaped Artistic Virtuosity as a Fitness Indicator and Aesthetic Preferences as Mate Choice Criteria." *Bulletin of Psychology and the Arts* 2.1:20–25.

———. (2003) "Fear of Fitness Indicators: How to Deal with Our Ideological Anxieties About the Role of Sexual Selection in the Origins of Human Culture," in *Being Human.* Wellington: Royal Society of New Zealand.

Mills, John FitzMaurice, and John M. Mansfield. (1979). *The Genuine Article: The Making and Unmasking of Fakes and Forgeries.* New York: Universe Books.

Mithen, Steven. (2003). "Handaxes: The First Aesthetic Artifacts," in Voland and Grammer (2003).

———. (2006). *The Singing Neanderthal: The Origins of Music, Language, Mind, and Body.* Cambridge: Harvard University Press.

Moravcsik, Julius. (1988). "Art and Its Diachronic Dimensions." *Monist* 71.2:157–70.

———. (1991). "Art and 'Art,'" *Midwest Studies in Philosophy* 16:302–13.

———. (1993). "Why Philosophy of Art in Cross-Cultural Perspective?" *Journal of Aesthetics and Art Criticism* 51:425–36.

Murray, Charles. (2003). *Human Accomplishment: The Pursuit of Excellence in the Arts and Sciences, 800 B.C. to 1950.* New York: HarperCollins.

Nehamas, Alexander. (1981). "The Postulated Author: Critical Monism as a Regulative Ideal." *Critical Inquiry* 8:133–49.

———. (1987). "Writer, Text, Work, Author," in Cascardi (1987).

Nettle, Daniel. (2002). "Women's Height, Reproductive Success, and the Evolution of Sexual Dimorphism in Modern Humans." *Proceedings of the Royal Society* 269:1919–23.

Novitz, David (1998). "Art by Another Name." *British Journal of Aesthetics* 38:12–32.

———. (2001). *The Boundaries of Art*, 2nd ed. Christchurch, New Zealand: Cybereditions.

Nussbaum, Martha C. (1997). *Poetic Justice: The Literary Imagination and Public Life*. Boston: Beacon Press.

Orians, Gordon H., and Judith H. Heerwagen. (1992). "Evolved Responses to Landscapes," in Barkow et al (1992).

Otten, Charlotte M., ed. (1971). *Anthropology and Art: Readings in Cross-Cultural Aesthetics*. Garden City, New York: Natural History Press.

Pfeiffer, John E. (1982). *The Creative Explosion: An Inquiry into the Origins of Art and Religion*. New York: Harper & Row.

Pinker, Steven. (1994). *The Language Instinct*. New York: William Morrow.

———. (1997). *How the Mind Works*. New York: W. W. Norton.

———. (2002). *The Blank Slate*. New York: Viking.

———. (2005). "How *Does* the Mind Work?" *Mind and Language* 20:1–24.

———. (2007). "Toward a Consilient Study of Literature," review of Gottschall and Wilson (2005). *Philosophy and Literature* 31:161–77.

Pinker, Steven, and Paul Bloom. (1992). "Natural Language and Natural Selection," in Barkow et al. (1992).

Posner, Richard. (1997). "Against Ethical Criticism." *Philosophy and Literature* 21:1–27.

Rubin, Paul H. (2002). *Darwinian Politics: The Evolutionary Origin of Freedom*. New Brunswick, New Jersey: Rutgers University Press.

Rubin, William S. (1984). *Dada, Surrealism, and Their Heritage*. New York: Abrams.

Ruso, Bernhart, LeeAnn Renninger, and Klaus Atzwanger. (2003). "Human Habitat Preferences: A Generative Territory for Evolutionary Aesthetics Research," in Voland and Grammer (2003).

Schiller, Friedrich. (1967). *On the Aesthetic Education of Man*. Trans. Elizabeth M. Wilkinson and L. A. Willoughby. Oxford: Oxford University Press. Originally published in 1794.

Searle, John R. (1958). "Proper Names." *Mind* 67:166–73.

Shiner, Larry, and Yulia Kriskovets. (2007). "The Aesthetics of Smelly Art." *Journal of Aesthetics and Art Criticism* 65:273–86.

Sibley, Frank. (2001). "Tastes, Smells, and Aesthetics," in *Approach to Aesthetics: Collected Papers on Philosophical Aesthetics*. Oxford: Oxford University Press.

Simonton, Dean Keith. (1999). *Origins of Genius: Darwinian Perspectives on Creativity*. New York: Oxford University Press.

Singh, Devendra, and Robert K. Young. (1995). "Body Weight, Waist-to-Hip Ratio, Breasts, and Hips: Role in Judgments of Female Attractiveness and Desirability for Relationships." *Ethology and Sociobiology* 16:483–507.

Smidt, Dirk. (1990). "Kominimung Sacred Woodcarvings," in *The Language of Things: Studies in Ethnocommunication*, ed. Pieter ter Keurs and Dirk Smidt. Leiden: Rijksmuseum voor Volkenkunde.

Smith, Marian W., ed. (1961) *The Artist in Tribal Society*. London: Routledge & Kegan Paul.

Sober, Elliott, and David Sloan Wilson. (1998). *Unto Others: The Evolution and Psychology of Unselfish Behavior*. Cambridge: Harvard University Press.

Sparshott, Francis. (1982). *The Theory of the Arts*. Princeton: Princeton University Press.

———. (1999). *The Concept of Criticism*. Christchurch, New Zealand: Cybereditions. Originally published in 1967.

Stern, Laurent. (1980). "On Interpreting." *Journal of Aesthetics and Art Criticism* 39:119–29.

Storey, Robert. (1996). *Mimesis and the Human Animal: On the Biogenetic Foundations of Literary Representation*. Evanston: Northwestern University Press.

Sugiyama, Michelle Scalise. (2005). "Reverse-Engineering Narrative: Evidence of Special Design," in Gottschall and Wilson (2005).

Swirski, Peter. (2008). *Of Literature and Knowledge: Explorations in Narrative Thought Experiments, Evolution, and Game Theory*. London: Routledge.

Symons, Donald. (1979). *The Evolution of Human Sexuality*. New York: Oxford University Press.

Tavinor, Grant. (2005). "Video Games and Interactive Fiction," *Philosophy and Literature* 29:24–40.

———. (2009). *The Art of Videogames*. Oxford: Blackwell.

Telfer, Elizabeth. (1996). *Food for Thought*. London: Routledge.

Thornhill, Randy. (1998). "Darwinian Aesthetics," in *Handbook of Evolutionary Psychology*, ed. Charles Crawford and Dennis Krebs, Mahwah, New Jersey: Lawrence Erlbaum.

Tolstoy, Leo. (1960). *What is Art?* Trans. Aylmer Maude. Indianapolis: Bobbs-Merrill. Originally published in 1896.

Tooby, John, and Leda Cosmides. (1990). "The Past Explains the Present: Emotional Adaptations and the Structure of Ancestral Environments." *Ethology and Sociobiology* 11:375–424.

———. (2001). "Does Beauty Build Adapted Minds? Toward an Evolutionary Theory of Aesthetics, Fiction, and the Arts." *SubStance* 94/95:6–27.

Ulrich, Roger S. (1993). "Biophilia, Biophobia, and Natural Landscapes," in *The Biophilia Hypothesis*, ed. Stephen R. Kellert and Edward O. Wilson. Washington: Shearwater/Island Press.

Van Damme, Wilfried. (1996). *Beauty in Context: Towards an Anthropological Approach to Aesthetics*. Leiden: Brill.

Veblen, Thorstein. (1994). *The Theory of the Leisure Class*. New York: Dover. Originally published in 1899.

Vogel, Susan Mullin. (1991). "Elastic Continuum," in *Africa Explores: 20th Century African Art*. New York: Center for African Art.

————. (1997). *Baule: African Art, Western Eyes*. New Haven: Yale University Press.

Voland, Eckart. (2003). "Aesthetic Preferences in the World of Artifacts: Adaptations for the Evaluation of Honest Signals?" in Voland and Grammer (2003).

Voland, Eckart, and Karl Grammer, eds. (2003). *Evolutionary Aesthetics*. Berlin: Springer-Verlag.

Wallin, Nils L., Björn Merker, and Steven Brown, eds. (1999). *The Origins of Music*. Cambridge: MIT Press.

Weiner, James, ed. (1994). *Aesthetics Is a Cross-cultural Category*. Manchester: University of Manchester.

Werness, Hope B. (1983). "Han van Meegeren *Fecit*," in Dutton (1983).

Whorf, Benjamin Lee. (1956). *Language, Thought, and Reality*. Cambridge: MIT Press.

Wilson, David Sloan. (2002). *Darwin's Cathedral: Evolution, Religion, and the Nature of Society*. Chicago: University of Chicago Press.

————. (2007). *Evolution for Everyone*. New York: Delacorte Press.

Wilson, Edward O. (1998). *Consilience: The Unity of Knowledge*. New York: Alfred A. Knopf.

Wimsatt, William K., and Monroe C. Beardsley. (1946). "The Intentional Fallacy." *Sewanee Review* 54:468–88.

Wittgenstein, Ludwig. (1958). *Philosophical Investigations*, 2nd ed. New York: Macmillan. Originally published in 1953.

Wright, Robert. (1994). *The Moral Animal*. New York: Pantheon.

Wyndham Lewis, D. B., and Charles Lee. (2003). *The Stuffed Owl: An Anthology of Bad Verse*. New York: NYRB Classics. The first of many editions was published in 1930.

Wynne, Frank. (2006). *I Was Vermeer: The Legend of the Forger Who Swindled the Nazis*. London: Bloomsbury.

Wypijewski, JoAnn, ed. (1997). *Painting by Numbers: Komar and Melamid's Scientific Guide to Art*. New York: Farrar, Straus & Giroux.

Zahavi, Amotz, and Avishag Zahavi. (1997). *The Handicap Principle: A Missing Piece of Darwin's Puzzle*. New York: Oxford University Press.

Zunshine, Lisa. (2006). *Why We Read Fiction: Theory of Mind and the Novel*. Columbus: Ohio State University Press.

————. (2007). "Response to Brian Boyd." *Philosophy and Literature* 31:189–96.

Index

A Note on the Author

Denis Dutton is a professor of aesthetics and the philosophy of art at the University of Canterbury, New Zealand. He founded and still edits the highly successful Johns Hopkins University Press scholarly journal *Philosophy and Literature*. He also conceived and continues to edit *Arts & Letters Daily*, one of the most heavily trafficked Web sites anywhere for news and opinion in science, the arts, and ideas. *Arts & Letters Daily* was named by the *Guardian/Observer* as the "best website in the world."